ART AND ARCHAEOLOGY OF
ROME

From Ancient Times to the Baroque

edited by
Andrea Augenti

texts by
Maria Conconi, Ilaria Miarelli Mariani,
Fabio Pagano, Enrico Parlato, Cristina Romano,
Patrizia Tosini, Caterina Volpi

SCALA/RIVERSIDE

ART AND ARCHAEOLOGY OF ROME
From Ancient Times to the Baroque

edited by *Andrea Augenti*

Contributing authors

Maria Conconi, pages 5-59
Fabio Pagano, pages 61-70, 72-78, 91, 97
Cristina Romano, pages 71, 79-90, 92-96, 98-103
Enrico Parlato, pages 105-135, 158-159
Patrizia Tosini, pages 136-157
Caterina Volpi, pages 161-188, 194-197
Ilaria Miarelli Mariani, pages 189-193, 198-223

Translation
Huw Evans

Editing
Patrizia Bevilacqua

Photographs
Archivio Fotografico SCALA Group (Falsini, Migliorati, Sarri)
except: pages 74, 118, 119, 150 b, 157, 174-175 (Vasari);
page 115 (Migliorati); page 123 (Musées Royaux des Beaux-Arts,
Bruxelles); pages 129, 130, 131, 132 (Archivio Fotografico dei
Musei Vaticani); page 140 (Museum of Fine Arts, Boston);
page 156 a (Centro di Studi sulla cultura e l'immagine di Roma);
page 176 b (Segretariato Generale della Presidenza della
Repubblica – Editoriale Lavoro); page 190 b (Jemolo); page 216
Musei Capitolini / A. Idini)

Drawings
Giorgio Albertini

Published by
Riverside Book Company, Inc.
250 West 57th Street
New York, N.Y. 10107
www.riversidebook.com

ISBN 1-878351-56-7

Contents

ANCIENT
ROME

From the Origins to the Age of the
 Kings 5
■ The Walls of Rome 8
The Republic 9
The Works of Caesar 13
Augustus and the Birth of the
 Empire 16
■ The Bridges of Ancient Rome 19
■ The Appian Way 22
■ Ancient Rome Emerges from the
 Modern City 30
Nero and the Flavian Dynasty 30
From the Apogee to the Late
 Classical Era 39
■ The Excavation of the Imperial
 Forums 49
◆ National Etruscan Museum of
 Villa Giulia 50
◆ The National Roman Museum 52
◆ Capitoline Museums 56
◆ The Vatican Museums 57

MEDIEVAL
ROME

The Age of Constantine 61
■ The Catacombs 71
The New Monumental Buildings:
 the Fifth Century 72
The City is Transformed 79
■ The Cosmati 82
■ The Cloisters 85
The Carolingian Era 86
■ The Leonine City 91
Toward the New Millennium 91
The Late Middle Ages 92
■ The Towers of Rome 97
■ Pietro Cavallini, Jacopo Torriti
 and Arnolfo di Cambio 101

RENAISSANCE
ROME

The Pontificate of Martin V 105
■ The Branda Chapel in San
 Clemente 107
Nicholas V 111
■ The Bronze Door of St. Peter's 112
■ The Chapel of Nicholas V 113
Paul II 114
Sixtus IV 115
■ The Carafa Chapel in Santa
 Maria sopra Minerva 118
■ Santa Maria del Popolo 120
■ Innocent VIII's Belvedere 123
Julius II 123
■ The Sistine Chapel 128
■ The Basilica of St. Peter 133
■ Raphael's Stanze 136
From the Sack of Rome to
 Paul III's Renovatio Urbis 140
■ Paul III's Apartment in Castel
 Sant'Angelo 143
■ Michelangelo's Reorganization of
 the Capitol 144
From Julius III to Sixtus V 146
■ The Patronage of Alessandro
 Farnese 150
■ The Decoration of the
 Oratories 153
■ Sixtus V's Pictorial
 Enterprises 156
◆ The Pinacoteca Vaticana 158

BAROQUE
ROME

"The Variety of Manner" 161
"Decorously Adorning Palaces with
 Pictures" 161
The Art of Clement VIII and
 "the Flavor of the Good" 164

"Look Out for Things by Annibale
 and Caravaggio" 166
■ The Farnese Gallery 167
Private Aestheticism and Public
 Virtue 175
The Emilians in Rome 180
The Empire of a Pope 184
Frugality and the Jubilee 189
Cardinal Camillo Pamphilj 192
■ The Fountains of Rome 194
The Predominance of Pietro da
 Cortona 198
The Grandiose City-Planning
 Schemes of Alexander VII 200
■ Francesco Borromini in
 Rome 208
◆ National Gallery of
 Ancient Art 210
◆ Capitoline Picture Gallery 216
◆ Doria Pamphilj Gallery 217
◆ Borghese Gallery 220
◆ Spada Gallery 223

Bibliography 224

ANCIENT
ROME

From the Origins
to the Age of the Kings

Rome grew up in the valley of the Tiber, at a point where the riverbed, which used to be narrower and deeper than at present, spread out to form a series of marshes and was easy to cross. Two important means of communication met here: the river itself, navigable for much of its course and linking the coast and the hinterland, and the route running in a north-south direction between Etruria and Campania. The Via Salaria or Salt Road, used by the peoples of the interior since the remote past to transport salt from the sea, also passed through this point. Thus the site of the future city was an important place of meeting and exchange between different peoples: a fair and a market developed there, and were to remain active for centuries under the names of the Forum Boarium (Cattle Fair) and Forum Holitorium (Vegetable Market). Archeological finds suggest that the area was permanently occupied from the middle of the Bronze Age onward (fourteenth-thirteenth century BC).

In the Iron Age (around the beginning of the tenth century BC), a number of groups progressively settled on the hills around the Palatine, which was favored right from the start as it commanded the river crossing. Thus a series of villages grew up. It is quite likely that they were originally independent of one another, both as a consequence of their different ethnic origins and because the valleys that separated the hills were deeper than they are today (over the centuries the valleys have slowly filled up, a process

due in large part to the practice of building on top of the ruins of older constructions). Huts datable to this period have been found on the Palatine, Esquiline and Quirinal. Gradually, however, the different communities were integrated into a sort of federation with common religious and administrative practices, as is testified by records of the Septimontium (the name of the federation that united settlements on the Palatine, Velia, Germalus, Caelian, Cispius, Oppian, Fagutal and Subura hills; the term was later used for a religious ceremony) and the appearance of a necropolis shared by the various villages, on the Esquiline. This process of assimilation is summed up in the tradition of the city's origins, which according to legend was founded by Romulus on the Palatine in 754-753 BC. A hut discovered on the southwestern corner of the hill was identified as that of Romulus and has been reconstructed and maintained for centuries.

During the eighth and seventh centuries BC Rome expanded and extended its control over the whole of the lower course of the Tiber, but it was the sixth century that brought its urbanization and a reorganization of its political and military structures. Traditionally, this phase is held to coincide with the reigns of Tarquinius Priscus, Servius Tullius and Tarquinius Superbus, kings of Etruscan origin who ruled Rome from 616 to 510-509 BC, when the last king was driven out and the republic founded.

Under the Tarquins the city was ringed with walls and the *pomerium*, the juridical and religious boundary of the city, was defined. The urban part was divided into four administrative *regiones* (Palatine, Collina, Esquiline, Suburana) and the population was organized on the basis of property,

Top, cinerary urn in the shape of a hut. Antiquarium of the Forum

Right, model of archaic hut. Antiquarium of the Palatine

On facing page, fragment of fresco with Apollo from a building on the Palatine. Antiquarium of the Palatine

Archaic Rome

1 **Walls of Servius Tullius**
2 **Quirinal**
3 **Viminal**
4 **Cispius**
5 **Esquiline**
6 **Oppian**
7 **Caelian**
8 **Aventine**
9 **Palatine**
10 **Capitol**
11 **Temple of Jupiter on the Capitol**
12 *Volcanal*
13 **Temples of Fortuna and the Mater Matuta**
14 **Forum Boarium**
15 **Hut of Romulus**
16 **Tabularium**
17 **Roman Forum**
18 **Regia**

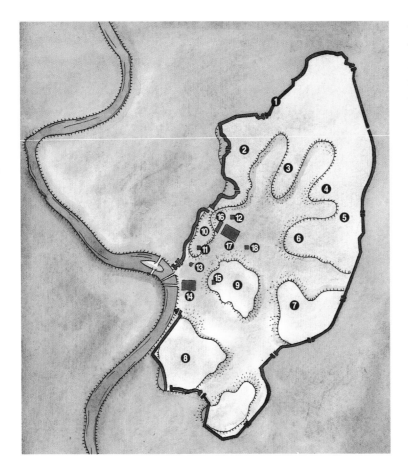

A section of the ancient Servian Wall on the Aventine, rebuilt in the 4th century BC.

Bottom, the outlet of the Cloaca Maxima near the Ponte Rotto

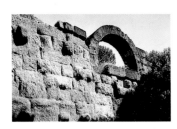

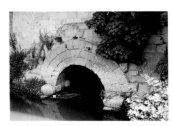

with earth and a series of cuts were made (in both ancient and modern times) into the surrounding hillsides, enlarging the original piece of level ground. The reclamation and paving of the Forum, archeologically documented since the end of the seventh century BC, were the earliest of these changes and they turned the area into the center of the city's political and administrative life. Strictly speaking, the part reserved for political assemblies and judicial activities was the Comitium, in the northern part of the valley, at the foot of the Capitol. It is also the area in which the small sanctuary of the Lapis Niger, containing an inscription of a sacred character dating from the seventh-sixth century BC, was found. To the south of the Comitium lay the Forum proper, a marketplace surrounded by porticoes and *tabernae* (small stores). We know that at the end of the sixth century the Regia was also reconstructed: traditionally the house of King Numa Pompilius (which in the republican era became the seat of the highest priestly office, the *pontifex maximus*), it was situated in the southeastern part of the Forum, in front of the temple of Vesta. This temple, also linked by tradition to King Numa, was one of the city's most important shrines and housed the sacred fire.

The sixth century saw important developments in the field of religious construction as well. It was at this time that the temple dedicated to Jupiter, Juno and Minerva, the protective deities of Rome, was built. Founded, according to the sources, by Tarquinius Priscus, the temple was completed during the reign of Tarquinius Superbus, although its consecration did not take place until after his expulsion, during the first year of the republic's existence (510-509). The building, set on an imposing podium, had a columned front and was divided internally into three cells, one for each of the deities

which was used to determine the political rights, military duties and tax liabilities of citizens.

It has been calculated that Rome had some 30-40 thousand inhabitants at the time and that it covered an area of around 300 hectares (740 acres), which made it from three to four times as big as the largest of the other Latin cities. However, it should be borne in mind that many uninhabited zones, such as woods and marshes, were included in this territory. It was during the age of the Tarquins that the marshy land on the valley bottoms between the hills was drained, with the digging of a series of canals. In particular, the swamp of the Velabrum, which extended from the Forum Boarium to the valley of the Forum Romanum, was drained by the construction of the Cloaca Maxima. Today it is difficult for us to imagine what this valley looked like in the archaic era. In fact the original narrow basin has been transformed over the centuries as it progressively filled up

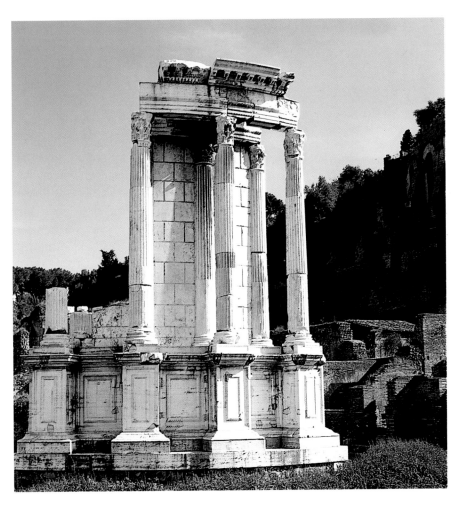

Roman Forum, the temple of Vesta in its 1930 reconstruction

Capitoline She-Wolf, **early 5th century BC. Musei Capitolini**

used to cover the wooden structure of the temples and allow us to reconstruct their appearance in broad outline. The Tarquins are also believed to have been responsible for the first layout of what later came to be known as the Circus Maximus, in the valley between the Palatine and Aventine, the *vallis Murcia*, used for chariot races.

Hence Rome assumed a truly urban aspect under the Tarquins, with defensive structures and functional and symbolic areas, and began to attract traders in luxury goods (some of Greek origin) and skilled artists. It was a workshop of artists from Etruria or Magna Graecia active in Rome that made the famous statue of the *Capitoline She-Wolf*, dating from the beginning of the fifth century BC and one of the few examples of bronze sculpture from the archaic era to have survived.

This specific trait of the city, i.e. the fact that it has been open to cultural contact and exchange with different peoples from the earliest times, is also a characteristic of the history of Roman art, which is defined as such not because the artists who created it were Roman in the ethnic sense, but because it developed and found its patrons within the Roman political and social system. As we have seen, Roman art was initially produced by Etruscan artists, and Etruscan, Italic and Greek artistic forms existed side by side in Rome for a long time. It was not until the first century BC, during the final years of the republic and then under the reign of Augustus, that these different traditions were fused into an art that can be described as distinctively Roman.

venerated. Tradition has it that Etruscan craftsmen from the city of Veii, and in particular the famous Vulca, were summoned by the Tarquins to decorate the sanctuary with clay figures. Unfortunately none of these have survived (though we know that Jupiter's four-horse chariot was set on the roof).

Etruscan craftsmen and masons were also involved in the construction of the temples of Fortuna and the Mater Matuta, traditionally attributed to Servius Tullius, in the Forum Boarium (this zone, like the Forum itself, had been drained, and steps had also been taken to reorganize the city's river port, the Portus Tiberinus). Partial remains of these two temples, dating from the middle of the sixth century, were brought to light during excavations carried out in the so-called sacred area of Sant'Omobono. The buildings were twin structures whose plan remains uncertain. Archeologists have unearthed a considerable number of architectural fragments made of clay, datable to the years 540-530 BC. These decorative elements were

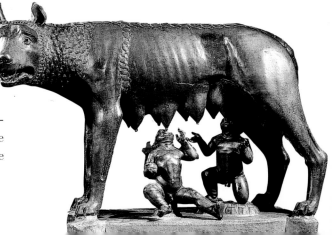

The Walls of Rome

The construction of Rome's first walls is traditionally ascribed to King Servius Tullius. Whether a ring of walls actually existed in the archaic period has long been a matter of debate, but it now seems probable: traces of fortifications in *opus quadratum* datable to the sixth century BC have been identified in various parts of the city, although it remains difficult to reconstruct the layout of these first walls. However, these fortifications were not enough to stop the Gauls, who sacked the city in 390 BC. This prompted the Romans to undertake the construction of a new and more effective defensive structure. Erroneously called the Servian Wall, this extended for around 11 kilometers or 7 miles, linking the Capitol, Quirinal, Esquiline, Oppian, Caelian and Palatine. The wall, around 4 meters or 13 feet thick and up to 10 meters or 33 feet high, is built out of blocks of tufa laid alternatively head-on and edge-on. In the most exposed stretch, between the Quirinal and Esquiline, the wall was reinforced by an embankment and ditch. The fourth-century walls were repaired on several occasions but gradually fell into ruin. Part of them had already collapsed by the first century BC. The best-preserved section is located on the southern side of the Aventine and on Piazza dei Cinquecento.

It was only under the emperor Aurelian, in AD 271, that the decision was taken to construct new walls. The work was carried out in haste, as is evidenced by the fact that numerous preexisting buildings were incorporated into the fortifications, and was already complete by the emperor's death, in 275. The Aurelian Wall, of which long sections are still visible, ran for a distance of around 19 kilometers or 12 miles and included the majority of the 14 Augustan *regiones* as well as part of what is now Trastevere. Built out of brick, it was about 3·5 meters or 11·5 feet thick and 6 meters or nearly 20 feet high. It was studded with a total of 381 rectangular towers, located approximately every 30 meters or 100 feet (100 Roman feet). The walls were pierced by numerous gates, of which the most important were flanked by semicircular towers.

Over the centuries the Aurelian Wall was repeatedly repaired and strengthened: first by Maxentius, at the beginning of the fourth century, and then again at the start of the

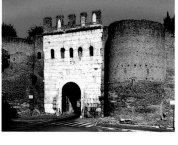

next, when the height of the walls was doubled by the construction of a gallery. Various other interventions followed, right up to the modern era, when the walls were defended against Italian troops by the papal army in 1870.

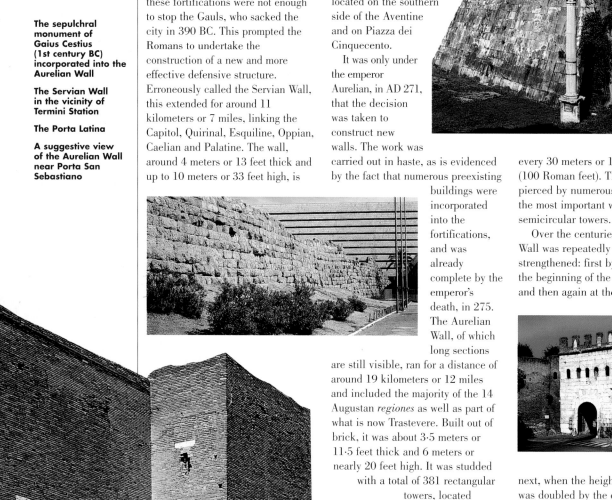

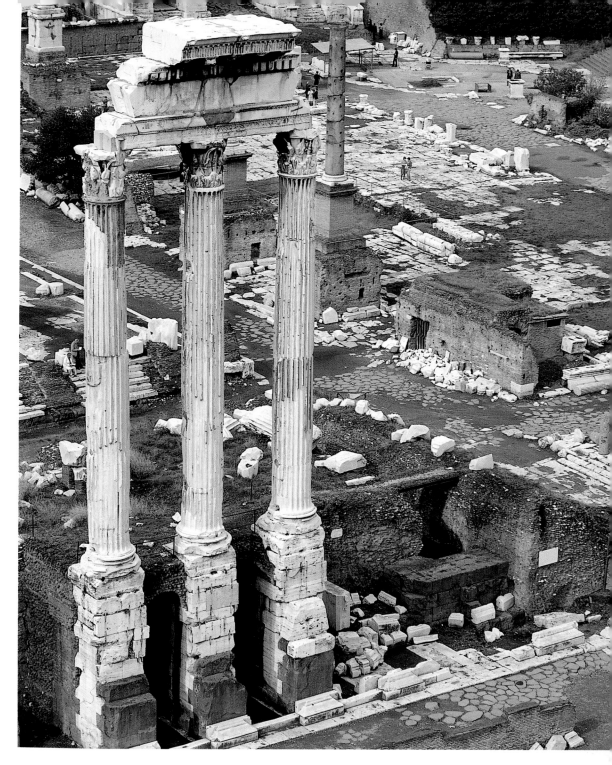

Roman Forum, the temple of Castor and Pollux or the Dioscuri (484 BC)

The Republic

In the early years of the republic the frenzy of construction that had commenced under the Tarquins continued: the temples of Saturn (501-493 BC) and of Castor and Pollux (484), in the Forum, and the temple of Ceres Liber and Libera (493), at the foot of the Aventine, date from this period. In the years that followed, however, this was brought to a standstill as Rome engaged in a struggle for the control of Latium and was beset by internal conflict between patricians and plebs.

A resumption of building did not get under way until after the middle of the fourth century. It was at this time that the city received its new walls, its first aqueduct, the Aqua Appia (312 BC) and numerous places of worship, of which unfortunately very little has survived. But the temples in the sacred area of Largo Argentina, on the southern Campus Martius, give us some idea of what these structures must have looked like. Here we find four temples with their fronts more or less in line, built at different times but united in a single complex by the paving of the whole area and by the

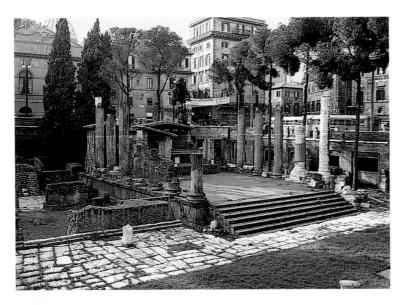

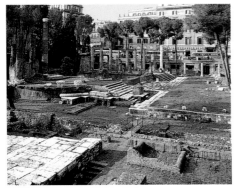

The temples in the sacred area of Largo Argentina

Capitoline Brutus, **mid-3rd century BC. Musei Capitolini**

gentina, with their different phases of construction, accurately reflect the development of temple architecture in the republican period. The architecture was characterized by an effort to reconcile the rigorous axiality of the Tuscan temple with the pattern of the Greek temple which, surrounded by columns, was meant to be viewed from all sides.

The revival of building in the fourth to third century affected the Forum as well. During this period the square ceased to be used as a food market and the *tabernae argentariae* were constructed: used for financial activities, they were surmounted by wooden platforms known as *maeniana*, from which people could watch theatrical performances or gladiatorial contests held in the Forum. In the same years the tribune of the orators of the Comitium was decorated with the *rostra* of ships captured by the Romans at the battle of Antium in 338 BC (whence the name Rostra given to the tribune), and numerous honorary bronze statues were erected in the Forum (including those of Romulus, Alcibiades and Pythagoras).

In most cases these works have been lost, but one has survived in the famous head known as the *Capitoline Brutus*, dating from around the middle of the third century BC. This sculpture, part of a now lost statue, was carved by a first-rate workshop which made use of the spare and essential formal language of middle Italic art. While the head may not be an actual portrait, the evident attention paid to physiognomic details constitutes an early example of the new need for self-representation felt by the emerging *nobilitas*.

We do not know much about Roman painting either, but the literary sources record the existence of "triumphal paintings" in this period. These pictures were displayed at parades celebrating triumphs and depicted battles and other episodes in the war. Nothing remains of these paintings, but the fresco found in a tomb on the Esquiline (now in the Palazzo dei Conservatori) and dated to the end of the third century exemplifies their characteristics. It represents the military exploits of the deceased, arranged in several rows. The episodes in which the protagonist himself is involved run across the four surviving rows

porticoes that surround it. The identity of these temples is controversial and they are usually referred to by the first four letters of the alphabet, in order from north to south. The oldest of the four buildings – and the earliest surviving stone temple in Rome – is temple C, dating from the fourth century BC. Set on a tall podium with a broad flight of steps, the temple was peripteral *sine postico*, i.e. it had columns on all sides except the rear. The next in chronological order is temple A, whose oldest part dates from the third century. The original building had columns only at the front, but at the beginning of the first century BC it was transformed into a peripteral temple. Temple D, datable to the second half of the second century BC, has only been partially excavated and is the one about which the least is known. At the end of the second century BC the level of the whole area was raised and the sacred precincts were paved with tufa. At the level of this paving stands temple B, a building on a low podium with a round cell that is ringed by eighteen columns with Corinthian capitals.

The temples of Largo Ar-

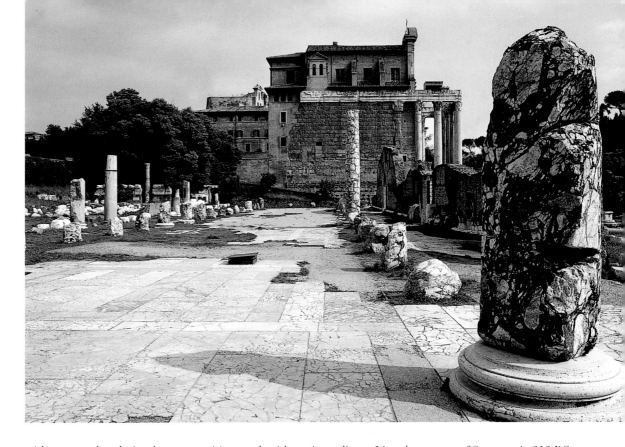

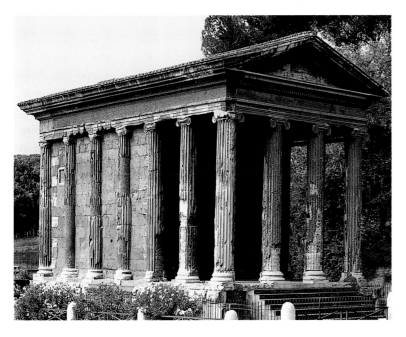

Roman Forum, the remains of the Basilica Aemilia

Forum Boarium, the temple of Portunus, an example of architecture from the republican era (1st century BC)

without any break in the composition and with scanty respect shown for perspective and proportions. The intention is narrative and commemorative, rather than artistic. The encounter of the Roman aristocracy's conceptual requirements with the formal language of the Greek tradition was to give rise to the characteristic genres of Roman figurative art, the portrait and the historical relief.

Between the third and the second century Rome expanded its dominion over the whole of the Mediterranean and came into direct contact with cities in which Hellenist culture and art held sway.

According to Livy, the capture of Syracuse in 212 BC "marked the beginning of admiration for the works of art produced by the Greeks" and in these years a large number of Greek sculptures and paintings must have been brought back to Rome as war booty. They included originals from different periods and in different styles as well as copies produced to satisfy the growing demand on the part of wealthy Roman collectors, who were eclectic in their tastes and often more interested in the rarity and monetary value of the pieces than in their artistic worth. The formal innovations of Greek art would not be fully understood and assimilated by Roman art until the reign of Augustus.

The role of a major power that Rome came to assume in the third and second century led to a new phase of construction in the city. *Insulae*, houses on several stories that could accommodate various families, started to be built to house its growing population. The more prosperous classes lived in larger houses, the *domus*, which had colonnaded courtyards and were richly decorated. Various parts of the city were given an increasingly monumental appearance. This was especially true of the Forum, where four basilicas were constructed over the course of the second century BC. Large covered halls, they were used for business and legal activities when the weather was inclement. The first of them was the Basilica Porcia, built in 184 BC at the behest of Cato. It was followed within a short

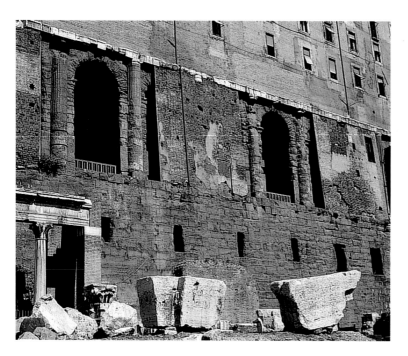

Detail of the arches of the Tabularium

The Porticus Octaviae

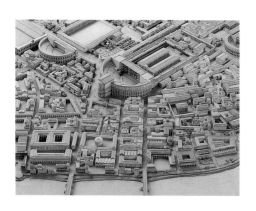

Model of Rome, detail with the theater of Pompey. Museo della Civiltà Romana

space of time by the Aemilia, Sempronia and Opimia. Of these only the Basilica Aemilia retains its original plan and some of its original structures, although the building has undergone several restorations over the course of time. Built in 179 BC on the north side of the Forum – behind the *tabernae argentariae* – the Basilica Aemilia is a large rectangular space (70 x 29 meters or 230 x 95 feet), divided into a central nave and three aisles, one on the south side and two on the north side, by a series of columns. The surviving columns, like the marble flooring, date from Augustus's reign. The basilica was renovated one more time at the beginning of the fifth century AD, after it had burned down during the sack of the city by the Goths in 410: a number of coins that had melted during the fire can still be seen on the Augustan paving.

The layout of the Forum, whose northern and southern limits were marked by the Basilica Aemilia and the Basilica Sempronia respectively, was regularized on the western side by the construction of the state archives, known as the Tabularium (78 BC). This building, with two stories set on imposing substruc-

tures, is significant from the architectural viewpoint as, in addition to documenting the now established use of *opus caementicium*, or concrete, and vaulted roofs, it constitutes the earliest known example of the arch framed by half columns. This solution would later be adopted in numerous other buildings, from the theater of Marcellus to the Colosseum.

Another part of the city which saw the construction of large numbers of monuments in the middle and late republican periods was the Campus Martius, especially the area around the Circus Flaminius (built in 221 BC), which served as the starting point for triumphal parades. Numerous temples, buildings used for entertainment purposes, baths and monumental porticoes were built in this area. Only one of these porticoes has survived in part, the Porticus Metelli, constructed in 146 BC around the temples of Juno Regina, which already existed, and Jupiter Stator, erected at the same time as the portico and the first temple in Rome to be built entirely out of marble. The build-

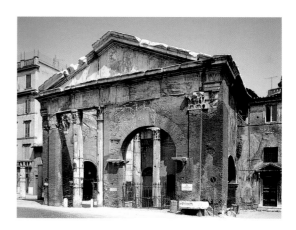

ing has undergone several renovations. Augustus was the first to restore it and also renamed the complex in honor of his sister, calling it the Porticus Octaviae. The portico attained its present dimensions (about 119 x 132 meters or 390 x 433 feet) following an intervention in the Severian period and the remains that can be seen today date from that time. The best-preserved part is the entrance propylaeum on the southern side, where some of the columns and the side walls of brick are still standing.

It was on the Campus Martius that Rome's first masonry theater was built between 61 and 55 BC. Pompey's Theater was an imposing structure with an immense portico behind the stage.

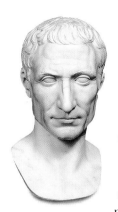

**Head of Caesar.
Museo
Pio-Clementino,
Vatican**

**The theater of
Marcellus**

The Works of Caesar

Julius Caesar, according to Cicero, had ambitious plans for the urban development of Rome, including that of diverting part of the course of the Tiber so as to link the Campus Martius with the Ager Vaticanus. The dictator was assassinated before he could bring this project to a conclusion. However, we can ascribe the construction of several buildings on the Campus Martius to his initiative, including the theater of Marcellus, later completed by Augustus (probably in 17 BC) and dedicated to his nephew and presumed heir. The building was erected on the eastern side of the Circus Flaminius, which was then turned into a square. The *cavea* was constructed on imposing substructures (originally over 32 meters or 105 feet high), decorated on the outer front by a travertine façade consisting of two tiers of arches framed by half columns with Doric

and Ionic capitals respectively. Many of these have survived to the present day, incorporated into the façade of Palazzo Orsini. The third story, a solid attic decorated with pilaster strips with Corinthian capitals, has now vanished. Nothing is left of the scene building either, but we know that it was celebrated in antiquity for the richness of its scenery and that behind it stood a portico, or perhaps an exedra, as well as two small *sacelli*, or votive shrines, dedicated to Diana and Pietas.

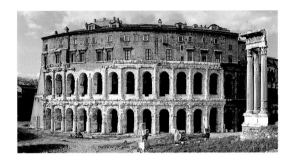

Caesar made up for the demolition of the Circus Flaminius by enlarging the Circus Maximus. According to the ancient sources, the new circus was 621 meters (680 yards) long and 118 meters (130 yards) wide, and it had an estimated capacity of 150,000 spectators. Augustus completed the work by erecting the obelisk of Rameses II on the *spina* in the middle. Almost 24 meters (78 feet) high, it was moved to Piazza del Popolo in the sixteenth century. A second one was added in 357 by Constantius II: the obelisk of Thutmosis III, it was 32·5 meters (107 feet) high and transferred to Piazza di San Giovanni in Laterano in the sixteenth century.

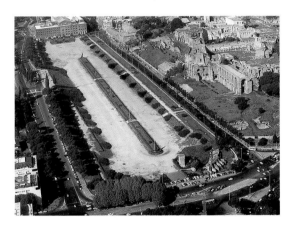

**Aerial view of the
Circus Maximus**

**Relief with chariot
races in the
Circus Maximus,
late 2nd-early 3rd
century AD. Museo
Archeologico, Foligno**

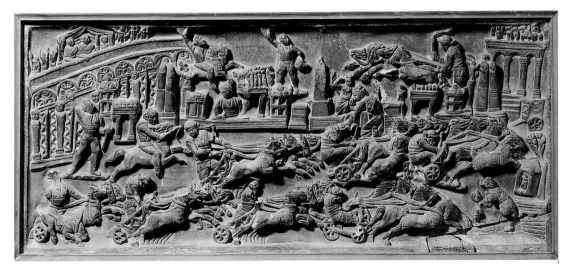

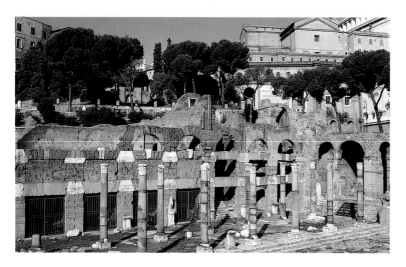

Two views of Caesar's Forum with detail of the stores, or *tabernae*, in the picture at the top

dred years (at least up until the fourth century AD) and over this time was damaged by several fires, requiring it to be rebuilt or restored. The remains still visible today, and in particular the western stretch of the curved side, date from the reign of Trajan.

Caesar's building schemes extended to the area of the Forum as well. One of the few projects that he was able to inaugurate in person, in 46 BC (though it was completed by Augustus) was that of the new forum, dedicated to the mythical ancestress of the *gens Julia*, the goddess Venus. The complex, which was the first of the Imperial Forums and served as the model for subsequent ones, consisted of a rectangular, porticoed square (75 x 160 meters or 246 x 525 feet), with an entrance on one of the short sides and the temple of Venus Genetrix on the other. This building, a peripteral *sine postico* temple with Corinthian columns, was constructed out of marble on a high podium with flights of steps at the sides.

In addition to the obelisks, seven bronze eggs and dolphins (the latter added by Agrippa), used to keep count of the number of laps completed by the chariots, were set on the *spina*, along with various small shrines. The Circus Maximus remained in use for several hun-

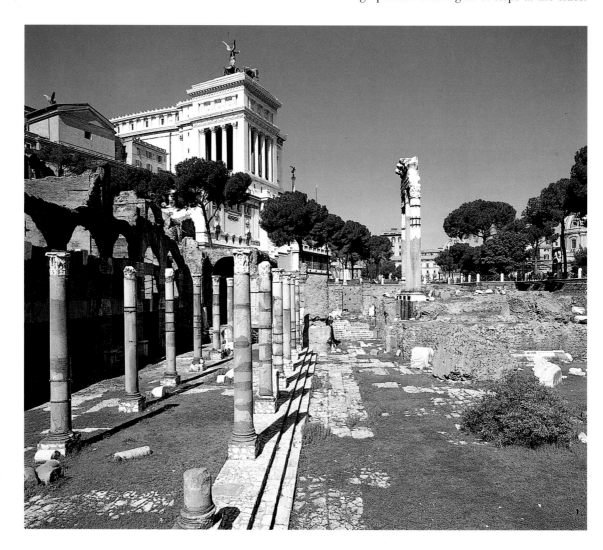

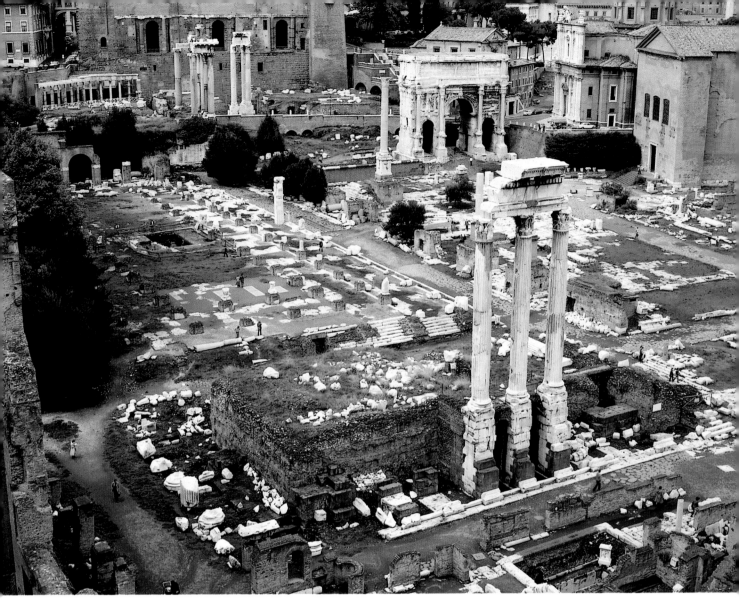

We know from the sources that the temple used to
house celebrated paintings and a precious collection
of gems. An equestrian statue of Caesar stood in the
middle of the square. Nothing is left of the original
forum except its general layout. The remains that
are still visible are chiefly those of a restoration
carried out in the time of Trajan, who completely
rebuilt the temple and colonnade, which were ad-
joined by the Basilica Argentaria at the southwest
corner. The construction of Caesar's Forum in the
northeast corner of the Republican Forum entailed
a rearrangement of the latter that was to condition
all subsequent interventions in the area: to make
room for the new complex the old Curia Hostilia
was demolished and rebuilt in a different position
as the Curia Julia, the Rostra were moved and the
Comitium itself was drastically reduced in size.
Finally, work commenced on construction of the
Basilica Julia (on the site of the Basilica Sempro-
nia) and on renovation of the Basilica Aemilia.

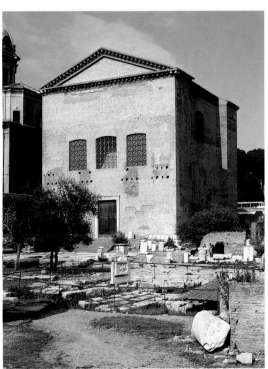

Augustus and the Birth of the Empire

Roman Forum

1 **Tabularium**
2 **Temple of Concordia**
3 **Temple of Saturn**
4 **Basilica Julia**
5 **Rostra**
6 **Curia**
7 **Basilica Aemilia**
8 **Temple of Castor and Pollux**
9 **Temple of Vesta**
10 **Temple of the Divine Julius**
11 **Arch of Augustus**

The shift from a republic government to a monarchic one, which took place in Rome under Gaius Julius Caesar Octavian, who later took the name of Augustus, was the culmination of a period of crisis in the Roman state that had commenced in the second century BC with the political, economic and social changes that accompanied the extension of Rome's sway over the whole of the Mediterranean. For more than a century Rome was torn apart by bloody civil strife. Augustus was able to exploit the widespread desire for peace by putting himself forward as a leader capable of restoring traditional values and morals. Displaying great political skill, he turned Rome into a state with a sound bureaucratic machinery, able to manage the vast territories of the empire in a way that the old republican form of government had proved incapable of doing.

Perhaps the monument that best illustrates Augustus's political propaganda is the altar known as the *Ara Pacis*, voted by the Senate in 13 BC to commemorate the *Pax Augusta* and dedicated in 9 BC. The altar we see today is a modern reconstruction, assembled out of fragments of the original one but on a different site and with a different orientation. The *Ara Pacis* consists of a sacrificial altar located in the middle of an open rectangular enclosure (around 10·5 x 11·5 meters or 34 x 38 feet) set on a low podium, with two openings for access in the longer sides. The wall around the enclosure is richly adorned with sculptural reliefs on the inside and outside. The internal decoration is split into two levels separated by a band of palmettes: the lower part is an imitation of the temporary wooden palisade erected in 13 BC, when the decision was

The *Ara Pacis Augustae* with details of the decoration of the marble enclosure

taken to build the altar; the upper part is ornamented with plant festoons hanging from ox's heads (a symbol of sacrifice), with *paterae* at the top center. The corners are decorated with smooth pilaster strips with Corinthian capitals. The outside of the enclosure is also decorated on two levels, separated by a motif of meanders and framed by smooth pilaster strips with Corinthian capitals and painted ornaments. A frieze with acanthus volutes and small animals runs along the lower part. The upper level has a far more complex decoration, with four panels of a mythological and allegorical character alongside the gates and a frieze with scenes of a procession on the short sides. The panels on each side of the main entrance depict episodes related to the origins of Rome: on the left is the scene of the Lupercal (the cave in which Romulus and Remus were found by the shepherd Faustulus), in a very poor state of preservation; on the right we see Aeneas in the act of offering a sacrifice to the Penates. The entrance opposite is flanked on the left by a panel with a personification of the Earth, depicted at the

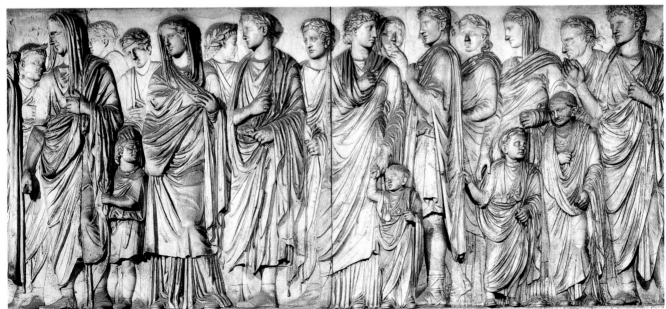

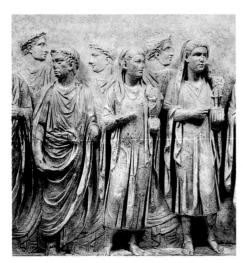

Detail of the *Base of the Vicomagistri*, middle of the 1st century AD. Museo Gregoriano Profano, Vatican

Augustus of Via Labicana. Palazzo Massimo alle Terme

Below, *Augustus of Prima Porta.* Museo Chiaramonti, Vatican

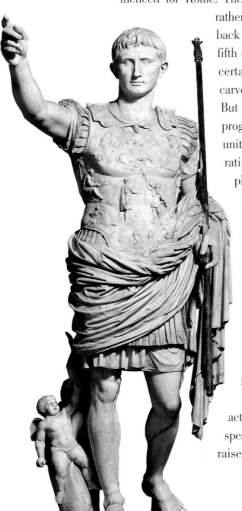

center as a woman with two children and accompanied by two figures symbolizing water and air. The panel on the right contains a representation, much of it now lost, of the goddess Roma. The frieze on the short sides is "historical" in character: it probably represents the procession that took place at the time of the altar's dedication. Not all the figures can be identified with certainty, but on the right-hand side Augustus, wearing the veil of the *pontifex maximus*, and the most important members of the imperial family are clearly recognizable. The overall propaganda message of the altar is clear: with Augustus, a member of the Julian family and descendant of Aeneas, the city's mythical founder, an era of prosperity and peace had commenced for Rome. The formal style adopted is a rather cold naturalism that harks back to the Athenian art of the fifth century BC and it is almost certain that the artists who carved the panels were Greek. But it is the typically Roman programmatic symbolism that unites the altar's various decorative elements, which are completely independent from the structural viewpoint.

This blend of calculated propaganda and classical naturalism is characteristic of Augustan art and what makes it a definite style in its own right. The *Augustus of Prima Porta*, one of the most famous statues of the emperor, is a typical example of this art: Augustus is portrayed in the act of calling for silence before speaking, with his right arm raised and his left leg set slightly back, a scheme based on that of Polyclitus's *Doryphorus* (a Greek sculpture from the fifth century BC). He is wearing an ornate cuirass, decorated at the center with a scene of the return of the military emblems that had been lost by Crassus in a battle with the Parthians in 53 BC. Rather than a work of art, what we have here is a political manifesto, skillfully carved but stiff and formal.

More successful, from an artistic point of view, is the portrait found on Via Labicana, executed in the last years of Augustus's reign. Here the emperor is portrayed as *pontifex maximus*, with his head veiled, in the act of making a sacrifice. There is an expression of calm wisdom on his face, but his features are rendered with an intensity that is lacking from the Prima Porta portrait and that makes this work one of the most significant of the age.

It should be remembered, however, that the works described above are expressions of an art that remained circumscribed to a privileged elite. Far more widespread was "plebeian" art, a continuation of the middle Italic artistic tradition that had absorbed some formal aspects of Hellenism but dispensed with its naturalism for the sake of narrative effect. This was the style used for the numerous commemorative and sepulchral monuments of minor nobility or freedmen produced between the Augustan and Flavian eras. An example from the former is the *Base of the Vicomagistri*, dating from the middle of the first century AD and now in the Vatican Museums. As the name suggests, this is a base (either of an altar or of a group of statues), with a frieze representing a sacred procession in which the animals to be sacrificed are disproportionately small. Here the emphasis is placed not

The Bridges of Ancient Rome

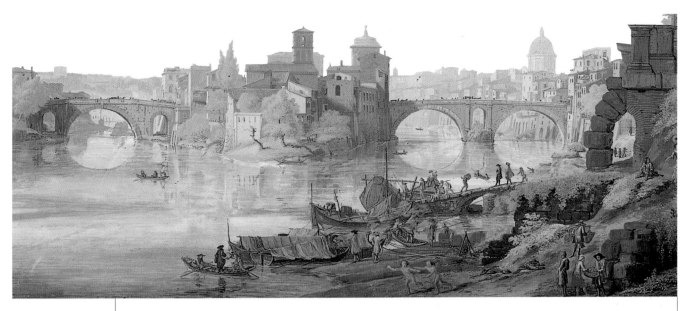

The birth and early success of Rome are closely linked to the fact that the course of the Tiber grew marshy and was easy to cross at the point where the city stood. The construction of the first permanent bridge, the *Pons Sublicius* (not far from the modern Palatine Bridge), is traditionally attributed to the reign of Ancus Marcius, in the second half of the seventh century BC. This was an entirely wooden structure (in fact the bridge takes its name from the Latin for wooden planks, *sublicae*): indeed there was a prohibition on the use of iron for its repair (something that suggests the structure preceded the introduction of iron to Rome).

The piers of the city's first stone bridge, the *Pons Aemilius*, were constructed in 179 BC. It was completed in 142 BC with the construction of the arches and probably stood on the site of the modern Ponte Rotto or "Broken

Bridge" (although the latter is a reconstruction dating from the Renaissance). A large part of the structure of the Fabrician Bridge, on the other hand, is original.

The *Pons Fabricius* was built in 62 BC and still links the left bank of the river with Tiber Island. With an overall length of 62 meters or 203 feet and a width of 5·5 meters or 18 feet, the bridge has two depressed arches, each with a span of 24·5 meters or 80 feet. A small arch is set in the central pier to assist the flow of water and reduce the pressure on the

bridge's structure. The brick facing dates from 1679 but some of the original travertine slabs that were used for this purpose have been preserved. The Cestian Bridge, between the Tiber Island and Trastevere, must date from shortly afterward. It was completely rebuilt in AD 370, when it was called the *Pons Gratianus*, and partially demolished at the end of the last century.

Nothing is left of the bridge built

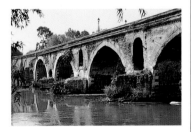

by Agrippa as part of his redevelopment of the Campus Martius at the point where the Sistine Bridge now stands, or of the *Pons Neronianus*, which was located further upstream. On the other hand, three of the original piers of the bridge built by Hadrian to link his mausoleum with the Campus Martius, the *Pons Aelius*, still stand: altered several times over the centuries, the bridge is now known as the Ponte Sant'Angelo.

Finally, we know of the existence of two more bridges, the *Pons Aurelius* and the *Pons Probi*, though their exact position remains uncertain.

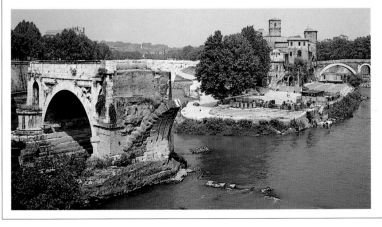

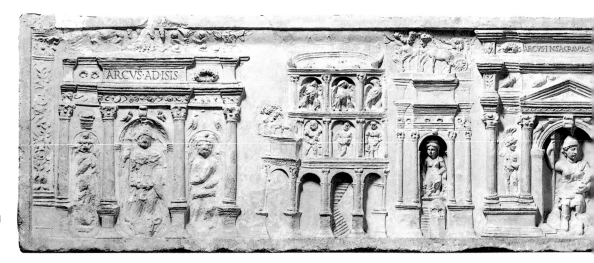

Two reliefs from the *Funeral Monument of the Haterii* representing buildings of ancient Rome and a wheeled machine. Museo Gregoriano Profano, Vatican

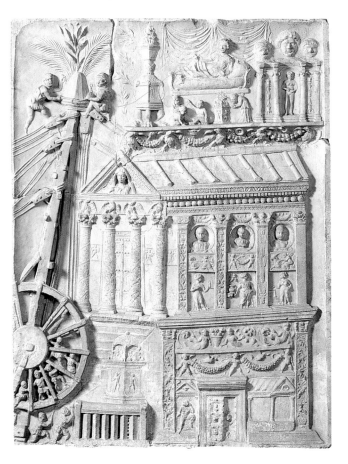

on naturalistic representation of the subject, but on describing the act of sacrifice. The same concern for symbolism is to be found in the figured reliefs of the *Funeral Monument of the Haterii*, datable to AD 90 (also in the Vatican Museums). In these the owner of the tomb is identified as a building contractor by a series of monuments (including the Colosseum and the Arch of Titus), rendered recognizable by the presence of inscriptions or the figures of deities. The various stages of the funeral rite are narrated in great detail, but no respect is shown for proportions and spatial relationships. More interest is shown in content than in formal accuracy. These characteristics of the plebeian artistic tradition need to be kept in mind, as they were to have an important influence on the development of late classical art.

During his long reign (from 28 BC to AD 14), Augustus carried out numerous city-planning schemes in Rome, based in part on Caesar's plans. The city was reorganized into fourteen *regiones*, eighty-two temples were restored, new aqueducts constructed, the banks of the Tiber regularized and porticoes, libraries and places of entertainment built.

Agrippa, Augustus's son-in-law and deputy, restructured the whole central part of the Campus Martius. He was responsible for the first baths open to the public (Agrippa's Baths) and for the construction (between 27 and 25 BC) of the first Pantheon, a temple dedicated in particular to deities linked with the Julian family: Mars, Venus and the Divine Julius (the deified Caesar). The original plan of the temple (whose remains are located underneath the building we see today) was rectangular, with the front opening to the south along one of the long sides. Agrippa's building was damaged by fire in AD 80; restored by Domitian, it burned down again in Trajan's reign. The temple we

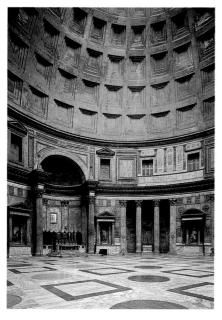

now see was built by Hadrian, who moved the entrance from the south to the north and radically altered its structure, turning it into a circular building preceded by a deep portico. The pronaos has eight columns of gray granite at the front, topped by Corinthian capitals of white marble, and eight columns of pink granite set further back. They are arranged in two rows to form a nave and two aisles, with the entrance to the cell set at the end of the nave and two niches that must have housed statues of Augustus and Agrippa concluding the aisles. The cell is a rotunda with a semicircular apse in the lower part, flanked by three recesses on each side, alternately semicircular and rectangular in shape. Each has two columns in front and niches for statues. Between the recesses are set eight aedicules with triangular or arched tympana that probably also contained statues. A high cornice used to separate

the first tier from the second, but the latter has now vanished. The floor is paved with pieces of polychrome marble arranged in patterns of circles and squares and the same material is used for the rest of the interior's lavish decoration. The large dome that surmounts the building is 43·3 meters or 142 feet high and perfectly semicircular. Five concentric circles of coffers surround a circular opening (*oculus*) at the top, almost 9 meters or 30 feet in diameter. A complex system has been used to support and contain the loads produced by the weight of the dome. All these characteristics make the Pantheon a remarkable technical achievement.

In his city-planning activities in the area of the Forum, Augustus followed the example set by Caesar. Like him, Augustus built a new forum, dedicated in 42 BC – before the battle against Caesar's assassins Brutus and Cassius at Philippi – to Mars Ultor (i.e. the Avenger) but not inaugurated until forty years later, in 2 BC. The general layout of the complex echoes that of Caesar's Forum: a large porticoed square (125 x 118 meters or 137 x 129 yards), with the temple closing one of the short sides. The main entrance must have been located on the other side, contiguous with the north side of Caesar's Forum, but we can only guess at what it looked like, as it was destroyed along with the front section of the square at the time of the construction of Via dei Fori Imperiali, unfortunately without having been excavated first. Part of the high wall (around 33 meters or 108 feet) built out of *opus quad-*

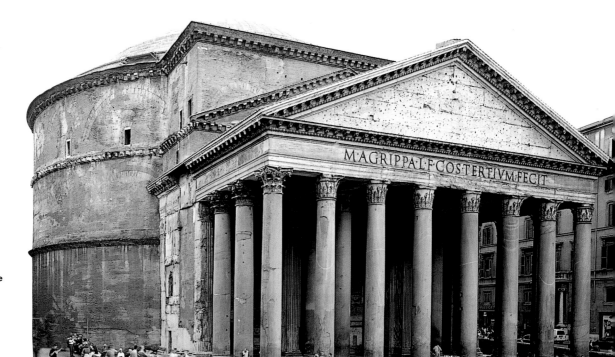

The massive pile of the Pantheon and, above, a view of the interior

The Appian Way

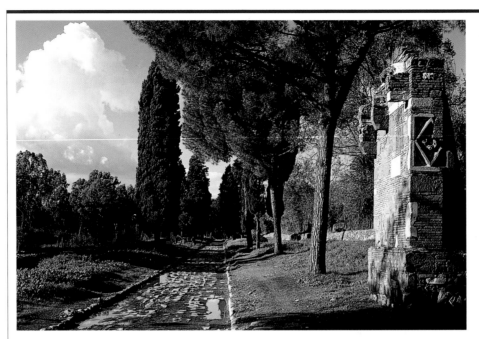

A view of the Via Appia

Constructed on the initiative of the censor Appius Claudius Caecus in 312 BC, the Via Appia became the principal means of communication between Rome and Southern Italy. Originally the road led from the capital to Capua; later, probably as early as 244 BC, it was extended as far as Brindisi. The Appian Way was the first systematically planned Roman road, following a regular route and employing sophisticated works of engineering. The paving, which has been preserved in some stretches, consists of large slabs of volcanic stone and was laid with great care.

The Appian Way commenced on the southern side of the Circus Maximus and emerged from the city through the Porta Capena, the point from which distances were measured in miles. A large number of monuments have been found along the urban section of the road. One of the most interesting of these is the tomb

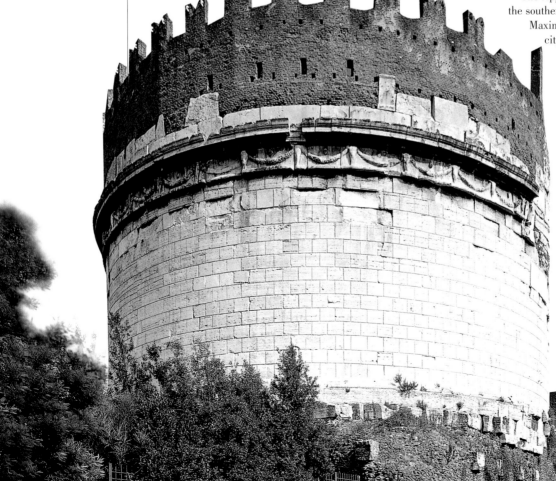

The tomb of Cecilia Metella

One of the ancient statues that line the Via Appia

The two semicylindrical towers of the Circus of Maxentius on the Via Appia

discovered not far from Porta San Sebastiano, which belonged to the Scipio family (as is attested by the numerous inscriptions unearthed). Used for several generations, from the third century BC up until the beginning of the first century BC, the tomb eventually held more than thirty sarcophagi. The earliest of these – now in the Vatican Museums – is that of L. Cornelius Scipio Barbatus, consul in 298 BC. The oldest part of the tomb, carved out of the stone, is in the shape of an irregular square and is divided up internally by two perpendicular corridors. Sometime after 150 BC the hypogeum was enlarged with the addition of a new section, to the east of the first. It was probably at the same time that the monumental façade of the building was erected: only a small part has survived but it must originally have had the appearance of the wing of a theater. This façade was set on a preexisting stone base on which it is possible to make out the traces of various paintings, some of a military and triumphal character.

Not far from the tomb of the Scipio family, between the Via Appia and the Via Latina, we find the columbarium of Pomponius Hylas. Dating from the beginning of the imperial age, it has a rich stucco and pictorial decoration (the vault and apse are particularly interesting, with

female figures amidst delicate vegetation). Further down the road we come to the large complex of Maxentius's Villa, which also comprises the substantial remains of a circus and the mausoleum of Romulus (the emperor's son, who died in AD 309). The tomb of Cecilia Metella is located a short distance away. This is a circular mausoleum from the Augustan period, built to house the mortal remains of a consul's daughter. Later the tomb was incorporated into the fortress of the Caetani family, of which a few remains are still visible, and converted into a tower. This stretch of the Appian Way, where the blend of the ancient and the medieval has created a unique set of monumental ruins, is undoubtedly one of the most fascinating sights in the countryside around Rome.

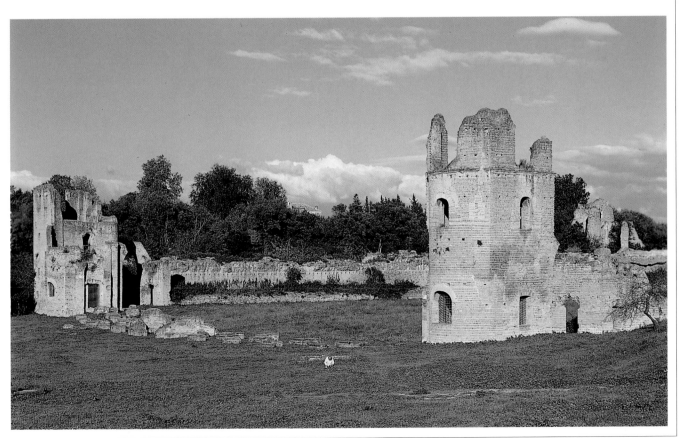

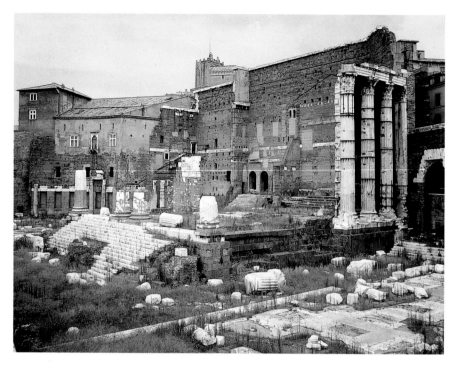

per part was decorated with caryatids alternating with shields bearing the head of Jupiter Ammon. Behind the porticoes and opposite the temple of Mars were set two large exedras. The walls of the porticoes and exedras are lined with niches containing statues of the principal figures in the history of Rome and their respective *elogia* (inscriptions describing their deeds). Twenty-five of these personages can be identified from the surviving fragments of these statues and their inscriptions. At the center of the northwestern exedra stood Aeneas, the mythical Trojan founder of Rome and the *gens Julia*; statues of members of the Julian clan were located to the right of Aeneas, while the kings of Alba Longa were placed on his left. Romulus stood in the middle of the other exedra, accompanied by the *summi viri*, the most illustrious men of the republican period, whose statues were ranged in the niches of the porticoes. The markedly ideological character of the entire complex is evident, with its attempt to present the *gens Julia* and Augustus, whose bronze chariot was set at the center of the forum, as the culmination of the mythical and historical traditions of Rome.

The remains of the temple of Mars Ultor in the Forum of Augustus

Hadrian's Mausoleum (now Castel Sant'Angelo); bottom, the Mausoleum of Augustus

ratum at the back of the forum has been preserved, however: in it were set two more entrances to the forum, one on each side of the temple of Mars. The temple, which stands on a tall podium with a flight of steps in the middle, is peripteral *sine postico* and has Corinthian columns (15 meters or nearly 50 feet high) of Carrara marble, eight at the front and eight at the sides. The cell, whose walls were lined with seven columns on each side, ends in an apse that housed statues of Venus, Mars and Divus Julius. There is debate over whether the porticoes on the two longer sides of the forum, also of the Corinthian order, were a single story high with an attic on top or had two tiers of columns. In any case, the up-

The same ideological connotation is to be found in Augustan interventions in the old Republican Forum. The Basilica Julia, which Augustus dedicated to his grandchildren Gaius and Lucius Caesar, the chosen successors to his reign who were to meet a premature death, was completed on one of the long sides of the square, while the Basilica Aemilia on the other side was renovated. The temple of the Divine Julius was erected on the southeastern side, at the place where Caesar's body had been cremated. It was flanked to the east by a short portico linking it with the Basilica Aemilia, also dedicated to Augustus's grandchildren, and to the west by the arch commemorating Octavian's victory over Antony and Cleopatra at Actium in 31 BC. After the death of Gaius and Lucius Caesar, Augustus's new heir Tiberius had the temple of

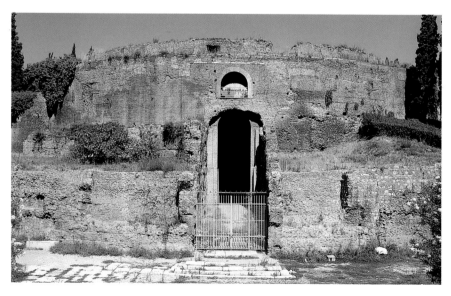

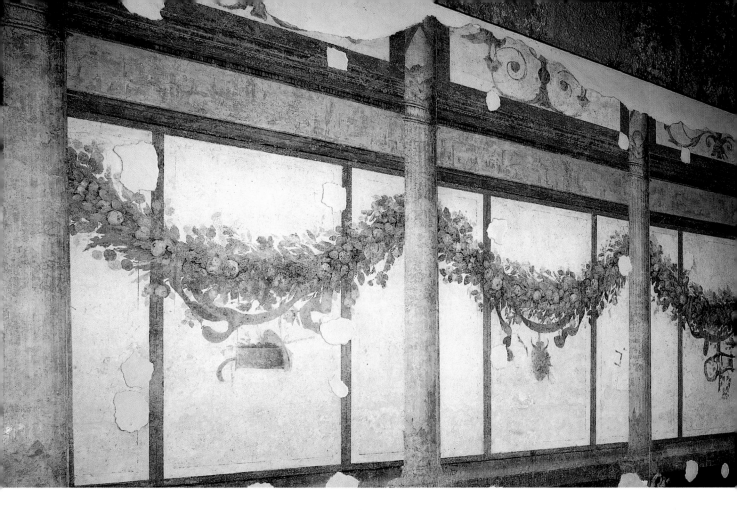

Concordia and temple of Castor and Pollux restored in 10 and 7 BC respectively, with the evident aim of legitimizing his own right to the succession.

It is also clear that the desire to ensure the stability of the ruling house was what lay behind the mausoleum Augustus started to build for himself on the Campus Martius right at the beginning of his reign, in 29 BC. The building, probably inspired by the tomb of Alexander the Great which Augustus had visited in Egypt, is conceived in the manner of the dynastic tomb of a Hellenistic monarch. It consists of a circular drum of marble-clad tufa, 87 meters (285 feet) in diameter and 12 meters (39 feet) high, probably with a second floor on top. It is not sure what form this took, but it may well have been topped by a statue of the *princeps*. Inside, a series of circular walls linked by radial ones enclosed a round cell, with its entrance to the south and three niches in the walls at the axes, intended for use as the burial places of other mem-

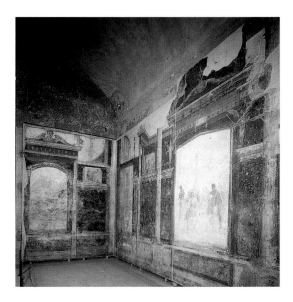

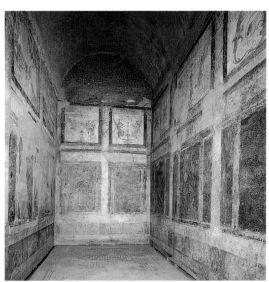

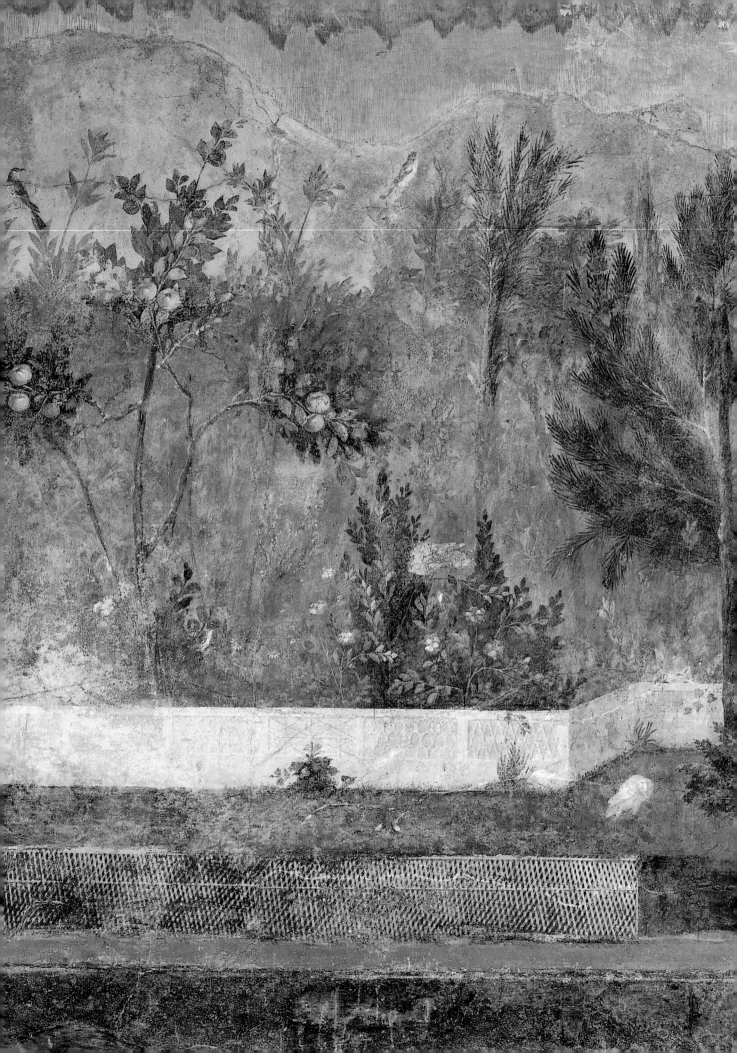

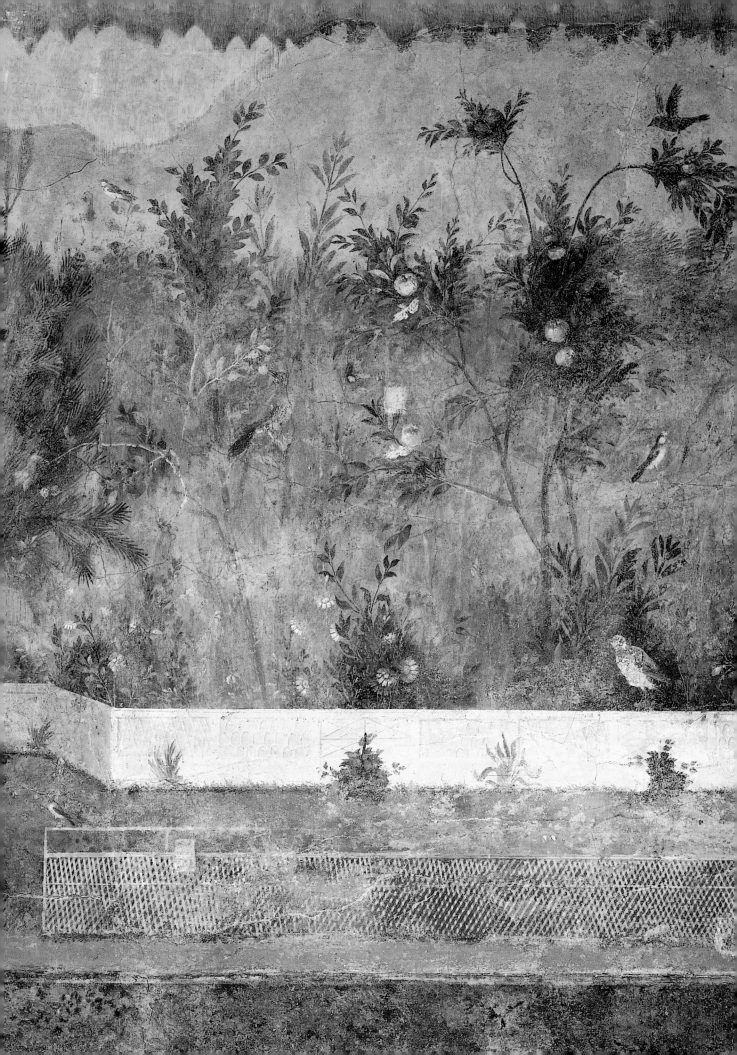

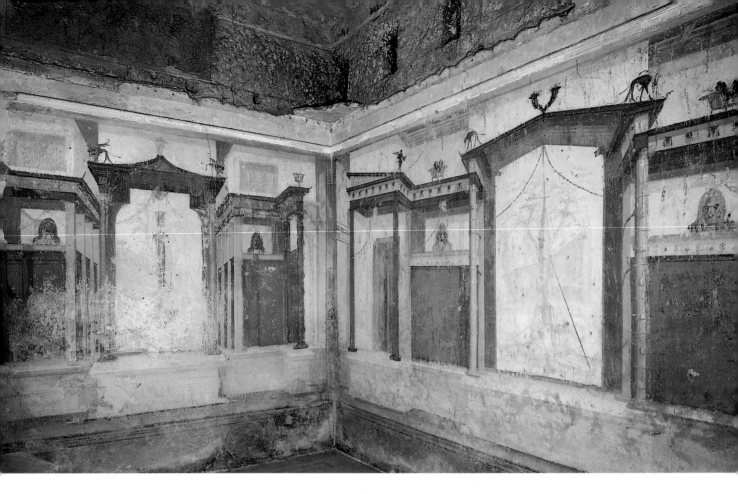

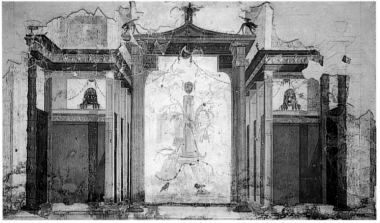

In contrast to this imposing sepulchral monument, Augustus's house on the Palatine is described by the sources as "neither very large, nor luxurious." The private part of the house and the apartments of his wife Livia have been identified with a fair degree of certainty to the west of the temple of Apollo. These consist of a series of late republican structures, originally belonging to different dwellings and later grouped together in a complex with a disjointed plan and rooms of modest size, its floors simply paved with black-and-white mosaic.

The Room of the Masks in the House of Augustus and a detail of the wall decoration

Right, fragment of a Bacchic scene with figure. Antiquarium of the Palatine

bers of the imperial family. In the middle of the cell stands a pillar with a small square space hollowed out of it, which must have been used to house the ashes of Augustus himself. On the outside, the entrance to the tomb was flanked by two pillars, bearing bronze tablets engraved with the *res gestae* of Augustus (the official version of his deeds), and by two obelisks, in accordance with an ancient tradition of Egyptian kings (the obelisks are now located on Piazza del Quirinale and Piazza Esquilino). Hadrian used the tomb as a model for his own mausoleum, which was converted into a fortress as early as the sixth century AD and today forms the core of Castel Sant'Angelo.

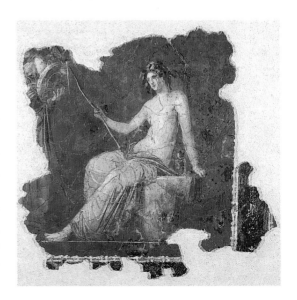

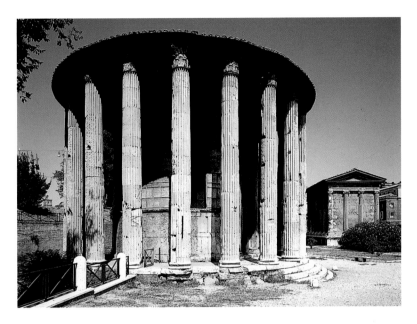

The temple of Hercules Olivarius, erected at the end of the 2nd century BC but extensively restored during the reign of Tiberius

The custom of decorating the walls of houses was undoubtedly of Hellenistic origin. We know little about how it came into widespread use in Rome owing to the scarcity of documents on the subject. It is certain, however, that Roman wall painting subsequently developed along its own lines. The different stages in this development can be traced in the paintings that have been preserved at Pompeii and Herculaneum (the so-called four Pompeian styles).

The quality of the pictorial decorations is remarkable, however. In particular, the paintings in the tablinum of the House of Livia and in the Room of the Masks of the House of Augustus are some of the best examples of the Second Pompeian style. High-quality paintings have also been brought to light at Livia's Villa at Prima Porta: particularly interesting are the unusual pictures with views of a garden that used to decorate the walls of the summer triclinium. They can now be seen at Palazzo Massimo.

Augustus's decision to live on the Palatine hill was followed by his successors, with the result that the very name *Palatium* came to be synonymous with the emperor's residence (and the origin of our own word "palace"). On the western side of the hill, in the area which is now largely taken up by the Farnese Gardens, Tiberius built the *Domus Tiberiana*. Unlike Augustus's house, this was supposed to have been an organic and monumental complex, something which is confirmed by the archeological finds.

Fragments of flooring from the Domus Tiberiana. Antiquarium of the Palatine

The Domus Tiberiana from the Roman Forum

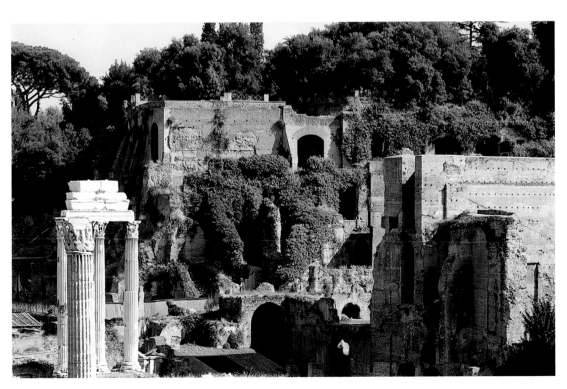

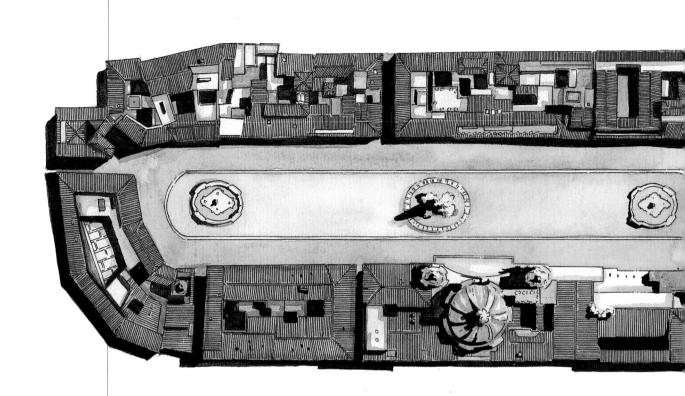

Rome is one of the very few cities in the world that has been continuously inhabited from the Bronze Age to our own day. The fact that it has been rebuilt time and time again on its own ruins has left profound marks on its fabric, and it is through these that it has often proved possible to retrace its architectural history.

Thus, for example, the structure of the stadium built by Domitian around AD 86 is preserved in present-day Piazza Navona, whose rectangular shape, with one end curved, exactly follows the layout of the track in the ancient monument. The buildings that surround the square were in fact constructed on the *cavea* of Domitian's stadium, using the tiers as foundations. One part of the curved side of the structure is still clearly visible in Piazza di Tor Sanguigna, incorporated into the modern walls. In a similar way the façade of Palazzo Massimo, on Corso Vittorio

Nero and the Flavian Dynasty

Nero's famous Domus Aurea, or Golden House, also extended as far as the Palatine. A palace of enormous size, it covered part of the Caelian and Esquiline as well as the valley between the three hills, where an artificial lake was constructed. After his death Nero was subjected to *damnatio memoriae* (a custom that entailed expunging all trace of the existence of a person considered unworthy). Much of his gigantic palace was destroyed and many of the areas it had occu-pied restored to public use. Just one part of the complex was preserved: a section about 300 meters (330 yards) long and 200 meters (220 yards) wide, inserted into the foundations of Trajan's Baths on the Oppian hill. It is divided into two clearly distinguishable parts, one to the west and one to the east. The former has a traditional layout, organized around perpendicular axes and a spacious rectangular courtyard. The eastern sector, which represents one of the finest achievements of Roman architecture, has a more fluid plan of Hellenistic inspiration, with the spaces hinged around two focal points: a large, polygonal open space and an octagonal room roofed with a dome. It has been suggested that the western sector originally be-

**The octagonal room
of the Domus Aurea**

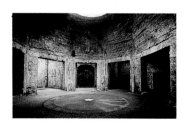

houses on Piazza di Grotta Pinta, while the outside can be seen on Via del Biscione and Piazza Pollarola). In addition, Palazzo Righetti incorporates the substructures of the temple of Venus Genetrix, which used to stand right behind the *cavea*. Today only a small part of the large *pone scenam* portico that completed Pompey's complex remains. Yet it has shaped the development of the quarter that occupied the site subsequently, in which it is still possible to discern the proportions of the *porticus*.

Another interesting example of the survival of ancient structures in the fabric of the modern city is that of the temple of Hadrian, dedicated to the deified emperor in AD 145. The temple stood on a podium that was four meters or thirteen feet high, with a flight of steps on the eastern side, and was peripteral. It had eight Corinthian columns of white marble on each of the short sides and thirteen on the longer ones. Eleven of the thirteen columns on the northern flank of the building and the part of the podium on which they stood are still visible in Piazza di Pietra, on one side of the Palazzo della Borsa: an evocative "window on antiquity" located in the heart of the historic center.

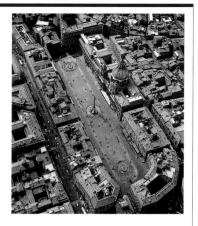

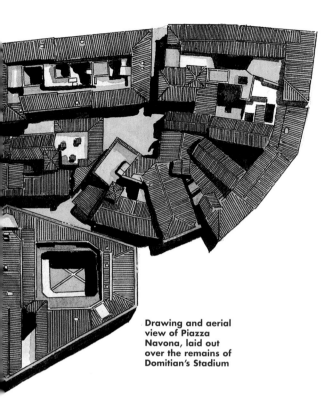

Drawing and aerial view of Piazza Navona, laid out over the remains of Domitian's Stadium

Emanuele, echoes the curve of the *cavea* of Domitian's Odeon.

The theater built by Pompey between 61 and 55 BC, the first masonry theater in Rome, has also left its mark on the modern city. Here too the buildings constructed on the *cavea* have maintained its curve (the inside of the curve is visible in the

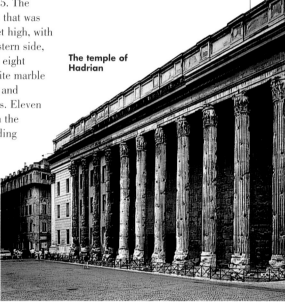

The temple of Hadrian

longed to the Domus Transitoria, the palace occupied by Nero at the beginning of his reign, part of which was incorporated into the new palace. Little has survived of the Domus Aurea's decorations, which must have been extremely rich, apart from a

Remains of frescoes from the Domus Transitoria, Nero's first residence. Antiquarium of the Palatine

few wall paintings. Some of these – the ones in the hall with an apse where Achilles is depicted among the daughters of Lycomedes in the middle of the ceiling and the ones in the Room of the Golden Vault, to cite the two most famous examples – are of very high quality and among the finest examples of the Fourth Pompeian style known to us. We know that the furnishings of the palace included numerous statues from Greece and from Asia Minor. Most of them were Hellenistic works in a somewhat bombastic style and included celebrated groups from Pergamum, such as the ones commemorating the king of Perga-

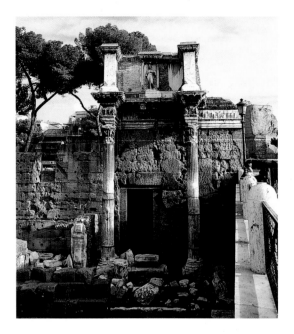

mum's victories over the Galatians (the so-called
Dying Gaul, now in the Capitoline Museums, and
the *Galatian Committing Suicide with His Wife*, in
Palazzo Altemps, are marble copies of the bronze
Pergamene originals, commissioned by Julius Cae-
sar for his villa on the Quirinal, where they were
found). The Domus Aurea may also have housed the
Laocoön now in the Vatican Museums: the sculpture,
which portrays the Trojan priest and his sons being
attacked by Athena's snakes, is a reproduction made
in the time of Tiberius of an original that
once again came from Pergamum.

The year after Nero's death, AD 69,
was marked by bloody struggles
for control of the empire, con-
cluding in the victory of Ves-
pasian, the first of the Flavian
emperors. To celebrate the restora-
tion of stability in the state after
these events and Rome's defeat of
the Jews (AD 70), Vespasian had
the temple of Peace (sometimes
incorrectly called the Forum of
Peace) built to the southwest of
the Forum of Augustus between
71 and 75. Very little remains of
the building (the best-preserved
part is the southeastern corner,
subsequently incorporated into the
church of Santi Cosma e Damiano).

Yet we are able to reconstruct its layout from a
fragment of the *Forma Urbis*, the great plan of
Rome carved out of marble and dating from the be-
ginning of the third century AD which used to be
located inside the temple of Peace. The complex
was made up of a large porticoed square (around
135 x 110 meters or 148 x 120 yards) laid out as a
garden, with the entrance on one of the shorter
sides and the place of worship in the middle of the
opposite one, with the altar in front. The six
columns of the temple's pronaos were aligned with
those of the portico, in which the building's façade
was inserted. A second row of six columns marked
the entrance to the cell, a rectangular hall ending
in a small apse for the idol. Various other cham-
bers opened onto the rear of the portico alongside
the temple and onto the two longer sides of the
square. It is known from the sources that these used
to house two libraries, one Greek and one Latin, as
well as numerous statues and paintings, part of
which came from the Domus Aurea while others
were booty from the wars with the Jews.

Another project carried out under the Flavian
dynasty was the Forum Transitorium, commenced
by Domitian but inaugurated by Nerva in AD 97.
This narrow colonnaded square, concluded to the
north by a temple dedicated to Minerva, was laid
out at the point of passage between the Republican
Forum and Subura, and between the Imperial Fo-
rums and the temple of Peace (whence its name).
All that can be seen of the forum today are the
foundations of the temple and a pair of columns
complete with their attic (known as the *Colon-
nacce*) on the eastern side of the square.

From the viewpoint of the history of art, the
Flavian era was characterized by a progres-
sive shift away from Augustan classicism
and toward a more animated
and plastic naturalism. Thus
while the reliefs in the
Palazzo della Cancel-
leria (dated to around
AD 83 and depicting
the young Domitian
setting off for war and his victori-
ous return to Rome) are still
imbued with a Julio-Claudian
neo-Atticism, the roughly con-

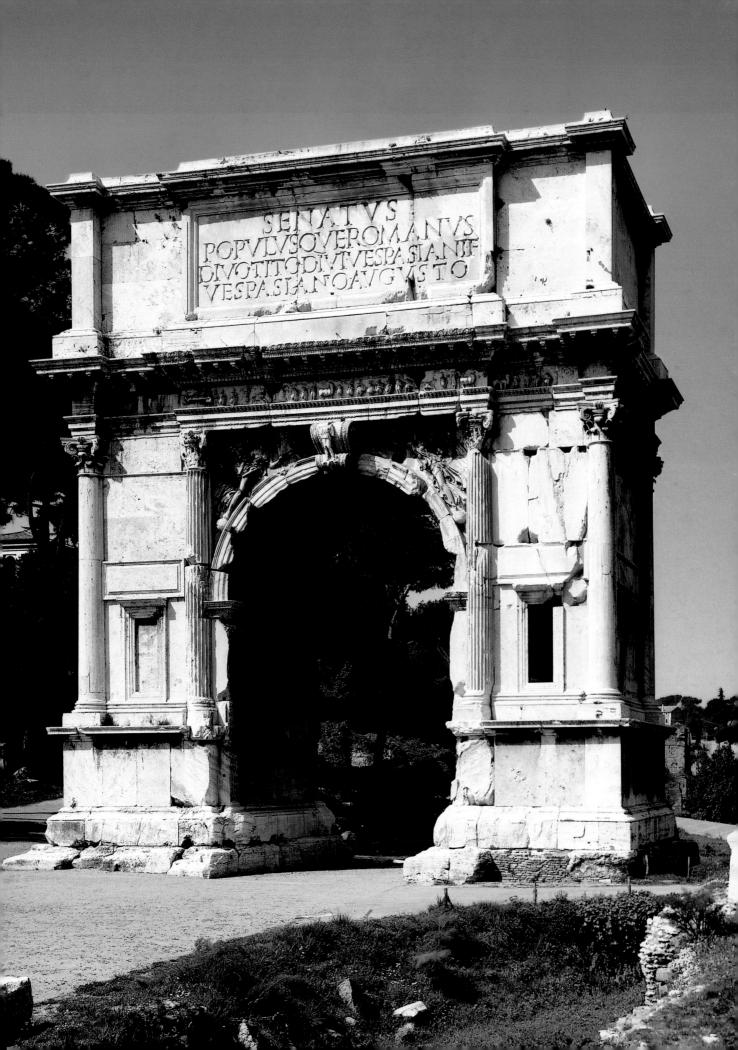

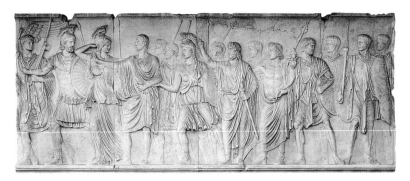

four horses, is being crowned by a winged figure of Victory and in the other the triumphal procession is entering Rome through the Porta Triumphalis).

The last of the great imperial palaces, occupying the whole northwestern part of the Palatine, was completed by Domitian in AD 92. The building, on a grandiose scale, is now in a very poor state of preservation, but on the whole its plan, noteworthy for its frequent use of mixtilinear solutions and "baroque" architecture, is fairly well understood. The complex is divided into three sections, running from west to east: a ceremonial wing, the Domus Flavia, a private wing, the Domus Augustana, and the so-called Stadium. The public part of the

Relief from the Palazzo della Cancelleria with *The Departure of the Emperor Domitian*, 1st century AD. Museo Gregoriano Profano, Vatican

temporary ones on the Arch of Titus display a much more lively handling of space and movement. Particularly worthy of note are the two side panels with scenes of the triumph over the Jews (in the one on the right Titus, on a chariot drawn by

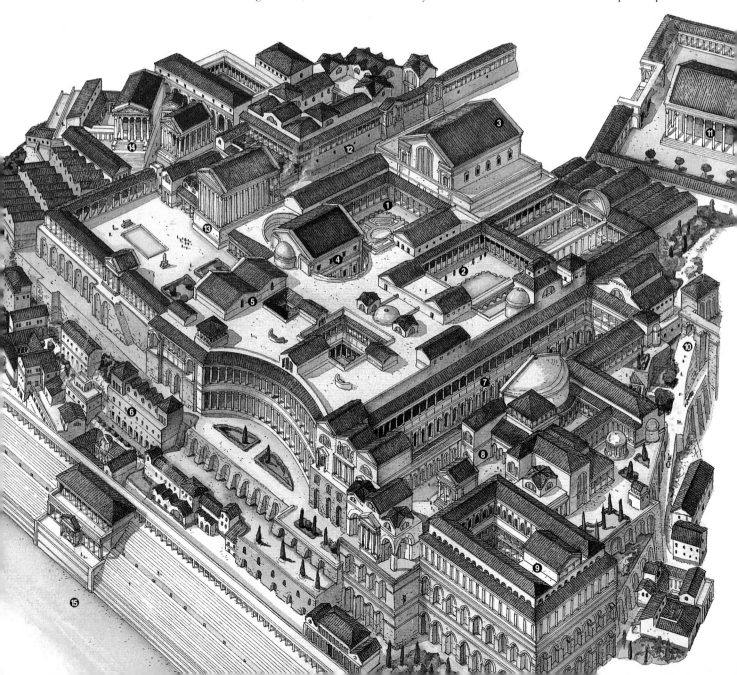

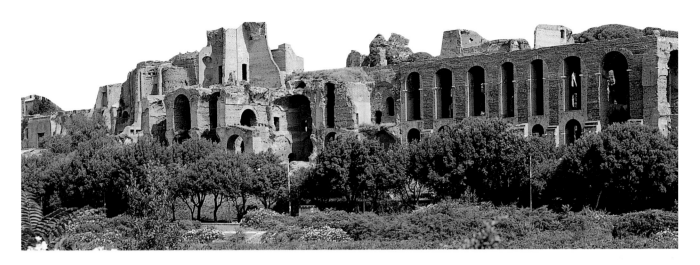

The imposing ruins of the Domus Severiana on the Palatine

Below, the so-called Stadium of Domitian's Palace

The Palatine

1 Domus Flavia
2 Domus Augustana
3 Aula Regia
4 Triclinium
5 Library
6 Pedagogium
7 Hippodromus
8 Baths of Septimius Severus
9 Domus Severiana
10 Aqua Claudia
11 Temple of Elagabalus
12 Domus Tiberiana
13 Temple of Apollo
14 Temple of Cybele
15 Circus Maximus

Alongside, the Domus Flavia

Right, the Domus Augustana

palace, which was entered from the Palatine through a series of porticoes, is laid out around a peristyle with a large octagonal fountain in the middle. Large reception rooms open onto the peristyle in the north and south. In the middle of the north side is set the "Aula Regia," or Throne Room, a huge hall that may well have been reserved for official audiences, with niches framed by columns on the side walls and a small apse housing the throne at the rear. On the opposite side of the peristyle to this hall lies a large triclinium with an apse, which must have

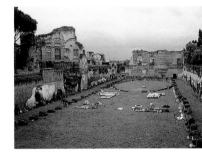

been used for the emperor's banquets. Along the side walls, lined with columns, a series of windows gave onto two symmetrical nymphaea, with oval fountains. Passageways connect the public part of the palace with the emperor's private residence, the Domus Augustana. The northern section of this wing is also laid out around a central peristyle, but its poor state of preservation makes it difficult to reconstruct its original appearance. The southern part of the building is on two levels owing to the slope of the hill. At the center of the lower floor lies a square courtyard

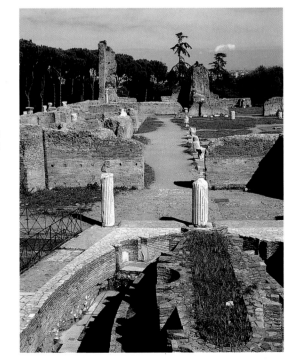

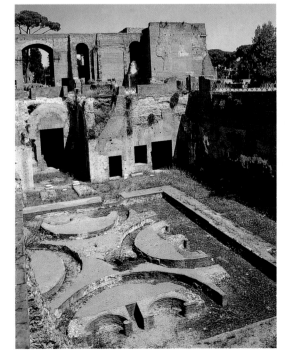

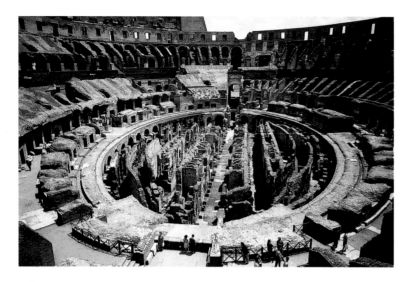

Top, the tiers and arena of the Colosseum and, above, the gallery on the ground floor

The Colosseum

The Flavian emperors were also responsible for the construction of the first permanent amphitheater in Rome, the Amphiteatrum Flavium, on the site of the artificial lake at the center of the Domus Aurea, which was drained for the purpose. Dedicated by Vespasian in AD 79, this imposing building (188 x 156 meters or 617 x 512 feet, and over 48 meters or 158 feet tall) was built rapidly and inaugurated by Titus in AD 80 with games that lasted for a hundred days. The name Colosseum, by which the amphitheater is now known, is of medieval origin and derives from the colossal bronze statue of Emperor Nero (over 35 meters or 115 feet high, the biggest in the ancient world), originally located in the atrium of the Domus Aurea and moved by Hadrian to the vicinity of the amphitheater. Part of

with an ornamental fountain in the middle. Onto it face a series of two-story-high spaces, most of them arranged in a regular pattern. The entrance to the private part of the imperial palace was located in the large exedra facing onto the Circus Maximus, which adjoins the building on the southern side. On the eastern side is set the Stadium, in reality an extensive garden surrounded by a two-story portico and adorned with fountains. With just a few interventions of restoration and a slight enlargement, Domitian's great palace remained the abode of the *principes* of Rome until the fall of the empire.

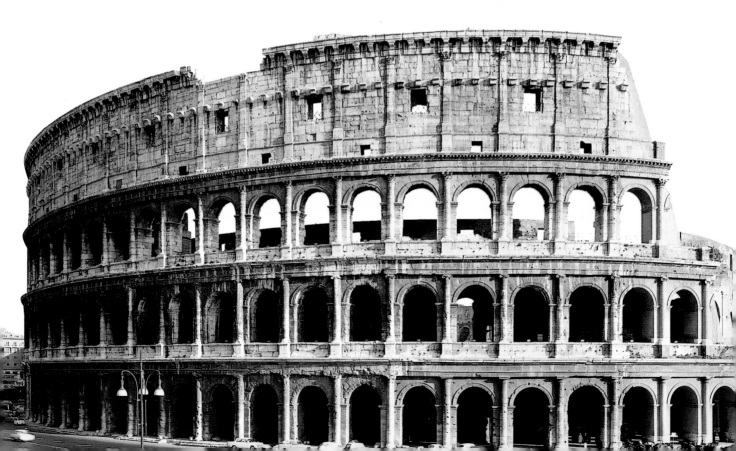

Mosaics with circus scenes, 3rd century AD. Galleria Borghese

the outer façade, built entirely from travertine, has now been lost. It has three tiers of eighty arches, framed by half columns with Tuscan, Ionic and Corinthian capitals respectively, and is surmounted by an attic decorated with pilaster strips with Corinthian capitals. Above this runs a cornice with a series of holes that used to house the supports of the huge *velarium* that sheltered the spectators from the sun. The first tier of arches provided access to the various sectors of the *cavea* through a series of flights of steps and annular corridors. The four arches set at the building's main axes were each decorated with a small marble portico and were reserved for the use of the emperor and the

city's notables. Inside, the *cavea* was divided up horizontally into five sectors (*maeniana*), to which access was determined on the basis of social class (no charge was made for entrance). The first three sectors had tiers of marble seating, now vanished. The fourth, separated from the ones below by a high wall, was a sort of wooden gallery, reserved for women. On top of the gallery was a terrace with standing room only, used by the lowest classes of the plebs. Differing estimates have been made of the amphitheater's capacity, but it must have been able to hold at least 70,000 spectators. A tall podium (around 4 meters or 13 feet high) and a strong safety net separated the *cavea* from

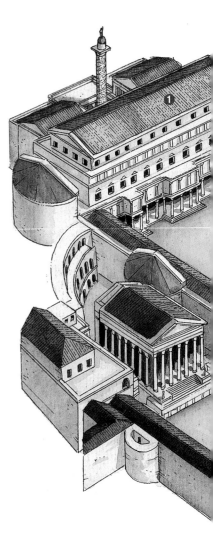

**Detail of a mosaic
with hunting scene,
3rd century AD.
Galleria Borghese**

the large elliptical arena. The floor of the arena was made of wooden boards, which have vanished, exposing the galleries and rooms underneath that were used to house wild beasts and equipment for the games. The two central tunnels, running along the axes, continued outside the amphitheater. The eastern one stretched all the way to the Ludus Magnus, the main barracks for the gladiators which have been partially excavated by archeologists. The Colosseum was used to stage *venationes* (animal hunts) and *munera* (gladiator combats) up until the sixth century, and underwent restoration on several occasions over this span of time. It was turned into a fortress in the Middle Ages and then finally abandoned in the modern era, when it was simply quarried for its materials.

Another section of the Domus Aurea that was probably opened for public use by the Flavian emperors was that of the baths. In fact it is likely that the baths dedicated by Titus in 80 originally belonged to Nero's palace: they bordered it to the east and had the same orientation. This complex and that of Nero's Baths in the Campus Martius (also known after their restoration by Severus Alexander in 227 as the Thermae Alexandrinae) are of considerable architectural interest, even though very little remains of either, as they constitute the earliest known examples of the organization of a series of rooms around a symmetrical axis, later to become standard practice.

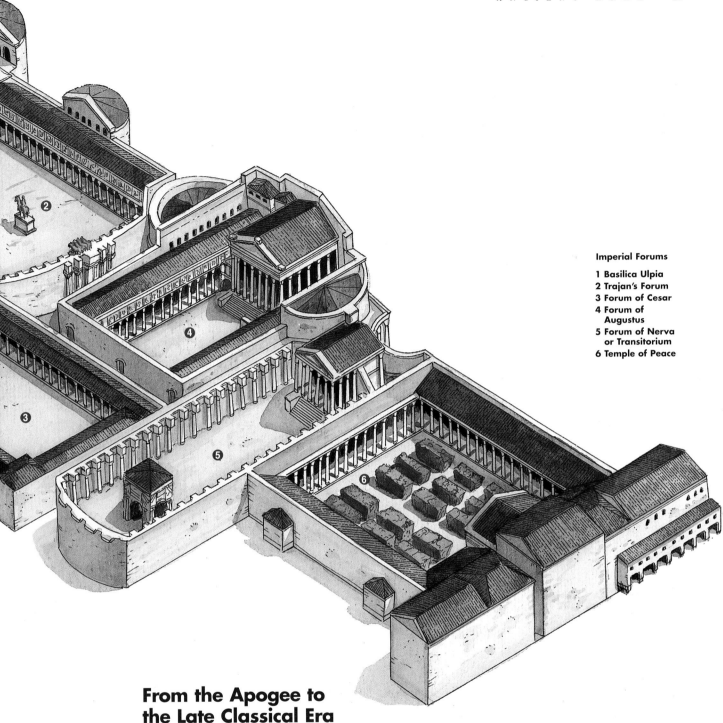

Imperial Forums

1 Basilica Ulpia
2 Trajan's Forum
3 Forum of Cesar
4 Forum of
 Augustus
5 Forum of Nerva
 or Transitorium
6 Temple of Peace

From the Apogee to
the Late Classical Era
(Second to Fourth Centuries)

The second century AD was a period of great
stability and prosperity for the Roman em-
pire, which reached its maximum extent
with the conquest of Dacia under Trajan (98-117).
It was to celebrate his triumph over the Dacians
that Trajan had the last and biggest of the Imperi-
al Forums (around 300 x 185 meters or 330 x 200
yards overall) constructed between 107 and 113.
This required the demolition of a series of republi-
can buildings and cutting through the saddle be-

tween the Capitol and Quirinal. The main entrance
was situated to the northwest of the Forum of Au-
gustus and was marked by an arch which led into
a rectangular square (though the side on which the
arch stood was curved). At the center stood an
equestrian statue of the emperor. The two longer
sides were lined with porticoes, their attics deco-
rated with statues of Dacian prisoners. In the mid-
dle of each portico was set a large exedra, proba-
bly housing statues portraying Trajan's predeces-

Trajan's Forum with,
in the foreground,
the exedra of
Trajan's Markets and
the profile of the
Torre delle Milizie

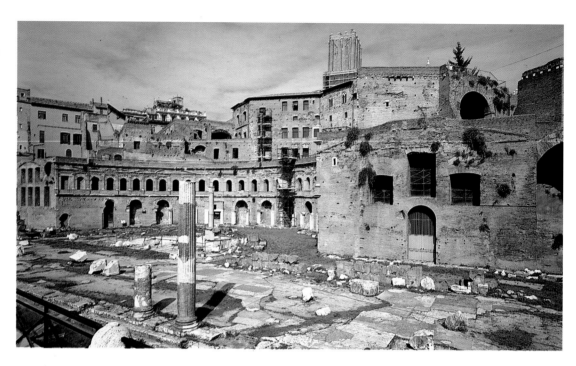

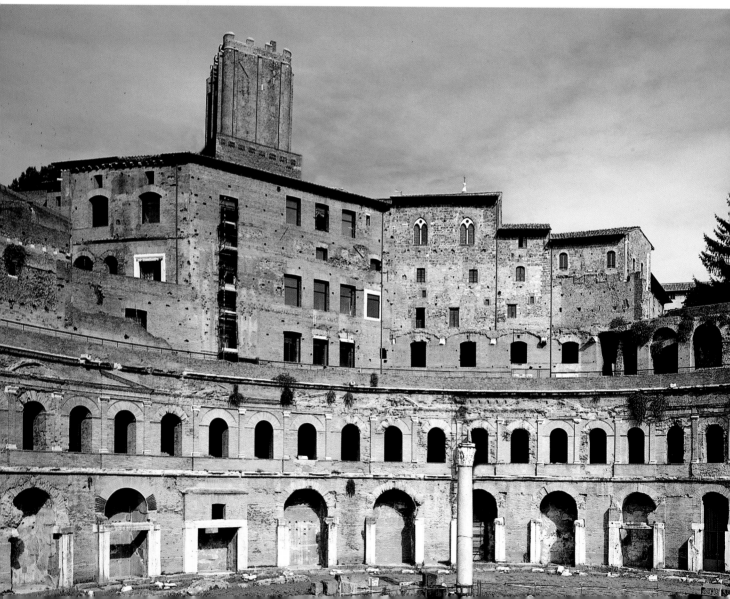

The great hall of Trajan's Markets

Right, the Via Biberatica in the Markets of Trajan, which was lined with numerous *tabernae*

Bottom, the temple of Venus and Roma; designed by the emperor Hadrian, it was the largest sanctuary in ancient Rome

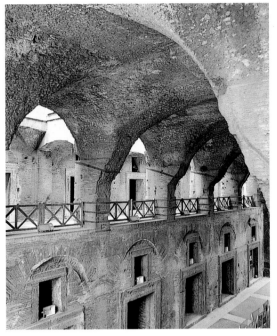

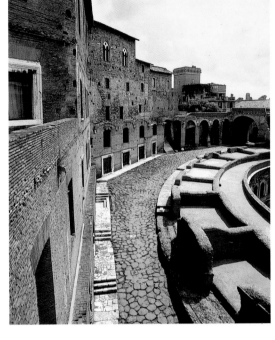

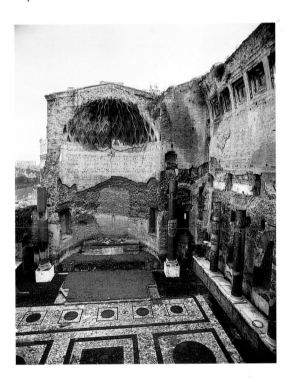

sors and their families (an obvious reference to the Forum of Augustus). On the side of the square opposite the entrance stood the Basilica Ulpia, a large hall (about 170 x 60 meters or 558 x 197 feet) divided into a nave and four aisles and concluded on the shorter sides by two exedras similar to those of the porticoes. In addition to the customary mercantile and judicial functions, the basilica was probably used for acts of *manumissio* (freeing) of slaves, which had previously been carried out in the Atrium Libertatis, demolished to make way for the new forum. Behind the basilica two libraries flanked the great spiral column, which is almost 30 meters or 98 feet high. Trajan's ashes were placed in a gold urn at its base and a statue of the emperor was set on top of the monument (though this was replaced by one of *Saint Peter* in the modern era).

The complex was completed, to the north of the column, by a porticoed square with a curved side at the back. At its center stood a magnificent peripteral temple, dedicated to Trajan and his wife Plotina by Hadrian but probably planned by Trajan himself. Trajan's project also set out to regularize the slopes of the Quirinal, to the east of the new forum, through the construction of a series of utilitarian buildings on terraces: known as Trajan's Markets, they were probably a wholesale trade market for food. The markets face onto the forum

with a large exedra built out of brick, flanked by two semicircular structures roofed with vaults, perhaps *auditoria* or schools; two-story *tabernae* open onto the hemicycle itself. Behind the exedra Trajan's Markets are made up of a complicated series of structures – stores and other spaces – that adapt to the slope and character of the terrain, with architectural solutions of remarkable coherence. Perhaps it is here that the skill of the architect who de-

42

Trajan's Column and, on facing page, details of the reliefs with episodes from the war against the Dacians

Right, two reliefs of the base of the Column of Antoninus Pius. Cortile della Pigna, Vatican

signed the entire complex, Apollodorus of Damascus, finds its clearest expression.

According to some scholars, Apollodorus was also responsible for the frieze that winds around Trajan's Column in a wholly original manner. The relief, which was painted in bright colors and had inserts of gilded bronze, recounts the history of the two campaigns in Dacia that Trajan led personally (101-02 and 105-06) in a way that is more educational in its intent than celebratory. It commences with the crossing of the Danube on a bridge of boats and ends with the final surrender of the Dacians. The frieze is an extraordinary work of art and constitutes a highly successful blend of strictly Roman narrative content with the formal language of Hellenism, which here takes the form of a lively naturalism very different from the neo-Attic refinements of Augustus's time. The reliefs on the column mark the culminating point of the influence of the Hellenistic tradition on Roman art, which from this moment on went into gradual decline. In parallel, elements typical of the plebeian artistic tradition made their appearance in official art, in a process that was to lead to the development of late classical art. In this connection, the reliefs on the base of the column – unfortunately no longer in existence – erected by Marcus Aurelius and Lucius Verus in the Campus Martius, on the site where the body of Antoninus Pius had been cremated, are significant. On one side of the base (now in the Cortile della Pigna in the Vatican) runs the dedicatory inscription; on the other there is an allegory of the apotheosis of Antoninus Pius and his wife Faustina, who are borne aloft by a winged genius under the gaze of two figures personifying the Campus Martius and Rome. In contrast with the rather arid classicism of this representation, the reliefs on the shorter sides of the monument depict the ceremony of the *decursio*, an ancient ritual in which horsemen and foot soldiers paraded around the *ustrinum*, or place of cremation. In a device typical of plebeian art, the two phases of the procession are represented contemporaneously, with no respect for chronological sequence. The representation of the circling horsemen on two superimposed planes, as if in a bird's-eye view, belongs to the same plebeian tradition. These images, carved in almost full relief, do not display the refinement and sophistication of the

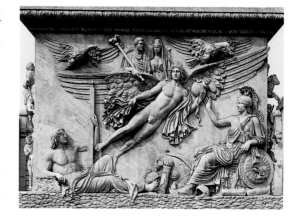

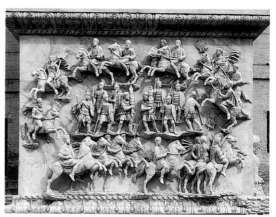

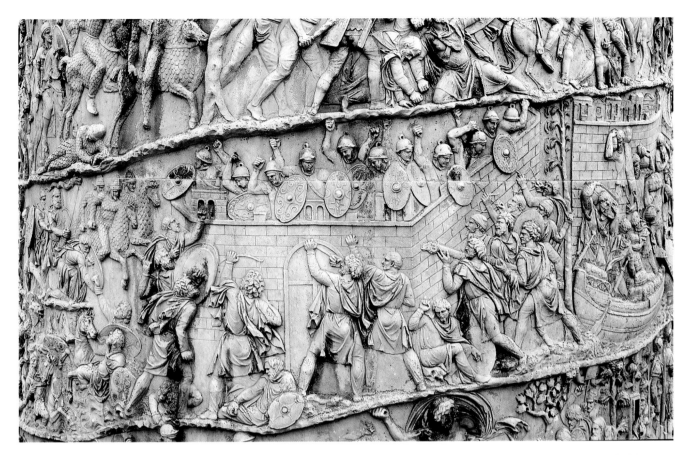

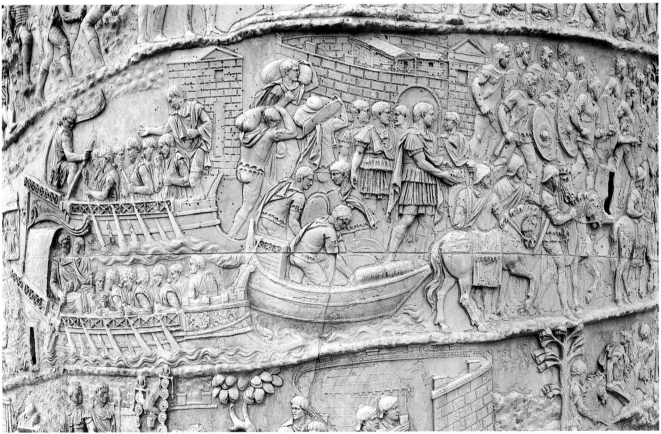

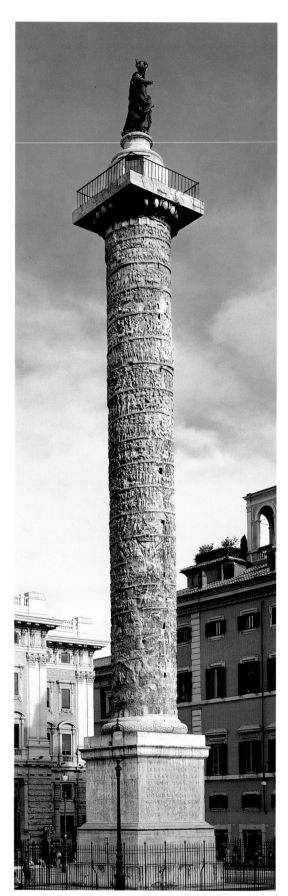

first panel, but are much more lively and immediate.

The influence of this formal language can also be discerned in the Column of Marcus Aurelius, raised in the Campus Martius about eighty years after Trajan's, on which it was obviously modeled. The relief winding around the shaft of the monument, also a hundred Roman feet high, illustrates Marcus Aurelius's expedition against the Germans and Sarmatians. Though the theme is the same, the account is presented in a schematic fashion and lacks the compositional and formal coherence of its model. Narrative efficacy is achieved through the technique adopted to execute the relief, which is rendered extremely expressionistic through extensive use of the drill. The figure of the emperor is often presented frontally, in an iconography that expresses a new and almost sacred conception of his

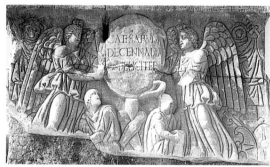

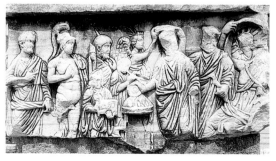

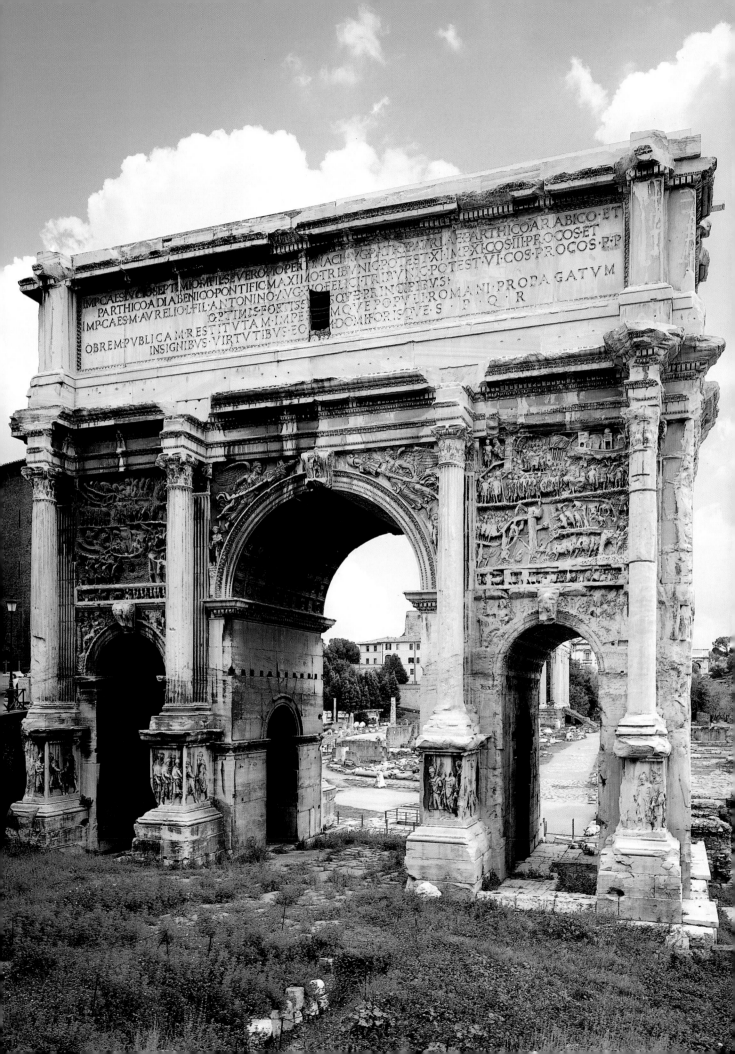

majestas. Over the course of the third century this imperial iconography became canonical. We find it again on the Arch of the Moneychangers, erected in 204 on the square of the Forum Boarium by local bankers and cattle dealers in honor of Septimius Severus and his family. In reality the structure is an architraved gate with lavish decorations, carved in high relief to create an effect of marked chiaroscuro. The two main panels, set inside the archway, depict sacrifices carried out by members of the imperial family: on the left Caracalla and Plautilla, on the right Septimius Severus, Julia Domna and Geta (the figures of the latter and of Plautilla, who were put to death by Caracalla, were chiseled out in ancient times). The personages are portrayed from the front, occupying the whole of the space available so that all sense of depth is lost.

Remains of the Baths of Caracalla

Bottom, mosaic with figures of athletes from the Baths of Caracalla. Museo Gregoriano Profano, Vatican

Unquestionably the most important architectural project of the third century was that of the Baths of Caracalla (or Antonine Baths), built between 212 and 216 to the southwest of the Circus Maximus.

The building of the baths proper (220 x 214 meters or 722 x 702 feet) was surrounded by an extensive garden with a massive wall, constructed by Caracalla's successors, Elagabalus and Severus Alexander. A portico ran along the northern side of the enclosure, with the entrance in the middle, but almost nothing of it has survived. On the opposite side of the structure were located the enormous cisterns that held water for the baths (their capacity has been estimated at 80,000 cubic meters or 2,825,000 cubic feet), concealed from view by a sort of stepped exedra that was probably used for gymnastic displays. This was flanked by two rooms with apses, perhaps libraries. On the eastern and western sides two large hemicycles were set in the walls, each with three rooms whose function is unclear. Along the central axis of the building runs the traditional sequence of bath chambers: from east to west, the *natatio*, an open-air pool with niches for statues at the rear; the *frigidarium*, a huge basilican hall (58 x 24 meters or 190 x 79 feet) with four pools, roofed with a groin vault; the small *tepidarium* with an apse; and finally the *calidarium*, a round hall (34 meters or 112 feet in diameter) with six tubs set in recesses in the walls and a circular one in the middle, roofed with a vault and illuminated by a series of large windows. The various service rooms in the baths (including those used for changing, massage

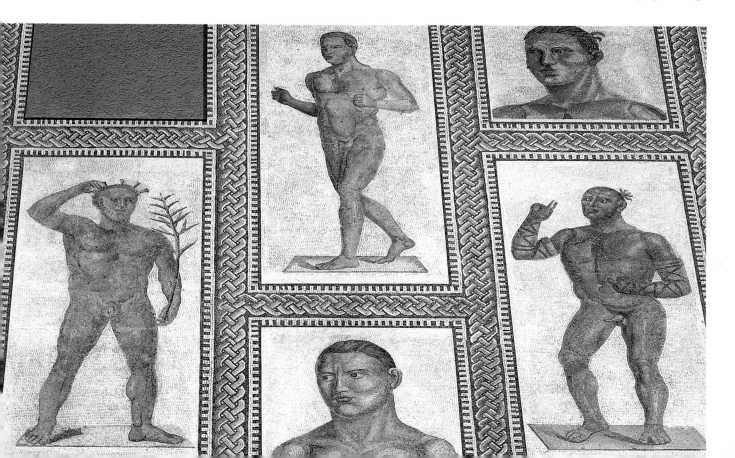

Map of Imperial Rome

1 Aurelian Wall
2 Mausoleum of Augustus
3 Hadrian's Mausoleum
4 Sundial of Augustus
5 *Ara Pacis Augustae*
6 Domitian's Stadium
7 Nero's Baths
8 Pantheon
9 Odeon
10 Agrippa's Baths
11 Saepta Julia
12 Temple of Isis
13 Temple of the Divine Hadrian
14 Theater of Pompey
15 Porticus of Pompey
16 Porticus Minucia Frumentaria
17 Theater of Balbus
18 Porticus Octaviae
19 Theater of Marcellus
20 Castra Praetoria
21 Baths of Diocletian
22 Forum of Trajan
23 Forum of Augustus
24 Forum of Cesar
25 Forum of Nerva
26 Temple of Peace
27 Temple of Juno Moneta
28 Temple of Jupiter on the Capitol
29 Porticus of Livia
30 Trajan's Baths
31 Baths of Titus
32 Temple of Venus and Roma
33 Amphitheatrum Flavium
34 Ludus Magnus
35 Domus Tiberiana
36 Temple of Elagabalus
37 Temple of Apollo
38 Domus Augustana
39 Domus Severiana
40 Circus Maximus
41 Temple of the Divine Claudius
42 Porticus Aemilia
43 Horrea Galbana
44 Baths of Antoninus
45 Amphitheatrum Castri
46 Pons Aelius
47 Pons Neronianus
48 Pons Agrippa
49 Pons Aurelius
50 Pons Fabricius
51 Pons Cestius
52 Pons Aemilius
53 Pons Sublicius
54 Pons Probi

and exercise) are located symmetrically on each side of this central axis, laid out around two rectangular peristyles that were undoubtedly gymnasia. The baths were not just imposing from the architectural viewpoint, but sumptuously decorated with mosaics, marble and large sculptures (the three statues of the *Farnese Hercules*, *Bull* and *Flora*, now in the National Museum of Naples, all came from here).

The Baths of Caracalla were only exceeded in size by the ones built by Diocletian between 298 and 306: the largest ever constructed, these were located to the north of the densely populated quarters between the Quirinal and Viminal.

The outer enclosure of the Baths of Diocletian, of which little remains today, measured 380 x 370 meters or 416 x 405 yards and contained numerous spaces with a variety of functions. In particu-

lar, there was a large hemicycle in the middle of the western side (the modern semicircular square of Piazza della Repubblica was laid out on top of it) that may have been used for theatrical performances. On the other hand the function of the two round halls at the corners of this side of the enclosure is not clear (the one in the southwest corner has been converted into the church of San Bernardo alle Terme). On the eastern side all that have survived are three exedras, perhaps used for public lectures. The central complex (250 x 180 meters or 820 x 591 feet) is laid out in the standard pattern, with the bath chambers along the east-west axis and the service rooms set symmetrically on each side, around two peristyles used as gymnasia. Some of these structures have come down to us in a good state of preservation, having been in-

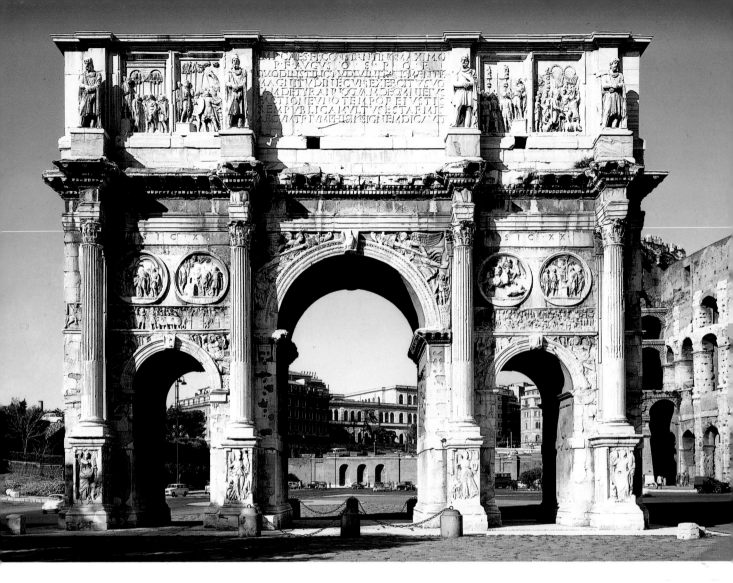

Roman Forum, the Arch of Constantine

The Basilica of Maxentius erected at the beginning of the 4th century AD and completed by Constantine

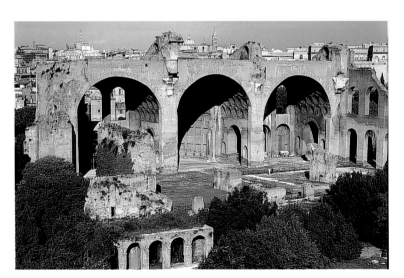

corporated into the church of Santa Maria degli Angeli. The main part of the church is located in what was once the *frigidarium* (a rectangular hall roofed with groin vaults whose walls are lined with eight granite columns). The entrance is set in the northern apse of the *calidarium*, from where you pass through the *tepidarium*, a circular chamber with two square exedras at the sides, on your way into the church. In the Museo delle Terme parts of some of the service rooms and one section of the *natatio* have been preserved.

The process of formation of late classical art can be said to have reached completion with the Arch of Constantine, which in a way recapitulates it. Erected near the Colosseum to celebrate the emperor's victory over Maxentius in 312, the monument is decorated with a series of reliefs and sculptures (as well as architectural elements) taken from other buildings: the statues of Dacians on top of the columns that flank the three openings come from Trajan's Forum, as in all likelihood do the four panels inside the central archway and on the sides of the attic, which originally formed part of a single frieze. The eight tondi above the lateral openings date from Hadrian's reign. Lastly, the eight reliefs on the attic, set at the sides of the inscription, are from the time of Marcus Aurelius. The most noteworthy of the sculptures dating from Constantine's own time that complete the decora-

The Excavation of the Imperial Forums

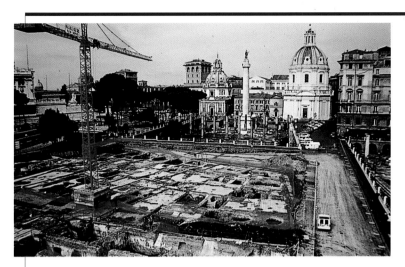

Trajan's Forum, excavation of the statue of a Dacian prisoner

A vast area covering 13,800 square meters or 148,488 square feet, a total of 55,200 cubic meters or 1,949,112 cubic feet of earth excavated by archeologists in the space of a year and a half: these are the figures associated with the operation known as the "Imperial Forums Project." The initiative was conceived as a first step toward reunifying the complex of monumental squares created from the first century BC onward. In fact the temple of Peace and the forums of Caesar, Augustus, Nerva and Trajan, situated at the heart of the city, were first incorporated into the medieval and modern fabric of buildings and then damaged and split up during the Fascist period, with the construction of Via dei Fori Imperiali.

Commencing in 1995 in the area of the Forum of Nerva and extended to all the others in September 1998, the excavations will be completed by the end of 2000. Results of great scientific interest have not been slow to arrive. Some of the most significant discoveries have been made in the Forum of Trajan, where the exact position of the temple dedicated to the emperor has at last been identified, along with that of his equestrian statue (it is thought that it was twice as big as the *Equestrian Statue of Marcus Aurelius* now in the Capitoline Museums). Then in the area of the temple of Peace – never previously explored – traces of the large gardens that used to adorn the square have been found, while the details of the layout of the Forum of Caesar have been defined and a number of tombs from the tenth century BC have been discovered underneath its paving. A great deal of interesting information with regard to the medieval period has also emerged. We now know that a large part of the Imperial Forums survived in good condition right up to the sixth century. Data on the subsequent period is fairly scanty, but it is clear that many of the monumental complexes embarked on a long process of decline. The excavations have also uncovered one totally unexpected fact: numerous private houses were built in this area around the ninth century, something that reflects a major change on the level of urban development. Some of these early medieval dwellings, probably built by members of the Roman aristocracy, can still be seen in the area of the Forum of Nerva.

Naturally, the excavations have also brought to light structures dating from after the year 1000 and from the modern era and the work of the archeologists has made it possible to reconstruct in great detail the complicated process by which the city has continued to grow on top of itself over the centuries.

tion is the frieze running above the smaller openings and on the sides of the arch. The relief illustrates episodes from the campaign against Maxentius (starting from the western short side), from the departure of Constantine's troops from Mediolanum (Milan) to the decisive battle of the Milvian Bridge and the emperor's entry into Rome, and concludes with an *oratio* given by the emperor in the Forum and the distribution of money to the people. No trace of naturalism remains in these reliefs: the figures are represented according to a rigid hierarchy, with the principal ones depicted from the front, and there is no longer any attempt to create an impression of depth.

After the *felicia tempora* of the second century, the third brought a period of great economic and social upheaval for Rome, due mainly to the pressure exerted by barbarian peoples on the empire's borders. The city began to undergo a slow and difficult process of transformation. Constantine completed some of the building projects initiated by Maxentius, but in 330 he moved the empire's capital to Byzantium, henceforth known as Constantinople. In a sense this event marked the end of classical, pagan Rome: from this time on the monuments of the former capital were gradually abandoned or converted to other purposes. It was the birth of a new Rome, Christian Rome.

National Etruscan Museum of Villa Giulia

The materials from the region of Falerii and Capena and from Latium include the remains of the clay decoration of the sanctuaries of Falerii Veteres (fifth-third century BC) and the rich grave goods from the Barberini and Bernardini tombs, dating from the period of Oriental influence, that were discovered near Palestrina. Among the examples of gold work, we cannot fail to mention

Top left, detail of one of the gold pectorals from Palestrina, middle of the 7th century BC

Center, votive bronze group of the *Plowman of Arezzo*, end of 5th century BC

Below, clay statue of *Apollo* from the temple of Portonaccio, end of 6th century BC

Above, one of the gold plaques from Pyrgi, first half of the 5th century BC

B uilt for Pope Julius III between 1550 and 1555 by Jacopo Vignola, Villa Giulia was turned into a section of the Museo Nazionale Romano in 1889 and originally used to house pre-Roman antiquities from Latium. Later these were joined by some important Etruscan finds and acquisitions. The museum (currently undergoing renovation) is organized on a geographical basis, with the objects on show arranged according to their place of origin.

The acroteria, or roof sculptures, of the Portonaccio temple at Veii (late sixth century BC) are true masterpieces of Etruscan art and include the polychrome terracotta statues of *Heracles and Apulu* (the Etruscan version of Apollo) fighting over the Cerynean hind, the *Statue of a Goddess with a Child in Her Arms* (possibly Leto with Apollo) and *Hermes*.

The celebrated *Husband and Wife Sarcophagus*, in polychrome terracotta (*c.* 530 BC), comes from Cerveteri, along with numerous Greek vases. The gold plaques with bilingual dedications (in Etruscan and Punic) to the goddess Uni-Astarte, found at Pyrgi, are also of great interest.

two extremely refined pectorals decorated with the molded heads of felines, chimeras and sphinxes. As far as the bronzes are concerned, the celebrated *Ficoroni Cist*, named after its former owner, is a work from the end of the fourth century BC engraved with a scene from the myth of the Argonauts.

The Villa Giulia Museum also houses the important Castellani collection of jewelry. Offering a fascinating overview of the history of jewelry from the eighth century BC up to the nineteenth century, it has recently been reorganized and made accessible to the public.

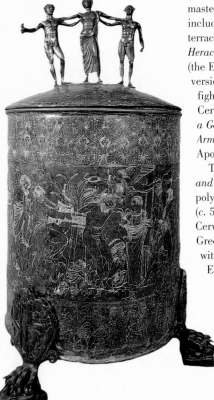

The *Ficoroni Cist*, end of 4th century BC

On facing page, detail of the *Husband and Wife Sarcophagus*, c. 530 BC

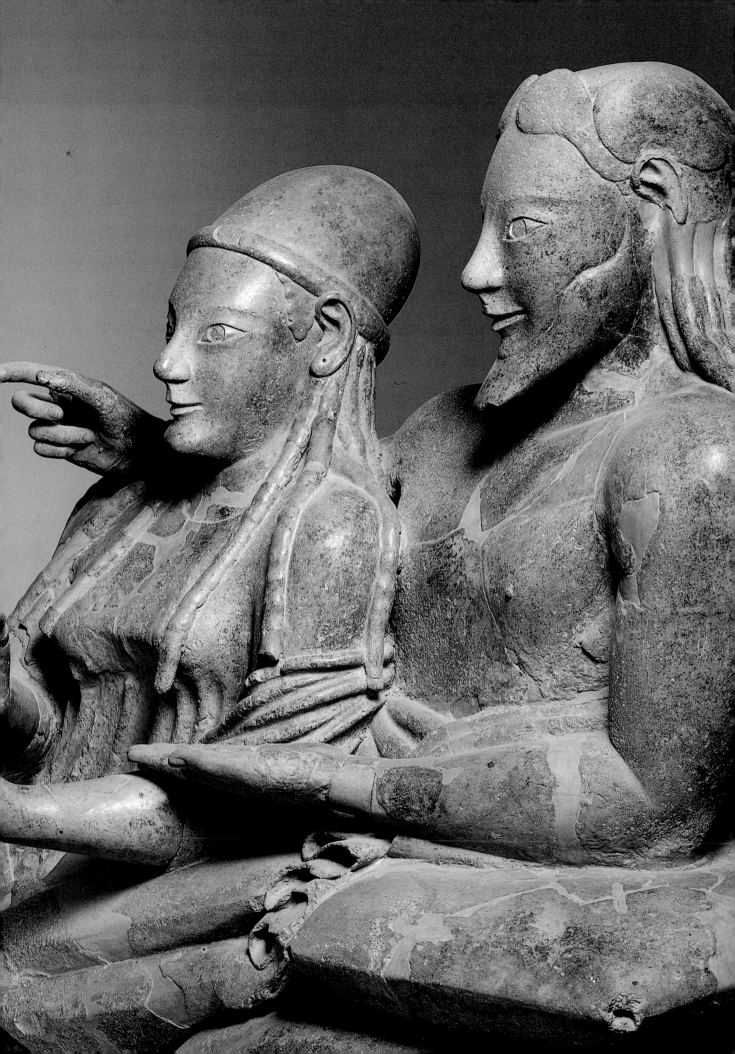

The National Roman Museum

The Museo Nazionale Romano was set up in 1889 and has since grown into one of the most important archeological collections in the world. Part of the museum is housed in rooms that were once part of Diocletian's Baths, while two more sections are located in Palazzo Massimo and Palazzo Altemps.

Portrait of Plautilla, 3rd century AD

Lancellotti Discobolus, 2nd century AD

Palazzo Massimo alle Terme

Since 1995 Palazzo Massimo has been the principal seat of the Museo Nazionale Romano.

Commissioned from the architect Camillo Pistrucci by the Jesuit Massimiliano Massimo, it was built between 1883 and 1887 in a style typical of the late sixteenth century and initially housed the Jesuit College. It retained this function up until 1960, when it was taken over by the State, which set about adapting the building for use as a museum.

Significant Roman works of sculpture and portraiture from the late republican and imperial periods are displayed on the ground floor. Outstanding among these are the statues of the so-called *Tivoli General* and of *Augustus* in the guise of *pontifex maximus* from Via Labicana, as well as some Greek originals, including the *Wounded Daughter of Niobe*, dating from the fifth century BC. The second floor is devoted to sculptural decorations from the great imperial residences. In addition to reliefs and sarcophagi, these include numerous formal portraits of emperors and celebrated statues, such as two Roman copies of the original bronze by the Greek sculptor Myron known as the *Discobolus (Lancellotti Discobolus, Discobolus of Castel Porziano)*, the *Apollo of the Tiber*, after an original probably by Phidias, and the *Chigi Apollo*. The bronze ornaments of two of Caligula's ships that were found in Lake Nemi are also interesting.

On the third floor we find a series of paintings, stuccoes and mosaics that exemplify Roman civilization. In particular, it is

Panels in *opus sectile* from the Basilica of Junius Bassus depicting *The Abduction of Hylas* and *The Consul between the Factions of the Circus*, 4th century AD

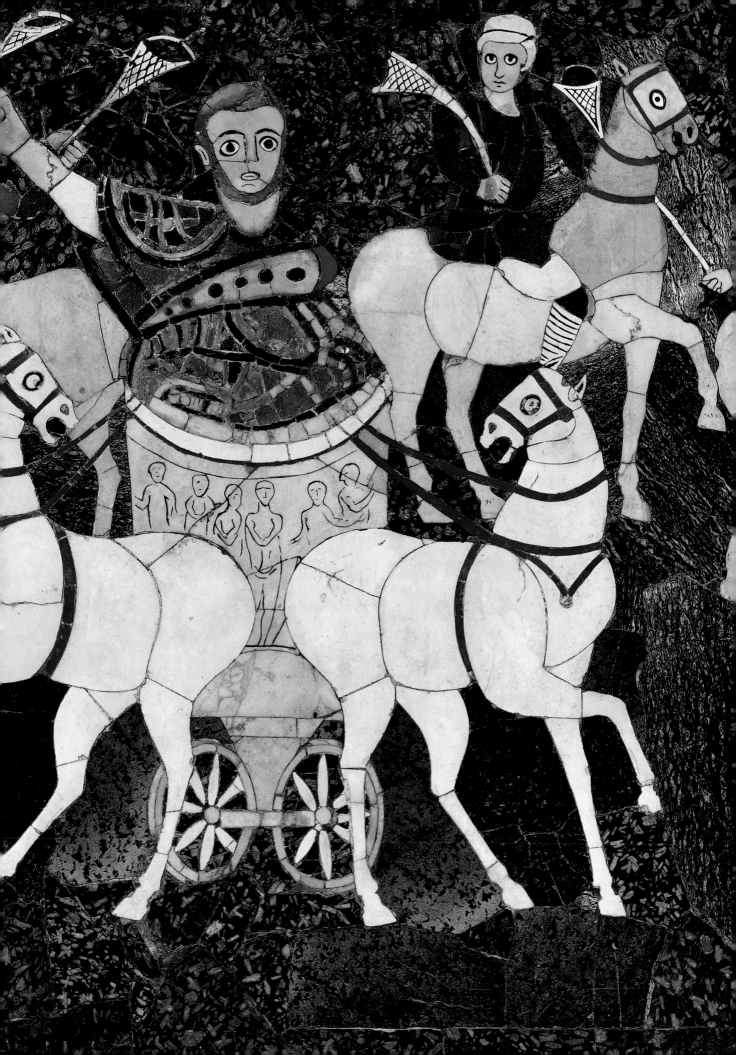

Palazzo Altemps

Though work commenced on Palazzo Altemps for the nephew of Sixtus V, Girolamo Riario, at the end of the fifteenth century, it was not completed until the seventeenth century and is the product of contributions from a long series of architects. The most decisive of these was made by Martino Longhi the Elder, who designed the roof terrace cum belvedere that characterizes the building. Since 1998 it has housed material that used to belong to archeological collections assembled in the Renaissance and baroque periods, such as the Boncompagni Ludovisi, Mattei and Altemps collections, though all that remains of the latter are sixteen sculptures.

Some of the works from the Ludovisi collection are particularly famous, including the much debated *Throne* (in all likelihood a fifth-century BC original from Magna Graecia) and a number of interesting Roman copies of Greek originals, such as the *Athena Parthenos*, a copy made by

The Palazzo Altemps and a view of the loggia painted with frescoes at the end of the 16th century

The so-called *Large Ludovisi Sarcophagus*, middle of 3rd century BC

worth mentioning the paintings of garden scenes from Livia's Villa at Prima Porta and the frescoes and stuccoes from the Villa Farnesina. Discovered in the second half of the nineteenth century while work was being varied out near the Tiber, where the villa used to stand, they provide tangible evidence of the refined Augustan style. The panels in *opus sectile* from the basilica of Junius Bassus (fourth century AD) are also very fine.

In the basement of the museum there is a noteworthy collection of coins and a section devoted to jewelry.

Wall of cubiculum with decoration in the Second Pompeian style from the Villa della Farnesina

Statue of *Christ the Teacher*, mid-3rd to mid-4th century BC

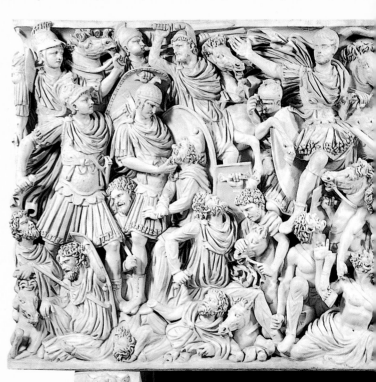

Antiochus in the first century BC from an original by Phidias; the second-century AD *Heracles*, copy of an original by Lysippus or Scopas; the *Ares*, attributable to the school of Lysippus and

The reliefs of the
Ludovisi Throne

restored by Bernini in 1622; the group representing a *Galatian Committing Suicide with His Wife*; and the group of *Orestes and Electra*.

Nor should we forget the monumental piece known as the *Large Ludovisi Sarcophagus*, which depicts a scene of battle between Romans and barbarians with notes of intense drama. In addition to Roman works, Palazzo Altemps houses the Egyptian collection of the National Roman Museum.

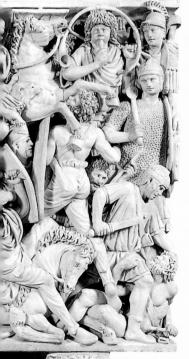

The Baths of Diocletian

The Baths of Diocletian – the historic seat of the Museo Nazionale Romano, located in the former Charterhouse of Santa Maria degli Angeli – are currently closed for renovation, but will eventually house the museum's Epigraphic Department, made up of over 10,000 inscriptions.

On the other side of Via Cernaia the octagonal structure known as the "Hall of Minerva" has been used since 1991 to display those sculptures in the Museo Nazionale Romano that came originally from the city's baths, including the famous *Aphrodite of Cyrene*, a second-century AD replica of a work by Praxiteles, and an interesting group of pieces from the Baths of Caracalla. Also worthy of note are the two bronzes of the so-called *Hellenistic Prince* (second century BC), which is probably the honorary portrait of a Roman general, and the *Seated Boxer*, dated to the first century BC.

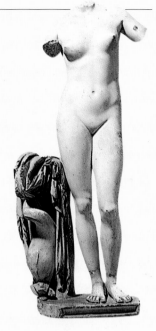

Baldassarre Peruzzi,
Relief in the Baths of Diocletian. **Gabinetto dei Disegni e delle Stampe of the Uffizi, Florence**

Aphrodite of Cyrene, **replica from the 2nd century AD**

Seated Boxer, **1st century BC**

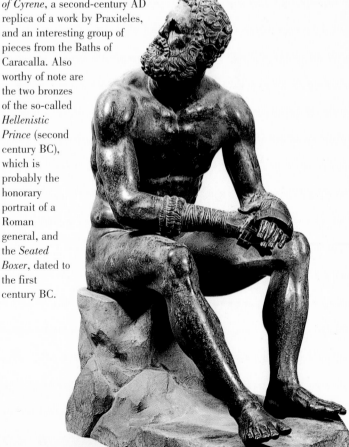

Capitoline Museums

F ounded in 1471, the Musei Capitolini house the oldest public collection in the world. They are now located in the Palazzo dei Conservatori (which contains the Appartamento dei Conservatori, the Museo del Palazzo dei Conservatori, the Braccio Nuovo, the Museo Nuovo and the Pinacoteca Capitolina) and in the Palazzo Nuovo (seat of the Museo Capitolino).

Palazzo dei Conservatori

I n the courtyard of the Palace of the Conservators you can see the remains of a colossal statue of Constantine and a series of interesting reliefs from the imperial age.

The rooms of the APPARTAMENTO DEI CONSERVATORI (Apartment of the Conservators) contain several pieces of great importance, including the *Capitoline She-Wolf*, a bronze from the early fifth century BC (the twins are a fifteenth-century addition). On the rear wall of the Sala della Lupa, as the room containing this sculpture is known, are set fragments of the *Fasti consulares et triumphales*, or *Lists of Consuls and Triumphs*, originally on the Arch of Augustus in the Forum. The so-called *Capitoline Brutus* is another celebrated bronze, datable to sometime between the third and second century BC.

The MUSEO DEL PALAZZO DEI CONSERVATORI (Museum of the Palace of the Conservators), currently undergoing reorganization, also boasts bronze works of great interest, including a funerary bed from Amiterno (first century BC). Among the sculptures are the pieces found in the Horti Lamiani, on the Esquiline. The museum's collections also include the *Krater of Aristhonothos*, signed by the artist and decorated with the oldest known representation of the myth of Ulysses and Polyphemus (early seventh century BC).

The BRACCIO NUOVO (New Wing) and the MUSEO NUOVO (New Museum), which house finds made in excavations subsequent to 1870, are also closed at present for renovation.

Museo Capitolino

S et up from the outset exclusively to house ancient works of sculpture, the Capitoline Museum now boasts an impressive collection, of which perhaps the most prestigious exhibit is the bronze equestrian statue of *Marcus Aurelius* (long set at the center of Piazza del Campidoglio and now on show in a room on the right of the museum's courtyard). Among the numerous Roman copies of Hellenistic originals,

Top, fragments of the colossal statue of Constantine

Dying Gaul, **Roman copy of Greek original from the 3rd century BC**

The Vatican Museums

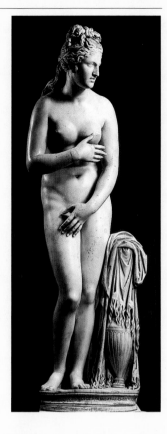

Equestrian statue of Marcus Aurelius, 2nd century AD

Capitoline Venus, Roman copy of Greek original from the 2nd century BC

many of them of great quality, it is worth mentioning in particular the *Capitoline Venus*, modeled on the *Venus of Cnidus*, the *Wounded Amazon*, a replica of an original by Cresilas, and the statue known as the *Dying Gaul*, a copy of a Pergamene bronze from the third century BC. The museum's collection of busts of emperors is also interesting: its sixty-five pieces make it one of the largest of its kind. There is also a room with seventy-nine busts of Greek and Roman philosophers, poets, physicians, orators and historians.

The Musei Vaticani constitute a complex of exceptional importance and house the largest collection of antiquities in Rome, the original nucleus of which was assembled by popes during the Renaissance. The place that was initially chosen to display Pope Julius II's personal collection of classical sculptures and sarcophagi was the courtyard of the Palazzetto del Belvedere, laid out as a garden with charming naturalistic effects. This collection, the seed out of which the Vatican Museums grew, was added to by subsequent popes up until the election of Pius V (1566-72), strict custodian of the spirit of the Counter Reformation, who initiated a process of dispersion of the works of art that had been accumulated. Afterward, the papacy sought to stem this process and reorganize the collections, especially during the eighteenth and nineteenth centuries. It was during this time that the museums took on their present form, on the initiative of Clement XIV, Pius VI, Pius VII and Gregory XIV. Of necessity, only the sections most closely connected with the ancient history of the city will be described here.

Museo Gregoriano Profano

The Gregorian Profane Museum was set up by Gregory XVI (1844) in the Lateran Palace in the middle of the nineteenth century. Later it was transferred to modern premises in the Vatican designed by the architects Vincenzo, Lucio and Fausto Passarelli on the initiative of Pope John XXIII (1958-63), together with the Museo Pio Cristiano and the Museo Missionario Etnologico. A large part of the material on display comes from nineteenth-century discoveries or excavations carried out in the Papal States. Many of

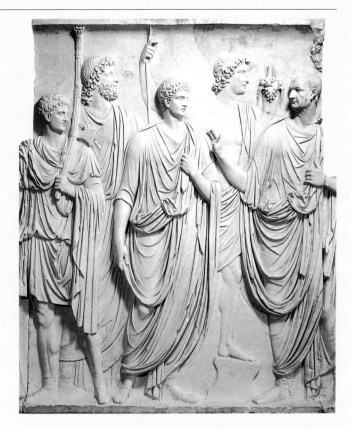

them are copies or reworkings of Greek originals (*Poseidon*, *Athena and Marsyas*, *Chiaramonti Niobid*). The museum also houses interesting examples of Roman sculpture from the first and second centuries AD, such as the *Altar of the Vicomagistri*, probably once just part of a larger imperial altar, two reliefs from the reign of Domitian (*Arrival of Vespasian*, *Departure of Domitian*) originally in the Palazzo della Cancelleria and the reliefs from the *Tomb of the Haterii*.

Museo Chiaramonti

The Chiaramonti Museum, named after its founder, Pope Pius VII Chiaramonti (1800-23), was laid out in the long corridor of the Belvedere by Canova. Much of his original selection and

arrangement has been left unchanged. It houses numerous interesting Roman sculptures including, in the Braccio Nuovo (New Wing), a copy of Polyclitus's *Doryphorus* and the statue called the *Augustus of Prima Porta*. The section known as the Galleria Lapidaria (Lapidary Gallery) – open to specialists on request – contains over 4000 pagan and Christian inscriptions, making it one of the most important collections of its kind.

Top, relief from the Palazzo della Cancelleria with the *Arrival of the Emperor Vespasian*, 1st century AD

Chiaramonti Niobid, 2nd century BC

Museo Pio-Clementino

The Pio Christian Museum houses some of the oldest and most celebrated sculptures in the Vatican collections, many of them once on display in Julius II's Antiquarium.

It is made up of a series of rooms of considerable historical interest that provide a worthy setting for the works on display and testify to the efforts made by a number of popes to show them off to the best effect, sometimes with "unfortunate" results as in the case of the destruction of

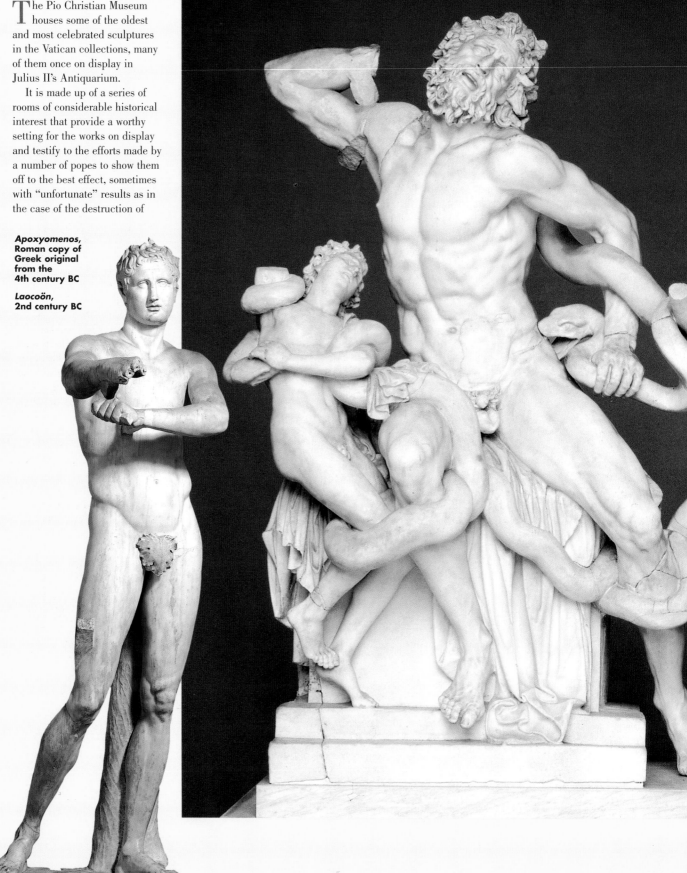

Apoxyomenos, Roman copy of Greek original from the 4th century BC

Laocoön, 2nd century BC

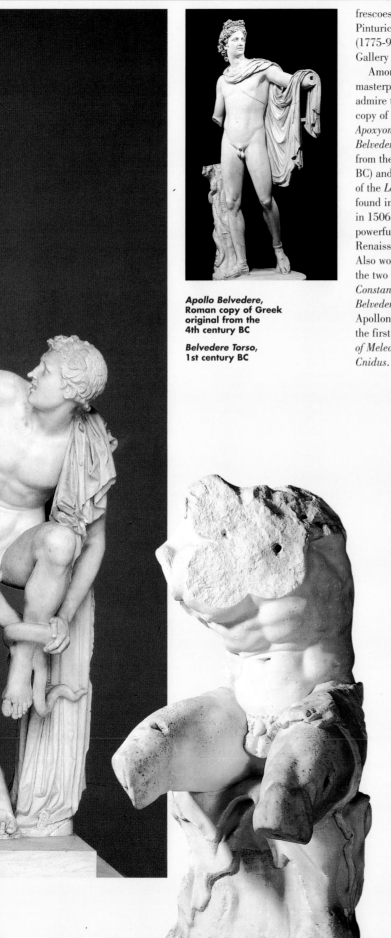

**Apollo Belvedere,
Roman copy of Greek
original from the
4th century BC**

**Belvedere Torso,
1st century BC**

frescoes by Mantegna and Pinturicchio when Pius VI (1775-99) decided to extend the Gallery of Statues.

Among the many masterpieces we can admire the only known copy of Lysippus's *Apoxyomenos*, the *Apollo Belvedere* (after an original from the fourth century BC) and the famous group of the *Laocoön* which, found in the *Domus Aurea* in 1506, exercised such a powerful influence on Renaissance statuary. Also worth mentioning are the two porphyry sarcophagi of *Constantia* and *Saint Helen*, the *Belvedere Torso*, signed by Apollonius, an Athenian artist of the first century BC, the *Statue of Meleager* and the *Venus of Cnidus*.

Museo Gregoriano Etrusco

Much of the material in the museum, founded by Gregory XVI in 1837, came from private excavations carried out in the necropolises of southern Etruria. Further additions have been made through donations (Guglielmi Donation, Astarita Donation) and acquisitions (Falcioni Collection). The museum houses a collection of Etruscan and Greek pottery ranging from the Villanovian period to the Hellenistic era, interesting finds from the period of Oriental influence made in the necropolis of Sorbo (Cerveteri) – whose best-known tomb, the Regolini-Galassi, is named after its co-discoverers – and the celebrated *Mars of Todi*, a bronze sculpture from the end of the fifth century BC.

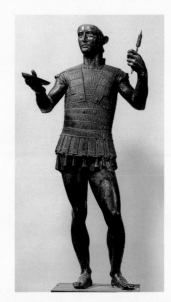

**Top, fibula made of
gold plate from the
Regolini-Galassi
Tomb, 7th century BC**

***Mars of Todi*, end of
5th century BC**

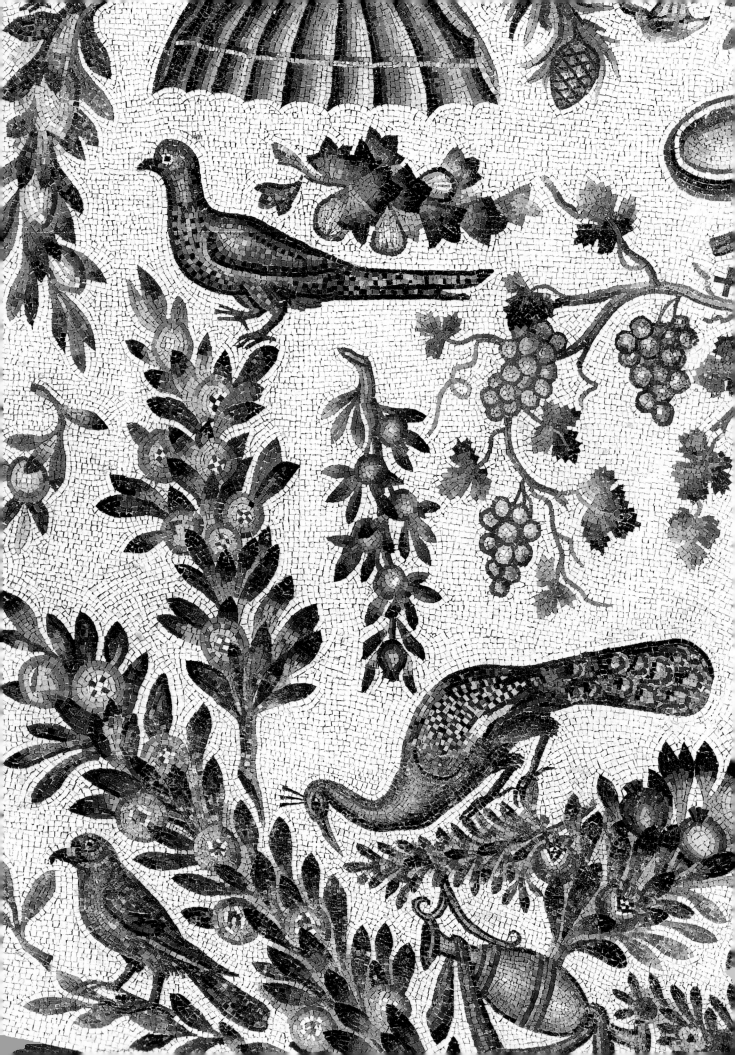

MEDIEVAL
ROME

The Age of Constantine (Fourth Century)

If we want to trace the development of artistic forms in Rome during the Middle Ages, what this means in essence is analyzing the monumental stamp that the Church left on the city, once it had supplanted the imperial government. From the fourth century onward, in fact, the greater part of cultural and artistic energies were channeled into fostering the spread of the Christian faith and shedding luster on the process of ecclesiastical organization.

The Edict of Milan in 313, by which the state granted Christians the legal right to practice their religion, marks a fundamental step in the process of development of a Christian artistic culture, as it allowed the new creed to escape from its "domestic" bounds (the first places of worship were in fact the halls of private *domus* in which Christians used to gather) and assume, with the favor shown to it by the emperor Constantine, specific monumental characteristics. It was after 313, in fact, that the Christianization of the city of Rome got under way, with the construction of new buildings for the Roman community. Constantine took it upon himself to promote the construction of the cathedral, dedicated to the Savior (now San Giovanni in Laterano), a palatine church for the empress Helen (the present-day Santa Croce in Gerusalemme), the martyrium dedicated to St. Peter and a series of buildings of a sepulchral character that were erected in the suburbs to serve as indoor cemeteries and then converted into ordinary churches. Although none of these buildings has come down to us

in its original form, we are able to reconstruct their appearance on the basis of a vast range of documentary sources and archeological investigations.

What is immediately apparent is the custom of using public architecture as a model. The scheme most frequently adopted was that of the late classical basilicas, buildings that on the one hand were highly versatile from the functional viewpoint and on the other had no direct links with pagan religion. The earliest basilicas must have been extremely plain on the outside, but with animated interiors enriched by the use of precious materials like marble and by columns.

The only well-preserved building from the Constantinian era is the MAUSOLEUM OF SANTA COSTANZA, built to house the mortal remains of the emperor's daughter, Constantia (who in reality was never made a saint). The building was erected alongside the burial hall dedicated to the martyr Agnes on the Via Nomentana, of which nothing survives but a section of the outer wall reinforced with buttresses. The mausoleum, built between 337 and 354, has

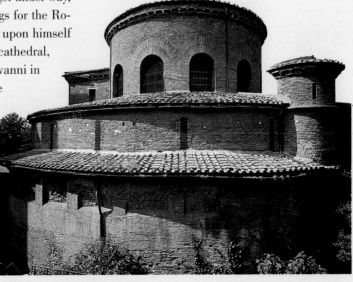

On facing page, detail of a mosaic in the ambulatory of the Mausoleum of Constantia, known as the church of Santa Costanza

The Mausoleum of Constantia

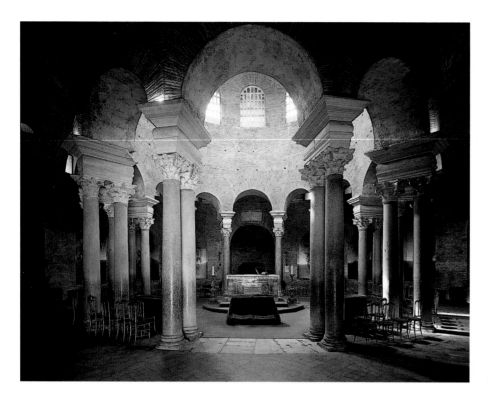

The interior of the
Mausoleum of
Constantia

*Porphyry
Sarcophagus of
Constantia,*
4th century AD.
Museo Pio-
Clementino, Vatican

on the outside by a high cylindrical wall surmounted by a conical roof. The whole structure stands on twelve pairs of columns with Composite capitals, which separate the central part from the external lower ambulatory, covered by a tunnel vault. Fifteen niches are set in the outer wall, with the largest four located at the main axes of the building. Originally, it had another story on the outside, made up of a portico with columns.

The structure of the mausoleum, though clearly derived from the characteristic classical scheme of the central plan, displays some substantial innovations on the formal plane. In Santa Costanza everything is designed to create an impression of spatial movement: the division of the space into several concentric aisles with independent roofs, the double ring of columns, the alternation of semicircular and square niches in the outer wall and above all the strong contrast between the brightly-lit central hall and the semidarkness of the ambulatory. Every element focuses attention on the center of the mausoleum, where the porphyry sarcophagus containing the remains of Constantia originally stood (it was moved to the Vatican Museums in 1791).

So the Christian architecture of the early days took its inspiration from the classical tradition's substantial repertoire of forms, but presented some original features in its reinterpretation of architectural types in relation to their new functions. Much

changed its function several times, becoming first the baptistery of a new church dedicated to the same St. Agnes in the seventh century and then, probably in 865, a church in its own right. The structure, which is entered through a narthex that was originally connected with the early Christian hall, has a circular plan with a diameter of 22·5 meters or 74 feet. The central space is roofed by a hemispherical dome, which is concealed from view

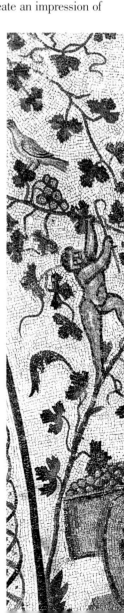

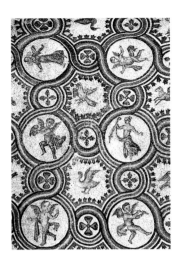

Details of the mosaic decoration in the ambulatory of the Mausoleum of Constantia

the same can be said of the figurative arts, and from this perspective too the Mausoleum of Constantia is important, as it houses the richest surviving decoration of a religious building constructed in Constantine's time. The greater part of the original figurative decoration, that of the dome, has been lost, but the mosaics on the vault of the annular ambulatory have been preserved. The decoration is subdivided into trapezoidal panels, adorned with geometric, plant and allegorical motifs. Some of the panels are filled with interlaced lozenges and octagonal crosses, a figured version of the patterns of coffered ceilings, while others contain lively decorations of foliage surrounding personifications of the dead, embellished with Bacchic scenes typical of sepulchral

paintings. The style of the mosaics is derived directly from popular art, as is evident from the almost caricatural expressions on the faces of the putti and bacchantes, where no attempt at naturalistic representation seems to have been made. Two more fragments of the original decoration – heavily restored, it must be said – are located in the niches at the sides and depict scenes of a doctrinal character. In one we see Christ seated on the globe while he hands the keys to Peter, while in the other Christ descends from the clouds to present the scroll of the law to Peter and Paul. The style and the iconography, derived from imperial art, suggest that they were executed by different craftsmen from the ones who did the mosaics on the vaults. We can discern a classical tone, more evident in certain specific contexts, such as the figure of Paul, than in the handling of space.

The religious foundations of Constantine's time

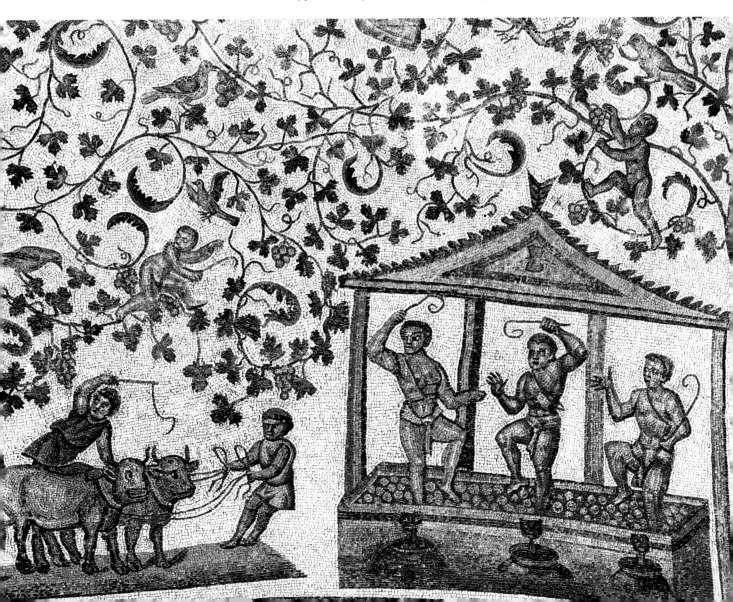

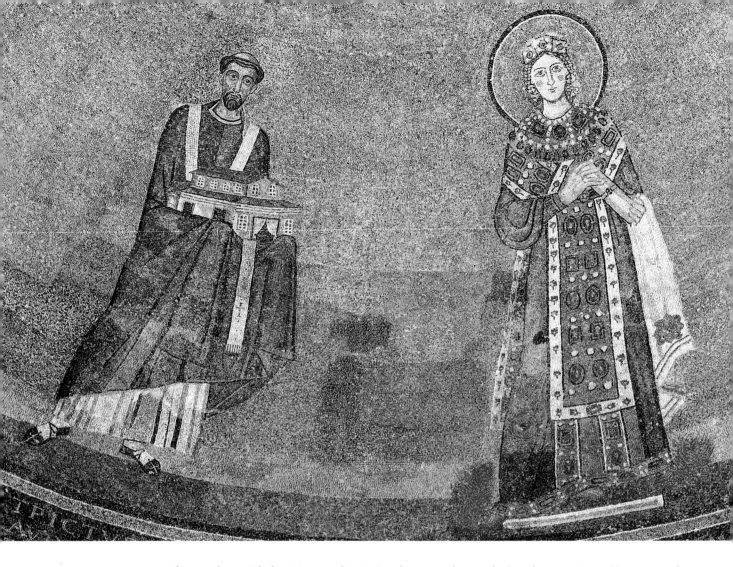

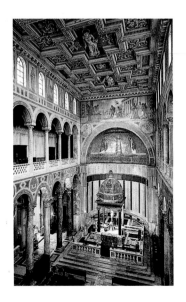

made no substantial alterations to the city's urban layout, as they were located exclusively on its edges or outside the walls. For the whole of the fourth century, the center of Rome continued to display an essentially pagan character. Toward the end of that century and in the fifth this began to change, as the Christian community started to advertise its presence more openly by setting up religious institutions in increasingly central areas. Thus the Church took over the classical city, setting down roots in residential quarters like the Caelian, Aventine and Quirinal hills or Trastevere, in zones filled with public monuments like the Campus Martius and even in the city center, on the slopes of the Capitol.

Very often these new institutions were established on the sites of places used for worship in pre-Constantinian Rome. Meeting a whole range of religious and administrative needs, they were usually located in private homes and named after the proprietor. No structural remains of these ancient institutions have come down to us, with the possible exception of a few buildings discovered underneath the church of SANTI GIOVANNI E PAOLO. The church was founded by Senator Pammachius at the end of the fourth century on the western slope of the Caelian hill, on the site of the martyrdom of the two saints to whom it is dedicated, John and Paul, who were beheaded in their home in the year 362 during the revival of paganism by the emperor Julian. Excavations carried out beneath the church at the end of the last century brought to light a remarkable series of phases of construction. The oldest structures belong to a private house, equipped with a heating system on the ground floor, that can be dated to the mid-second century AD. During the third century the house was connected to a building containing a number of shops, forming a large structure with at least three stories. While the arrangement of rooms in the western wing suggests that it was used for residential purposes, the large two-story-high hall on the eastern side, split into two pseudo-

Top, the ancient Clivus Scauri with the arches buttressing the church of Santi Giovanni e Paolo

The apse, interior and exterior of Santi Giovanni e Paolo with its suggestive Romanesque campanile

naves, is not consonant with such a function. In addition, a room decorated with a series of frescoes has been found underneath it, on the ground floor. One of these paintings, depicting a figure at prayer, is particularly interesting as this is a typical element of the early Christian iconographic repertory. The structure of this building fits perfectly the description of the ancient centers of the Christian community – called *tituli* – to be found in the written sources: a vestibule on the ground floor, decorated with paintings of Christian subjects, and an assembly hall on the upper floor. Consequently, it has been suggested that these remains constitute the only archeological evidence for a *titulus* in Rome. The church, built toward the end of the fourth century and incor-

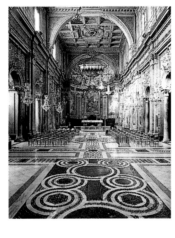

porating these buildings, underwent its first restoration as early as the papacy of Leo the Great (440-61) and was later involved in the major program of restorations undertaken by Adrian I (772-95). In order to repair the damage inflicted by the Norman troops of Robert Guiscard, the basilica was completely renovated in the twelfth century, with the addition of the monastery, campanile and portico and the replacement of the interior decoration, all in a now characteristically Romanesque style.

A fundamental insight into architectural developments in late classical and medieval Rome can be gained from a visit to the church of SAN CLEMENTE, which represents a true paradigm of the historical continuity to be found in the city, with its extraordinary accumulation of places of worship spanning almost a thousand years.

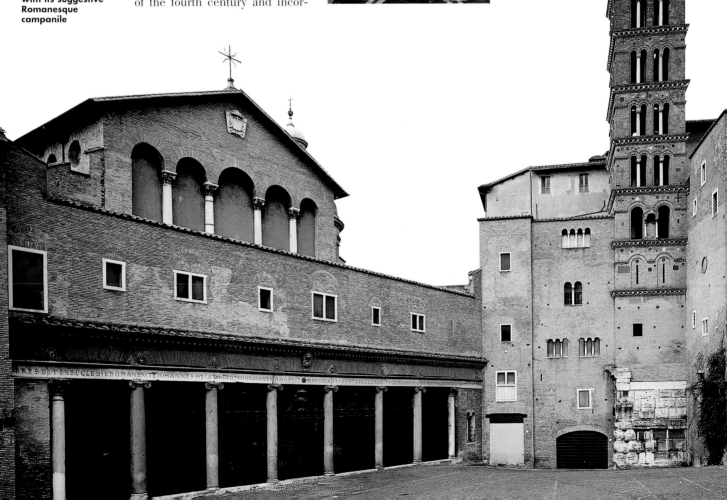

The interior of
San Clemente

The mosaic on the
apsidal vault of
San Clemente with
the *Triumph of the
Cross* and a detail of
the decoration

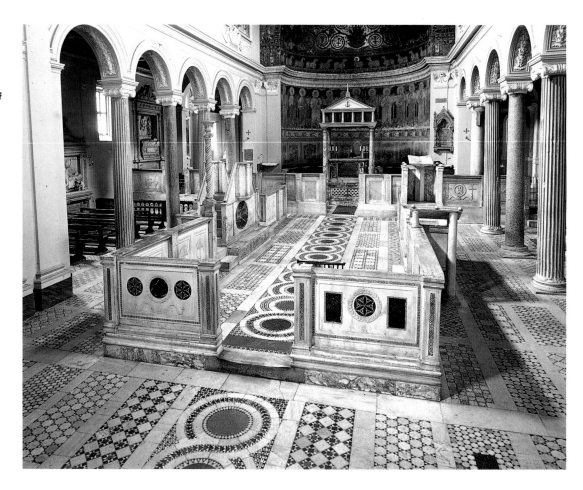

At the present-day street level we find a church that was built in 1108. This has numerous features of interest, such as the distyle porch in the Byzantine style, the atrium and the decoration of the hall. The interior, divided into a nave and two aisles, houses a noteworthy Cosmatesque floor, an enclosure for the choristers (*schola cantorum*) constructed by Cosmati craftsmen out of early medieval plutei, a Gothic tabernacle attributed by some to Arnolfo di Cambio and above all a magnificent mosaic on the vault of the apse dating from the beginning of the twelfth century. In this mosaic, depicting the *Triumph of the Cross*, volutes spread out from a cluster of acanthus leaves – representing the Tree of Life – and wind around scenes of daily life and figures of the Fathers of the Church. In the middle is set Christ crucified, between Mary and John, with the hand of God above, reaching down to place a crown on his head.

The first excavations were conducted in 1857 and it was discovered that another and much older basilica lay underneath the medieval church: in a perfect state of preservation, it could be dated to sometime between the end of the fourth century and the beginning of the next. At this point archeological confirmation of the existence of an early Christian church, probably dedicated to St. Clement, the third Roman pope, was found. We can hypothesize that it was one of the finest and most important churches in Rome during the early Middle Ages, given that it was chosen as the venue for councils on several occasions. It was

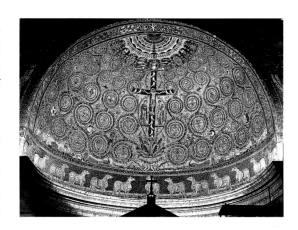

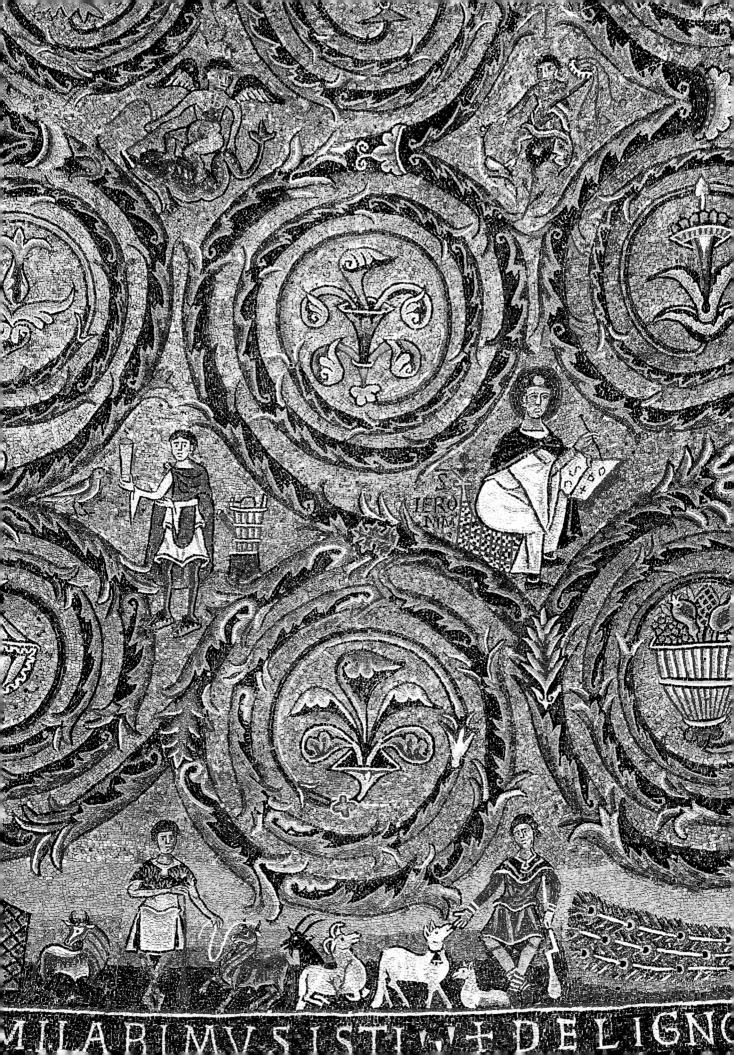

S
IERO
NIM

MILARIMVS ISTI ÆDELIGNO

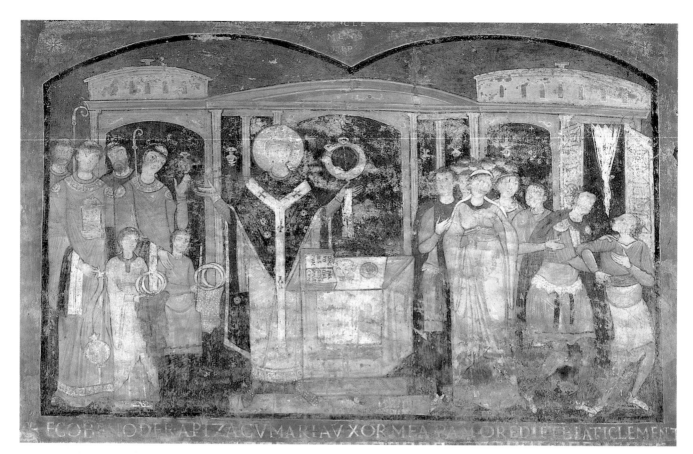

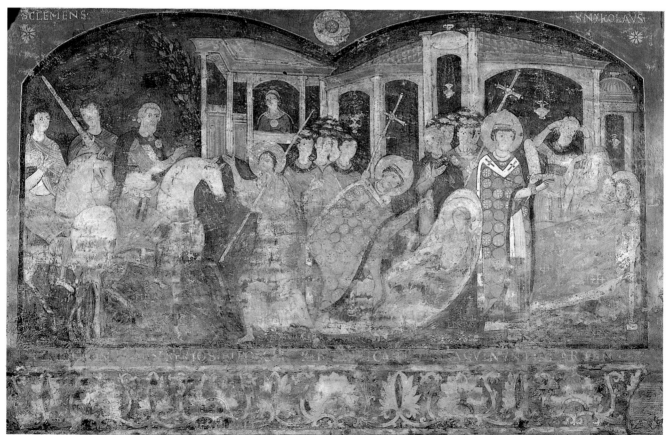

Frescoes in the lower church of San Clemente depicting the *Legend of Sisinnius*, the *Legend of Saint Alexius* and, on this page, the *Miracle of Saint Clement*

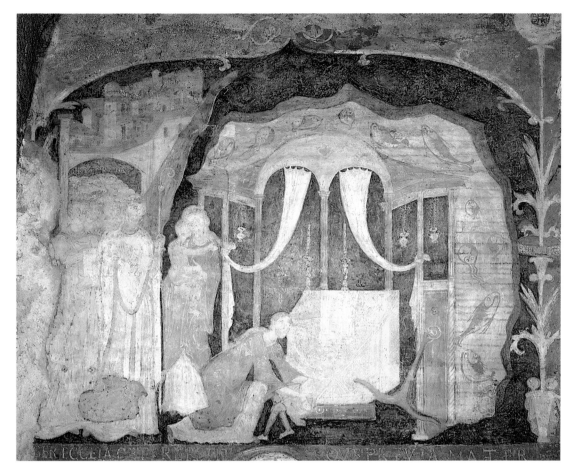

destroyed in the fire started by Norman soldiers in 1084 and filled with rubble up to the height of the springers of its arches at the beginning of the twelfth century, so that a new church could be built on top. It is not easy to make sense of the lower church owing to the presence of the massive structures of the medieval building's foundations. However, we can tell that the basilica had a longitudinal plan with no transept, was divided into a nave and two aisles with a semicircular apse at the end of the nave and had a narthex. The building contains numerous frescoes dating from between the ninth and eleventh centuries. Several of these represent the miracles of St. Clement, in scenes accompanied by inscriptions that include some of the earliest examples of the use of the vernacular Italian language. The fresco datable to the ninth century that has been preserved in a niche in the right-hand aisle, depicting the *Virgin and Child En-*

The shrine of Mithras in the lower church of San Clemente

throned, is particularly important: it has been identified as a reworking of an earlier picture of the Byzantine empress Theodora, dating from the sixth century.

Yet another level was found underneath the basilica, with the remains of constructions dating from the first-second century AD. In particular, there are two buildings separated by an alley, one of them with formal characteristics that suggest it was a *domus*, while the other may have been part of the Moneta, the mint of ancient Rome. At the beginning of the third century a sanctuary to the god Mithras was set up in the *domus*. The hall of this shrine is roofed with a vault faced with volcanic stone to make it look like a cavern and has seats at the sides for the worshipers and a marble altar in the middle with a relief representing Mithras killing a bull. Both of these ancient structures were completely modified toward the end of

the fourth century, when the first church with a nave and two aisles was constructed. Finally, further investigations carried out at the beginning of the twentieth century have revealed yet another layer of buildings underneath, consisting of a number of structures of uncertain function that were destroyed in the great fire of AD 64, during Nero's reign.

The end of the fourth century saw a major shift in politics that was to leave a profound mark on the development of art forms in Rome: in 395 paganism was definitively outlawed. This religious and political triumph made it possible for the Church to embrace the classical tradition, allowing it to draw on the achievements of many centuries of civilization. And so the Church was able to base the administrative organization and architectural theories of the new religion on the political and cultural experience of the Roman empire. A number of figures of great significance to the history of Christianity played a part in this process, including St. Ambrose, St. Jerome and St. Augustine, all of them steeped in classical culture.

Undoubtedly, one of the most important figures in Rome at the end of the fourth century was Pope Damasus (366-84), who made it his mission to try to turn Rome into a holy city, chiefly by fostering the cult of martyrs. In Damasus's view, this entailed reconciling the requirements of the Christian religion with the tradition of classical antiquity. Solemn testimony to the policy pursued by this pope is provided by the numerous monumental inscriptions that he had placed on the tombs of the martyrs, characterized by their original and elegant script, which was clearly inspired by the capital letters used for epigraphs in the Augustan era.

At the same time the classical influence was establishing itself in the most visible sector of papal propaganda: that of the decoration of places of worship. At the end of the fourth century an old bath chamber on the Esquiline was converted into the church of SANTA PUDENZIANA and for the first time the vault of the apse, fulcrum of the basilican building, was not simply covered with gold, but decorated with a figured mosaic, inaugurating a tradition that would see the adoption of the apsidal mosaic as the key element in Christian architectural decoration. The mosaic in the apse of Santa Pudenziana depicts *Christ Enthroned*, surrounded by apostles dressed in the togas of Roman senators. The magnificent architectural backdrop is crowded with buildings in the classical style, while in the middle ground, on a hill, stands a *crux gemmata* with the symbols of the evangelists hovering at its sides. The plastic representation of the figures, the spaces and the highly realistic faces hark back directly to the golden age of the classical artistic tradition.

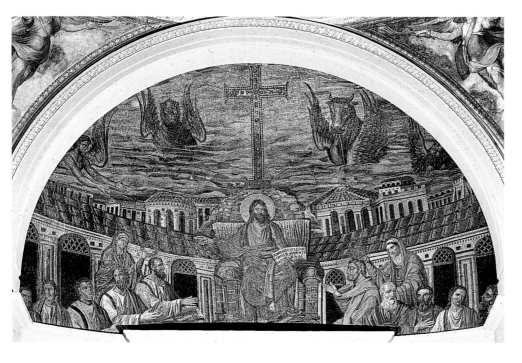

Fresco with the *Good Shepherd*. Catacomb of St. Callistus

Gallery excavated in the tufa in the catacomb of Priscilla

***Madonna Enthroned and Child with Saints*. Catacomb of Commodilla**

A view of the catacomb of Via Latina

The ancient underground passages where the early Christians used to bury their dead were simply called "cemeteries" (the Latin word *coemeterium* came from the Greek *koimeterion*, which in turn derived from the verb *koiman*, to put to sleep), in reference to their function as a place of rest prior to the Resurrection. The name "catacomb," on the other hand, which was used specifically for subterranean cemeteries, arose from a transfer of meaning: in fact the term *ad catacumbas* (again stemming from the Greek, *kata*, downward, and *kymbé*, a cup) was used to refer to a hollow located in front of the Circus of

Maxentius on the Via Appia, between two small heights. In the Middle Ages the term was used to designate all the other underground Christian cemeteries that had been found.

Evidence for the existence of catacombs emerges around the first half of the second century. Previously, Christians were buried in mixed necropolises located above ground. Most of the catacombs were located beneath pieces of land donated by a patrician, sometimes using preexisting cavities such as tufa quarries or conduits for water, as in the case of the Priscilla catacomb. A very steep staircase cut out of the tufa, often faced with brick, led down to the galleries lined with rectangular recesses. These were used to house the bodies of the dead and were closed by tiles or slabs of marble on which an inscription was sometimes painted. Much rarer is the arcosolium, a tomb surmounted by an arch, generally carved out of the tufa or built of masonry.

Illumination was provided by oil lamps, often set inside small niches or on shelves, and by skylights, actual windows opening onto the world outside.

Among the most important of the Roman catacombs are those of St. Callistus and Priscilla. The St. Callistus catacomb, whose original nucleus was already in existence at the end of the second century, is named after the deacon Callistus, the man responsible for administration of the cemetery, who later became pope (217-22). This was the first cemetery owned by the Christian community: its passages extended for over ten kilometers or six and a quarter miles, and in some places on five different levels. St. Callistus contains the crypt of the popes, so-called owing to the presence of the graves of nine popes from the third century. Among the paintings that have survived it is worth mentioning in particular one in the crypt of Lucina: a splendid representation of the *Good Shepherd* dating from the third century.

The catacombs are named not just after saints but also ordinary people, perhaps the donors of the land in which the cemetery was excavated. This is the case with the catacomb of Priscilla on the Via Salaria, whose site belonged to a matron of the noble family of the Acilia. Here we find the Greek Chapel, so-called owing to the presence of two inscriptions in the

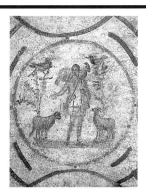

Greek language. The lower part is decorated with stuccoes and the upper part and ceiling with paintings of ornamental and biblical subjects, datable to the second century, including the earliest known representation of the *Virgin and Child*.

More recent than the chapel is the cubiculum of the Velatio, or "Taking of the Veil," with third-century paintings. It is named after one of the scenes from the life of the deceased woman on the rear wall: on the right we see a bishop blessing the woman's marriage while the young groom hands her the bridal veil (*flammeum*); on the left, the same woman holds her baby in her arms, indicating, even after many centuries have passed, what were the two most important moments in her life.

The catacombs were used as burial places more or less up until the beginning of the sixth century. Later they were still used as sanctuaries where people came to venerate the tombs of the martyrs, until their relics were moved to churches located within the city walls in the ninth century.

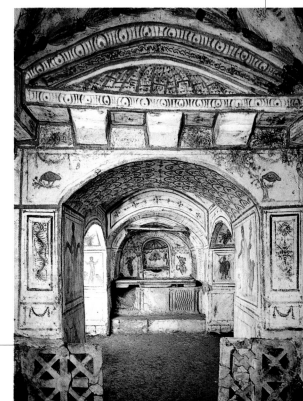

The New Monumental Buildings: the Fifth Century

While the tendency to make use of aesthetic canons derived from the classical heritage emerged toward the end of

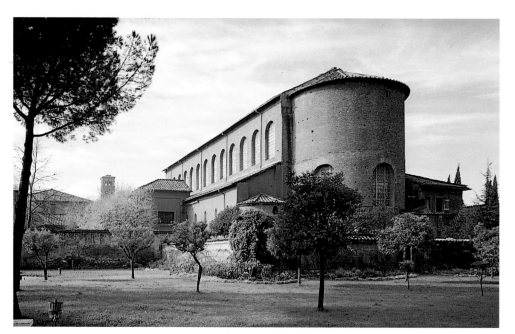

The basilica of Santa Sabina and a detail of the polychrome marble frieze in the nave

the fourth century, it did not reach its peak until after 410, the year in which the city was sacked by a barbarian army for the first time for many centuries, with the invasion of the Goths under Alaric. The Church took advantage of this catastrophe to strengthen its ties with the city of Rome, assuming complete responsibility for its administration: by then paganism no longer presented an obstacle and the classical cultural tradition constituted the best means of confirming the supremacy of the Eastern Church.

The artistic culmination of this process is marked by the basilica of SANTA SABINA, which probably represents the finest example of an early Christian church to have survived in Rome. The basilica was built during the pontificate of Celestine I (422-32), as the mosaic inscription on the inside of the façade records, on the site of an ancient *titulus* dedicated to the martyr Sabina, who according to legend had lived in a house on the Aventine hill. A series of archeological excavations carried out from the mid-nineteenth century to the present

day have uncovered extensive remains of Roman dwellings. It was to one of these that the column embedded in the external wall halfway along the right-hand aisle belonged.

The basilica was subjected to various restorations and additions in the early Middle Ages, the most significant of which were the interventions made under Eugenius II (824-27), when the *schola cantorum* and crypt were constructed. In the tenth century the church was incorporated into the set of fortifications built on the Aventine by the Savelli family, whose remains can be seen in the nearby Parco degli Aranci (Savello Park). And it was in the church of Santa Sabina that St. Dominic presented the rule of the monastic order he had founded to Pope Honorius III in 1222.

The basilica stands out for the harmony of its proportions and the beauty and richness of its decorations, which convey the spirit of classical revival in its full vigor. The interior is divided into a nave and two aisles by twenty-four columns with Corinthian capitals supporting arches. The particularly high nave is brilliantly lit by the large windows that are set above the arches and the apse, framed by a majestic triumphal arch, is perfectly in tune with the spatial rhythm of the building. The decoration stems from the same cultural matrix, although few of its elements are contemporary with the construction of the basilica. Among those that are, it is worth mentioning the polychrome marble inlays that cover the whole of

The main portal of Santa Sabina with its precious cypress-wood doors from the 5th century

the band running above the arches and depict Roman military emblems with crosses set on top.

Originally the entire section of wall between the arches and the windows must have been decorated with mosaics, as were the apse and triumphal arch. Old engravings – which were used as a guide for the modern restoration work – testify to the presence of tondi with busts of Christ and the apostles. The only surviving mosaic is the metrical inscription in gold letters on a blue ground set above the entrance portal. It is dedicated to the church's founder, Bishop Peter of Illyria, and is flanked by female figures personifying the Church of the Jews and the Church of the Gentiles. The formal characteristics of the inscription are especially interesting as they are directly derived from the script typical of the late fourth century, whose use as we have already seen was promoted by Pope Damasus. Another element of great value is the main portal of the basilica, which still has its original doors, made out of cypress wood and carved with scenes from the Old and New Testament. They include the oldest known representation of *Christ Crucified*, an iconographic motif that was to become extraordinarily widespread in the Middle Ages.

The progressive increase in the temporal power of the Church of Rome went hand in hand with the growing importance of its central figure, the pope, who came to play a fundamental role in the political sphere as well, filling the power vacuum that had developed as the Roman empire died a lingering death and the Byzantine empire failed to make its weight felt in the West. In the works of art produced

during the pontificate of Sixtus III (432-40) we can discern some of the earliest signs of an awareness of this new role on the part of the papacy.

Around 430 the church of SANTA MARIA MAGGIORE was completed on the Esquiline. This was the first basilica to have been built on the pope's own initiative rather than that of the imperial authorities. Although the church underwent many restorations in the Renaissance and baroque periods, it is still possible to work out its original appearance.

Its layout reproduces the canonical basilican scheme but on a larger scale, with a tall nave terminating in a semicircular apse and two aisles, just as in the earlier Santa Sabina. One fundamental difference, though, lies in the presence of a continuous entablature resting on forty columns with Ionic capitals, in a fully classical style. Above the entablature the high walls of the nave are subdivided by pilaster strips, creating intermediate spaces that are filled with mosaic panels, originally framed inside stucco aedicules. Above them were set the windows, one to each intercolumniation. The harmonious division of the spaces and the solemnity of the architectural elements hark

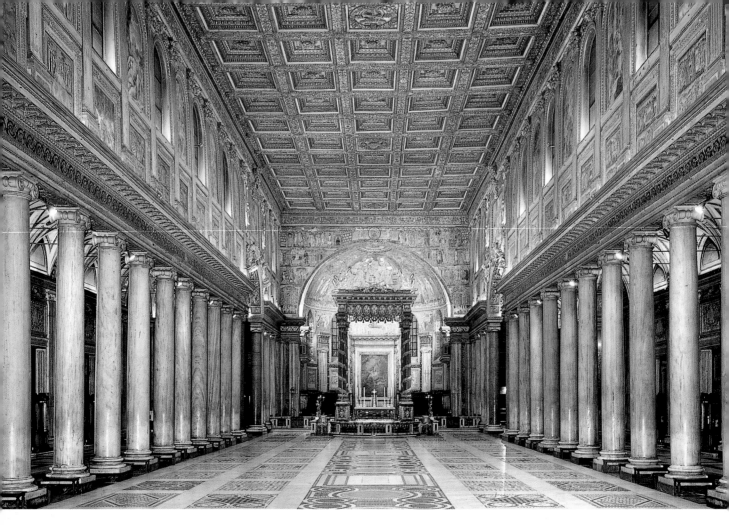

The interior of Santa Maria Maggiore

The mosaics of the triumphal arch of Santa Maria Maggiore and, on facing page, detail of the *Heavenly Jerusalem*

directly back to the finest examples of the Roman architecture of the early imperial age. The same intention to evoke classical antiquity is apparent in the cycle of mosaics in the nave and on the triumphal arch. The architectural layout and the decoration are both part of a single aesthetic program, which seems to have been targeted chiefly at that part of the population which still had strong ties with the pagan tradition: the aristocracy. The Church, which had commissioned the construction of the basilica, set out to extol its apostolic mission by using the internal space of the building as a teaching device, through a figurative account couched in a courtly language. In this sense Santa Maria Maggiore played a role of exceptional importance, in that it ushered in the tendency to use the walls of places of worship not just for decoration but also to communicate.

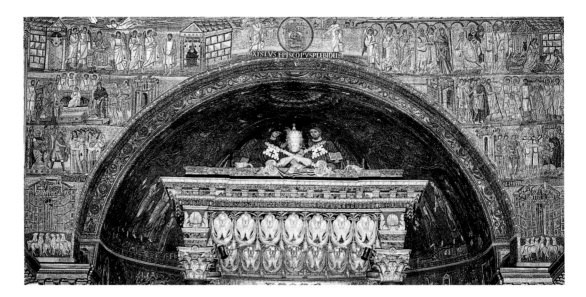

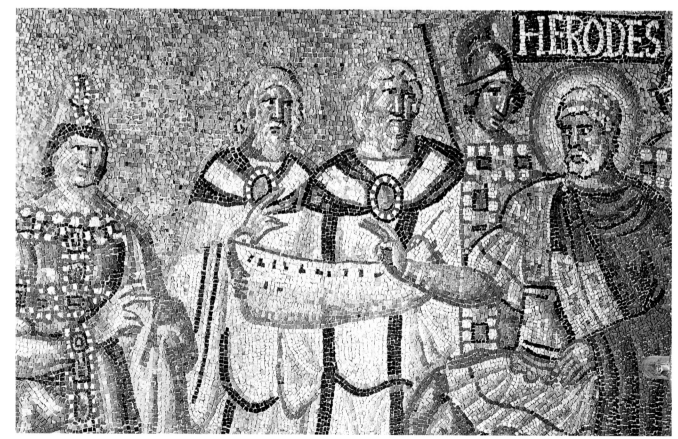

The mosaics in the nave depict scenes from the Old Testament while the ones on the triumphal arch illustrate the Advent, celebrating the figure of the Virgin. Taken overall, it is evident that the aim was to explain God's providential design, from the premises of salvation to be found in the Old Testament to the birth of Christ.

The personages from the Bible represented in the nave wear togas in the classical manner. The composition of the mosaics is rooted in the artistic style sanctioned in the late classical period, and are marked by a renewed naturalism. The formats of the pictures conjure up the contemporary experience of the miniatures that were used to decorate Virgilian manuscripts.

The mosaics on the triumphal arch have the same tone of solemnity. The subdivision of the cycle into superimposed and continuous bands is a direct reference to classical monuments. The themes, drawn in part from the Apocryphal Gospels, are handled with extreme freedom of composition, not constrained by the usual iconographic schemes. In the *Annunciation* the angel descends from heaven to meet Mary, who is wearing a diadem and golden clothing, while in the *Adoration of the Magi* Christ is depicted not in his mother's arms but seated on a throne, in the manner of an emperor. The technique used by the mosaicists is characterized by the particular attention paid to the plastic representation of the figures, achieved through effects of light and shade, and by the great refinement of detail, such as in the clothing and buildings. The composition does not have a true unity of narrative but takes the form of a series of isolated figures that rarely interact with one another, a fact that helps to set the episodes on a superhuman plane.

This conception of the relationship between decoration and place of worship, sanctioned in Santa Maria Maggiore, was to remain a guiding principle throughout the Middle Ages.

The revival of classical antiquity, so evident in the basilica of Santa Maria Maggiore, is also particularly clear in the renovation of

On facing page, mosaics in the nave of Santa Maria Maggiore with scenes from the Old Testament

The Lateran Baptistery and, at top, a view of the interior

visible is in the right-hand apse of the narthex and consists of luxuriant volutes in green and gold on a blue ground, a motif that was widely used in the fifth and sixth centuries. The evocation of classical elements is also evident in the way the walls were decorated with marble slabs, traces of which remain in the narthex.

A building that fits into the same classicistic tradition but presents some notable innovations as well is the church of SANTO STEFANO ROTONDO, erected on the Caelian hill by Pope Simplicius (468-83). The monument has a complex plan, a synthesis of elements drawn from imperial architecture and Oriental models. The prototype on which it was probably based was the Constantinian church of the Holy Sepulcher on Jerusalem. The first renovation of the church was carried out by Theodorus I (642-49), who had a chapel built to house the relics of St. Primus and St. Felician, while further interventions were made in the time of Adrian I (772-95). Then Innocent II (1130-43) had the entrance portico added, along with the three arches that run diametrically across the inner hall.

The original plan of the building, much larger than it is today, was made up of a central hall, 22 meters or 72 feet high, and three concentric aisles. The circular chamber in the middle is perfectly proportioned: its height is the same as its diameter. An entablature stands on an unbroken ring of columns and in turn supports a drum that used to be roofed with a dome. The colonnade separates the central space from the annular aisle, from which four chapels originally stuck out, giving the building the appearance of a Greek-cross church. The whole church was richly adorned with mosaics and precious marbles. Recent archeological excavations have brought to light some ancient structures underneath, pertaining to a barracks of the imperial era (the Castra Peregrina) and to a Mithraeum.

The interior of Santo Stefano Rotondo and a detail of the 7th-century mosaic depicting *Saint Primus*

the LATERAN BAPTISTERY, once again carried out during the pontificate of Sixtus III. The baptistery was erected in Constantine's time over the remains of a hall with an apse and a tub that used to be part of the villa of the Lateranus family. Between 430 and 442 the building was completely restructured and given its present octagonal plan, which was to become one of the most popular for baptismal buildings. The structure, which belongs to the tradition of late classical buildings with a central plan, was divided into a tall chamber, probably roofed with a dome, and a lower aisle, roofed with a tunnel vault that was originally decorated with mosaics, though these were lost in the renovations carried out during the Renaissance. The only portion of the original mosaic decoration that is still

The City is Transformed (Sixth-Eighth Centuries)

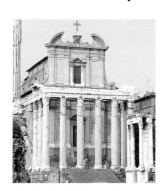

The church of San Lorenzo in Miranda built inside the ancient temple of Antoninus and Faustina

One of the most characteristic phenomena of the sixth century was the Church's conquest of the ancient pagan center of the city. In fact several ecclesiastical buildings were constructed in the vicinity of the Forum over this period, in demonstration of the fact that Christianity was no longer prepared to keep its distance from traditionally pagan areas, but intended to colonize them too, converting ancient religious and civil buildings to its own purposes. Thus the church of Santa Maria Antiqua was created around the middle of the sixth century in a structure that used to be the vestibule of the imperial palace, while that of Santi Cosma e Damiano was located in a hall of the urban prefecture. Sant'Adriano was installed in the Curia, the former seat of the senate, in the first decades of the seventh century and the nearby temple of Antoninus and Faustina was probably turned into San Lorenzo in Miranda shortly afterward.

The appropriation of public buildings – stripped of their original functions – by the Church shows that the civil administration was gradually being sup-

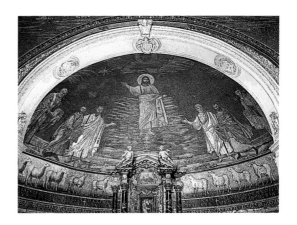

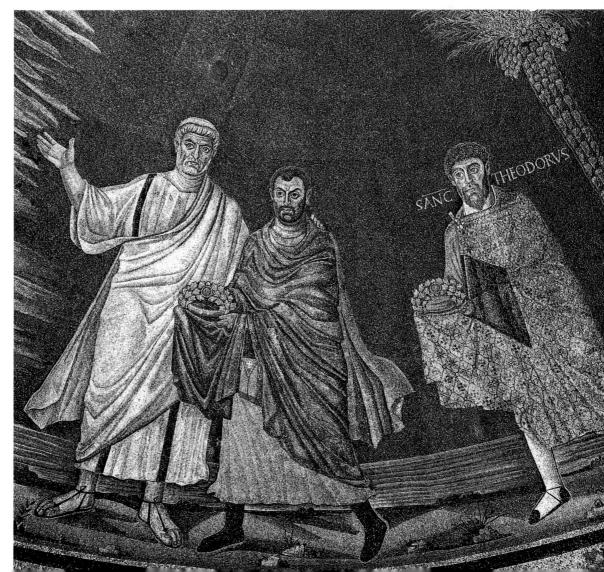

The apsidal mosaic of the church of Santi Cosma e Damiano and detail

The interior of San Saba and, above, the bishop's throne with a 14th-century fresco

planted by the ecclesiastic one, as the only force capable of ensuring the maintenance of urban structures and meeting the population's basic needs.

Part of the offices of the city's prefect had already been taken over by the Church in the time of Pope Felix IV (around the years 526-30), with their conversion into the church of SANTI COSMA E DAMIANO, dedicated to Cosmas and Damian, two physicians of Syrian origin. Worshipers entered the building from the Via Sacra after passing through the bronze door of a circular vestibule dating from the fourth century, sumptuously decorated with polychrome marble. Felix IV did no more than add the mosaics on the vault and perhaps the arch of the apse. On the bowl-shaped vault we see Christ, with his right arm raised, descending to Earth at the time of the Second Coming (*Parousia*) on a carpet of pink and blue clouds. Reaching up to him are Peter and Paul, the two titular saints of the church, Theodore (another Oriental saint) and the pope

with a model of the church. In this mosaic Christ is not standing on the ground, surrounded by many other figures, as in the representation in Santa Pudenziana, but is suspended in the sky and presented with rigid frontality, as are the few figures around him. This is a mark of the Byzantine manner that had begun to spread through Italy in the late fifth century. Yet the details of the mosaic in Santi Cosma e Damiano are fully within the Roman tradition: brightly-colored clothing and a cobalt blue sky as opposed to the celestial gold ground of Byzantine mosaics, a characterization of the faces that approaches portraiture (especially in the figure of Cosmas, on the right) and the imposing and solid rendering of the saints' bodies.

Hence this mosaic constitutes, at least in part, a precursor of Byzantine art in Rome. And it is precisely this dual character of the work, straddling the legacy of Rome's past and the anticipation of Byzantine stylistic features, that casts doubt on the dating of the apsidal arch, decorated with the *Adoration of the Lamb*, *Angels* and *Symbols of the Evangelists*. In fact historians are uncertain whether to consider it contemporary with the mosaic on the vault or to attribute it to the time of Pope Sergius I (687-701), because of the greater abstraction conferred on it by the gold ground. In addition, it has to be pointed out that our present view of the mosaics is not the same as the original one, since one of the alterations carried out in the seventeenth century included a substantial raising of the floor. This has changed the proportional relationships and makes the figures look as if they are towering over us, and therefore even more imposing.

Over the course of the seventh century, following the Arab conquests in the Mediterranean, various waves of pilgrims washed up in Italy. Among them were several groups of monks, such as the one that settled on the Aventine in 645, in a *domus* that had traditionally belonged to St. Sylvia, the mother of Gregory the Great. The building was later transformed into the church of SAN SABA, dedicated to St. Sabas of Cappadocia like the monastery in the hills of Judea from which the small community had fled. The reception room of the *domus* was converted into an oratory and decorated with frescoes between the end of the seventh century and

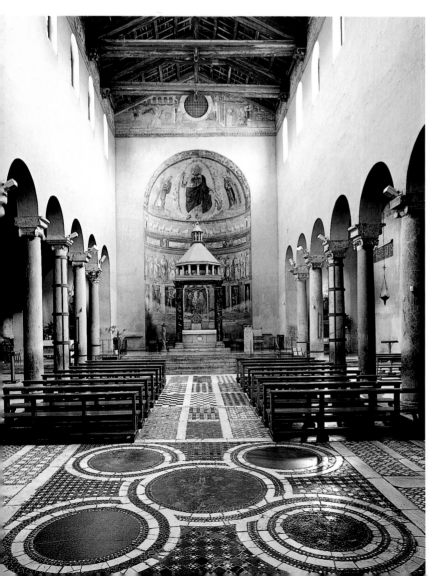

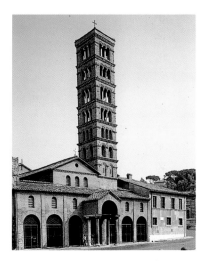

Top, Santa Maria in Cosmedin and, above, the *Bocca della Verità*, or "Mouth of Truth," an ancient stone effigy of a river god located in the portico of the church

Right, the interior of Santa Maria in Cosmedin and, below, the crypt

the beginning of the eighth, the greater part of which have been lost today. What have survived are seven saint's heads, now located in the sacristy. Only four of them have been identified: Sebastian, Stephen, Lawrence and Peter of Alexandria. They lie fully within the Oriental current that characterized the art of this period: the figures and busts tend to assume rigid poses against a neutral background, devoid of any sense of space, and the elongated faces have large eyes, straight noses, small mouths and jutting chins. These images, together with scenes from the Bible in rectangular panels, used to decorate the upper part of the oratory walls, while the lower part was painted with *trompe-l'oeil* drapes. The sacristy contains a number of other frescoes detached from their original locations, including a fragment depicting a group of Benedictine monks. In the absence of any record of what happened to the oratory over the following centuries in the written sources, this has led to the conclusion that the monastery passed into the hands of the community based in Montecassino in the ninth-tenth century. In fact the monks are wearing dark hoods with black borders that also appear in tenth- and eleventh-century codices from Montecassino.

The church above probably dates from the twelfth century, around the time that the monastery was assigned to the Cluniac congregation, in 1145. The entrance portal and floor are Cosmati work. The columns which divide the interior into a nave and two aisles were salvaged from ancient build-

ings, while part of the original marble ornamentation is now set in the wall of the right-hand aisle.

Another church linked to the influx of migrants from the East is SANTA MARIA IN COSMEDIN. Its original nucleus, consisting of a *diaconia* (a building providing assistance to the poor), was restructured around 780 by Pope Adrian I and handed over to Byzantine monks fleeing persecution by the iconoclasts. For this reason the church was given the name *Santa Maria in Schola graeca*, to which was added the attribute of *kosmeidion*, or "ornament," owing to the splendor of its decorations. The Oriental aspect of the church, which has a nave and two aisles separated by columns with capitals from the late classical period, lies in the architectural choice of a plan with three apses.

All that remains of the eighth-century church is the layout, the floor underneath the altar, fragments of the frescoes on the apsidal arch and the crypt cum oratory that may have been created by

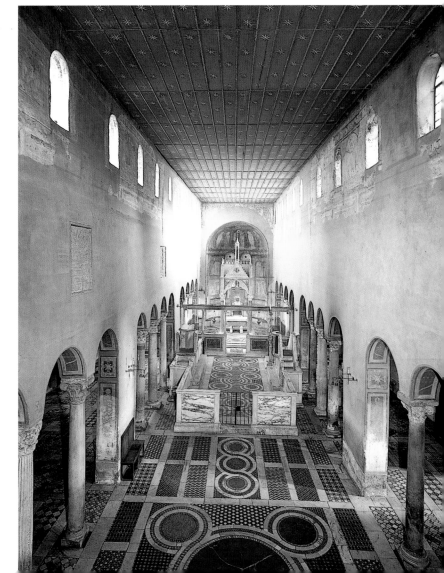

The Cosmati

In the twelfth and thirteenth centuries a number of workshops of Roman marble cutters distinguished themselves in Rome and Lazio by the quality of their work. They specialized in the construction and decoration of cloisters, arcades, floors and a whole range of church ornaments and furnishings: pulpits, ambones, bishop's thrones, *scholae cantorum* and Easter candleholders. The name Cosmati was given to these craftsmen at the beginning of the twentieth century in the mistaken belief that a single family, descended from a certain Cosmas, was responsible for this activity. The misunderstanding arose out of the essentially homogeneous character of their work, which was explained away as the product of a single artist or his circle. On the contrary, there must have been many different marble workshops active in Rome at the same time. The question needs further investigation, from both the historical and the artistic viewpoint. However, the names of around sixty artists have been identified and in general terms we know which were the most important of the families who carried out these activities: the Cosmati themselves and the Vassalletto.

These marble workers operated in the fields of architecture, sculpture and

Above, remains of the ancient presbyterial enclosure of San Saba

Left, Gothic tabernacle in San Clemente

Below, the precious bishop's throne of San Lorenzo fuori le Mura

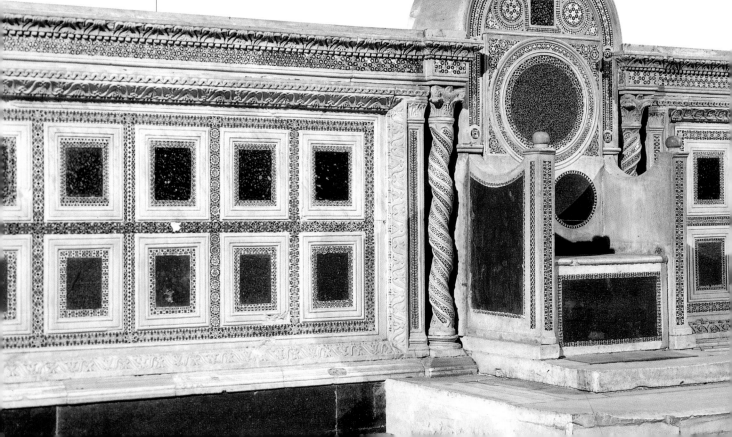

The two bishop's thrones of San Saba (on left) and Santa Maria in Cosmedin

Bottom, the tabernacle of San Giorgio in Velabro

polychrome decoration, often fusing all three arts. One common element was the revival of the ancient Roman art of *opus sectile*, literally "cut work," a technique of inlay of which they felt themselves to be the proud repositories, signing their work *magistri doctissimi romani*. This reference to antiquity was due in the first place to the raw material they made use of, drawn for the most part from the enormous mine of materials represented by ancient monuments: columns, tombstones and pieces of architrave were all either reworked or used as elements in new decorations. Examples of the sculptural skill of these artists, who rarely tried their

hands at representing the human figure, are provided by the lions that stand guard at numerous Roman churches or that support Easter candleholders, distinguished by the naturalistic way in which their manes are carved.

Cosmatesque art flourished at the beginning of the thirteenth century, during the pontificate of Innocent III (1198-1216), when the Church was going through a period of considerable splendor and felt the need to renovate and embellish its buildings with new furnishings and ornaments.

Among the most common of these furnishings were the ones used to enclose the *schola cantorum*, the space reserved for the choir and clergy in the middle of the nave, right in front of the presbytery. An example is to be found at San Saba, now set against the right-hand wall of the church: it is made up of plutei adorned with inserts of porphyry and serpentine, framed by carved moldings and mosaics, and of spiral columns flanking an architraved opening. Two ambones must originally have been connected to these elements, but no

trace of them remains. Examples of the latter can be seen in the church of San Lorenzo fuori le Mura, however: the one on the left, used for reading the Epistles, is fairly simple, while the one for the Gospels, on the right, is more complex, with a double flight of steps and a projecting upper section.

The bishop's throne must have taken on special importance in Rome, in that it was intended for use by the pope himself and therefore linked to a series of symbolic meanings that underlined his theocratic policies. A case in point is the throne in San Saba, surmounted by a marble disk that evokes the halo and thus the concept of *sanctitas*, while the decoration inside the structure, with the palmate cross, a Christological symbol, emphasizes the divine origin of papal authority.

Finally, we must not forget the Cosmatesque floors. Usually inlaid in a pattern of five disks – one larger one at the center and four smaller ones at the sides – they constitute complex and elegant decorations of great effect.

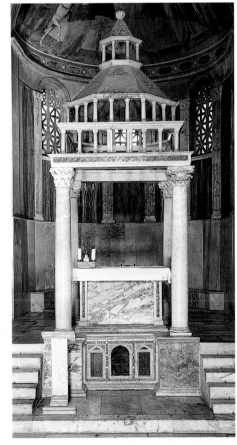

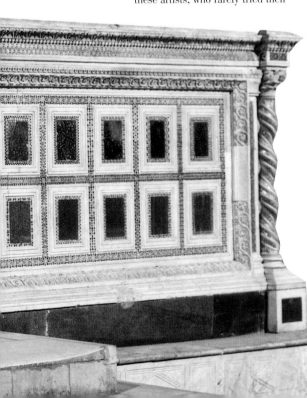

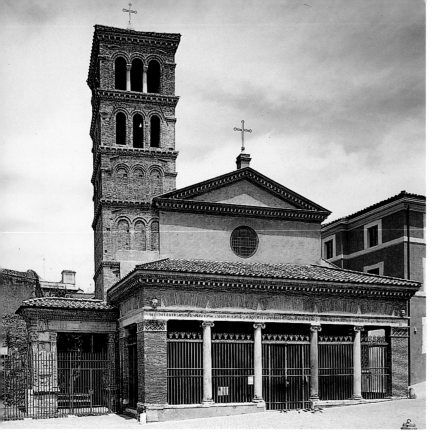

The exterior and interior of San Giorgio in Velabro

ies outside the city walls. Thus the building, set on top of a communal crypt in the form of a basilica, conveys the symbolic message that the Church is founded on the *ecclesia* of the martyrs.

The frescoes on the apsidal arch, representing choirs of angels paying homage to Christ, also date from Adrian's pontificate.

Santa Maria in Cosmedin was rebuilt between 1118 and 1124, after suffering damage in the Norman sack of the city in 1084. In addition to the heavily restored Cosmatesque floor, the image of the *Madonna*, the campanile and the *schola cantorum* all date from the Romanesque era. The latter is the work of Roman marble cutters, who for once chose to preserve intact the iconostasis, a sort of canopy enclosed with veils that served to separate the areas occupied by the congregation from the place where the mystery of consecration was performed.

Nearby, in the heart of the ancient Velabrum quarter, stands the church of SAN GIORGIO, it too originally a *diaconia* and then converted into a Greek-rite church at the behest of Pope Zacharias (741-52). The church was dedicated to St. George by the same pope following the transfer of the supposed head of the saint, who was believed to have been martyred in the fourth century. The building was partly reconstructed in the time of Gregory IV (847-55). The interior, split into a nave and two aisles by salvaged columns supporting arches, has a somewhat irregular appearance: in fact it grows narrower toward the apse, probably as a consequence of the presence of adjoining buildings. Although much of the structure dates from the eighth century, the church is characterized by its later additions, with the construction, in the thirteenth century, of a brick portico (now rebuilt after it was damaged a few years ago by a bomb) and a Romanesque campanile. The frescoes in the apse have been attributed by some to Pietro Cavallini.

excavating the site of an altar dedicated to Hercules, the *Ara maxima Herculis*. The rectangular crypt, divided into a nave and two aisles by six columns, terminates in an apsidiole with an altar, echoing the form of the basilica. A series of niches along the walls must have been used to house relics of saints, brought here when it was no longer possible to ensure the maintenance of the cemeter-

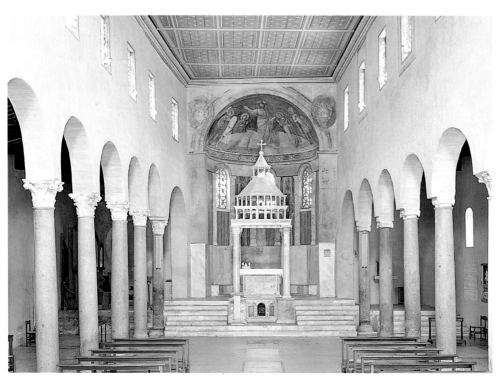

The Cloisters

Although at the level of its architecture the cloister harks back to a wide range of classical and late classical structures, such as the porticoed courtyards of the Roman house (*atrium* and *peristilium*) or the enclosed open space in front of early Christian basilicas (*paradisum*), its essence is only really comprehensible when viewed as part of medieval monastic life and its architecture.

In its typical form, the cloister is a quadrangular courtyard set alongside the church, surrounded by porticoes and with a pool of water in the middle. Within the monastery the cloister performed to some extent the functions of a city square, linking the numerous rooms that were ranged around its sides (chapterhouse, library, refectory) and – on the social level – providing the monks with an opportunity to meet and to spend time in the open air.

Rome boasts a wide range of

cloisters that allow us to trace the evolution of the structure from the Middle Ages to the baroque era. The oldest of them, dating from the twelfth century, like those of Santa Cecilia, San Lorenzo and Santi Vincenzo e Anastasio alle Tre Fontane, are fairly simple in form, without much decoration.

The following century, on the other hand, saw the construction of some of the most elaborate and enchanting cloisters of medieval Rome, including those of the Santi Quattro Coronati, Santa Sabina, San Paolo fuori le Mura and San Giovanni in Laterano. In these we find a general enrichment of forms, enhanced by the introduction of coupled columns and the use of colored and gilded tesserae in the Cosmatesque manner of the period.

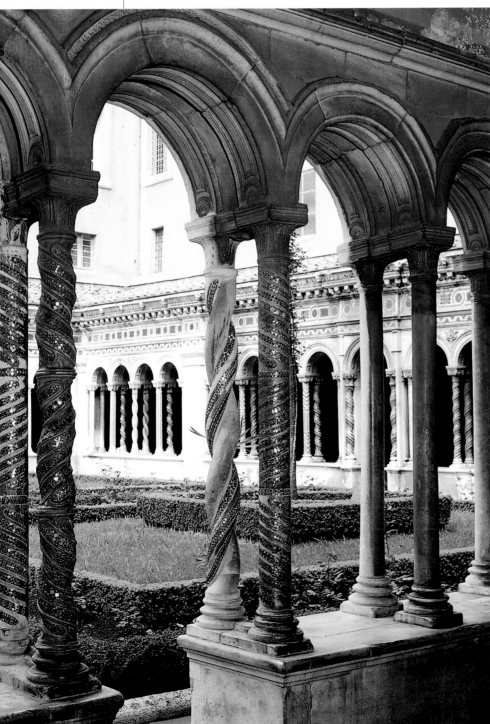

The Carolingian Era (Eighth-Ninth Centuries)

The Carolingian era was probably the most flourishing period for the Church of Rome in the early Middle Ages. Supported – economically as well as politically – by the new alliance formed with Charlemagne, the papacy was once again able to invest considerable resources in the construction of places of worship.

Byzantine models and Oriental schemes still prevailed in the architecture and decoration of the pontificates of Adrian I (772-95) and Leo III (795-816). Under Paschal I, around 819-20, Santa Maria in Domnica was still built with three apses. However, this influx of Eastern characteristics soon dried up, gradually giving way to a return to the models of early Christianity and in particular the time of Constantine, for which preference was shown throughout the ninth century. Testimony to this phase is provided by the churches erected by Pope Paschal I (817-24), which are among the most significant buildings of the Carolingian period.

On the top of the Caelian hill we find SANTA MARIA IN DOMNICA, often called the church of the Navicella after a sculpture in the shape of a small ship that stands in the square in front. Connected with a *diaconia* in the seventh century, the church was rebuilt during the pontificate of Paschal I and still retains some aspects of its original appearance, with a nave and two aisles separated by eighteen granite columns with salvaged Corinthian capitals.

In the precious mosaics that adorn the vault and arch of the apse – the latter is set on two splendid porphyry columns with Ionic capitals – the early Christian tradition was revived through the technique employed (using predominantly vitreous tesserae, a typical feature of ninth-century mosaics in Rome) and through the iconography of the apsidal arch: the apostles advancing toward Christ, who is set inside a mandorla, between two angels. In the decoration of the apse itself, however, the Byzantine tradition was still at work, as is clear from the *Virgin and Child Enthroned amidst Hosts of Angels*: here the multitude of angels is suggested by the way three rows of heads, with only the upper parts or just their haloes visible, are placed above the figures at the bottom. The personage surrounded by a square aureole – signifying that he was alive at the time of the mosaic's execution – is the man who commissioned the work.

The reference to the origins of the Church is even more tangible in SANTA PRASSEDE on the Esquiline, which can be taken as an example of the basilican pattern that was in vogue in the eighth century. According to tradition, Praxedes was martyred along with her sister Pudentiana (to whom, as we have already seen, a church had been dedicated not very far away, on the Vico Patrizio) after she had collected the blood of Christians who had been killed with a sponge and poured it into a well. The saint's active participation in the cult of martyrs is probably connected with the responsibility for the custody of the bodies of many martyrs assumed by the Church.

The plan echoed that of the most important martyrium in Rome, St. Peter's, though on a reduced scale. Thus it had a four-sided portico with arches, now reduced to a mere atrium. Inside, the nave is separated from the two aisles by colonnades supporting a simple entablature (the three transverse

Bottom, detail of the apsidal mosaic of Santa Maria in Domnica

Below, detail of the figure of Pope Paschal I from the apsidal mosaic of Santa Prassede

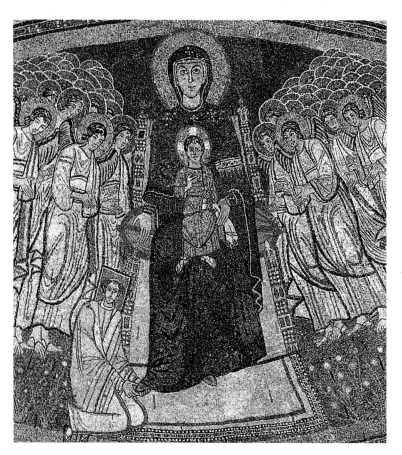

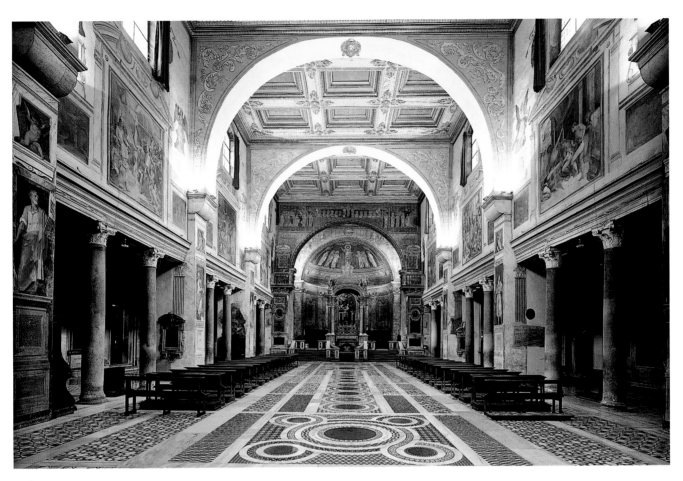

The interior and exterior of the chapel of San Zenone in Santa Prassede

Top, the interior of Santa Prassede

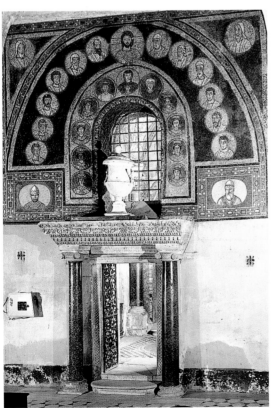

piers, incorporating the same number of columns, were only added to shore up the nave in the Romanesque era, along with the campanile). The triumphal arch leads into a not very deep transept terminating in a single apse, underneath which is set a crypt in the shape of a half ring, similar to that of the basilica of St. Peter. The mosaic decoration of the apsidal vault and the triumphal arch is also intended to evoke early Christian themes: Christ hovers in a dark blue sky dotted with multicolored clouds; a bit lower down Peter and Paul, standing on a green meadow, are presenting the titular saint, her sister Pudentiana, their brother and the pope who founded the church, with a square aureole. On each side of the group stands a palm tree, with a phoenix (symbol of the Resurrection) perched on one of them. There is a clear reference to the mosaic in the apse of Santi Cosma e Damiano, both in the frieze underneath, with a row of lambs on a gold ground and the dedication in gold letters on a blue ground, and in the decoration of the apsidal arch, where

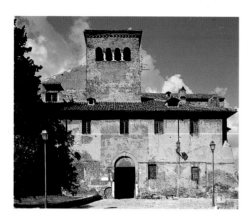

The church of the Santi Quattro Coronati

Detail of the fresco with *Pope Sylvester on Monte Soratte* in the chapel of San Silvestro in the Santi Quattro Coronati

the Lamb of the Apocalypse is flanked by four angels and the symbols of the Evangelists and adored by the four and twenty elders.

The chapel of San Zenone, with its sumptuous marble and mosaic ornamentation, is entered from the right-hand aisle of the church. Dedicated to the memory of Pope Paschal I's mother Theodora and housing the relics of several martyrs, the chapel has a cruciform plan that makes it closely resemble a late classical mausoleum. Even the decorative elements are based on fifth-century models: the window above the portal is framed by a double ring of medallions with busts of Christ, apostles and martyrs just like the series of medallions that used to decorate the apsidal arch of Santa Sabina. On the inside of the same wall, Saints Peter and Paul are pointing to a throne adorned with gems on which is set a cross, an image that refers directly to the iconography of the triumphal arch of Santa Maria Maggiore (it too dating from the fifth century). Even the mosaic on the groin vault, in which four angels support a clipeus with the bust of Christ, has early Christian antecedents. The allusion goes well beyond the theme and the position of the figures, extending to the technique as well, with the use of color for the outlines and drapery instead of black lines, just as was the custom at that time.

The church of the SANTI QUATTRO CORONATI, or Four Crowned Saints, was founded on the site of a pagan building in the fourth century by Pope Miltiades (311-14). The story of the four martyrs to whom the church is dedicated is still shrouded in mystery. The fact that they were chosen as the patron saints of the marble workers' guild in Rome has given rise to the legend that they were four sculptors who had refused to carve the statue of a pagan god, perhaps Aesculapius. The church was completely rebuilt in the ninth century by Pope Leo IV (847-55), at the time when the relics of the four martyrs were transferred there from the cemetery *ad duas lauros* on the Via Labicana.

Frescoes in the chapel of San Silvestro and, above, the _Donation of Constantine_

The interior of the church was divided into a nave and two aisles by rows of columns with an entablature made up of salvaged architraves, now embedded in the walls of the church's second courtyard. The architecture was probably based on another early Christian model, the basilica of San Giovanni in Laterano. The two chapels adjoining the aisles, with cruciform plans and apses, also date from the ninth century, as does the tower set at the entrance of the monastery, the only example of such a structure to have survived from the Carolingian period.

After the fire set in 1084 by the Norman troops of Robert Guiscard, the church was rebuilt by Pope Paschal II (1099-1118) on a smaller scale: the nave was split into a nave and two aisles, while one part of the original structure, 50 meters or 164 feet long, was converted into a new atrium. The women's galleries above the aisles, the Cosmatesque floor, the monastery and the cloister, one of the oldest and most beautiful in Rome, all date from this time. The chapel of San Silvestro was consecrated in 1246. Its frescoes clearly spell out a political message that was of particular importance to the popes of that time: an assertion of the papacy's supremacy and independence of the empire, just as was laid down in the Donation of Constantine.

The Leonine City

On August 26 of the year 846, the Saracens landed at the mouth of the Tiber and made their way up the river to Rome without meeting substantial resistance. On reaching the city, they sacked the basilica of San Paolo on the Via Ostiense as well as that of St. Peter in the Vatican. The ease and rapidity with which all this happened demonstrated the extreme vulnerability of any structure that lay outside the Aurelian Wall, including the great basilicas dedicated to the martyrs which stood along the consular roads. Even in the early Christian era the areas around them had become urbanized, owing to the large numbers of people who visited the places of worship and the need to provide them with facilities and assistance. So there was now an evident need to fortify these settlements, and the one that had grown up around Peter's tomb was the most densely populated of them all. In fact, immediately after Constantine had constructed the basilica over the apostle's tomb a large number of buildings had

sprung up in the area, including churches and welfare institutions such as almshouses, hospitals and *xenodochia* (hostels for pilgrims). Between 848 and 849 Pope Leo IV commenced work on the construction of a wall around the settlement, which from then on was known as Civitas Leoniana. A fifteen-meter or fifty-foot stretch of this wall can still be seen in the Vatican Gardens. It is built out of blocks of tufa and salvaged bricks laid in undulating rows, a technique typical of the Carolingian masons active in Rome. Leo IV's new "city" stood on a late classical system of roads linked to the bridges of Pons Aelius and Pons Neronianus and incorporated such classical monuments as the Meta Romuli (a now-vanished pyramid-shaped tomb that was very similar to that of Gaius Cestius) and Hadrian's Mausoleum. The latter, already used as a fortress during the conflict between Goths and Byzantines in the sixth century, was one of the strong points of the defensive system.

There can be no doubt that the construction of the Leonine City was the most significant urbanistic development in early medieval Rome.

Toward the New Millennium (Tenth Century)

Once the surge of construction in the Carolingian era had subsided, around 850, not so many churches were built in Rome. A few oratories were set up in the ruins of ancient monuments, to which only minor modifications were made (an example is Santa Barbara dei Librai, housed in an archway of Pompey's Theater), while a number of pagan temples were still used for Christian worship (such as the temple of Portunus in the Forum Boarium, converted into the church of Santa Maria Egiziaca). Yet new churches were founded in this period. Most of them were buildings with a fairly simple plan, a single nave and a single apse: this was the case with Santa Maria in Pallara (now SAN SEBASTIANO ALLA POLVERIERA), founded on the Palatine by a certain *medicus* called Pietro and annexed to a monastic community. The church was built on the site where St. Sebastian was believed to have been shot full of arrows by imperial soldiers.

The fresco in the apse, dating from sometime between 973 and 999, still uses the iconographic scheme with seven figures (though reduced to five here, perhaps for reasons of space) that we have already encountered in the mosaic of the church of Santi Cosma e Damiano and in the group of mosaics commissioned by Paschal I: at the top *Christ between Saints Sebastian and Zoticus*, (the church was originally dedicated to both these saints) and the *Deacons Saint Stephen and Saint Lawrence*. In the band underneath, in accordance with the early Christian canon that has been taken as a model here, we see the Mystic Lamb and twelve lambs symbolizing the apostles, set above figures of other saints. The iconography of the scenes from the Gospel that were once painted on the walls and then lost at the time of the restoration carried out by Pope Urban VIII Barberini in 1626 showed close ties with the tradition of the sixth century, as we can see from a few drawings of them that have been preserved.

The Late Middle Ages (Eleventh-Fourteenth Centuries)

The church of San Bartolomeo with its 10th-century marble wellhead and a detail representing Jesus

The appearance of the city had begun to change as early as the tenth century. More and more fortifications were built inside the walls: some of the buildings in which upper-class families took refuge were out-and-out castles, usually created out of the ruins of ancient monuments. As time passed towers started to spring up in Rome as well: defensive structures *par excellence*, they were symptomatic of the high degree of militarization of the urban territory, with various families contending for the control of a particular area.

In spite of this the Church kept up its construction activity, and this intensified over the last thirty years of the eleventh century. During this period numerous new places of worship were built, chiefly in the area of the Campus Martius and in Trastevere.

SAN BARTOLOMEO, on the Isola Tiberina, was founded by Emperor Otto III on the site where the temple of Aesculapius had once stood. The church was completely rebuilt around 1160 and provided with a Romanesque campanile with three stories of two-light and three-light windows. Its position at the center of the island made it particularly vulnerable to the frequent floods to which the Tiber was subject. The one in 1557 was disastrous, destroying the right-hand aisle and the adjoining structures, together with the mosaic on the façade. The interior of the church has a basilican layout, divided into a nave and two aisles by two rows of ancient columns (with stucco capitals from the modern era) and a raised transept and apse. Underneath these is set a crypt divided into bays with vaults supported by spiral columns. A small part of the Cosmatesque floor has been preserved in front of the high altar. The wellhead, beautifully carved and in use up until the nineteenth century, is made from the shaft of an ancient column. It dates from the tenth century and is one of the few parts of the Ottonian church to have survived. The figures of St. Bartholomew, St. Paulinus of Nola (both of whom used to be buried in the church), Emperor Otto III and Jesus are carved on it in relief, set inside aedicules separated by spiral columns. The inscription declares: "Let those who are thirsty come to the source and draw from it a health-giving draft."

Another church that assumed its definitive form in the twelfth century is SAN LORENZO FUORI LE MURA, though the site had been in use as a place of worship for much longer: Constantine had erected a basilica there, but this has completely vanished. So the original nucleus of the structure we see today must have been the building constructed by Pope Pelagius II (579-90), with a nave and two aisles and an entrance on the opposite side to the current one. It now forms the presbytery of the church. When Cardinal Cencio Savelli, later Pope Honorius III (1216-27), decided to renovate the church at the end of the twelfth century, he gave it not only new and sumptuous decorations, but new proportions as well, demolishing the original apse and adding an entire basilican section. The tomb of St. Lawrence was also restored and decorated, in view of the growing number of pilgrims that it was attracting.

The portico, extensively reconstructed after the war as a result of the damage it suffered during the terrible bombing raids of 1943, is frescoed with *Scenes from the Lives of Saint Stephen and Saint Lawrence*. It leads into the church, whose nave is separated from the tall and narrow aisles by two rows of columns with entablatures, a system that had already been adopted in those years at San Crisogono and Santa

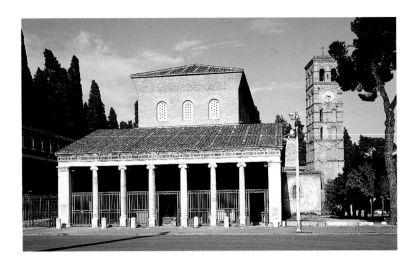

San Lorenzo fuori le Mura with its frescoed portico and interior dominated by the baldachin, carved by Roman marble workers

Maria in Trastevere. The church's furnishings and ornaments are the work of the best-known of the Roman marble cutters: the Cosmatesque floor, ambones and bishop's throne between two plutei (now located at the rear behind the high altar but originally in the middle of the church) are especially fine. The baldachin, constructed for the Pelagian basilica in 1148 and then placed above the high altar of the new basilica, has a double entablature,

the first quadrangular and the second polygonal. Its simplicity and elegance is in net contrast with the sumptuous decoration of the floor.

The presbytery is characterized by large cabled columns, surmounted by Corinthian capitals and an entablature that was obviously designed for a different building, as well as by women's galleries that overhang the narrow space in the middle.

With the loss of the original apse, the only mosaic to have survived is the one on the triumphal arch of the Pelagian basilica (and therefore dating from the sixth century). It depicts Christ seated on the celestial globe, flanked by Saints Paul, Stephen, and Hippolytus on the right and Saints Peter and Lawrence on the left, along with Pelagius II offering the basilica to the Lord. While the figures are generally represented in the Byzantine manner, greater attention has been paid to the physiognomic traits of the ones nearest to Christ, St. Hippolytus and Pelagius II. Alongside the basilica stands the cloister: a simple and delicate structure, it too is the work of Roman marble cutters, but unfortunately suffered extensive damage in the bombing raids of the last war.

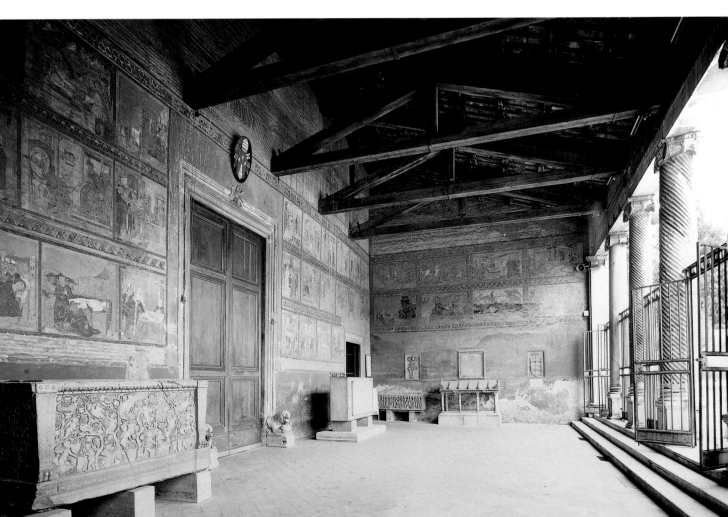

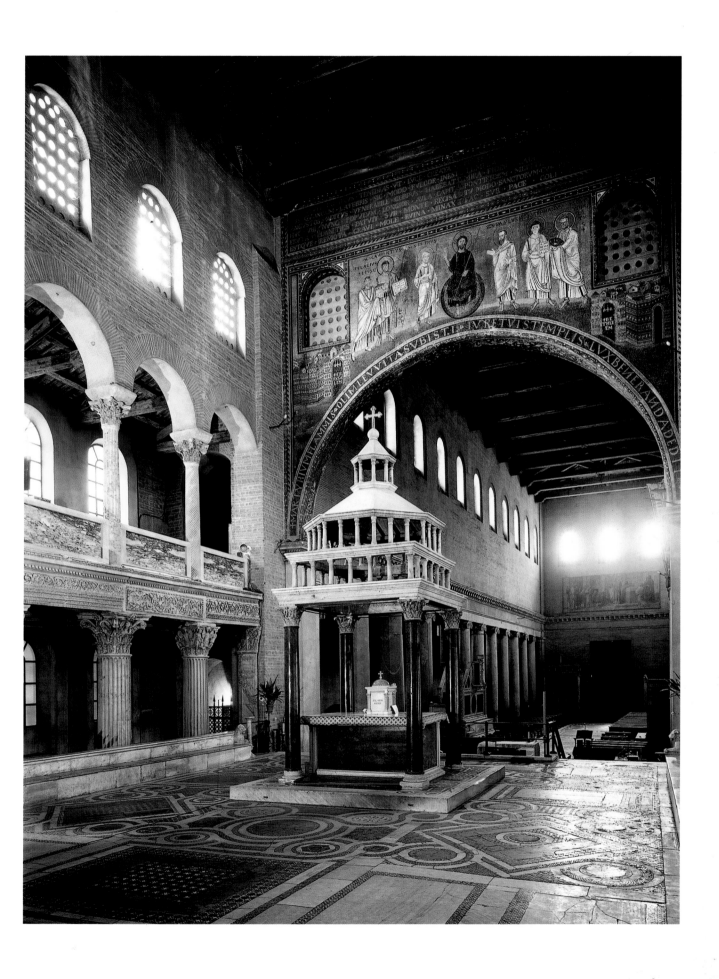

In spite of the fact that Gothic architecture had held sway north of the Alps for a century and a half, the style was slow to penetrate Italy and met with particular resistance in Rome. The basilican layout that had become established in Rome at the beginning of the twelfth century was still used for the Franciscan church of SANTA MARIA IN ARACOELI in 1260: apart from a few minor Gothic features, the building is basically a large basilica with a transept. The complex, located right next to the Capitol, has been stripped of its original context by the construction of the monument to Victor Emmanuel II, which entailed the demolition of the adjoining monastery. The steep flight of steps, built in 1348, leads up to a plain brick façade that must originally have been covered with mosaics.

The church houses numerous works of art, including the two pulpits carved by Lorenzo di Cosma and his son Giacomo at the end of the nave. In the

Santa Maria in Aracoeli showing the 10th-century panel depicting the *Madonna* set on the high altar

right-hand transept we find the celebrated *Tomb of Luca Savelli* (the father of Pope Honorius IV), attributed to Arnolfo di Cambio. It consists of a Roman sarcophagus surmounted by a parallelepiped with an inscription set between pinnacles and underneath a small sculpture of the *Madonna and Child*. The tomb in front, belonging to Vanna Savelli, Luca's wife and Honorius's mother, and bearing her effigy, can also be attributed to Arnolfo.

Lastly, the splendid *Tomb of Cardinal Matteo d'Acquasparta*, executed by the Cosmati, has a lunette decorated with a fresco of the *Madonna Enthroned between Saint John the Evangelist and Saint Francis*, with the latter presenting the deceased to Mary, attributable to Pietro Cavallini and dated to the early years of the fourteenth century. The work is characterized by the monumentality of the figures, a feature typical of the artist's other works in Santa Maria in Trastevere and Santa Cecilia.

The church of SANTA CECILIA IN TRASTEVERE can undoubtedly be considered one of the most representative late medieval buildings in Rome. In reality much of the church dates from the ninth century, when Pope Paschal I had it erected on the site of an earlier sanctuary to house the remains of the saint. The mosaic in the apse dates from the Carolingian phase of its construction, while the portico and the campanile were built in the twelfth century and the transformation of the entire basilica into a building in the Rayonnant style, at the behest of a French pope and cardinals, took place at the end of the thirteenth century. The church's new decorations consisted of frescoes by Cavallini and his school and a baldachin commissioned from Arnolfo di Cambio (who may have had the job of supervising the whole renovation). It is precisely the contributions of the two greatest artists of the time that make Santa Cecilia a symbol of the "new direction" in Roman art, and Rome a sort of cultural capital of Europe in the last two decades of the thirteenth century.

Arnolfo's baldachin represents one of the high-

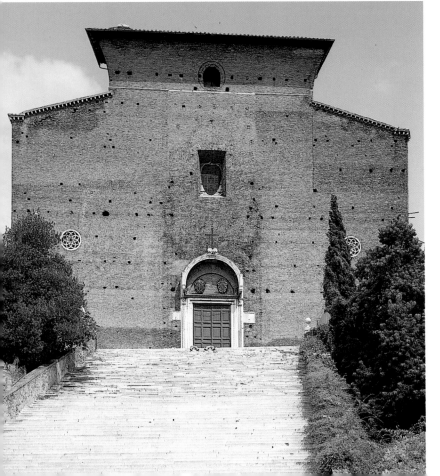

In panoramic views of Rome dating from the late Middle Ages or Renaissance, the city is represented as a built-up area with large open spaces, dotted chiefly with small houses, fortresses, towers and churches. In fact fortified structures and towers must have been a typical element of the medieval urban fabric: there were over three hundred of them, not counting the ones on the Aurelian Wall. The fact is that in Rome, especially in the eleventh and thirteenth centuries, there was no aristocratic family that did not possess some kind of defensive structure, such as a castle or tower. These not only offered security but also served as symbols of nobility and wealth. It has to be remembered that the few medieval towers to have survived the alterations to the urban fabric made during the Renaissance and baroque periods are generally the

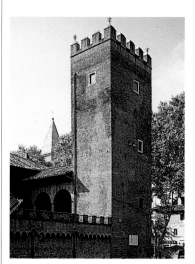

The Torre delle Milizie

The Torre delle Milizie in a detail of Ghirlandaio's *Adoration of the Magi*. Spedale degli Innocenti, Florence

remains of much larger fortifications, many of which were later turned into palaces and townhouses.

One zone particularly rich in towers and fortresses was the quarter that grew up around Trajan's Markets, a key area for the control of the city center. Even today the Torre delle Milizie, a building that reaches a height of over 42 meters or 138 feet and that was constructed between the twelfth and thirteenth century as part of a fortified complex, bestows a grim appearance on the quarter. This is underlined by the nearby Torre dei Conti, a lower but

no less imposing tower that can be recognized by its broad scarp and its walls made up of alternating bands of marble and flint.

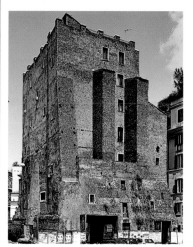

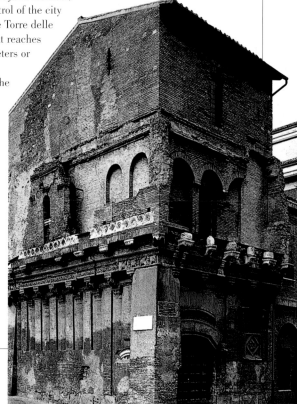

Above left, the Torre degli Anguillara and, below, the Torre dei Conti

Right, the Casa dei Crescenzi

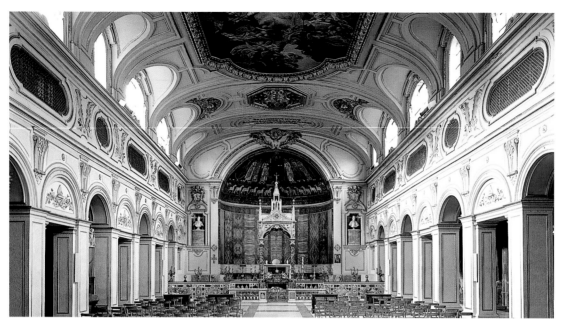

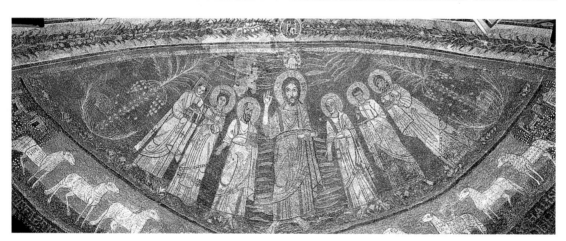

est achievements of Gothic art, though it also reflects the heritage of classical Rome in the balanced proportions of the whole and of the individual bas-reliefs set on the base of the pillars, in the pendentives and in the tympana.

In the frescoes by Cavallini (documented from 1273 until the third decade of the fourteenth century) depicting the *Last Judgment*, originally located on the inside wall of the façade, the figures are modeled by means of a modulation of color and light without the use of line. The sculptural, physical impression created by the figures, as well as the intense expressions on their faces, are achieved through a skillful use of chiaroscuro.

In the cycle with *Scenes from the Life of the Virgin* in SANTA MARIA IN TRASTEVERE, on the other hand, less reliance is placed on chiaroscuro. The semicircular space of the apse is decorated with the *Nativity of Mary*, *Annunciation*, *Nativity*, *Adoration of the Magi*, *Presentation in the Temple* and *Dormitio Virginis*.

Here we can discern a division of the space that does not exist in Santa Cecilia, where the reference is to Byzantine models that had come back into vogue as a consequence of the activity of Oriental mosaicists in Sicily and Venice, as well as the influence of illuminated manuscripts. In the Middle Ages the church, founded in the fourth century (but rebuilt by Innocent II in the twelfth with material salvaged from the Baths of Caracalla), was decorated with a sumptuous set of furnishings and ornaments donated by the pope, of which all that remains is the bishop's throne. This, supported by two winged and horned lions, has the

Santa Maria in Trastevere and the mosaics on the apsidal vault with *Christ and the Virgin Enthroned* and, below, the *Scenes from the Life of the Virgin* by Pietro Cavallini

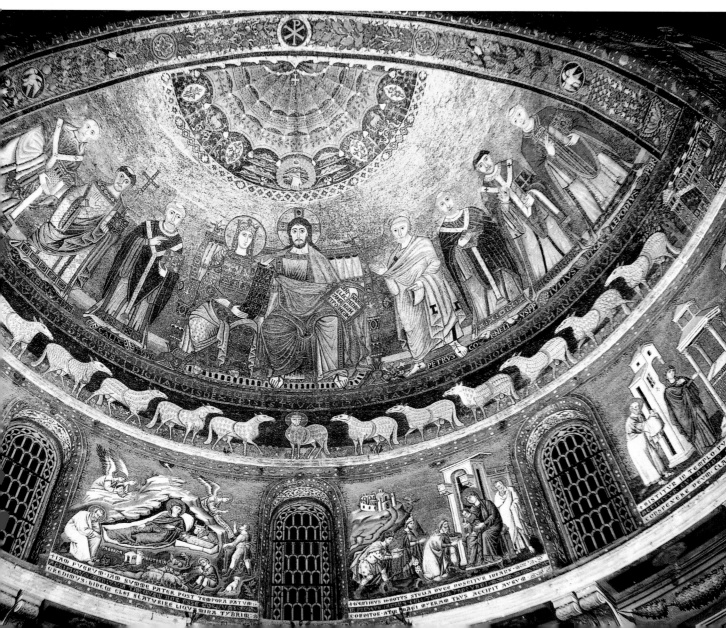

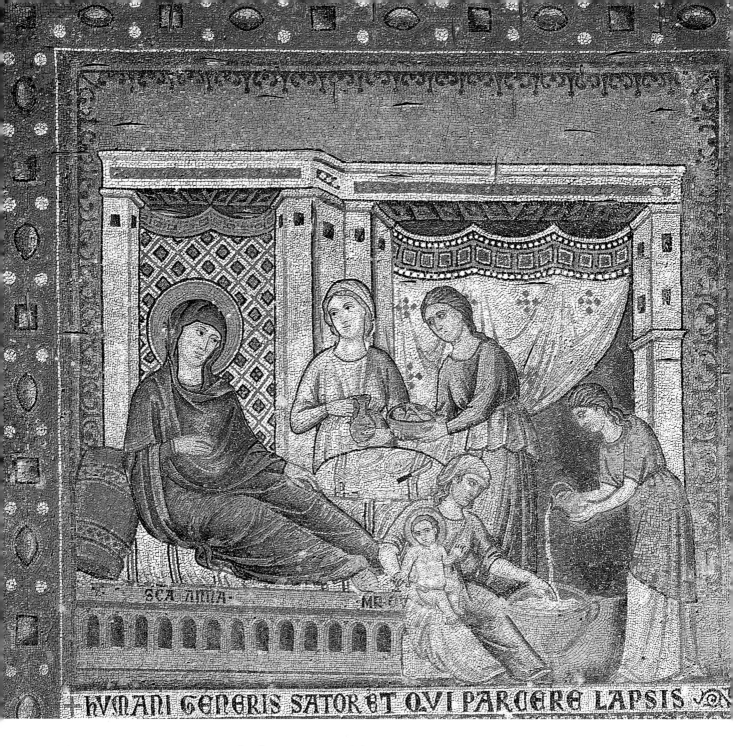

SCA ANNA MR...

HVMANI GENERIS SATOR ET QVI PARCERE LAPSIS

**Pietro Cavallini,
Nativity of Mary.
Santa Maria in
Trastevere**

appearance of a chariot, in a sort of glorification of the pope-sovereign that was consistent with the theocratic policy of the period. Other medieval ornaments included the candleholder and the *schola cantorum*: dismantled at the end of the sixteenth century, the remains of the latter can now be seen in the eighteenth-century portico. The Cosmatesque floor was brought to light again in the nineteenth century, when the architect Vespignani restored the church to its thirteenth-century appearance, eliminating many of the modifications that had been made in the modern era.

We cannot end this section without at least a brief mention of SANTA MARIA SOPRA MINERVA. The only building in Rome with an entirely Gothic structure – thought the interior was much altered during the nineteenth century – this church in the Campus Martius was built toward the end of the thirteenth century and has a nave and two aisles roofed with groin vaults supported by pillars. However, this was to remain a unique example among the churches of Rome, where artistic culture went through a prolonged period of stagnation following the transfer of the papal court to Avignon (1309-77).

Pietro Cavallini, Jacopo Torriti and Arnolfo di Cambio

At the end of the twelfth century and beginning of the thirteenth, Rome experienced an artistic renascence – though this was a time when the city was going through much internal conflict – that primarily affected ecclesiastical buildings, the first beneficiaries of the pope's patronage. As a consequence the city attracted some prestigious artists, among them Giotto and Filippo Rusuti. Three men in particular left a tangible and enduring mark of their genius on the city: Cavallini, Torriti and Arnolfo di Cambio.

We know little about the life of Pietro Cavallini (documented from 1273 up until the third decade of the fourteenth century). A painter and mosaicist, his earliest known work is probably the fresco decoration of the interior of the basilica of San Paolo fuori le Mura, of which all that survives today are seventeenth-century copies. On the contrary, the six *Scenes from the Life of Mary* set above the apsidal mosaic of the church of Santa Maria in Trastevere have come down to us almost intact. This allows us to clearly assess both the definition of the space through the

accurate architectural setting in which the figures are placed and the monumentality of the compositions and the solidity of the figures themselves.

While these features are linked to the classicism that held sway at the time, and not just in the West, they are also greatly influenced by Arnolfo di Cambio, with whom Cavallini had worked in San Paolo and Santa Cecilia. Here the artist painted the *Last Judgment* on the entrance wall: only one large

fragment of it remains, with Christ at the center surrounded by a host of angels. These frescoes are characterized by the imposing appearance of the figures.

Cavallini was to work in Rome again, on the painting in the tomb of Cardinal Matteo d'Acquasparta in Santa Maria d'Aracoeli and finally on the mosaic in San Paolo fuori le Mura, almost completely lost after the fire of 1823.

Jacopo Torriti (documented between 1287 and 1292) was working in Rome at the same time as Cavallini. He was a Franciscan friar, as is evident from the self-portrait in the mosaic on the vault of the apse of San Giovanni in Laterano, one of only two works signed by the artist, the other being the mosaic decorating the apsidal vault of Santa Maria Maggiore. The mosaic in San Giovanni was subjected to a disastrous restoration in the second half of the nineteenth century, resulting in its detachment and reconstruction, and can therefore be regarded as no more than a copy with modern additions. So we can only comment on the compositional

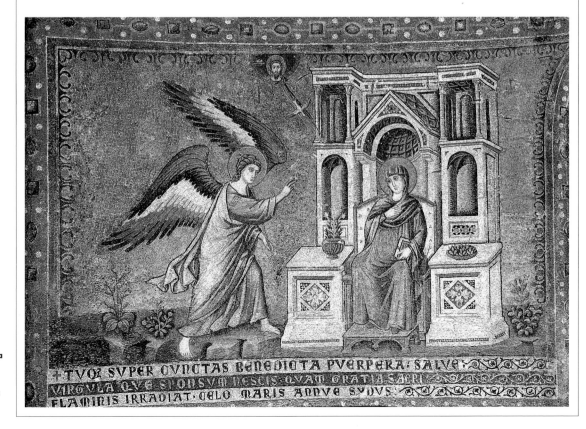

Pietro Cavallini, fragment with angels. Santa Cecilia in Trastevere

Pietro Cavallini, *Annunciation*. Santa Maria in Trastevere

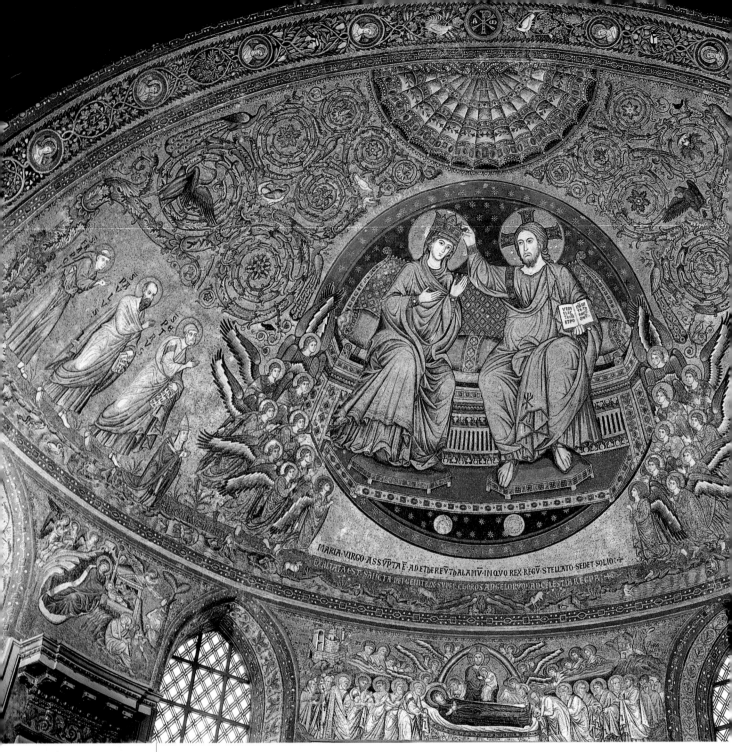

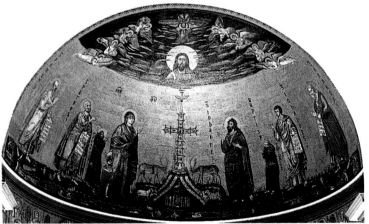

Jacopo Torriti, apsidal mosaic with the *Coronation of the Virgin*. Santa Maria Maggiore

19th-century reconstruction of Jacopo Torriti's apsidal mosaic in San Giovanni in Laterano

scheme of the work, with the cross placed in the middle, Mary and the Baptist on each side, Peter and Paul standing on the far left and John and Andrew on the right. The pope who commissioned the mosaic is portrayed kneeling in front of Mary, who has placed her hand on his head as a mark of protection. Below, we find river scenes that hark back to the early Christian repertoire, as does the bust of Christ set high up among the clouds: this was part of a previous decoration of the apse dating from

reduced to a sketchy backdrop.

Arnolfo di Cambio was a contemporary of these two artists. Toward the end of the thirteenth century, he directed a number of important undertakings in various fields (sculpture, architecture, painting) in Rome, but in these it is difficult to distinguish his own work from that of the members of his workshop. Born at Colle Val d'Elsa in Tuscany sometime between 1240 and 1245, Arnolfo trained under Nicola Pisano. In addition to the aforementioned interventions in the church of San Paolo fuori le Mura and Santa Cecilia, he was also responsible for the *Sepulchral Monument of Riccardo Annibaldi* in San Giovanni in Laterano, the *Crèche* in Santa Maria Maggiore, the *Sepulchral Monument of Boniface VIII* and the bronze statue of *Saint Peter* in the Vatican. In his works Arnolfo was able to fuse the highest expression of Roman Gothic with French Gothic models, and above all the *rayonnant* style, developing a highly personal manner that was to some degree influenced by antiquity.

Arnolfo di Cambio, the baldachins of Santa Cecilia in Trastevere and San Paolo fuori le Mura (below)

Arnolfo di Cambio, *Saint Peter*. St. Peter's basilica

the fifth century, which Torriti incorporated into his own.

The *Scenes from the Life of Mary* in Santa Maria Maggiore were probably painted earlier. Although Torriti borrowed the idea of placing the mosaics on the dado underneath the apse from Cavallini, it is easy to perceive the difference between the two artists in these works: in Torriti's scenes there is no hint of the monumentality that had characterized the figures in Santa Maria in Trastevere, while the architectural setting has been

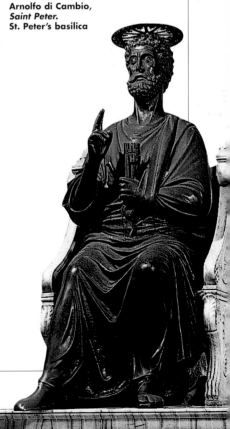

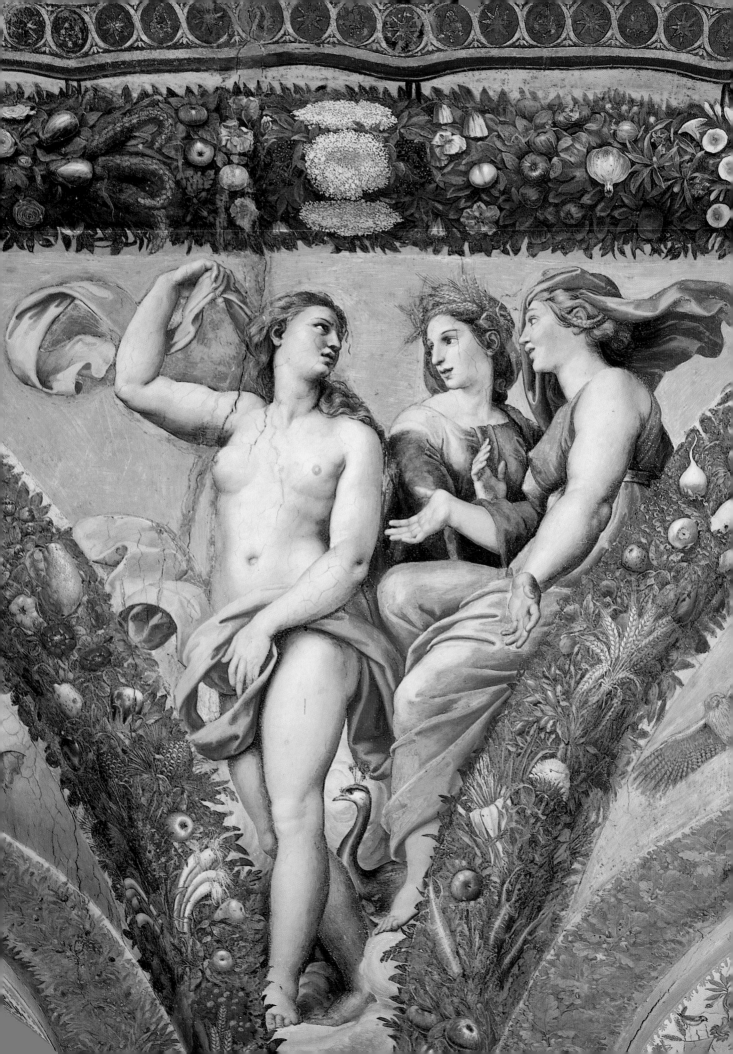

RENAISSANCE
ROME

The Pontificate of Martin V (1417-31)

The End of the Great Schism and the Rebuilding of the Roman Church

Martin V arrived in Rome on September 28, 1420, spent the night at Santa Maria del Popolo and entered the city proper the following day. The ceremony was conducted without a great deal of pomp, and yet it at last put an end to the Great Schism (1378-1417), the crisis that had split Western Christendom.

Oddone Colonna – that was the pope's name – had been elected three years earlier at Costanza with a speed and unanimity that not even the most optimistic would have dared hope. It was November 11, 1417, the feast of St. Martin, and the new pope assumed the name of the patron of a day that he felt to be truly propitious.

In Rome, the crisis in the papacy had left room on the one hand for the municipal forces and on the other for the great baronial *consorterie*, the aristocratic cliques whose power rested in their control of Latian fiefs and in which the Colonna family played a prominent role. The transfer of the papacy to Avignon (1309) and then the Schism – with the drastic reduction of funds flowing into the coffers of the Roman pontiffs that this entailed – had led to an almost total hiatus in the ar-

chitectural and decorative undertakings through which the bishops of Rome gave concrete expression to their authority.

Thus the pope was faced with an enormous task: reestablishing the spiritual and temporal authority of the Church and restoring the Christian monuments of Rome, which bore evident signs of the eclipse of papal power and (as a consequence) patronage. It was a tremendous undertaking, and one that could certainly not be completed within the space of a single pontificate. In fact it was to shape the policies of the vast majority of popes in the fifteenth century.

Where St. Peter's was concerned, Martin V restored the chapel of San Nicola, the portico of the basilica and some parts of the Vatican apostolic palace. In 1423 he turned his attention to the basilica of San Paolo fuori le Mura. But the interventions that left the most lasting mark were those in the basilicas of Santa Maria Maggiore and San Giovanni in Laterano, churches located in the part of the city where the power of the Colonna family had its base.

It was Colonna patronage that led to the commissioning of the triptych for the high altar of Pope Liberius's basilica from Masolino da Panicale (c. 1383-1440) and Masaccio (1401-28). The altarpiece (painted on both sides and now divided among museums in Naples, London and Philadelphia) contains many references to the Colonna pope: in the

Interior of San Giovanni in Laterano. San Martino ai Monti. The fresco, from the first half of the 17th century, shows the church as it looked in the Middle Ages

Tomb of Martin V. San Giovanni in Laterano

Giotto (attrib.), detail of the fresco with Boniface VIII Proclaiming the First Jubilee from the Loggia of the Lateran. San Giovanni in Laterano

Miracle of the Snow (Masolino, Capodimonte, Naples) Martin V is portrayed in the guise of Pope Liberius, the founder of Santa Maria Maggiore; the cope worn by *Saint Martin* (Masolino, Philadelphia) is decorated with the family's heraldic symbol of the column, underlining the identification of the saint with the pope who bore his name.

The painting was a collaboration in which the two main scenes – the *Assumption of the Virgin* and *Miracle of the Snow* – are unanimously attributed to Masolino, who must therefore have been in the position of head of the workshop on this occasion. In the second scene, in particular, the view of Rome – Monte Testaccio and the pyramid of Gaius Cestius are clearly recognizable – and the amplification of perspective in a space devoid of any concreteness are examples of a manner that can be found in pictures we know to have been painted by Masolino. It is harder to distinguish between the work of the two artists in the figures of the saints, where obvious signs of modifications made during the course of their execution have emerged. Generally speaking, it is still possible to ac-

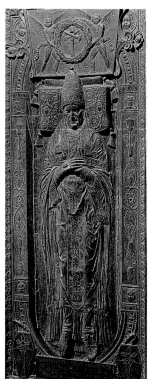

cept the traditional attribution of the panel in London with *Saints Jerome and John the Baptist* to Masaccio. The date of the triptych is much more controversial, wavering between 1423 and 1428, and therefore between the beginning and the end of the celebrated partnership between the mature Masolino and the young Masaccio.

Work in the basilica of San Giovanni in Laterano got under way in 1425. Rome's cathedral was in a state of serious decay, so that it was necessary to consolidate the structure, rebuild the roof and replace the floor, where the Colonna coats of arms can still be seen today. Martin V's attachment to San Giovanni in Laterano was very strong, even prompting him to choose the basilica as the location for his own bronze tomb.

The cathedral of Rome, along with the Patriarchate, had been the heart of the papacy in the Middle Ages. For Martin V, restoring the Lateran basilica meant forging a link with the popes of the pre-Avignon period, especially Boniface VIII who had left his mark in the great Loggia delle Benedizioni that dominated the Lateran square. Once the structure of the basilica had been repaired, Martin V decided to have it decorated by the most famous Italian painter of the day: Gentile da Fabriano (*c.* 1370-1427).

Although born in the Marche, Gentile was an exponent of the sophisticated figurative culture that had had its center in the Lombardy of the Visconti, the style known as "International Gothic" because it was diffused through the courts of Europe. The pontiff had had a chance to see Gentile's work when he crossed Lombardy in the course of his slow progress toward Rome. In 1419 the painter, who was in Brescia at the time, requested a safe-

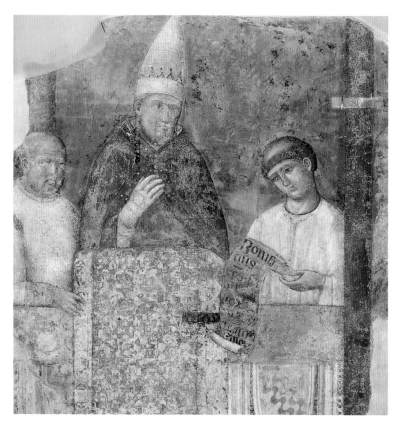

The Branda Chapel in San Clemente

Executed between 1428 and 1431, the pictorial decoration of the Branda Chapel in San Clemente was certainly the most significant work of painting carried out in Rome during the pontificate of Martin V (1417-31). Its importance would be even more apparent if it were possible to compare these paintings with other major pictorial undertakings dating from those years but which, unfortunately, have now vanished: the large cycle begun by Gentile and finished by Pisanello in San Giovanni in Laterano, Gentile's frescoes in Santa Maria Nova and the *Famous Men* painted by Masolino in Palazzo Orsini. A comparison between works by artists with different backgrounds would have made it possible to reconstruct a

much more varied and complex picture of Italian painting in the first few decades of the fifteenth century. For a long time the names Masolino and Masaccio have been linked with the paintings in the Branda Chapel, even though a close examination of the chronology excludes the possibility of Masaccio's participation.

The two artists came to Rome in May 1428 and Masaccio died in late June of the same year. This is too short a time for the young painter to have made a significant contribution to the decoration of San Clemente. Yet Masolino did not work alone. The styles of several assistants have been identified in the paintings and the names of Domenico Veneziano, Vecchietta and Paolo Uccello have been put forward.

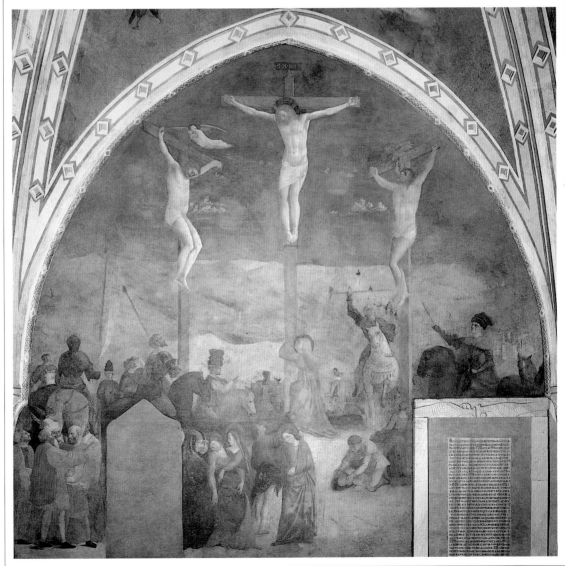

View of the Branda Chapel

Masolino, *Crucifixion*

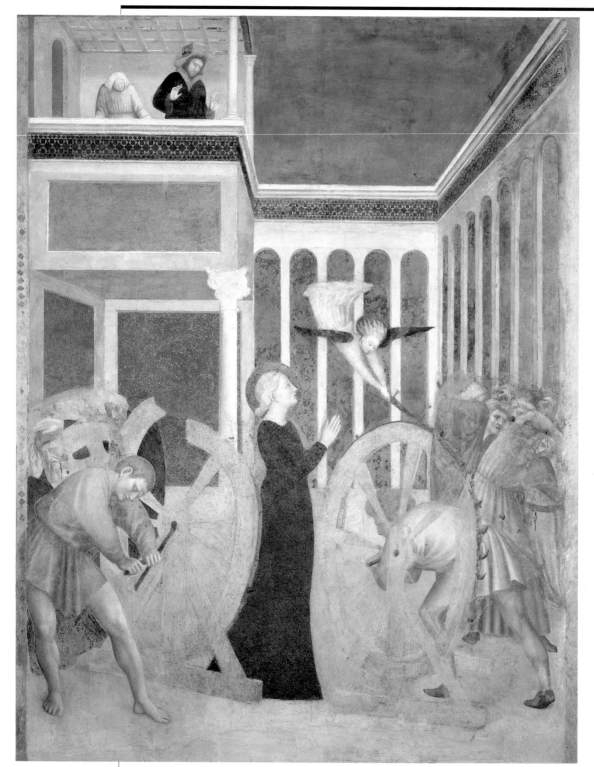

Masolino, *The Martyrdom of Saint Catherine* and, on facing page, *The Disputation of the Saint*

The decoration was commissioned by Cardinal Branda da Castiglione (c. 1360-1443) from Lombardy and the project is unanimously regarded as having formed part of the policy of improvements and embellishments promoted by Martin V and linked above all with San Giovanni in Laterano, located very close to San Clemente.

The cardinal was a diplomat and had traveled widely before settling in Rome. The landscape that extends as far as the eye can see in the *Crucifixion* painted on the altar wall and the extraordinary number of cities and towns that are included in it (now most clearly visible in the sinopia) may be a reflection of the fact that the client had visited so many countries in Europe. There can

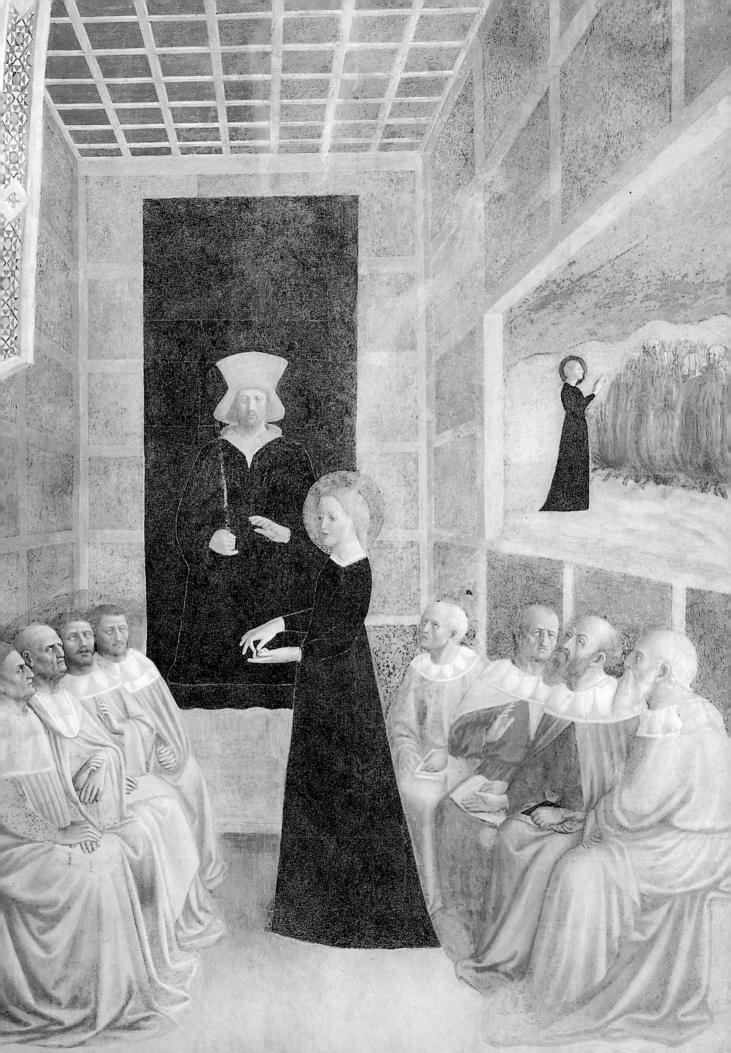

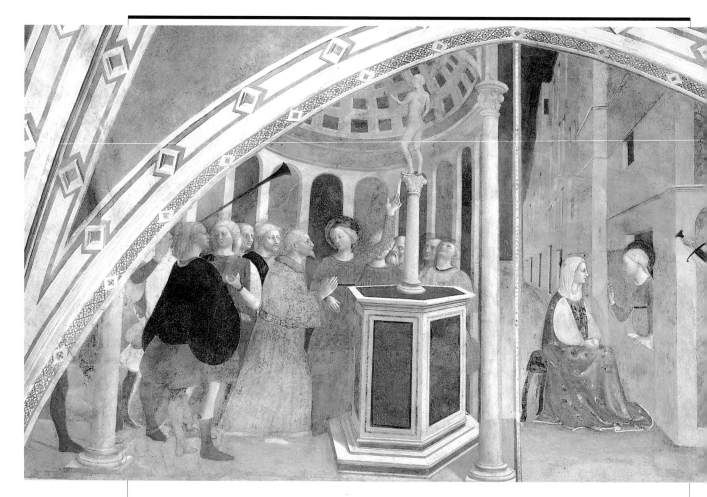

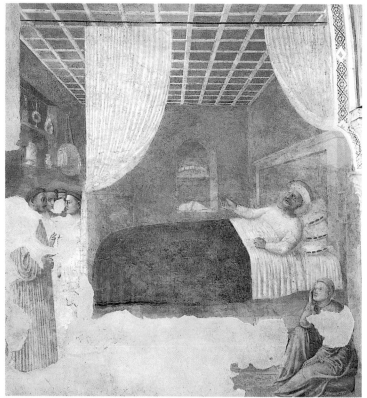

Masolino, *Saint Catherine with the Idolatrous Tyrant* and *The Saint Converting the Empress*

Masolino, *The Death of Saint Ambrose*

be no doubt that his university education and Lombard origins influenced the choice of iconography: the *Scenes from the Life of Saint Catherine of Alexandria* painted on the left-hand wall and those of *Saint Ambrose*, bishop of Milan, on the opposite side.

The two cycles do not follow a strictly chronological order but are arranged so as to create a symmetrical relationship and connections between the two stories. The study and alcove of St. Ambrose, in the *Death of the Saint*, are conceived as a counterpart to the chamber in which the *Disputation of Saint Catherine* is set. The perspective used by Masolino, as flexible and mobile as a pair of bellows, proposes an idea of space very different from that of Masaccio and much closer to fifteenth-century Sienese art than to that of Florence.

conduct so that he could go to Rome to serve the pope. It took him a long time to get there: first he went to the Marche and then he spent a long time in Florence, where he painted, among other things, the *Adoration of the Magi* (1423, Uffizi, Florence). Next he stopped in Siena and Orvieto, where he left behind traces of his passage. He may have arrived in Rome at the end of 1425 or the beginning of 1426, but it was not until 1427 that he is recorded as having received payment for the frescoes in San Giovanni, on which he had at last begun work.

Gentile died at the end of the summer of the same year and probably barely had time to sketch out the lines of this great decorative project. Not even Martin V lived to see the end of the work about which he cared so much: the frescoes in the nave of San Giovanni in Laterano were completed by Pisanello between 1431 and 1432, at the beginning of Eugenius IV's pontificate. All that remains of this cycle, representing *Scenes from the Life of the Baptist* and figures of *Apostles* and *Prophets*, are a few fragments just under the basilica's roof. Pisanello's drawings and the copies made by Borromini (*c.* 1650) are the only record we have of what was one of the most important pictorial undertakings in early fifteenth-century Rome. In 1450 Roger van der Weyden saw the frescoes when he came to Rome for the Jubilee. They made such an impression on him that he judged Gentile to be the greatest Italian painter of all.

Detail of the Biccherna tablet with the *Coronation of Nicholas V*. State Archives, Siena

Nicholas V (1447-55)

The fate of Eugenius IV (1431-47), forced to flee Rome disguised as a monk as the city rose in revolt, was certainly a warning to his successor. For Nicholas V the magnificence of architecture was a means of inspiring fear and reverence in the mob. Nicholas ushered in the mania for construction that was to infect the majority of his successors. He had the Vatican apostolic palace enlarged and fortified, aware that the Borgo, as the Vatican district is known, could be turned into a city within the city, safer and easier to defend. He also made the first attempt to restore St. Peter's in a grand style, thereby opening a fundamental chapter in the history of the Renaissance and baroque city. In contrast to his predecessor, this pope had a very good press and the writings of his friend and biographer Giannozzo Manetti provide a detailed description of his building projects, designed to transform the Borgo into a modern city, like Florence or Bologna. The presence of Leon Battista Alberti and the architect Bernardo Rossellino in Rome had a degree of influence on the drawing up of these plans. If they had been realized, the Borgo would have had a very different appearance to the one it has today: St. Peter's and Castel Sant'Angelo would have been connected by broad porticoed streets terminating in the monumental square in front of the basilica, used to stage ceremonies, in a layout of great formal and functional clarity.

The most evident trace of all this is Nicholas V's tower, while everything that was built in the Vatican has now been concealed by the numerous additions made by his successors and the changes made to St. Peter's vanished with the construction of the new basilica.

The Bronze Door of St. Peter's

Antonio Averlino called Filarete, bronze door and details representing *Abbot Andrea Visiting Florence and Rome* (top) and *The Martyrdom of Saint Peter*

The pontificate of Eugenius IV (1431-47), a Venetian who has received a bad press, was beset by difficulties at home and abroad and included a long period of exile in Florence. Even the great diplomatic success of the union with the Orthodox Church achieved at the Council of Florence (1439) was not sufficient to modify the overall assessment of his reign.

The fate of the bronze door of St. Peter's, a work commissioned by Eugenius IV and tantamount to a "portrait" of his pontificate, was not so different. The bronze leaves were cast and engraved between 1433 and 1445 by Antonio Averlino called Filarete (c. 1400-c. 1469). In

addition to the sacred scenes representing *Christ*, the *Virgin Mary*, *Saints Peter and Paul* and the pope himself, in *Eugenius IV Receiving the Keys from Saint Peter*, four historical episodes were included to extol the achievements of a pontiff who had succeeded (if only for a short time) in reunifying the Christian world and defeating (for once and for all) the attempts by the council to undermine the pope's authority.

The door of St. Peter's was executed at almost the same time as Ghiberti was working on the Door of Paradise for the Florence Baptistery. It is hard to stand up to such a comparison and Filarete's work was judged very harshly by Vasari, who described his manner as "wretched." And yet this door, so little appreciated, survived the demolition of the old St. Peter's and still stands at the main entrance of the basilica today.

The style adopted, in which a heavy baggage of archeological knowledge was fused with medieval ideas, stemmed from the desire of Filarete and his clients to create a Christian version of antiquity, reestablishing the tradition of continuity with the past that had always been so deeply rooted in Rome.

The pictorial decoration of the chapel of Nicholas V is the only surviving testimony to the activity of Fra Angelico (*c.* 1395-1455) and his workshop in the Vatican and St. Peter's. The painter had been summoned to Rome in 1446 by Eugenius IV, who had had an opportunity to appreciate his work during his years of exile in Florence. After Eugenius's death he remained in the service of Nicholas V up until 1450.

The chapel, defined "private" in the documents, was intended for the exclusive use of the pope and was frescoed between 1448 and 1449 on the orders of Nicholas V. The *Scenes from the Lives of Saints Stephen and Lawrence* – set in Jerusalem and Rome respectively – are arranged in two rows and are treated in a parallel way to underline the close ties between the two cities.

His experience of ancient Rome and the architectural projects promoted by Nicholas had influenced the painter, modifying his style: there are numerous references to the classical city, which was also that of the martyrs and of Constantine, as well as to the architecture of Alberti and Rossellino, whose echo can be seen in the sacred buildings represented in the cycle. Angelico's polished manner makes the most of the transparent effects permitted by the medium of fresco and of contrasts between alternating colors (e.g. blue and pink). In the portraits of Nicholas V, presented in the guise of Sixtus II, the influence of Northern European painting can be discerned.

In contrast with this elevated and courtly tone, the style of his chief assistant, Benozzo di Lese (1420-97), is distinguished by the use of incisive line to bring out the characteristic and anecdotal elements of the various figures. Here we see the first signs of the great gift for visual narration that was going to make Benozzo's fortune.

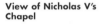

View of Nicholas V's Chapel

Fra Angelico, *Saint Lawrence Is Consecrated Deacon by Sixtus II*

Fra Angelico and Benozzo Gozzoli, *Saint Lawrence Distributing Alms*

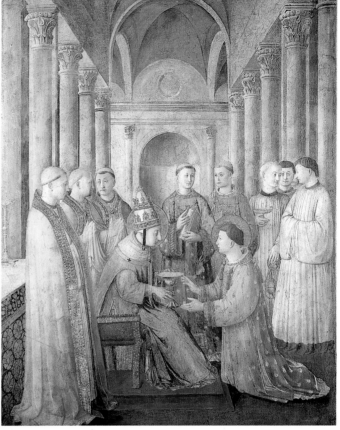

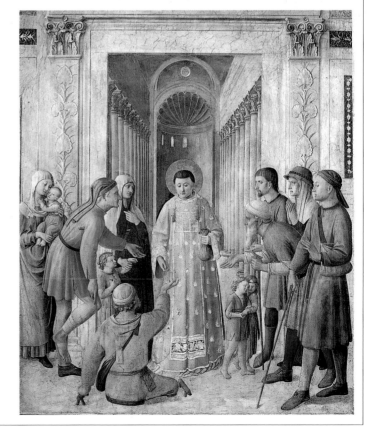

Paul II
(1464-71)

Cardinal Barbo was a Venetian. By virtue of his nationality he had obtained the title of San Marco at the end of Nicholas V's pontificate and had had a small house built next to the basilica dedicated to the evangelist and patron of Venice, St. Mark. After his election to the papal throne, under the name of Paul II, he decided to turn his home into a magnificent papal residence. The man he called on to realize this ambitious plan was Francesco del Borgo: an architect and mathematician, scholar and illustrator of Euclid and Archimedes, he was a fellow countryman of Piero della Francesca. During Pius II's reign (1459-64) he had built the Loggia delle Benedizioni in St. Peter's, one of the earliest works of architecture inspired by an ancient building, the Tabularium that overlooked the Roman Forum from the Capitol.

The new construction incorporated the ancient church of San Marco, which became its palatine

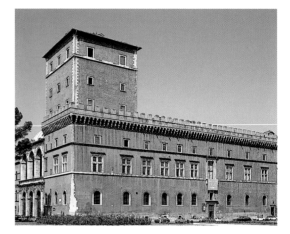

chapel. Its façade was hidden by a large portico with two tiers, a Loggia of Blessings modeled on the arches of the Colosseum. Palazzo Venezia, with its battlements and towers, and its smaller companion building, the Palazzetto (demolished and then reconstructed to make room for the Altar of the Fatherland), took their inspiration from the city halls of the Middle Ages, filtered through the tradition of fifteenth-century Tuscany. Inside, the palace's official function is still evident today from its suite of rooms of diminishing size, an example of a Renaissance state apartment whose magnificence is attested by the marble portals and by the large (unfinished) courtyard that underlines the grandeur of the layout planned by Paul II and his architect.

The Palazzetto, by contrast, housed a *viridarium*, a hanging garden enclosed by a portico, indicating that this wing of the building was intended for private use. Two squares were formed by the two constructions: the palace proper faced onto the larger one, at the end of Via Lata, and the church onto the smaller one. Thus it is clear that the pope was attempting to reorganize the city in a modern sense and to firmly embed papal authority in it: on a site that lay right at the foot of the Capitol, seat of the municipal magistracies that represented a counterweight to the power of the popes at that time.

Palazzo Venezia and its courtyard with the portico surmounted by a loggia, built by Francesco del Borgo

Sixtus IV
(1471-84)

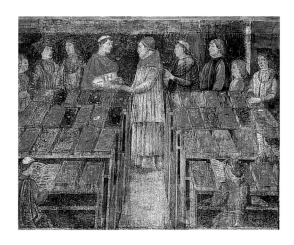

When Sixtus IV was elected pope the jubilee was only four years away. One of the first concerns of this Franciscan when he ascended Peter's throne was to restore the churches that attracted pilgrims and to set up public facilities for their reception. The hospital of Santo Spirito was designed between 1473 and 1474 by the Tuscan architect Meo del Caprina (1430-1501), who took his inspiration from the

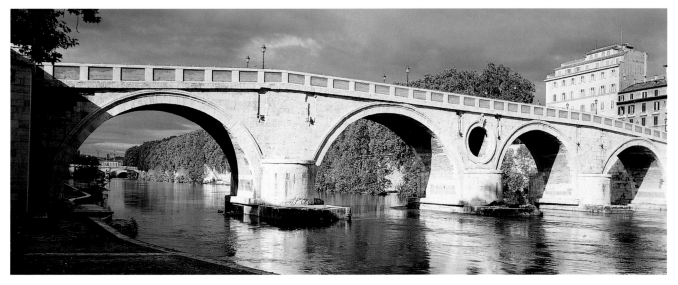

Anonymous 15th-century artist, *Sixtus IV on a Visit to the Library*. Ospedale di Santo Spirito

The Ponte Sisto

Palazzo della Cancelleria, built for Cardinal Riario, nephew of Sixtus IV

usual model of the fifteenth-century hospital – a Greek-cross plan with a rotunda at the center – but made some modifications to it. Owing to the restricted amount of space available, only two wards were built, converging on the octagonal tribune that formed their point of access.

Meo del Caprina also worked on the Ponte Sisto, whose foundation stone was laid in April 1473, thought it is not clear exactly what role he played in the project. With this construction, which replaced the ancient Aurelian Bridge, the pope hoped to make it easier to cross from one bank of the river to the other, as at that time the two parts of the city were only linked at Castel Sant'Angelo and the Isola Tiberina. Above all, he wanted to ease congestion for pilgrims crossing the Ponte Sant'Angelo, where a serious accident during the jubilee of 1450 had

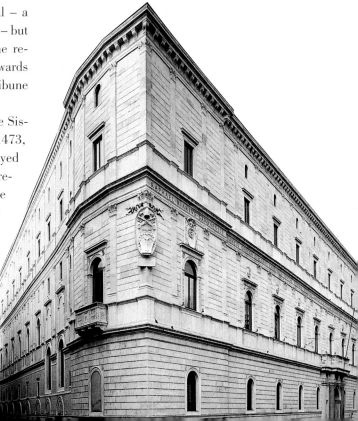

led to a large number of them falling into the Tiber.

Among the artists working under the patronage of Sixtus IV and his numerous clan, perhaps the most outstanding was Melozzo da Forlì (1438-94). The Romagnese painter produced two masterpieces to commissions from the Della Rovere family. One was the *Ascension of Christ* painted in the apse of the church of Santi Apostoli. This was destroyed in the eighteenth century, but large fragments of it can still be seen in the Quirinal Palace and the Vatican Museums. The use of perspective allowed Melozzo to transform the church's tribune into a grand and theatrical setting in which Christ hovered in the sky, accompanied by angels playing musical instruments and by the apostles, looking on from below.

If the date of 1472-73 proposed for the work is correct, the fresco in Santi Apostoli preceded Melozzo's other undertaking, the decoration of the old Vatican Library, which was located on the ground floor of the apostolic palace. This fresco, detached in the nineteenth century and now on show in the Vatican Museums, is entitled the *Appointment of Platina as Librarian*, but is actually a group portrait of the pope and his nephews. In it light and perspective are used to magnify the architecture and render it monumental, creating an image that almost encapsulates the significance of Sixtus's pontificate.

The Carafa Chapel in Santa Maria sopra Minerva

View of the Carafa Chapel

On facing page, Filippino Lippi, *The Triumph of Saint Thomas over the Heresiarchs*, and detail with view of the Lateran

The Carafa Chapel in Santa Maria sopra Minerva is named after its founder, the Neapolitan Cardinal Oliviero Carafa (1430-1511), who began its construction in 1486 and then, between 1488 and 1493, had it frescoed by Filippino Lippi (*c.* 1457-1504). The chapel's architecture, with its great entrance archway inspired by classical models, may be the work of Antonio da Sangallo and the frescoes, which were painted by a Florentine, constitute a singular exception in the artistic panorama of late fifteenth-century Rome, dominated by Umbrian painters. The architectural and scenic backdrop to the frescoes is designed to create a display of archeological splendor: the base painted in monochrome (of which only a fragment has survived) was conceived as an ample podium and the antiquarian intentions – to which the drawings made by Filippino during his stay in Rome also attest – are underlined by the decoration of the columns and the entablature, in which an attempt is made to impart a Christian significance to the classical frieze.

The chapel is dedicated to Our Lady of the Annunciation and St. Thomas Aquinas and was originally intended to serve as the cardinal's last resting place. His tomb is in fact situated in a small room to the left of the chapel proper and now concealed by the *Monument to Paul IV*, nephew of the founder and also a member of the Carafa family. All that remains of the decoration of Oliviero Carafa's tomb (now entered from the outside) is the vault with stucco partitions (a reference to the ceilings of the Domus Aurea) framing episodes from Roman history and allegorical and heraldic figures painted in tempera by Filippino's pupil Raffaellino del Garbo.

Originally the small mortuary chapel must have been connected with the main room by a broad archway and we can imagine that, if Oliviero's sepulchral monument had actually been built, then the deceased (in effigy) would have been able to see the *Annunciation*, where he is portrayed in prayer. The left-hand wall has also undergone substantial modification, destroying a fresco by Filippino Lippi. According to Vasari, Filippino had decorated it with a *Psychomachia*, a battle between vices and virtues, celebrating the qualities of his client.

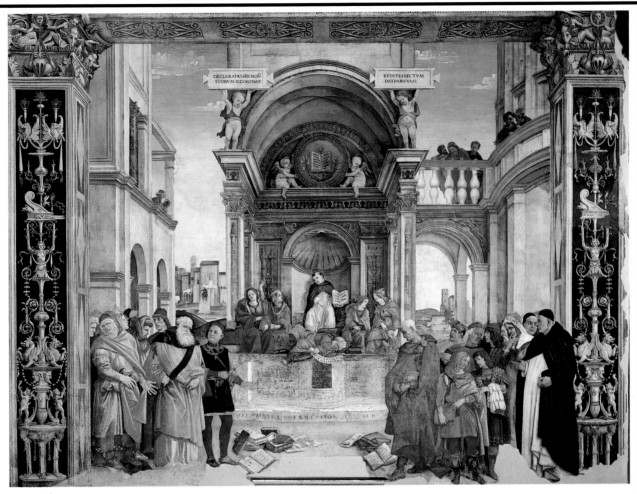

The opposite (right-hand) wall is dedicated to St. Thomas Aquinas, intellectual, philosopher and Dominican theologian. The Thomist definition of the nature of Christ, God and man at one and the same time, is the thematic core around which turns the *Triumph of Saint Thomas over the Heresiarchs*, a monumental scene from which Raphael drew more than one idea for the Stanza della Segnatura. Here Filippino came up with a complex orchestration of space, demonstrated his capacities as a landscapist in the views of Rome (the Lateran and Ripa Grande) and showed that he was familiar with the work of Leonardo in his handling of a variety of expressions and faces, passing from angelic figures to others that verge on caricature.

On the ceiling, the *Sibyls* (inspired by Pollaiolo's personifications of the *Arts* in Sixtus IV's tomb) foretell with their predictions the motherhood of the Virgin and indicate a way of salvation, which commences with the *Annunciation* and terminates with the swirling and dynamic image of the *Assumption*. In the former a number of variations on the usual iconography – in particular the presence of the donor kneeling in prayer – demonstrate that Filippino had had contact with the Flemish painting of the fifteenth century. The most striking feature of the latter is the extraordinary and ingenious way in which the spaces of the lower and upper parts are linked, by means of a canopy supported by angels and the energetic gestures of the apostles who are watching the Virgin being raised into the heavens. The landscape, peopled with Janissaries and exotic animals, serves as a reminder of the obsession with the Turkish threat that wove its way through Italian history and art in the second half of the fifteenth century, as well as the life of Carafa himself, who had led a naval expedition against the infidels.

Bramante's choir and, on facing page, detail of the decoration of the ceiling with Pinturicchio's *Coronation of the Virgin*

The Della Rovere Chapel, on left, and the Basso Della Rovere Chapel, both decorated by Pinturicchio and collaborators

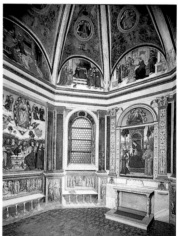

Of the many churches that were restored or completely rebuilt in the time of Sixtus IV, Santa Maria del Popolo is one of the most important. Its position, next to the gate of the same name, made it an obligatory halting place for all those arriving in Rome from the north.

In 1472 Sixtus IV ordered its reconstruction *a fundamentis* and the design of the new building was entrusted, in all probability, to Giovannino de' Dolci. The church, with its nave and two aisles, polygonal chapels and monks' choir,

reflects the experiences and interests of the Augustinians of the Lombard congregation: there are close links with the church of San Pietro at Gessate (Milan), designed a few years earlier by Guiniforte Solari.

From an architectural viewpoint, the plan shows the influence not only of churches built in Rome not long before but also, and above all, of the experiments carried out by Brunelleschi in Florence and Alberti's even more recent ones in Mantua. A link that is clearly apparent in the façade, perhaps not begun until 1475

and subsequently modified by the addition of tympana at the sides. As in the case of Santi Apostoli, the presence of a large number of chapels built for the pope's nephews led to the church coming under the almost exclusive patronage of the Della Rovere family. The pontiff and his nephews showed a predilection for the Umbrian painting of the late fifteenth century and that of Bernardino Pinturicchio (c. 1452-1513) in particular. Pinturicchio's workshop was one of the most active in the last two decades of the century: the Bufalini Chapel in Santa Maria d'Aracoeli and the decoration of the Borgia Apartment in the Vatican were its most significant undertakings.

The *Coronation of the Virgin with Prophets, Sibyls and Fathers of the Church*, painted on the chancel ceiling of Santa Maria del Popolo, is a late work: it was commissioned by Julius II (Sixtus IV's nephew) in 1509 and is an extraordinary example of the vogue for archeology and antiquity that left such a deep mark on artistic styles in Rome in the first decade of the sixteenth century: the way in which the fresco is subdivided is patently derived from the vault of the Great Baths of Hadrian's Villa at Tivoli. Bramante's chancel was also built at the behest of Julius II between 1507 and 1509: Bramante created a new backdrop to the church (of which little can be seen since the construction of the altar) in which the architecture of Brunelleschi's Pazzi Chapel in Santa Croce (Florence) is reworked in a way that places the emphasis on the modeling of forms and the disposition of masses. The deep coffers of the tunnel vault and the conch of the apse reflect the ideas that were emerging in the contemporary design of the new basilica of St. Peter.

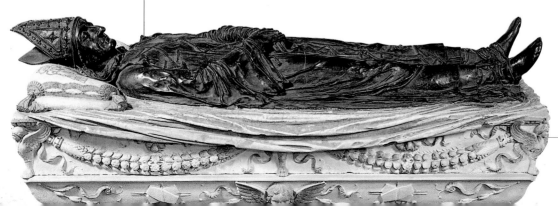

Lorenzo di Pietro called Vecchietta, *Sepulchral Monument of Pietro Foscari*

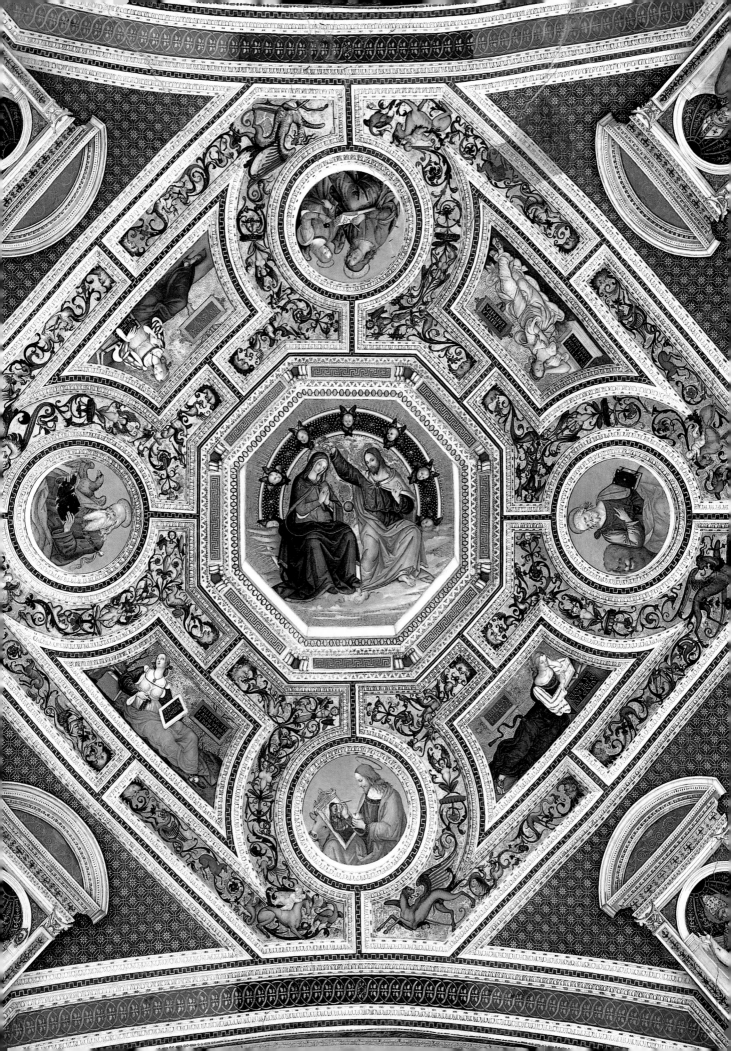

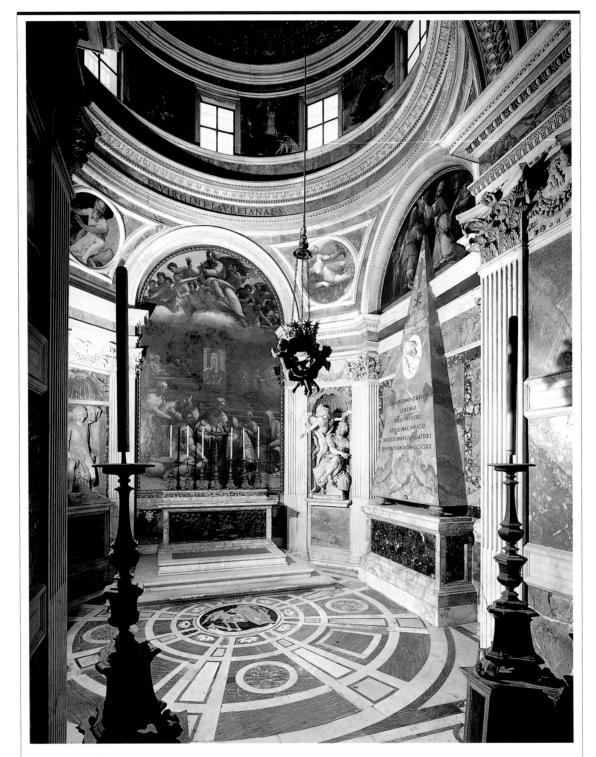

The Chigi
Chapel
designed by
Raphael

The mortuary chapel of Agostino Chigi and his descendents is the other great sixteenth-century masterpiece of Santa Maria del Popolo. The architecture of the octagonal chapel is by Raphael (c. 1513), who also produced the designs for the decoration which were then executed by his workshop: the mosaics on the ceiling (1516) are by the Venetian Luigi de Pace and the statue of *Jonah* is by Lorenzetto. The work continued into the 1540s with the participation of Francesco Salviati, who painted the *Scenes from Genesis* in oils in the drum and completed the *Nativity of the Virgin* begun by Sebastiano del Piombo.

The present appearance of the Chigi Chapel is the result of the alterations made by Gian Lorenzo Bernini at the behest of Alexander VII (1655-67), so that the church of Sixtus IV and Julius II is also linked to the seventeenth century and the baroque period, when it was decorated with masterpieces by Caravaggio and Annibale Carracci, among others.

The Belvedere Palace of Innocent VIII (1484-92) was the first suburban villa built in Rome during the Renaissance, a type of residence that within the space of a few years was to become a common status symbol for the city's wealthy prelates, bankers and courtiers.

It was constructed on the northern tip of the Vatican hill in an isolated and panoramic position. Now that it has been incorporated into the complex of Vatican palaces it is not easy, at first glance, to get an idea of what it must have looked like originally. It had a U-shaped plan and the arches and pillars set on the façades stood on a high base. As in many other Roman palaces, the crenelated cornice gave the villa the appearance of a fortress. Inside, Pinturicchio had painted a gallery with landscapes and views of famous cities, a sort of *panoptikon* that underlined the informal character of the leisure activities for which the villa was designed. During his stay in Rome, Mantegna (1431-1506) painted a chapel here that was admired for the *trompe-l'oeil* effects used by the artist to represent the liturgical instruments.

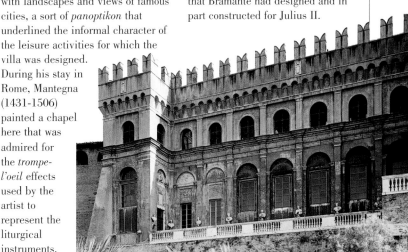

The isolated structure was then incorporated into the great courtyard that Bramante had designed and in part constructed for Julius II.

Julius II (1503-13)

Contrasting views have been expressed on the pontificate of Julius II. In a satirical pamphlet, Erasmus of Rotterdam suggested that the pope had not been allowed into Heaven: his conduct in life had been more that of a soldier than of a man of the Church. Energy and impulsiveness were distinctive features not just of his pontificate, but also of his patronage, which left a deep mark on the city of Rome: the names of Bramante, Raphael and Michelangelo – to mention just the most famous – are in themselves sufficient to give an idea of the extraordinary quality of what was produced at that time.

With the construction of the immense Belvedere Court, Bramante (1444-1514) altered the scale of the Vatican palaces to the point where they could truly compete, in dimensions and scenic effects, with the villas of antiquity. The decoration of the Stanze and the Sistine Chapel changed the course

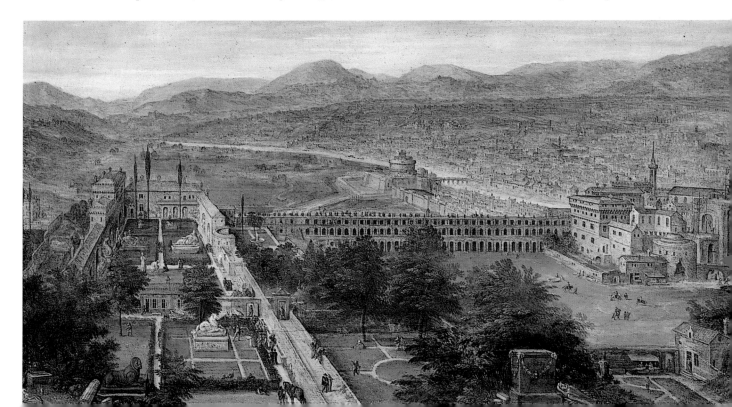

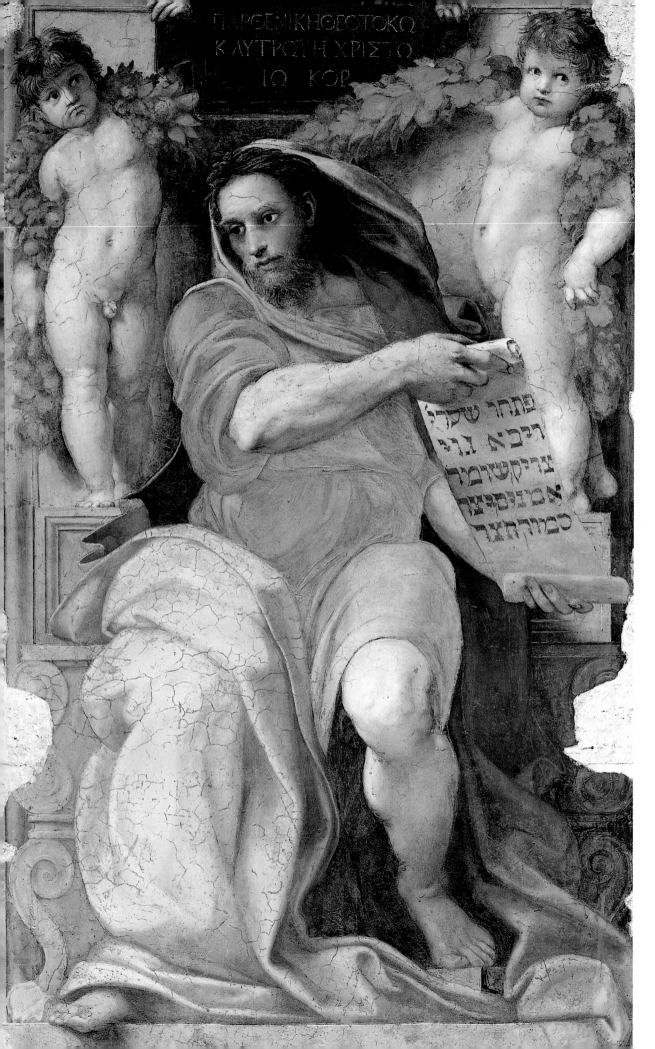

Raphael,
*The Prophet
Isaiah.*
Sant'Agostino

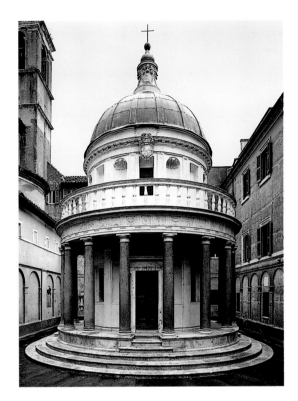

The Tempietto built by Bramante in the courtyard of San Pietro in Montorio

Via Giulia

Bottom, Raphael, *Sibyls and Angels*. Santa Maria della Pace

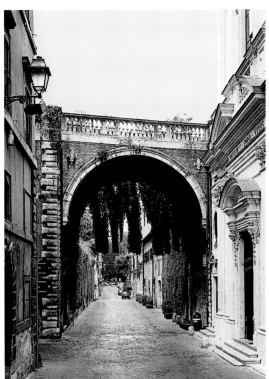

of the history of painting. The quantity and magnitude of the projects that were launched meant that many of them were left in an unfinished state or were only completed after many years had passed: this was the fate of the Palazzo dei Tribunali and its square, which were to have become Rome's new administrative center, and is perhaps best exemplified by the centuries-long story of the construction of the new St. Peter's.

It was during this period that the Villa Farnesina was constructed. The building known by this name was originally the villa of Agostino Chigi, an extremely wealthy Sienese banker and the financer of Julius II's military ventures (which earned the Chigi family the right to add the oak of the Della Rovere family to its own coat of arms), as well as a collector of antiquities and patron of the arts.

In the early years of the sixteenth century Agosti-

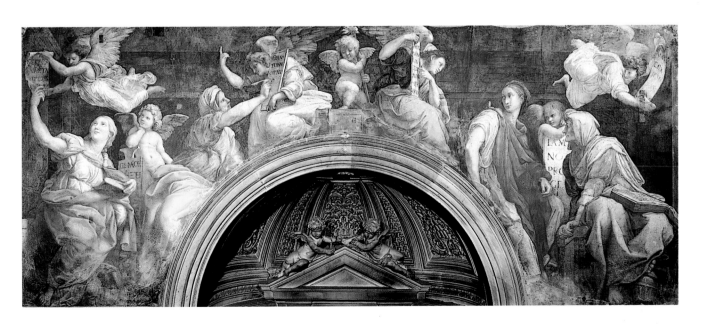

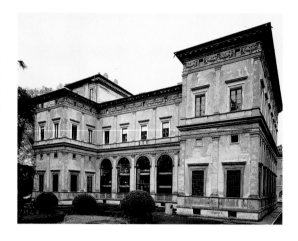

no entrusted his fellow citizen Baldassarre Peruzzi (1481-1536) with the task of building him a suburban villa: it was located at the foot of the Janiculum, on the right bank of the Tiber, just a few meters from the city walls. The site made it easily accessible both from Ponte, Rome's financial district where Chigi had his home and bank, and from the Vatican, and thus ideal for the function of representation and the display of magnificence appropriate to the abode of a great lord. The building was laid out on a U-shaped plan with a large open gallery set between the two projecting blocks and serving as its entrance. Originally, the whole of the building's exterior was decorated with monochrome paintings in imitation of marble reliefs, lending it the character of an ancient monument. The arrangement of rooms on the ground floor was characterized by the presence of loggias (once open) that underlined the continuity between the spaces inside and outside, between the *viridarium* and the house itself. In addition to the stables designed by Raphael, part of whose outer wall is still visible, the villa had a loggia overlooking the Tiber. This was famous for the parties staged there by the master of the house, culminating – according to legend – with the hurling of the precious crockery into the river.

Agostino's wealth permitted him to hire artists of the highest level. Among them was Baldassarre Peruzzi, author of the mythological scenes in the Room of the Frieze and the ceiling of the Loggia of Galatea. Here he painted the owner's horoscope – the configuration of stars at the time of his birth – in celebration of his auspicious destiny. In the same room we find the earliest Roman works of Sebastiano del Piombo (*c.* 1485-1547), whom Agostino had persuaded to move from Venice to Rome in 1511. The Venetian artist painted a picture of *Polyphemus*, which was later to be flanked by Raphael's *Galatea*, allowing a direct comparison to be made between the two schools of painting, between Sebastiano's feeling for color and nature and the wonderfully balanced composition of Raphael.

It was during a second phase in the villa's decoration that the frescoes in the Loggia of Psyche were painted (1517), along with the Room of Perspectives and the Room of Alexander and Roxanne's Wedding on the second floor. This last was painted to celebrate Agostino's marriage to Francesca Ordeaschi. Raphael produced the designs for the Loggia, but the execution of the paintings was entrusted to Giulio Romano and

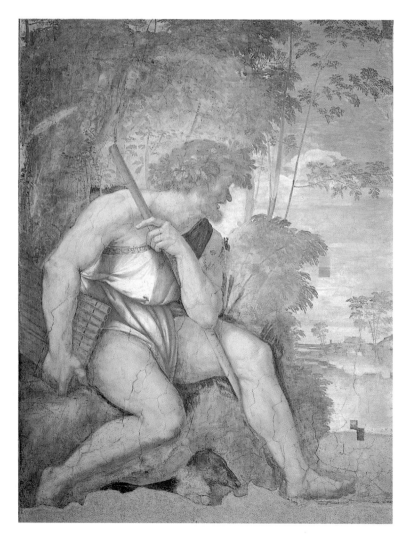

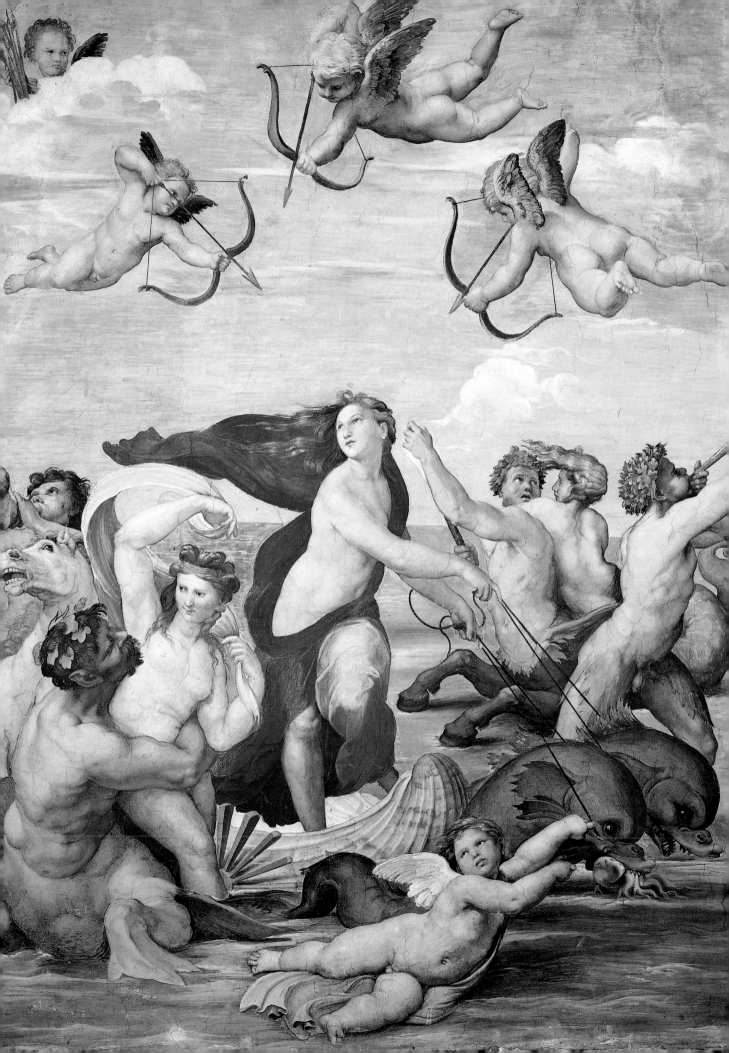

Giovanni da Udine. The garlands, made up largely of what were exotic plants at the time (native to America, discovered just a few decades earlier) and the mock hangings painted on the ceiling transform the solid architecture into a gazebo. An ephemeral and festive element that allows the *Scenes from the Myth of Psyche* to be interpreted in a half-serious manner: the story of a soul that gains immortality, but also of worldly snares and the enticements of love. In the paintings the solemn tone of the *Council of the Gods* contrasts with the dynamic and somewhat histrionic poses of Mercury and Venus.

The painted architecture and the landscape that extends for almost 360° in the Room of Perspectives are a true *tour de force*, through which Baldassarre Peruzzi, who was also a set designer and an architect, demonstrated his extraordinary capacity to move from real to simulated space.

The Loggia of Psyche. Villa Farnesina

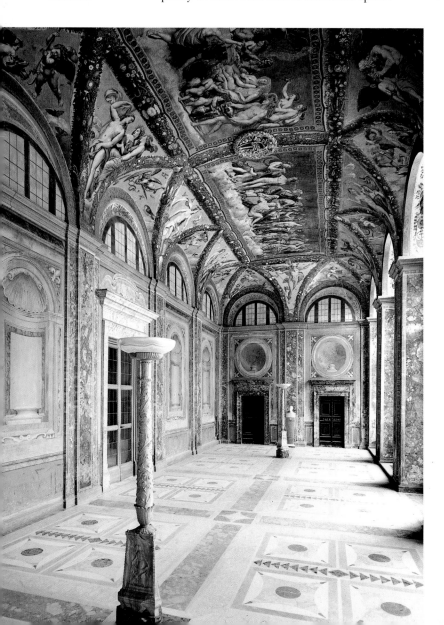

The Sistine Chapel

The Sistine Chapel was intended to be the center of liturgical and ceremonial life at the papal court and still retains that role today, at least in part. It is a palatine chapel, distinct in its function to the private chapels which the pontiffs had built in the Vatican apostolic palace over the course of the centuries, as well as to the basilica of St. Peter itself. Its typology is rooted in that of the papal residences, from the Patriarchate in the Lateran to the medieval Vatican and the Palace of the Popes in Avignon, and is inspired by medieval reconstructions of the Temple in Jerusalem.

The chapel is named after its founder, Sixtus IV, the pope who had it built on the same plan as the ancient *capella magna* in 1477: the outer walls retrace and incorporate the medieval ones, but the height was increased.

Even today, in spite of the alterations, the exterior still has an austere character: the curtain wall of brick is unadorned and the battlements give it the appearance of a fortress. The work was completed in 1480 and its architect was Giovannino de' Dolci (the figure with the set square in Perugino's *Delivery of the Keys* is usually considered to be his portrait), who gave the structure the qualities of simplicity and rationality that were so dear to the Franciscan Sixtus IV. In fact these characteristics are to be found in many of the buildings constructed during this pope's reign.

Inside, the chapel has a single nave roofed with a chamfered tunnel vault and divided into two parts by a marble transenna, the work of the Lombard sculptor Andrea Bregno (1418/19-1503/06). The *opus sectile* floor is based on the medieval tradition of Roman marble workers and forms a sort of carpet orientating the movement of people taking part in the ceremonies held in the chapel.

The first pictorial decoration dates from 1481-82 and was also commissioned by Sixtus IV. The paintings were arranged in three parallel rows running from the altar wall to that of the entrance. On the upper one, between the large windows of the clerestory, was set a series of portraits of popes that commenced with *Peter* himself. The middle row is the most important and depicts *Scenes from the*

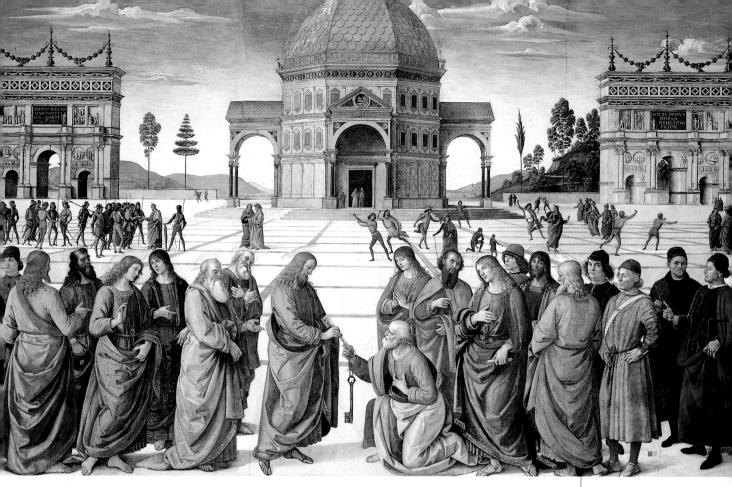

Lives of Moses and Christ arranged so
that the individual episodes mirror one
another, a technique frequently used
in Christian theology and founded on
the comparison of the Old and New
Testaments. The bottom row was
painted with *trompe-l'oeil* hangings
decorated with the Della Rovere coat
of arms, except in the area of the altar
where there was a fresco of the
Assumption of the Virgin.

Among the many artists who were
summoned to paint the papal chapel,
there can be no doubt that Pietro
Perugino (*c.* 1448-1523) played a
prominent role: he painted the whole
of the altar wall and the first scenes
from the lives of Christ and Moses on
the chapel's longer sides. He was the
only one granted the privilege of
signing his work and this can still be
seen in the frame of the *Baptism of
Christ*. So it is not unlikely that the
Umbrian painter was entrusted with
the role of directing the various
workshops that were employed on this
major undertaking.

Working alongside Perugino we find
the best artists active in Perugia and
Florence at the time: Sandro Botticelli
(1445-1510), who in the *Punishment
of Korah, Dathan and Abiram* found
himself competing directly with
Perugino, who had painted the

Delivery of the Keys on the opposite
wall; Domenico Ghirlandaio (1449-94),
who was the greatest Florentine
fresco painter of the last quarter of
the fifteenth century; and the young
Luca Signorelli (*c.* 1445-1523) who
painted the penultimate episode of
the *Life of Moses*.

Much has been written on the
significance of this cycle, telling the
stories of Christ and Moses, from the
Nativity and *Moses in the Bulrushes* up
to the *Resurrection of Christ* and the
*Battle between Angels and Devils for
Moses' Body*. The "parallel lives"
outline an ideal profile of the Roman
pontiff and, obviously, of Sixtus IV
himself, as the temporal and spiritual
guide of God's people.

The task of completing the
decoration fell to Julius II (1503-13),
who as has already been pointed out
was Sixtus IV's nephew. It seems
likely that the decision to fresco the
ceiling was taken when subsidence of
the structure made its consolidation a
matter of urgency.

Michelangelo (1475-1564) worked

**Perugino, *Delivery
of the Keys***

**Perugino, *Baptism
of Christ***

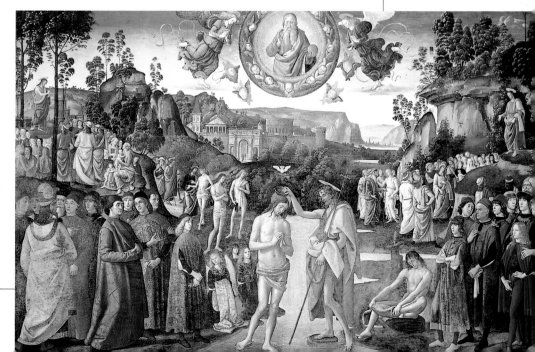

**Botticelli, *Trials
of Moses***

**On facing page,
Michelangelo,
ceiling of the
Sistine Chapel**

here for four years, from 1508 to 1512. In the first two years he painted its eastern section (from the entrance side) and over the next two the opposite side. Michelangelo's own memories – though these have to be treated with great caution – and a number of drawings allow us to reconstruct its gestation, at least in part. At first the artist planned to decorate the ceiling with figures of the apostles, thereby continuing the scheme of the portraits of popes painted in the fifteenth century. The figures were to be framed in a manner not all that different from the ceilings in the antique style that were in vogue in early sixteenth-century Rome. In the end, though, the decoration of the vault developed into something far more complex, from the viewpoint of both composition and iconography. The idea of the frames was abandoned in favor of a mock architecture (inspired by the first design for Julius II's tomb) that would open up in the middle of the ceiling, suggesting a view of the sky. It is in this central section that the narrative proper is located, made up of episodes from Genesis, ranging from the *Dividing of Light from Darkness* to the *Drunkenness of Noah* and running along the longitudinal axis of the chapel. But the vault can also be read

from bottom to top, from the *Ancestors of Christ* in the lunettes to the *Holy Families of the Bible* and from there on up to the *Sibyls* and *Prophets* and to the *Ignudi*, the nude figures whose identity is not clear and which are located closest to the divine revelation. The whole structure is supported, from an iconographic viewpoint, by the four pendentives in the corners, where the episodes of *David and Goliath*, *Judith and Holofernes*, the *Death of Haman* and *Moses and the Brazen Serpent* represent divine interventions in defense of the chosen people. Michelangelo started with the *Flood* and then moved in the direction of the altar. A comparison between the first and last scenes reveals a change in the painter's style. At the beginning he stuck to the narrative schemes developed in Ghirlandaio's workshop, where Buonarroti had served his apprenticeship. In the second section, however, a need for clarity prevailed – in part due to the great height of the ceiling – which led to an emphasis on eloquent gestures that could condense a complicated action into a few details: the widespread arms of the Eternal that stand for the *Dividing of Light from Darkness*, the fingers that almost touch in the celebrated *Creation of Adam*. A quarter of a century later, in 1537,

Michelangelo found himself back on the scaffolding in the Sistine Chapel, frescoing the *Last Judgment* on the vast surface of the altar wall. No minor undertaking – even simply in physical terms – for a man who was sixty-two years old. The project dated back to 1534, the last year of Clement VII's reign, and – as André Chastel pointed out – was seen as an expiation for the Sack of Rome (1527), a devastating defeat for the pope and one of the gravest humiliations ever inflicted on the papacy and Church. Michelangelo left Florence for Rome, never to return again. On the death of Clement VII the project received the energetic support of the new pope, Paul III Farnese (1534-49), and was completed on October 31, 1541. In order to paint the *Judgment* it was necessary to destroy the frescoes Perugino had painted on the altar wall, wall up two windows and eliminate two lunettes that Michelangelo himself had painted.

Michelangelo's composition constitutes a violent departure from the scheme of the rest of the Sistine Chapel's pictorial decoration. The gleaming surface and the groups of nude and heroic figures with which it is thronged have no relationship, either formal or thematic, with what had been painted in the chapel before. The dramatic and suspenseful atmosphere does not just reflect the collapse of a utopia, to which the sack of the city had put an abrupt end, but also current religious anxieties and uncertainties. The theme of salvation lies at the center of a work that quickly gave rise to doubts and criticisms: the figure of a beardless Christ wrapped in an aureole of light is not wholly in conformity with Christian iconography, and neither is the Virgin, who instead of interceding on behalf of the risen appears

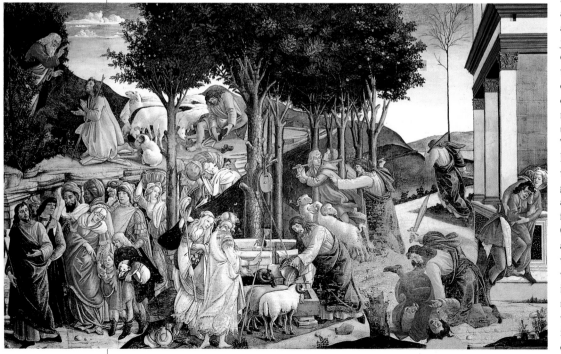

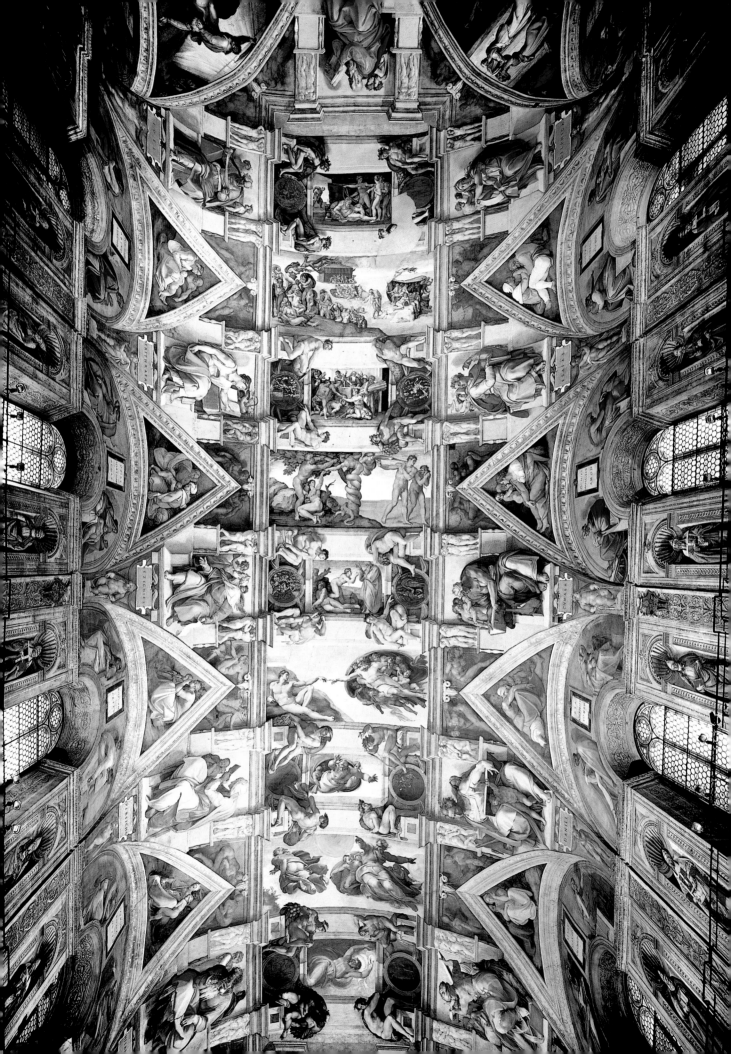

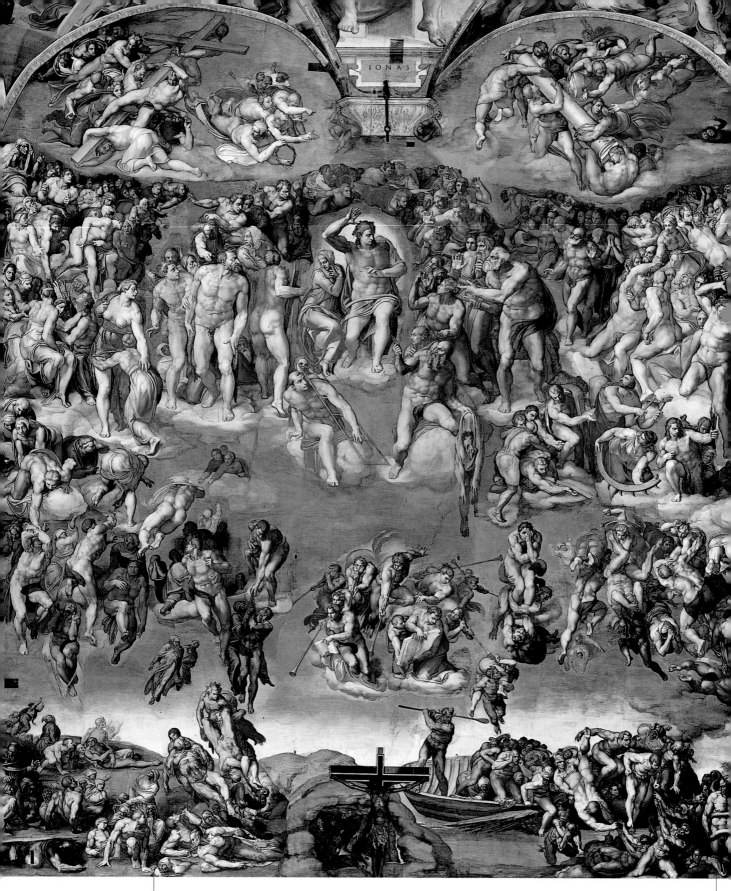

**Michelangelo,
Last Judgment**

herself to be terrified at the prospect of divine judgment. The heroic and superhuman nudity of the risen, set above the altar, appeared unseemly to many, commencing with Pietro Aretino.

In 1563, just a year prior to his death, Michelangelo was obliged to witness the first censorship of the *Last Judgment*: his pupil Daniele da Volterra painted out the nudity of St. Catherine of Alexandria and

St. Blaise. Perhaps this was the price that had to be paid to prevent the destruction of Michelangelo's masterpiece during the age of the Counter Reformation.

The Basilica of St. Peter

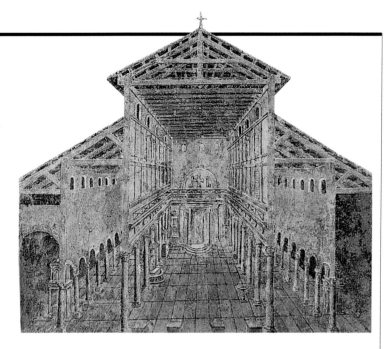

The history of St. Peter's basilica almost coincides with that of Christian Rome and the papacy. Peter's martyrdom in Rome in AD 64 and, above all, the cult that grew up around him were used by the bishops of Rome to assert their supremacy over the patriarchs of the great Christian centers of the East, commencing with Jerusalem itself.

From an archeological point of view, it can be stated with certainty that the cult of Peter is documented in the Vatican necropolis from the second half of the second century onward. A small sacellum was erected on the spot where the apostle was believed to be buried and this, after the Edict of Milan (313) was made the heart of the basilica founded by Constantine.

Work on the new construction commenced between 319 and 324 and lasted a long time: to make room for the building it proved necessary to fill in many of the pagan graves in the necropolis and carry out major works of excavation and leveling of the Vatican hill. The tomb was visible at the end of the nave but isolated and surrounded by slabs of marble that have been preserved. The construction was almost 100 meters or 330 feet long and was divided into a nave and four aisles terminating in a transverse block and an apse. In spite of its size and the richness of the marble with which it was decorated, the basilica of St. Peter was a far more modest affair in Constantine's time than the one in the Lateran, which was the seat of the bishop of Rome. Originally, in

fact, St. Peter's was a graveyard basilica located outside the city itself and without a clergy of its own.

The first important modifications were made in the second half of the fifth century and at the beginning of the sixth. Between 468 and 483 a large atrium was built in front of the façade and then decorated. Gregory the Great (590-604) raised the apsidal section, creating an annular crypt around the *confessio*, rendering Peter's tomb less visible. The campaigns of mass conversion promoted by this pope turned Rome into the capital of Western Christendom and ever growing numbers of pilgrims flocked to the tomb of Christ's first vicar. Over the centuries hostels were built around St. Peter's to accommodate them and then, with the fortifications erected

by Pope Leo IV (847-55), the area surrounding the basilica grew into a city in its own right, close to but separate from Rome, a development that altered the balance of the whole built-up area.

Major architectural interventions were carried out during the pontificate of Innocent III (1198-1216). This pope, who showed a special interest in the basilica, was responsible for the replacement of the mosaic in the apse, documented through drawings and a few surviving fragments. These interventions marked the beginning of a shift in the pendulum from the Lateran – Rome's cathedral – to St. Peter's and by the fifteenth century the latter had become dominant.

The mosaic on the façade was replaced a few decades later, during the reign of Gregory IX (1227-41), while Giotto's *Navicella* was commissioned by Cardinal Stefaneschi in the second decade of the fourteenth century. This was certainly the most famous of the decorations in the medieval basilica. The large mosaic was located on the eastern side of the atrium and represented the story of *Christ Walking on the Water*, when the boat in which the apostles were sailing on the Sea of Galilee was struck by a sudden storm and Peter walked on the water with Jesus's help. Here the Gospel story was presented as a metaphor of the long and dangerous

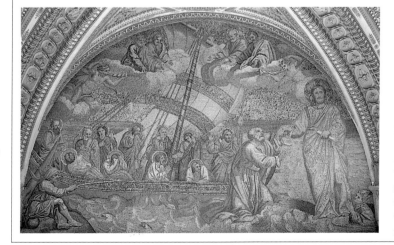

Domenico Tasselli, The Nave and Aisles of the Ancient Basilica of Constantine

17th-century reproduction of Giotto's mosaic the Navicella

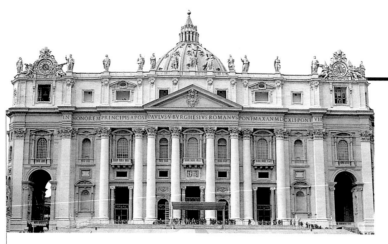

The façade of St. Peter's, built by Carlo Maderno

The interior of the basilica

path walked by the Church. The iconographic density of the *Navicella* set the precedent for the images filled with religious and political messages that typified the painting of the fourteenth century.

The changes made to the apse of St. Peter's by Nicholas V, on which work started between 1451 and 1453, did not just represent the first significant intervention after the interlude in Avignon and the Great Schism, but prepared the ground for the projects of Julius II. The Della Rovere pope first turned his attention to the renovation of the *capella Julia*, which was to have served as the new apse of the basilica, taking up from where Nicholas V had left off half a century earlier. It was also the place where the great tomb which the pontiff had asked Michelangelo to design for him would have stood. As is well known, things turned out differently and the first stone of what was to become the new basilica was laid on April 18, 1506. Julius II had given Bramante the task of rebuilding the whole presbyterial section of the church, creating a rotunda that would have dominated the apostle's tomb. After the death of Julius II (1513) and Bramante (1514), the work slowed down and then, with the Sack of Rome (1527), ground to a halt. We cannot ignore the fact that the raising of money for the construction of the new basilica (obtained by the

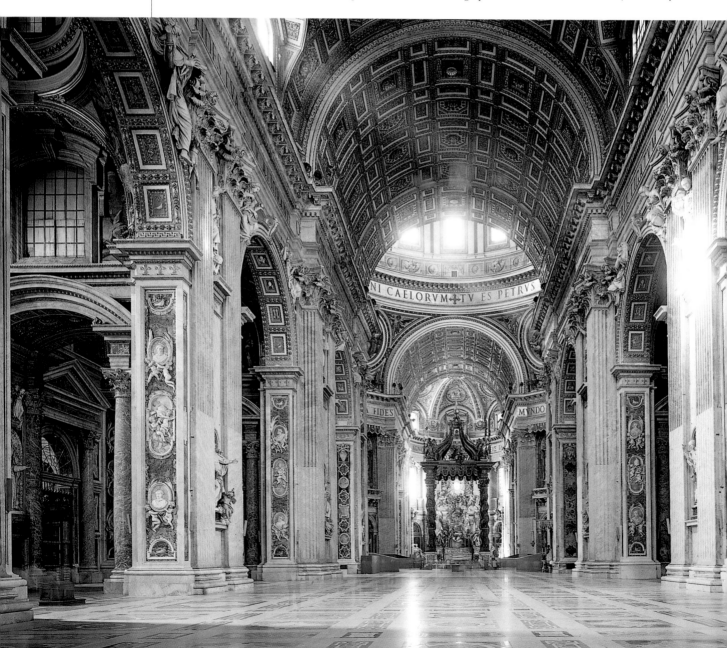

The interior of the dome decorated with mosaics

Michelangelo, *Pietà*

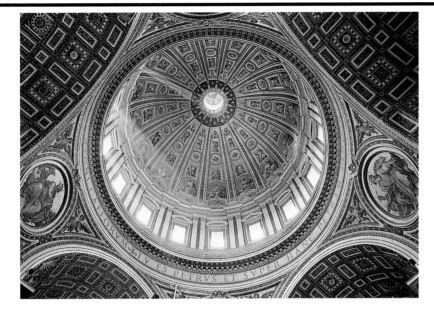

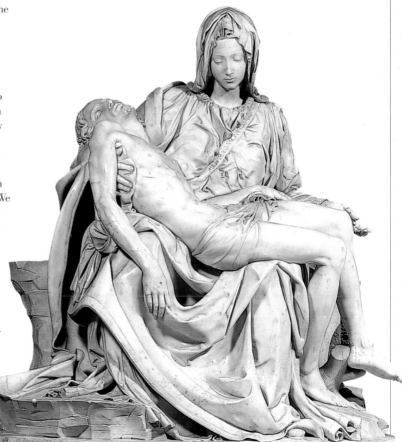

orderly and symmetrical manner that was to distinguish the new basilica from the chaotic jumble of altars and tombs in the medieval church.

Gian Lorenzo Bernini (1598-1680) was given the responsibility for the interventions that are still the principal features of the interior today: the bronze baldachin that covers the apostle's tomb and the altar cum throne in the apse that contains the remains of the *cathedra Petri*, or "St. Peter's Chair." Bernini also designed the colonnade that was built during the reign of Alexander VII (1655-67). The vast elliptical square not only became an impressive theater for papal ceremonies, but also resolved the unhappy relationship between the dome and the façade that had been created by the construction of Maderno's nave.

sale of indulgences) was the prime motivation for the Protestant Reformation.

It was not until the pontificate of Paul III (1534-49) that continuation of work on the basilica was made a priority. In 1538 a partition wall was built to separate the apsidal section, where Bramante had built the great piers that were destined to support the dome, from the nave of the early Christian basilica. Not only did this area – together with the four-sided portico – continue to be used for services, but new altars and tombs were built in it and there is reason to believe that the decision to demolish Constantine's church totally was only taken in the final stages of the work. On the death of Antonio da Sangallo (1546), Michelangelo was placed in charge of the construction, a position that he held until his death (1564). We can thank Buonarroti for the present conformation of the rotunda, with its giant order, the drum with its coupled columns and the dome, although this was completed under the supervision of Giacomo della Porta (1590), who altered Michelangelo's design to give the structure a markedly pointed profile.

During Paul V's pontificate (1605-21) the decision was made to demolish the nave and atrium. The work was entrusted to Carlo Maderno, who between 1608 and 1618 gave the basilica its present Latin-cross plan and built the new façade, thereby canceling out the last traces of the early Christian church. The reconstruction was now concluded, but much had still to be done to make the church functional.

The enormous interior of St. Peter's had to be decorated in the

Raphael's Stanze

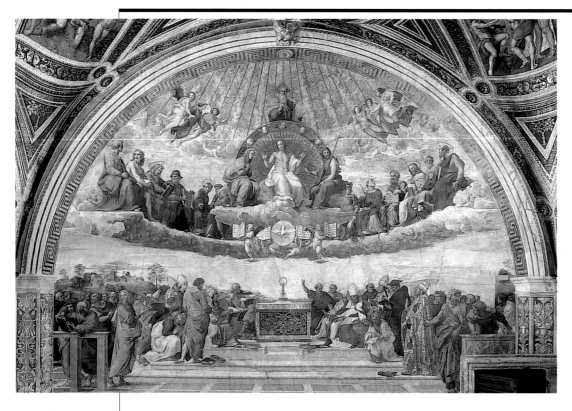

In 1508, at the same time as Michelangelo was painting the ceiling of the Sistine Chapel, Raphael started on the decoration of the rooms that Julius II had decided to turn into his new private apartments. The Stanza della Segnatura ("Room of the Signature"), based on the neoplatonic concepts of the Good, Beautiful and True at the probable suggestion of Egidio da Viterbo, general of the Augustinian Order, represents the acme of the "narrow crest" that embodied the idea of the Renaissance for Wölfflin, a perfect balance of form and content, of place, space and time. The paintings located on opposite walls of the room, the *School of Athens* and *Disputation over the Sacrament*, which were executed by 1511, express the concepts of Philosophy and Theology, i.e. natural and revealed Truth, through a common Bramantesque articulation of space in which the leading intellectuals of the pagan and Christian worlds are set like motionless figures on a stage. On the adjoining wall, the *Parnassus* presents the beauty and harmony of art as a natural complement to religion and science.

In the Stanza di Eliodoro ("Room of Heliodorus") abstract themes are abandoned in a response to the changed historical climate of the final, turbulent years of Julius II's pontificate, their place taken by episodes alluding directly to the pope and his reign: the *Freeing of Saint Peter from Prison*, a reference to his imprisonment; the *Expulsion of Heliodorus from the Temple*, intended to evoke the pope's reconquest of lands that had been appropriated by the Papal States' neighbors; the *Mass at Bolsena*, a celebration of Julius II's devotion to the Corpus Domini instituted by his uncle Sixtus IV; and finally the scene of *Leo the Great Halting Attila*, which symbolizes Leo X Medici's succession to the papal throne. In the decoration of this room, with its dynamic luministic effects, complex scenic constructions and sophisticated superimpositions of space and time, it is already possible to detect more than one crack in the perfect harmony Raphael had sought to achieve in the

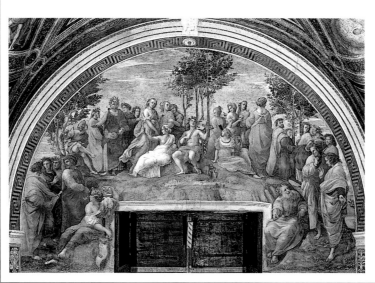

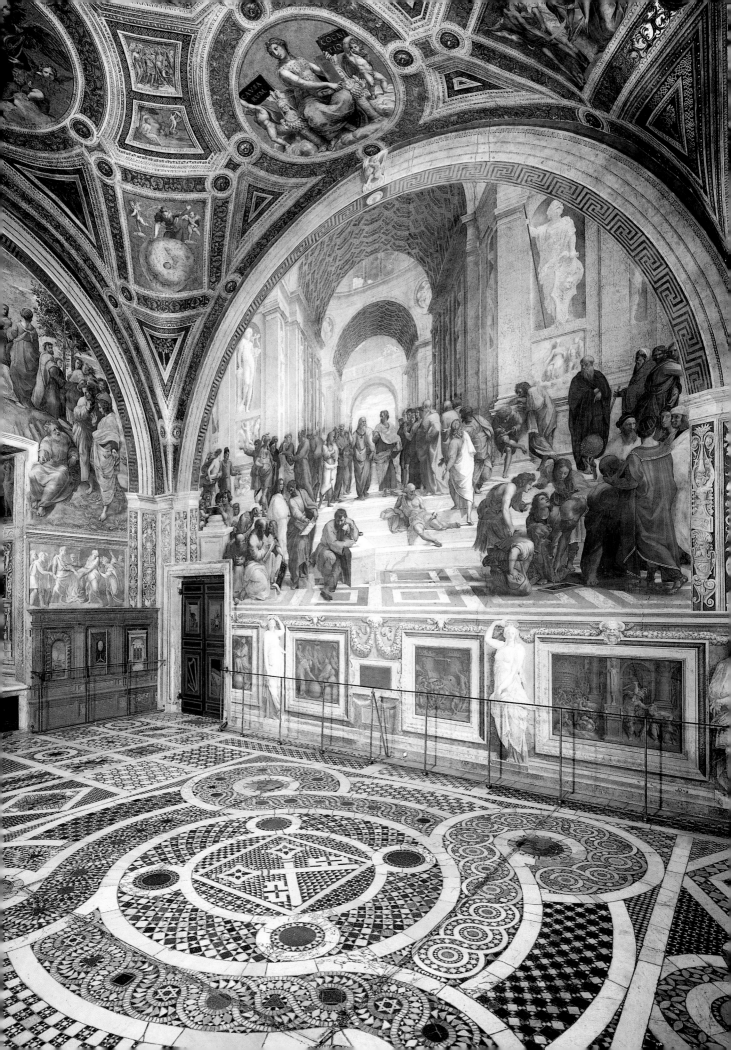

Raphael, *The Freeing of Saint Peter*

Raphael, *The Mass at Bolsena*

On facing page, Raphael, *The Borgo Fire*, detail

Stanza della Segnatura.

In the Stanza dell'Incendio di Borgo ("Room of the Borgo Fire"), the break is complete, partly owing to the contribution of his pupils, Giulio Romano, Giovan Francesco Penni, Giovanni da Udine and Pellegrino da Modena, key figures in the transition between Raphael's legacy and the new current of Roman Mannerism. While it is clear that the *Fire* and the *Battle of Ostia* are predominantly Raphael's own work, the same cannot be said for the other two frescoes, the *Coronation of Charlemagne* and the *Oath of Leo III*, in which the intervention of his assistants is easily

discernable. In those years, Raphael was also working on the prestigious commission of the cartoons for ten tapestries to be hung in the Sistine Chapel and on the frescoes in the Sala dei Palafrenieri for Leo X.

The last room, the Stanza di Costantino, was not begun until 1519, just a year before the artist's death: for the enormous expanses of the walls decorated with the *Battle of the Milvian Bridge* and the *Vision of Constantine*, Raphael designed two large cartoons, each made up of six pieces sewn together, which were probably executed by Giovan Francesco Penni on the basis of

sketches left by his master. Penni and Giulio Romano were to finish all the frescoes in the room, which as a consequence suffer from a degree of overcomplication and heaviness of execution, a mark of the changing times and of the premature death of the artist from Urbino. However, the decoration of the walls with a set of mock tapestries remained, like many of the other solutions invented by Raphael, a valid example throughout the sixteenth century and a citation that was widely adopted as a sign of continuity with the classical tradition that the artist had so perfectly embodied.

LEO · PP · IIII ·

From the Sack of Rome to Paul III's *Renovatio Urbis*

The fateful year of 1527, when the Sack of Rome took place, prompting the flight from the city of the most brilliant intellectuals and artists of the time, was in reality just the culmination of a political and cultural decline that had commenced with the ascent of the Dutchman Adrian Florenszoon Boeyens to the throne of St. Peter as Adrian VI (1522-23). This pope's well-known scorn for antiquity and for the arts in general brought a halt to the ambitious papal commissions that had characterized the first twenty years of the sixteenth century. The election of the second Medici pontiff, Clement VII (1523-34), was unable to revive the artistic fervor that had distinguished those two decades, partly as a consequence of the breakup of the principal studio of painting in Rome, that of Raphael: the departure of Giulio Romano for Mantua in 1524, Polidoro Caldara da Caravaggio for Naples in 1527 and Perino del Vaga for Genoa in 1528 resulted in a hiatus that was to last practically up until the advent of Paul III. And even if the project for Michelangelo's *Last Judgment* in the Sistine Chapel dates from the last year of Clement VII's pontificate, it was Paul III who saw him start work on it in 1535 and complete it in 1541.

In spite of the diaspora of Raphael's pupils, who exported the style of the artist from Urbino to the rest of Italy, it should be remembered that the most refined and extravagant exponents of Mannerism had arrived in Rome during the reign of the Medici pope: Rosso Fiorentino, who was active in 1524 in the Cesi Chapel in Santa Maria della Pace (dismissed by Vasari with the words "he never did anything worse"), probably at the very moment when he was painting the astonishing *Dead Christ Supported by Angels* (Museum of Fine Arts, Boston), and Parmigianino, whom the lansquenets responsible for the sack of the city would find hard at work in his studio – as Vasari records – on the *Dream of Saint Jerome* (now in the National Gallery, London). Parmigianino, the nickname of Francesco Mazzuoli, even prompted Vasari to declare that "the spirit of Raphael had entered into the body of Francesco, when that young man was seen to be as rare a painter and as gentle and gracious in his ways as was Raphael." On the pontiff's return to the plundered city at the beginning of the fourth decade, other Tuscan artists arrived from Florence who were to shape the destiny

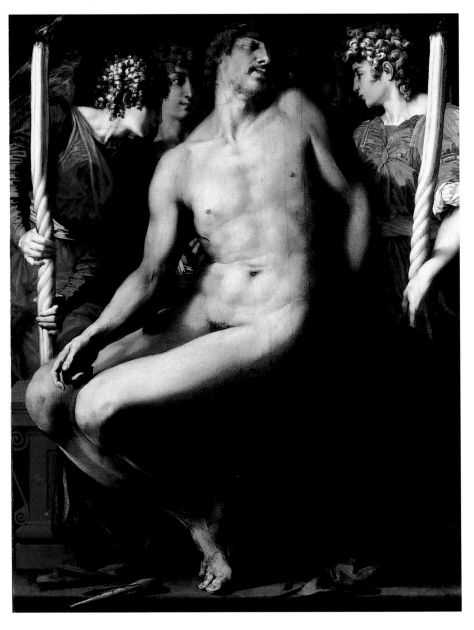

The Sala Regia in the Vatican and one of the frescoes of the decoration, Giorgio Vasari's *Return of Gregory XI from Avignon*

Below, Francesco Salviati, *Bathsheba on Her Way to David*. Palazzo Sacchetti

of Roman Mannerism: on the one hand Jacopino del Conte and Francesco Salviati, exponents of a figurative synthesis that has been described as the "Raphaelization of Michelangelo" (Longhi), and on the other Daniele da Volterra, who represented rather a continuation of Buonarroti's *terribilità*.

On the death of Clement VII, Cardinal Alessandro Farnese Senior became pope under the name of Paul III (1534-49): his pontificate saw the city's political and cultural resurgence under the banner of *renovatio urbis*, with a reference in papal apologetics to the imagery of a new "golden age" and the revival of imperial Rome. The same ideology underpinned Charles V's triumphal entry into the Eternal City, decked out with sensational temporary decorations for the occasion, in 1536, and Perino's frescoes in the Sala Regia of the Vatican (begun in 1542 but not completed until the reign of Gregory XIII), illustrating the theme of the continuity of Rome as the seat first of the empire and then of the papacy.

The work that best embodies the means and tastes

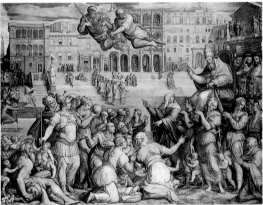

of the new pope is Palazzo Farnese, a monument to the Renaissance opulence of a family whose fortunes had grown immensely over the course of the previous fifty years: commenced by Alessandro at the time he was still a cardinal, in 1517, it was based on the refined plans drawn up by Antonio da Sangallo the Younger, who supervised its construction up until his death in 1547. The recent restoration (1999) of what was to become a prototype of

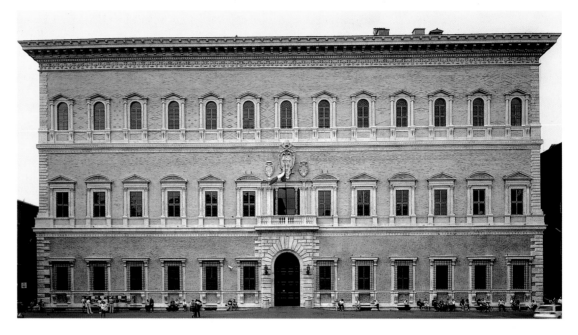

Top, Palazzo Farnese

Above, Giorgio Vasari, *Paul III Directing the Work on St. Peter's Basilica*. Palazzo della Cancelleria

the European royal palace (Argan) has revealed an irregular pattern of lozenges on its sober façade, obtained by inserting alternate rows of darker bricks, which somewhat undermines the idea of the perfect Renaissance edifice to which we were accustomed. The completion of what Sangallo described as "no longer the palace of a cardinal, but of a pope" was to require contributions from Michelangelo (who designed the cornice and the central window), Jacopo Vignola and Giacomo della Porta. In 1538 Paul III also had work resumed on the construction of St. Peter's basilica, which had been halted for about twenty years, entrusting the task first to Sangallo and then to Michelangelo, who went back to Bramante's concept of a central plan. Paul III showed an extraordi-

nary versatility – partly the consequence of his brilliant and elitist cultural education, imbibed from Pomponio Leto in Rome and in the circle of Lorenzo de' Medici in Florence – in his patronage of pictorial undertakings of the most varied expressive character, ranging from the charming pagan fables of Perino del Vaga in the Pauline Apartment of Castel Sant'Angelo to Michelangelo's admonitory frescoes of the *Last Judgment* and the scenes in the Pauline Chapel. In the latter, on which Buonarroti started work in 1542 and did not finish until the beginning of 1550, the two episodes of the *Conversion of Saint Paul* and the *Crucifixion of Saint Peter* sum up the shift in sacred painting toward an expressiveness that was intended to convey a lofty spiritual message.

Michelangelo, *Conversion of Saint Paul* and *Crucifixion of Saint Peter*. Pauline Chapel, Vatican

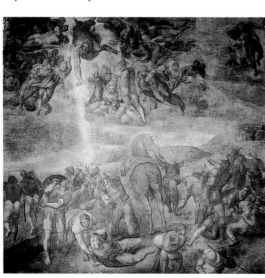

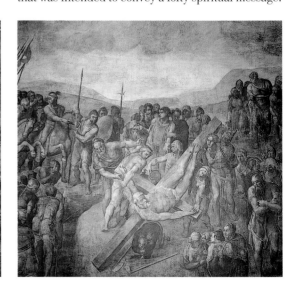

Paul III's Apartment in Castel Sant'Angelo

In 1544-45, at the height of his pontificate, Paul III Farnese commenced the decoration of his apartment in Castel Sant'Angelo, the fortress emblematic of papal power on the other side of the Tiber. The sumptuous decoration was carried out in two consecutive stages, one under the direction of Luzio Romano, who had been Perino del Vaga's pupil in Genoa, and the other supervised and partially executed by Perino himself. This was the last commission carried out in the capital by the artist, who worked on it until his death in 1547. The northern section of the apartment, made up of the Library, the Rooms of the Hadrianeum and of the Festoons and the three Cagliostra rooms, is decorated in the archeological style of Luzio, an artist whose career lasted an extremely long time but whose talents as a fresco painter, draftsman and stucco worker have still not been clearly defined. On the other hand the decorations of the

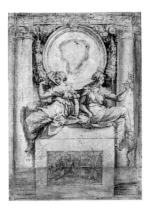

great Council Room, or Sala Paolina, with the adjoining Room of Psyche and Room of Perseus and the Room of Apollo underneath, were designed and partly executed by Perino, who had adopted a more flowing and dynamic style toward the end of his life.

The Council Room, where Perino was backed up by a large group of assistants – including some who would be counted among the most significant painters of the second half of the century – is the product of this maturation of his art, probably stemming from his encounter with the Roman works of Salviati and Vasari and perhaps even those of the young Bolognese painter Tibaldi. The complexity of the decoration, with its continual illusory intersection of painting, sculpture and architecture, is by now remote from the last works of Raphael, though Perino still based the organization of his studio on the example set by his master.

The ideological program of the Sala Paolina, centering on the parallel lives of Alexander the Great and St. Paul, the two eponymous tutelary geniuses of the pope, is the outcome of a cultural syncretism of Christianity and paganism that was still possible at the time of Paul III, who set out to glorify his pontificate as a rediscovered golden age even though these were the very years in which the Council of Trent was being held.

*Perin del Vaga, **Study for a Wall with Two Allegorical Figures**. Gabinetto dei Disegni e delle Stampe, Galleria degli Uffizi, Florence*

*Perin del Vaga and Pellegrino Tibaldi, wall with **Saint Michael Archangel**. Paul III's Apartment, Castel Sant'Angelo*

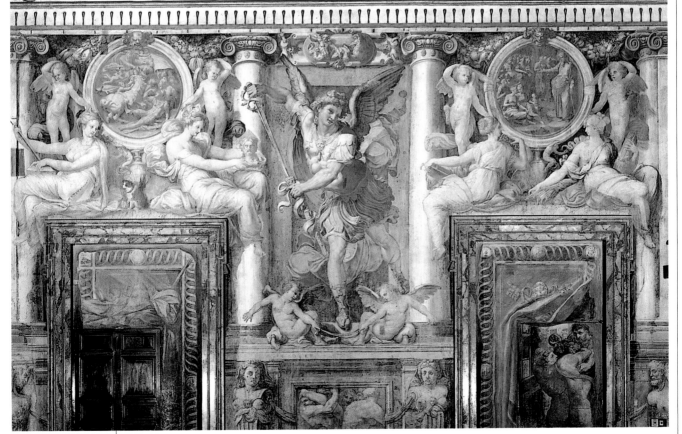

Michelangelo's Reorganization of the Capitol

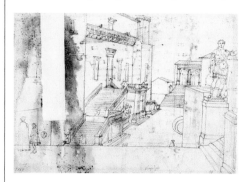

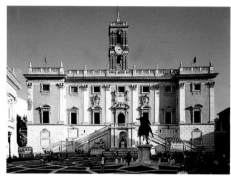

The Campidoglio, or Capitoline hill, is the fruit of a complicated series of architectural and urbanistic interventions made in the modern era, commencing at least as early as the fifteenth century. However its actual configuration bears the sixteenth-century stamp left on it by Paul III Farnese (1534-49), who had the first plans drawn up for the reorganization of the area.

Though the idea of renovating the Capitol in time for Charles V's passage through Rome on his return from the expedition to Algiers in 1536 came to nothing, two years later Paul III had the equestrian statue of *Marcus Aurelius* transferred from Piazza di San Giovanni in Laterano to the center of Piazza del Campidoglio, where it was placed on a marble base designed by Michelangelo. This was a highly symbolic act, intended as a reminder of the "imperial" role of the pope, who also liked to draw a parallel between himself and Alexander the Great with precise reference to his position as a political counterweight to Charles V.

Extremely important to our knowledge of the Capitol in the first half of the century are the drawings made by Marten van Heemskerck in the years 1535-36, which attest to the fascinating atmosphere of the ruins that stood on the site prior to the pope's interventions. In 1539 work was completed on the tower of Paul III, linked by a "passageway" to his residence of Palazzo Venezia, though this was destroyed during the construction of the monument to Victor Emmanuel II.

In 1547 the pope decided to demolish the ancient loggia on the front of the Senatorial Palace. Five years later it was replaced by the present double staircase and the monumental entrance built out of travertine, both of them designed by Michelangelo. In 1537 the latter had been granted Roman citizenship as a mark of his link with the Capitoline hill, which the artist had done so much to transform. In truth, however, though much of the pope's new projects can be said to have originated with Michelangelo, the buildings were completed long after his death in 1564 by other architects of great renown. For instance, while the flight of steps leading to the top of the hill is considered to have been Buonarroti's idea, it was completed, like the balustrade along the edge of the square, in 1565 and both were embellished with ancient marble statues (including the *Dioscuri* and the *Trophies of Marius*) over the course of the 1580s. This was also the period in which the statues of river gods were set up at the sides of the staircase of the Senatorial Palace. The bell tower was built by Martino Longhi the Elder in 1578-82 and the statue of *Minerva-Roma* placed in the middle of the façade one year later.

The façade is the work of Giacomo della Porta, the most faithful and gifted interpreter of Michelangelo's architectural ideas: constructed over the course of the seventies, it was not completed until 1598, as the heraldic devices of Clement VIII Aldobrandini visible on the attic attest.

The Palazzo dei Conservatori was commenced in 1563 and incorporates the preexisting fifteenth-century building, some of whose decorations can still be seen: Giacomo della Porta adapted Buonarroti's original design by inserting a large window in the middle of the façade's single order. The Palazzo Nuovo opposite was built in the middle of the seventeenth century by Girolamo and Carlo Rainaldi in imitation of Michelangelo's palace, concluding the long history of the layout of one of the city's most important locations.

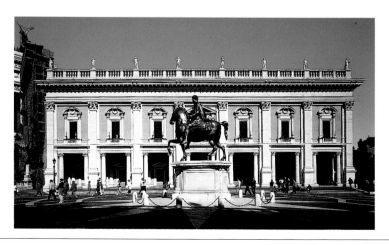

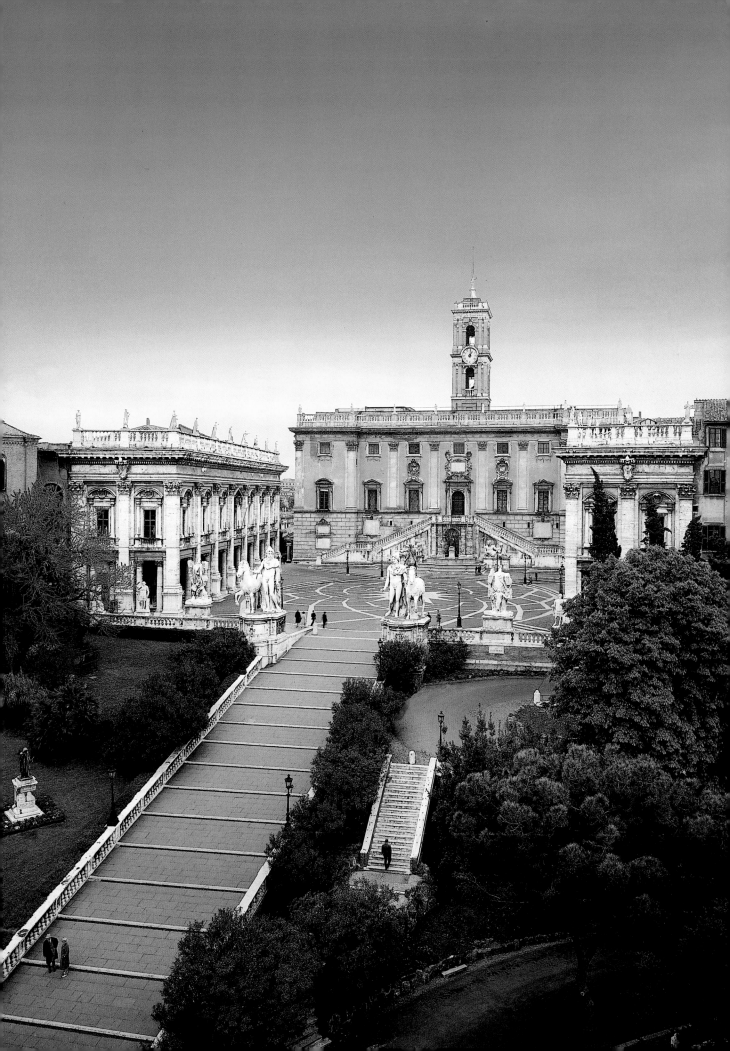

From Julius III to Sixtus V

Renaissance Tradition and the New Tridentine Spirituality

In 1550 Giovanni Maria Ciocchi Del Monte was elected pope as Julius III (1550-55) and commissioned Vasari to paint his family chapel in San Pietro in Montorio. This work played a crucial role in the context of Roman art, partly as a consequence of the extraordinary level of quality attained thanks to advice from Michelangelo, who supervised the whole project, including the sculptures of Bartolomeo Ammannati (effigies of Cardinal Antonio and Fabiano Del Monte, among others), and expressed his appreciation of Vasari's picture of the *Blind Saul Led by Ananias*. The main undertaking of Julius III's pontificate, Villa Giulia, or the "vineyard of Cardinal Del Monte," was also launched under the aegis of Michelangelo and Vasari, whose places were later taken by Vignola and Ammannati: the latter was responsible for the loggia and the celebrated nymphaeum, supplied by the Vergine Aqueduct. Despite Julius III's intention of emulating the prototype of Villa Madama, the mutable structure of Villa Giulia has led Tafuri to describe the multiple spaces laid out around the semicircular courtyard as a cognitive "route." This interpretation of architecture prepared the ground for the Mannerist suburban villas of Lazio, from Bomarzo to Villa d'Este, characterized by an inextricable interweaving of nature and architecture and by a thematic and spatial polycentrism.

Taddeo Zuccari,
Bacchanal.
Villa Giulia

The loggia and
nymphaeum of
Villa Giulia designed
by Bartolomeo
Ammannati

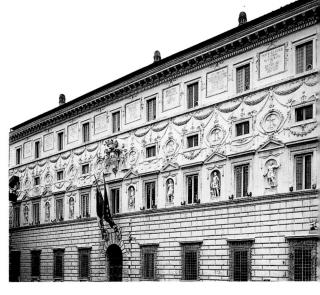

Details of the decoration of the portico of Villa Giulia

Right, Palazzo Spada Capodiferro

Bottom, Villa Medici, now the seat of the Academy of France

While it is clear that Julius III based the artistic choices of his pontificate on a distinct predilection for Florentine culture and in particular for the academic current that stemmed from the example set by Michelangelo – of which Ammannati's Palazzo Firenze is a case in point – it is also true that figurative enterprises of a quite different character were carried out during his reign and that these were to have a decisive influence in the years to come. In fact it was at Villa Giulia, where the frescoes were painted by the Bolognese artist Prospero Fontana (1512-97) and the young Taddeo Zuccari (1529-66), that a new and profane taste in painting emerged: sensitive to the more spirited ideas of the Po Valley school of painting as well, it was combined with Perino's mellower interpretation of the legacy of Raphael. And the views of the countryside in the Sala dei Sette Colli ("Room of the Seven Hills") are the earliest example of a type of painted frieze that would make its appearance in an enormous number of frescoes in Rome and Lazio during the second half of the sixteenth century.

The complex of Palazzo Spada Capodiferro is also emblematic of the openness toward influences from the Po Valley around the middle of the century. The architecture of Bartolomeo Baronino in conjunction with the stucco sculptures of Giulio Mazzoni from Piacenza (1550), who also painted most of the frescoes inside the building, represents an adoption of architectural and pictorial models that were completely new in the Roman context. However, their markedly eccentric character meant that they were to remain an isolated example of singular beauty.

The death of Julius III in 1555 and the election of Paul IV Carafa (1555-59) were to put a halt to the artistic flowering of the city for five years, as a conse-

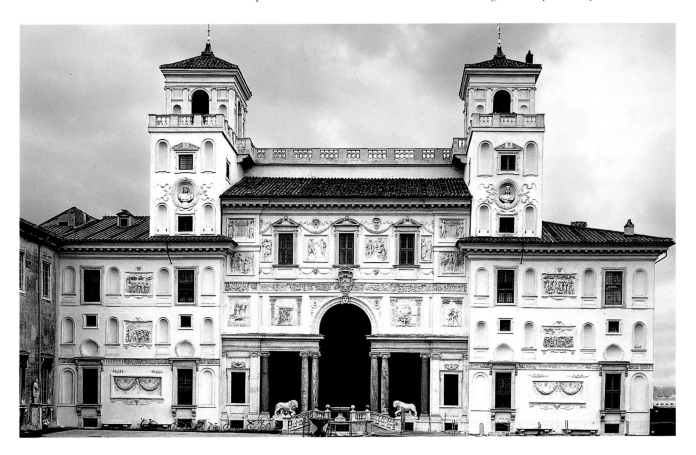

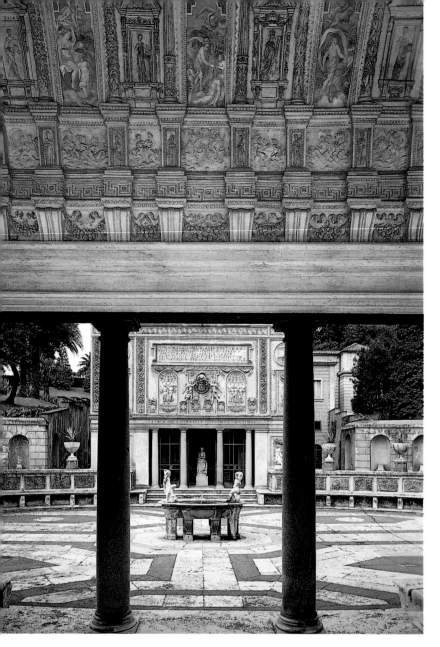

classical antiquity. In this sense, and in spite of the fact that the last act in the schism between Catholics and Protestants took place in 1564 with the publication of the Tridentine Catechism, the artistic activity of this pontificate represents the century's last true glimmer of Humanism, soon to be overtaken by a comprehensive renewal of the language of communication used by all the arts. In fact the emblem of Pope Pius IV is the Casino, also known as Villa Pia: perhaps begun under his predecessors, it nevertheless bears the unmistakable mark of the highly personal contribution made by the Neapolitan architect Pirro Ligorio (c. 1510-1583), a genuine example of a Renaissance man with his complementary activities as a scholar, archeologist, painter and draftsman. In this delightful retreat situated in the gardens of the Vatican Palaces, Ligorio assembled a sophisticated collection of images in the reliefs that cover every side of the graceful architectural structure, images that were derived from his thorough study of the ancient world and laid out for all to see in that encyclopedic miracle, the manuscripts of the *Libro dell'antichità*. The sculptures and frescoes of the "Wood in the Belvedere" consist of almost hermetic palimpsests of nature and astrological myths, closely bound up with Christian themes from the Bible in accordance with an established Neapolitan tradition that was revived by Pius IV and his nephew Carlo Borromeo (the future St. Charles) at sessions of the "*Noctes Vaticanae*" academy. A number of young painters who were to play important roles in the future made their debut working in the Casino of Pius IV and on the contemporary frescoes in the Belvedere Apartment, in particular Federico Barocci and Federico Zuccari from the Marche, antithetical exponents of two new conceptions of painting, those of "reason and sentiment."

The front of the courtyard of Pius IV's Casino designed by Pirro Ligorio

Federico Zuccari, *Taddeo Zuccari Copying the Sculptures in the Belvedere*. Gabinetto dei Disegni e delle Stampe, Galleria degli Uffizi, Florence

quence of the pope's obsession with vendettas and his decidedly obscurantist and anti-humanistic attitude.

Only the "*semper pius*" Giovan Angelo de' Medici of Marignano, Pope Pius IV (1559-65), succeeded in retying, for however short a time, the broken threads of the Renaissance tradition, with its roots in the philosophy and figurative culture of

The most important operation of city planning carried out during Pius IV's reign was the construction of the gate called Porta Pia, designed by Michelangelo, at the beginning of Via Nomentana to mark the opening up of Via Pia (now Via XX Settembre and Via del Quirinale), leading to what

Porta Pia

Paul Brill, *Monte Cavallo*. Gabinetto dei Disegni e delle Stampe, Galleria degli Uffizi, Florence

Bottom, Gaspare Vanvitelli, *The Quirinal*. Pinacoteca Capitolina

worldliness and religion, between the paganism of antiquity and the new Christian philosophy. In fact the last thirty years of the century would be distinguished by a decided affirmation of Catholic culture in all artistic undertakings in Rome, under the influence of the great religious orders (Jesuits, Franciscans and Dominicans) and of the emergence of the new spirituality of the followers of St. Philip Neri. Pius V's strict adherence to the Tridentine reforms and consequent disdain for profane culture are summed up in the emblematic episode in which the pope is supposed to have decided to have the statues known as Pasquino and Marforio thrown into the Tiber, perhaps at the instigation of his confidant and loyal follower of Carlo Borromeo, Niccolò Ormaneto, who had been summoned to Rome by Pius V himself to root out corruption in the religious orders. Consequently, art in the city of

was then the palace of Cardinal Ippolito II d'Este on Piazza di Monte Cavallo. The entrance to the city was completed in 1565 with the intervention of the sculptors Jacopo del Duca and Nardo de' Rossi.

The death of Pius IV in 1565 and the election of Pius V Ghislieri (1566-72), later to be canonized for the victory he had achieved over the Turks at Lepanto, finally brought to a close an artistic era that had still been marked by an essential balance between

The Patronage of Alessandro Farnese

The figure of Alessandro Farnese, the son of Pierluigi and grandson of Paul III and a great patron of the arts, was of an importance equal, if not in some ways superior, to that of a pope. The cardinal's culture, united with the enormous economic and political power that he acquired, meant that was able to gather the finest artists and intellectuals to pass through the papal city in those years around his court, based at the Palazzo Farnese and Palazzo della Cancelleria in Rome, as well as at the Villa di Caprarola, his residence during the last years of his life. From Titian, El Greco and Giulio Clovio to Onofrio Panvinio, Annibale Caro and Paolo Giovio, and from Perino del Vaga, Giorgio Vasari and Francesco Salviati to Jacopo Vignola and Giacomo della Porta, all the artists and scholars who worked for Paul III's grandson offered the best of themselves, sometimes accepting commissions from no one else. The cardinal's artistic choices seem highly diverse to us today, but in the figurative arts he showed a preference for artists from Venice or with ties to that city. However, these were balanced by the presence of

people like Vasari, Perino or Salviati, exponents – though in very different ways – of a distinctly Florentine culture.

Titian spent the years 1545-46 with the cardinal in Rome, where he produced some of his greatest Mannerist masterpieces, including the *Portrait of Alessandro Farnese* and the one of *Paul III with His Grandsons Alessandro and Ottavio Farnese*, as well as the *Danaë* (all now in the Farnese collections at the Museo di Capodimonte in Naples). In 1546 Vasari also inaugurated the stilted and over-intellectual Hall of the Hundred Days in the Palazzo della Cancelleria. Around 1554-55 Salviati returned to Rome to carry out for the cardinal what is perhaps the artist's most brilliant undertaking, the Sala dei Fasti Farnesiani ("Room of the Farnese Annals") in Palazzo Farnese, a lofty example of inventiveness and stylistic sophistication. We can also thank the "Gran Cardinale" for the realization of the palace at Caprarola, given its definitive form by Vignola and frescoed over a period of fifteen years (1560-75) by a large team of painters under the supervision of Taddeo and Federico Zuccari, Jacopo Bertoja and Giovanni de' Vecchi.

In the final years of his existence, prior to his death in 1589, Alessandro was one of the forerunners of the revival of early Christian culture that was to prove

such a success at the end of the century, a backward-looking style in line with the desire to return to the original purity of the Christian religion that was prompted by the outcome of the Council of Trent. The shift in the cardinal's passions toward a stricter morality gave rise in 1568 to his most ambitious and costly project, the construction of Il Gesù, prototypical church of the Counter Reformation. Begun to a design by Vignola, who was responsible for the marvelous space of the interior, it was continued by Giacomo della Porta, who had completed the elegant façade by the middle of the seventies.

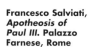

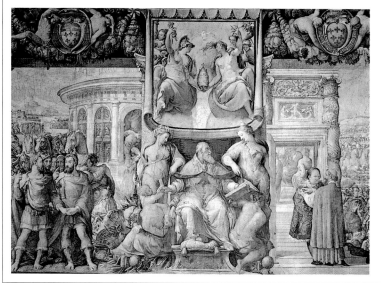

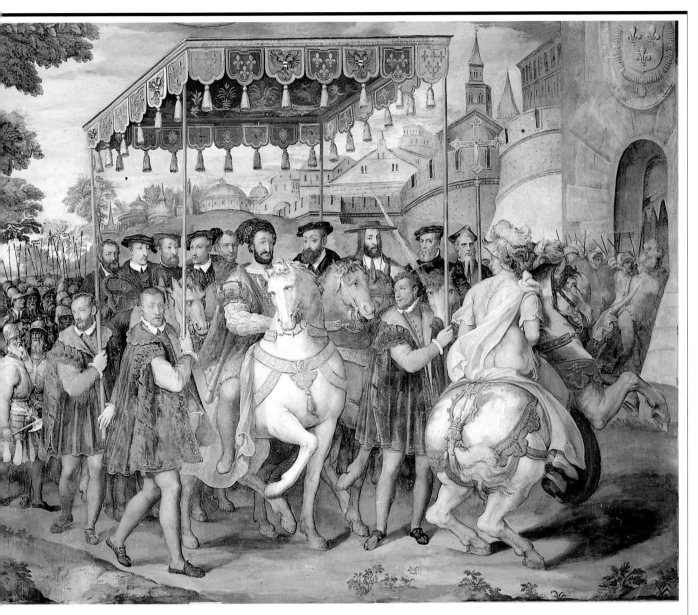

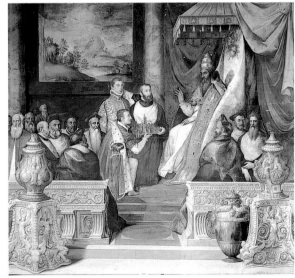

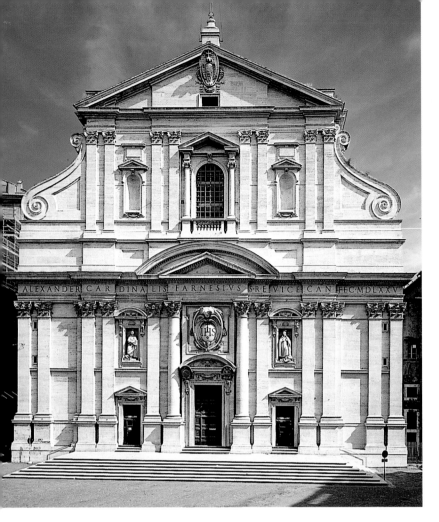

The church of Il Gesù with the façade designed by Giacomo della Porta

The Gallery of Maps, Musei Vaticani

Partly as a consequence of the good-natured and simple character attributed to him by his contemporaries, Gregory XIII Boncompagni (1572-85) mitigated some of the severity of his predecessor Pius V and his long and tranquil reign reestablished the conditions for a new flowering of the arts. With the *Quae pubblice utilia* of 1574, Boncompagni issued the first building regulations designed to encourage new construction, something that also received an impetus from the support given by the pope to the religious orders, and in particular the Capuchins, the Jesuits and the Oratorians of St. Philip Neri, whose presence was having an ever increasing influence on Rome's social and cultural makeup. At the time of the great jubilee of 1575 (which brought some 400,000 pilgrims to the city), the Oratorians set about rebuilding their own church, Santa Maria in Vallicella, to plans drawn up by Matteo Bartolini da Castello. The work was completed toward the end of the century by Martino Longhi the Elder and Fausto Rughesi, who built the façade, while the followers of St. Ignatius, in addition to the work being carried out on the church of Il Gesù, promoted the construction of the Collegio Romano, inaugurated in 1584. Alongside these major centers of the Catholic community, greater and greater influence would be exercised by the confraternities and oratories, a phenomenon that was given a considerable boost by the decisions taken at the Council of Trent.

Pius V was dominated by the two most important patrons of the second half of the century: Cardinal Ippolito II d'Este, responsible for the embellishment of his residence on Monte Cavallo, now the Quirinal, and the construction of the villa at Tivoli, and the "Gran Cardinale," Alessandro Farnese, whose commissions were the most significant events in the Roman art world for over forty years.

In more strictly pictorial matters, the Bolognese Pope Gregory XIII at first showed a preference for his fellow citizens Lorenzo Sabatini, Ottaviano Mascherino and Lavinia Fontana, and then turned more and more often to Girolamo Muziano, a Lombard painter who epitomizes the artistic character of the pontificate. In fact Muziano was placed in charge of all the principal undertakings in the Vatican, from the glittering Gallery of Maps (1578-80), a "beautiful stroll" stretching for 120

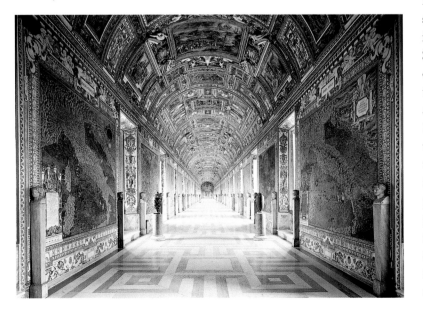

The Decoration of the Oratories

In the Tridentine and post-Tridentine era the oratories represented a crucial element in the religious and social life of the pontifical city. They brought together the most distinguished members of the Roman society of the day, who used their participation in the welfare activities and artistic patronage of these institutes to maintain links with the communities to which they belonged, whether these were regional, corporative or simply aristocratic.

The oratory of San Giovanni Decollato was set up to provide assistance to prisoners on the initiative of Florentine representatives in Rome, and so most of the artists called on to paint its cycle of frescoes were Tuscan. The *Scenes from the Life of the Baptist* in the oratory were to constitute models for at least three centuries of painting to come, embodying as they did the various tendencies of the moment and oscillating between the complementary poles of the schools of Raphael and Michelangelo. Jacopino del Conte began work on the frescoes around 1536 and they were continued up until the middle of the century by Francesco Salviati and Pirro Ligorio. The annexed church was decorated during the reign of Sixtus V (1585-90) by the Tuscan painters Cristoforo Roncalli, Jacopo Zucchi, Giovan Battista Naldini and Giovanni Balducci called Cosci.

The formulas of extrinsic formal elegance employed by Salviati and Jacopino at San Giovanni Decollato were largely or totally abandoned in the decoration of oratories after the conclusion of the Council of Trent. This change in style, which took place from the 1570s onward, is attested by the frescoes on the walls of the seat of the Arciconfraternita del Gonfalone, which has been described as "the Sistine Chapel of the Counter Reformation" (Antal). Here the theme of the decoration is that of the *Way of the Cross*, a sacred representation of the *Passion* in pictorial images, focusing principally on the liturgical significance of individual episodes from the story of Christ's sacrifice. Work on the frescoes, commenced by the Emilian artist Jacopo Bertoja in 1569, was resumed and completed, probably around 1575, by Marcantonio del Forno, Cesare Nebbia, Livio Agresti, Federico Zuccari, Marco Pino, Matteo da Lecce, Raffaellino da Reggio and Domenico Carnevali da Modena, whose varied artistic languages are rendered homogeneous within a lavish architectural framework with spiral columns of Raphaelesque memory and attics overflowing with sculptures and reliefs, looking for all the world like theatrical scenery.

The sixteenth-century model of decoration for oratories underwent further development in the cycle that adorns the walls of the oratory of the Santissimo Crocifisso di San Marcello, an institution to which some of the most important noble families of Rome belonged, including the Cesi, Orsini, Mattei and Delfini, under the patronage of Cardinal Alessandro Farnese, who received artistic and intellectual advice here from Tommaso de' Cavalieri. It was in this context that the early forms of modern opera and oratorio emerged, developing out of the Passion Plays that were performed during the period of Lent. Emilio dei Cavalieri's celebrated *Representation of Soul and Body* was staged here for the first time in 1600. The decoration of the rooms is not very different from that of the Gonfalone, but with an accentuation of the theatrical aspect in the episodes of the *Legend of the True Cross*, in which the motionless *tableau vivant* is transformed into true dramatic action. This effect is clearly perceptible in the frescoes begun in 1578 by Giovanni de' Vecchi – who had the "genuine temperament of a poet," according to Federico Zeri – and Niccolò Circignani, though the cycle was concluded in a more placid narrative style by Cesare Nebbia in 1584.

Jacopino del Conte, *Preaching of Saint John the Baptist*. Oratory of San Giovanni Decollato

Francesco Salviati, *Visitation*. Oratory of San Giovanni Decollato

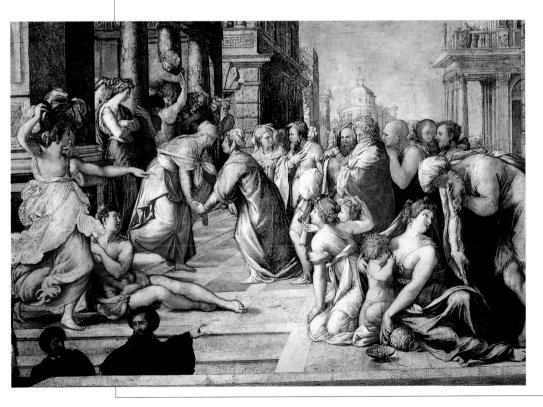

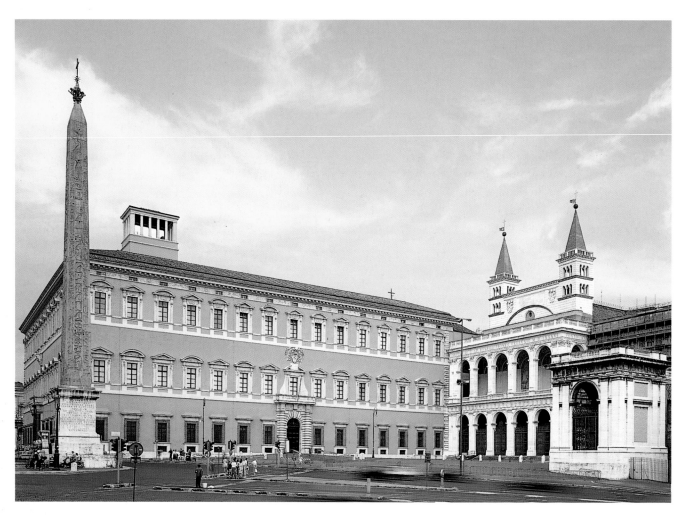

Piazza San Giovanni in Laterano with the Loggia delle Benedizioni and the Palazzo Lateranense designed by Domenico Fontana

The *Fountain of Moses* built by Domenico and Giovanni Fontana for Sixtus V

meters or nearly 400 feet and lined with maps of the regions of Italy devised by the cartographer Egnazio Danti, a manifesto of the ecumenical and encyclopedic role assumed by the post-Tridentine Church, to the Gregorian Chapel in St. Peter's (1574-80), designed by Giacomo della Porta and decorated with mosaics based on cartoons by the Lombard painter.

Under Sixtus V (1585-90) the guidelines of the policy with regard to the arts and urban reorganization implemented by Gregory XIII were not repudiated, but on the contrary underpinned by an even more coherent ideological and symbolical program. The city-planning schemes launched by Felice Peretti, this Franciscan from a remote village in the Marche who was the first pope to have fully grasped the relationship between the work of art and public utility in modern terms, are well-known to all. The most significant of these operations was the repair of the aqueduct known as the

Aqua Felice (built by Severus Alexander) to supply the quarters of the Pincio, Esquiline, Monti, Caelian, Quirinal, Campo Vaccino (Forum) and Capitol, for which sober and elegant fountains were built by Giacomo della Porta. In addition, the new streets opened up by the pope (Via Felice – now Via Sistina and Via Quattro Fontane – from Santa Maria Maggiore to Trinità dei Monti, Via di San Giovanni in Laterano, Via Panisperna and Via del Viminale) created a network linking up the nerve centers of the city, tracing out a star-shaped pattern studded with obelisks. The architect of this "new Rome" was Domenico Fontana (1543-1607), who was not only responsible for the principal city-planning interventions, but also all the main works of architecture constructed during Sixtus's reign, from the new Palazzo Lateranense to the Scala Santa and the Loggia delle Benedizioni.

It was Fontana who had the idea of adorning some of Rome's squares with the obelisks which Sixtus V himself had rescued from the oblivion to which they had been consigned for centuries. The tallest (32·5 meters or 107 feet) came from the Circus Maximus and was erected on Piazza del Laterano, while the other celebrated pillar, the Vatican obelisk at the center of St. Peter's Square, was taken from the adjacent Circus of Caligula.

Perhaps the operation that best sums up the dynamic character of the pontificate was the construction of Michelangelo's dome for St. Peter's. After decades of inactivity, the work was commenced by Giacomo della Porta in 1588 on the basis of Buonarroti's designs and was already complete by 1590.

**The obelisk in
St. Peter's Square**

Sixtus V's Pictorial Enterprises

Ferraù Fenzoni, drawing for *Moses and the Brazen Serpent*. Gabinetto dei Disegni e delle Stampe, Galleria degli Uffizi, Florence

The Scala Santa

On facing page, the Sistine Chapel in Santa Maria Maggiore

The ascent of the papal throne by Sixtus V (1585-90) marked a distinct change in the way that enterprises of pictorial decoration were structured and organized, as the culmination of a process that had already commenced during the previous papacy of Gregory XIII Boncompagni. What Sixtus V required from his decorative projects was that they should be at once grandiose and rapid, communicative and iconographically sophisticated. To achieve this the supervision and overall direction of each undertaking was entrusted to a pair of artist-entrepreneurs. They in turn relied on the services of a large number of more or less talented assistants, who were either employed directly or worked independently. At the outset such pictorial enterprises were entrusted to the little-known Giovanni Paolo Severi from Pesaro,

along with Giovan Battista Cavagna, but the artist from the Marche was soon replaced by the more incisive Cesare Nebbia and Giovanni Guerra (the latter was described by Baglione as "greatly experienced with major

works"), who from the end of 1586 onward took over the tasks of draftsman and inventor of the scenes respectively. In this pyramidal structure, it was the job of the other artists to rapidly and faithfully transpose into fresco the ideas and designs of the two supervisors. Occasionally, the older or more gifted painters, such Ferraù Fenzoni from Faenza or Andrea Lilio from Ancona, produced their own designs for individual episodes.

This was the approach taken in all the official papal undertakings, from the chapel of the Crèche in Santa Maria Maggiore, begun between 1586 and 1587, to the complex decoration of the Sistine Library, the frescoes in San Girolamo degli Schiavoni, the Peretti pope's favorite church, the friezes painted on the walls of the now destroyed Villa Peretti Montalto, of which a few detached fragments have survived, the colossal enterprise of the Palazzo Lateranense, an encyclopedic summation of Sistine culture, and the cycle of scenes from the Old and New Testaments on the Scala Santa and in the annexed chapel of the Sancta Sanctorum.

A series of painters with varied regional backgrounds took their turns on the scaffolding, their work rendered uniform by the flowing and immediate draftsmanship of Nebbia, who was originally from Orvieto. Giovanni Baglione, who also worked on Sixtus V's projects as a young man, recorded the presence of a total of thirty-one artists, including Giovan Battista Ricci from Novara, Ferraù Fenzoni from Faenza, Andrea Lilio from Ancona, the Romans Prospero Orsi, Paris Nogari, Giuseppe Franco and Girolamo Nanni, Angelo da Orvieto, the Lombard Giovan Battista Pozzo, the Fleming Paul Brill, the Pisan Orazio Gentileschi and Paolo Guidotti from Lucca: a true pictorial Babel whose organizational demiurges were the entrepreneurial duo of Nebbia and Guerra. The elaborate iconographies of the frescoes were drawn up in the pope's own circle, with Silvio Antoniano and Angelo Rocca acting as the most faithful interpreters of the great Sistine propaganda effort.

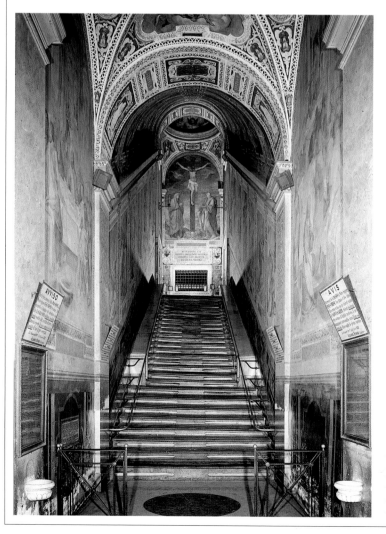

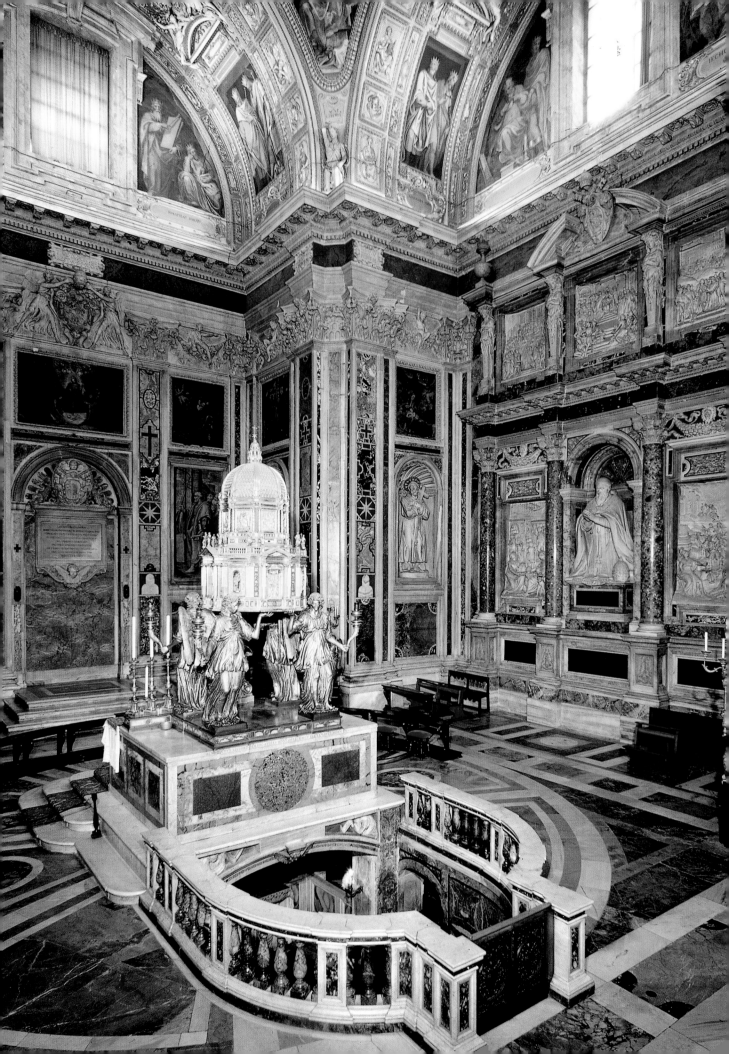

The Pinacoteca Vaticana

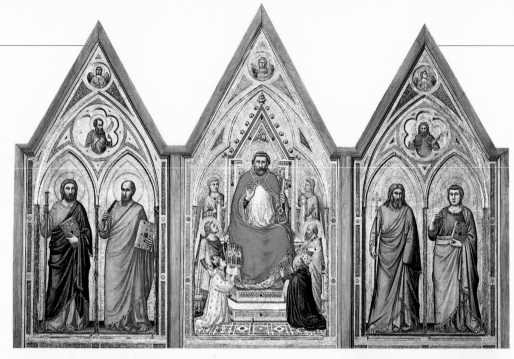

Among the collections that make up the Vatican Museums, the *pinacoteca* or picture gallery is relatively recent. It was set up during the pontificate of Pio VI (1775-99), when it consisted of 118 paintings, principally from the sixteenth and seventeenth centuries. After the treaty of Tolentino (1797), the most important of these were carried off to Paris and the collection virtually ceased to exist. With the restitution of the works of art plundered by the French, the museum not only recovered the majority of its pictures, but acquired more from the provinces of the Papal States. The result was a collection that included such masterpieces as Raphael's *Madonna di Foligno* and Guido Reni's *Crucifixion of St. Peter*. Further acquisitions

Giovanni Baronzio, Angel Holding the Hand of the Infant John the Baptist

Bottom, Melozzo da Forlì, Angel Playing Music

Top, Giotto's workshop, front of the Stefaneschi Polyptych, c. 1315

Left, Fra Angelico, Madonna and Child with Saints Dominic and Catherine of Alexandria, c. 1435

Raphael, Transfiguration, 1520

Raphael, Madonna di Foligno, 1512-13

were made throughout the nineteenth century, making the gallery into a significant record of the history of taste. The mark left in the nineteenth century can still be perceived today: it can be discerned in the large number of fifteenth-century pictures from Umbria and the Marche, a bias that was further accentuated by the acquisition of "primitives" and icons in the twentieth century and even by the neo-Renaissance architecture of the building in which it is now housed, constructed between 1929 and 1932.

The gallery is organized on a chronological basis, allowing the visitor to follow the evolution of painting in the territories of the former Papal States. After a

number of important paintings from the Romanesque era – including the *Last Judgment* from the monastery of Santa Maria in the Campus Martius – the *Stefaneschi Altarpiece* (*c.* 1315) constitutes one of the highlights of the collection. The work is attributed to Giotto's workshop and in particular the Master of the Vaulting Cells, Giotto's Umbrian collaborator in

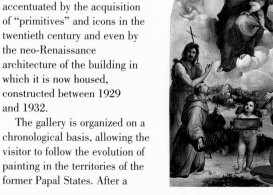

the Lower Basilica of San Francesco in Assisi. It is likely that the two-sided panel was set on the high altar of the old basilica di St. Peter: on the front (visible from the nave) we see *Saint Peter* seated in a throne and receiving from the donor, Cardinal Stefaneschi, a model of the altarpiece he had commissioned; on the back, *Christ Giving His Blessing* is flanked by two wings with the *Martyrdom of Saint Peter* (on the left) and the *Martyrdom of Saint Paul* (on the right), scenes that

to heaven to the low and dark one of the dead Christ, his arm hanging down in an explicit citation of Michelangelo. A highly controlled theatricality of gestures and emotions, underlined by the cunning disposition of the sources of light, an aspect to which we know the artist devoted a great deal of attention in his preparatory studies. Nicodemus's limbs, which loom above the observer, are examples of Caravaggio's "realism," of the almost brutal impact of his images which was one of the trademarks of the Lombard artist's painting.

On left, Giovanni Bellini, *Pietà*

Below, Federico Barocci, *Rest on the Flight into Egypt,* **1573**

Caravaggio, ***Deposition,* 1603**

were visible to the pope and the clergy seated behind the altar during services.

The room in which Raphael's famous *Transfiguration* hangs also contains his *Oddi Altarpiece*, the predella of the *Baglioni Altarpiece*, the *Madonna di Foligno*, and his tapestries for the Sistine Chapel, works that constitute a true monument to the artist's classicism. The *Transfiguration*, as is well known, was the last picture painted by Raphael before his sudden death in the April of

1520 and has become his pictorial testament: the order and clarity of the upper part – where Christ, bathed in light, hovers between Elijah and Moses, signifying his divine nature – contrasts with the lower part, depicting the *Miracle of the Man Possessed by the Devil*. Here the agitated gestures of the figures appear to negate the unity and rationality of the composition, marking an openness to the ideas of Mannerism.

In the rotunda we find,

alongside canvases by Reni, Domenichino, Poussin and Valentin de Boulogne, Caravaggio's *Deposition* (1571-1610), originally in the Roman church of Santa Maria in Vallicella and dated 1603, perhaps the high point of this section devoted to seventeenth-century painting. The foreshortened tombstone serves as the podium cum altar on which the nocturnal scene is set, a paradigm of the expression of sorrow: from the strident note of Mary Cleophas raising her arms

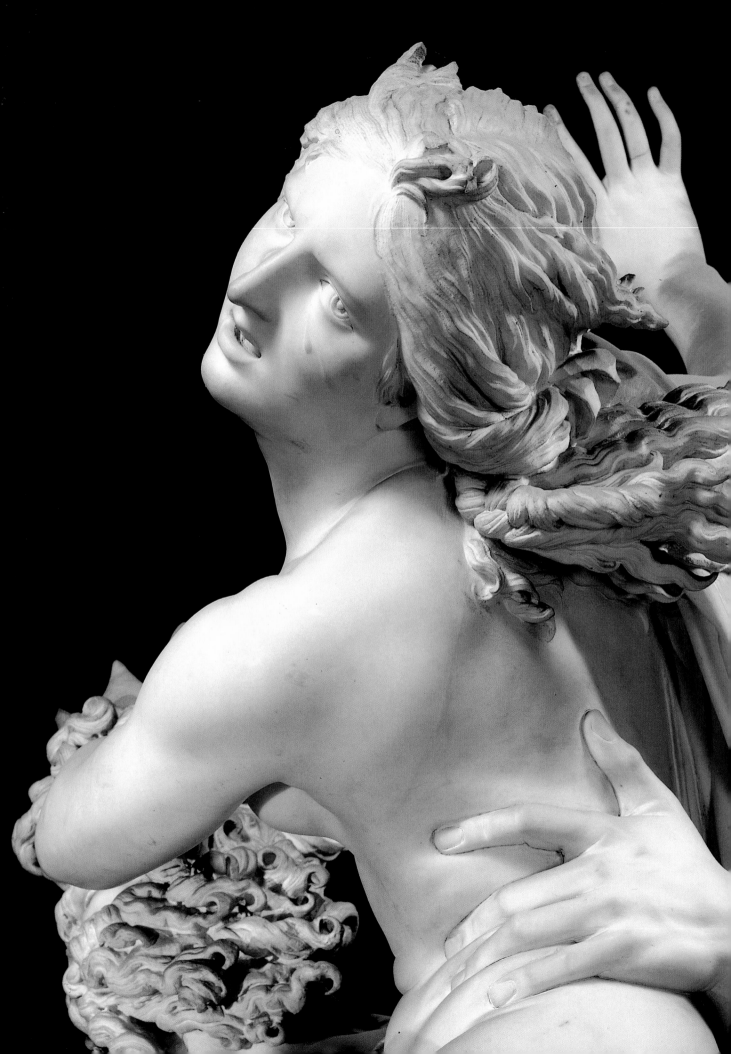

BAROQUE
ROME

"The Variety of Manner"

The date of 1600 is no more than a conventional limit that is commonly used to mark the change from the culture and art of the late Renaissance to the new forms of the baroque style. In reality, the situation in Rome at the beginning of the new century was an extremely complex one, resulting from a mixture of different tendencies and artists in a city that was rapidly embarking on an aesthetic and cultural revival after the austere pontificates of the devout Pius V and Sixtus V. With considerable difficulty, these disparate currents were put into some kind of order by pragmatic theorists like Giulio Mancini (1559-1630) or by thoughtful and well-informed collectors like Vincenzo Giustiniani (1564-1637). Mancini's writings, collected in his *Discorso di pittura* ("Treatise of Painting," 1617-19) and *Considerazioni sulla pittura* ("Considerations on Painting," 1619-21), and the ideas of Giustiniani, to be found in his justly celebrated letters to his German friend Theodor Ameyden, written well into the 1600s but the fruit of an experience stretching back to the early years of the century, present an eloquent and immediate picture of the many facets of an era which saw profound changes in artistic styles, culture and systems. Hence it is worth bearing these invaluable primary sources in mind as we venture into the new century.

The "variety of manner" that characterized the Roman scene in the first few decades of the century, according to the physician and art lover Mancini, who emphasized its

experimental character, is analyzed in detail by the wealthy Genoese nobleman Giustiniani. In his letters the various modes or "manners" of painting are identified and classified according to totally pragmatic criteria, referring not to abstract qualities of seemliness or ideal beauty but to the procedures involved in the production of the work of art. These are subdivided into twelve modes of increasing value, including copies, portraits, still lifes, landscapes, grotesques and monochromes. While the first nine of these modes are distinguished on the basis of their subjects and genres, the last three concern a diversification of styles in the principal tendencies of contemporary painting. They are summed up by the astute connoisseur as the mannered, or imaginary, painting of Barocci, Romanelli, Passignano and Giuseppe d'Arpino, as the painting "from the objects of nature" of Rubens, the Spaniard Gris, Gherardo, Enrico and Teodoro, and lastly as the "mannered painting, and from the example of nature" typical of artists "of the first rank," including Caravaggio, the Carracci and Guido Reni.

"Decorously Adorning Palaces with Pictures"

While Giustiniani displays an extraordinary breadth of taste in his letters, his viewpoint is a partial one. Consistent with his interests,

Gian Lorenzo Bernini, detail of the *Elephant Carrying an Obelisk* in Piazza della Minerva

Caravaggio, *Bacchus*, detail. Galleria degli Uffizi, Florence

On facing page, Gian Lorenzo Bernini, *Rape of Proserpine*, detail. Galleria Borghese

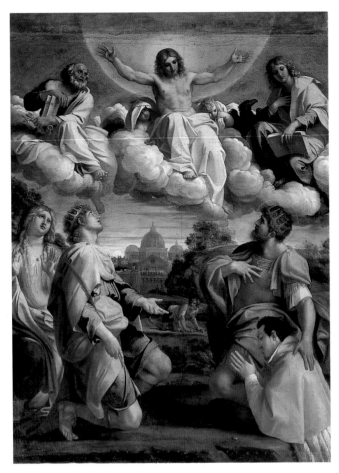

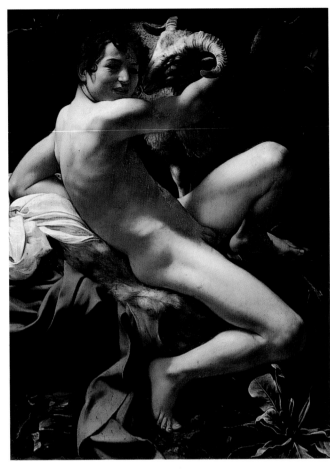

Annibale Carracci, *Christ in Glory and Saints*. Galleria Palatina, Florence

Caravaggio, *Saint John the Baptist*. Pinacoteca Capitolina

Annibale Carracci, *Landscape with the Flight into Egypt*. Galleria Doria Pamphilj

the Genoese nobleman saw painting chiefly as a matter of executing easel pictures for collectors, an activity that was growing with great rapidity, given that "…not just in Rome, Venice and other parts of Italy, but also in Flanders and France, it is nowadays customary to decorously adorn palaces with pictures, as a variation on the sumptuous hangings of the past, especially in Spain, and in the summertime."

Mancini and Giustiniani's reflections present a picture of the situation in Rome at the turn of the century, showing that the growing phenomenon of collecting represented a profound change: a change that was going to have an effect on painting, architecture and sculpture and to orient artistic production toward satisfying the needs of an increasingly broad range of clients. The birth of galleries as buildings designed specifically for the conservation and exhibition of works of art rapidly had a multitude of consequences in the field of art and prompted the emergence of new figures in society, such as connoisseurs, experts, scholars and dealers. In the theories of Giulio Mancini and Giovan Battista Agucchi, illustrious artistic adviser to the Aldobrandini and Farnese families, the reevaluation of the criteria for the disposition of works in palaces and townhouses set aside sixteenth-century ideas of

Palazzo Mattei di Giove

Caravaggio,
The Fortune Teller.
Louvre, Paris

décor and centered on wholly artistic factors, such as the representation of styles, schools or manners, or consistency of genre. In the new approach to interior decoration, paintings, objects and sculptures were either located in the same rooms or in areas specially set aside for the purpose, stimulating comparisons between the different artistic disciplines and to an even greater extent between the different schools, styles and manners. In the seventeenth century the traditional effort to vie with the ancients was transformed into competition among the moderns.

Whether the fruit and ostentation of newly acquired power, the chance result of inheritance or acquisition or the deliberate consequence of a passion for art, the collection served to reflect the rise or decline of noble families in the seventeenth century. Shaped by swings in taste and aesthetic values that it is difficult to reduce to a single principle, but often guided by connoisseurs, advisers and stewards, the art collection ended up itself modeling places, customs, taste and culture. At the beginning of the century the collections that were created or enlarged by the Ranuccio brothers (1569-1622) and Cardinal Odoardo (1573-1626) of the Farnese family, by Vincenzo and Benedetto Giustiniani, by Ciriaco (1542-1614) and Asdrubale (1554-1638) Mattei, by Cardinal Francesco Maria Del Monte (1549-1626) and, of course, by the family of Pope Clement VIII Aldobrandini (1592-1605) presented the best picture of the new directions in the Roman and Italian art of the time. It was in these collections and in the palaces that housed them that the two greatest artists of the day made their debut: Annibale Carracci and Caravaggio.

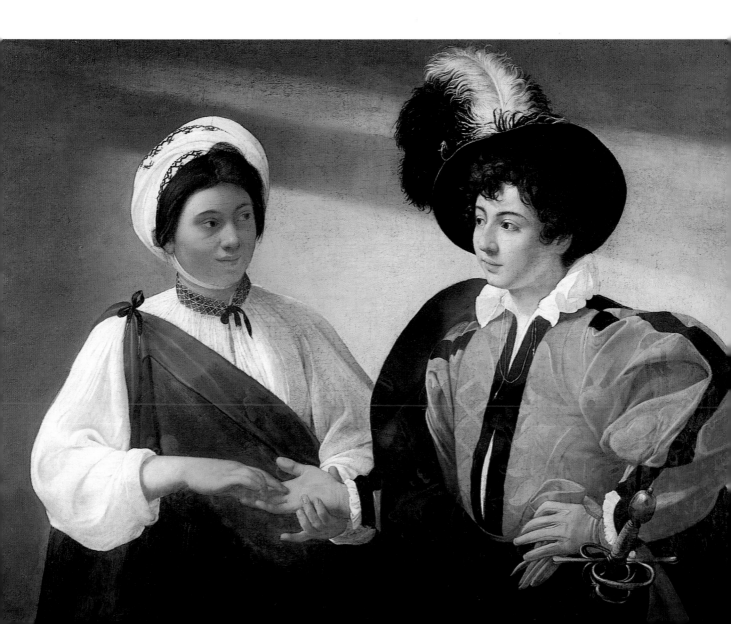

The Art of Clement VIII and "the Flavor of the Good"

While the incredible expansion in the number of private individuals interested in art and the consequent increase in orders and commissions for artists led to a broadening of its appreciation and a diversification of taste, the production of art for official commissions appears to have remained more close-knit in character. Yet it was certainly no less lively considering the number of new undertakings carried

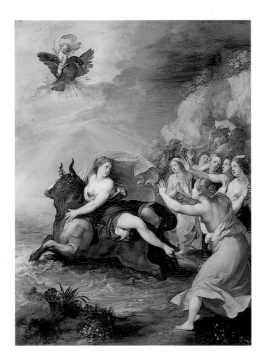

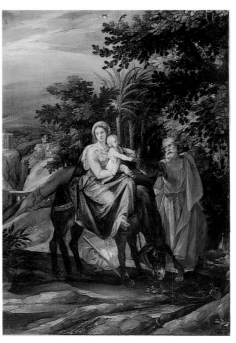

Giuseppe Cesari called Cavalier d'Arpino, *Rape of Europa* and *Flight into Egypt*. Galleria Borghese

out for the jubilee of 1600 and the enthusiasm displayed by the new pope, Clement VIII. "The works of Gregory and Sixtus, and many of Clement VIII's, almost took the flavor of the good away from the Roman school, but together they prepared for its recovery," wrote Lanzi, summing up the developments in art at the turn of the sixteenth century and identifying the elements of artistic continuity over the period of the three pontificates. In fact he viewed them as a single process of decline which allowed some of the Counter-Reformation tendencies to die off and left room for the emergence of artists who prepared the ground for the rise of the new stars of the 1600s.

The great efforts made by Sixtus V to renew the urbanistic and artistic aspects of Rome and his

struggle to reassert the authority of the Church and its seat through the power of images as well, probably with a view to the imminent celebration of the jubilee, were completed by similar projects and artists over the course of the following pontificate. Clement VIII succeeded in staging the jubilee in 1600; further motives for celebration were provided by the reconciliation of King Henry IV of France with the Holy See. A new era was commencing for the Church, which was now ready to move from its defensive and strict line to a more propulsive role. This new direction was to prove of enormous advantage to the arts as they set out to recover the "flavor of the good." The main undertakings launched or continued by Clement VIII in preparation for the jubilee involved artists who had been active in the service of Sixtus, such as Ferraù Fenzoni, Baldassarre Croce, Ventura Salimbeni, Paolo Guidotti, Paris Nogari, Giovanni Baglione and Paul Brill.

The same "team" that had worked on the Scala Santa carried out the demanding work of decorating the nave of Santa Maria Maggiore, commenced by Sixtus V and completed in 1599, and the same artists were to be found working on the frescoes in the transept of San Giovanni in Laterano. But in this last venture (1599-1601) the man who stepped into the role of official artist of the Aldobrandini pontificate was Giuseppe Cesari, known as Cavalier d'Arpino (1568-1640). He was to play a primary part in almost all the principal undertakings in Rome during the first ten years of the seventeenth century. Trained in the late sixteenth-century school of Tusco-Roman painting, d'Arpino was also an able impresario, a knight and a courtier. The pope's family called on him several times, to decorate their villa at Frascati, to supervise the mosaic decoration of the dome of St. Peter's, to fresco the Palazzo dei Conservatori on the Capitol and to accompany the pope's nephew Cardinal Pietro Aldobrandini on his legation to Paris in 1600-01.

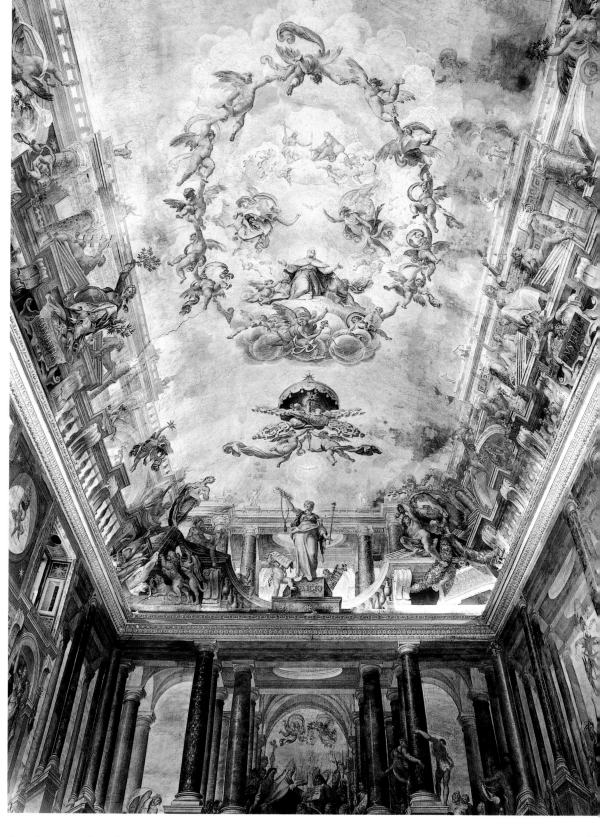

Cherubino and Giovanni Alberti, ceiling of the Sala Clementina in the Palazzi Vaticani

Cesari was not the only artist to enjoy the pope's favor: the brothers Cherubino (1553-1615) and Giovanni Alberti (1558-1601), natives of Sansepolcro, were also exponents of the Tusco-Roman style that was in vogue at the turn of the century. They worked alongside their younger colleague in San Giovanni in Laterano, where they frescoed the sacristy of the Canons (1592-94), and in the Olgiati Chapel in Santa Prassede (1595). In the Clementine Room, frescoed by 1600, and in the chancel of San Silvestro al Quirinale (1600-04), the Alberti brothers renovated the decoration of the ceilings with an original *quadratura* made up of rectangular *trompe-l'oeil* panels and *oculi* opening onto the sky that offered a foretaste of Pietro da Cortona's boldest designs.

"Look Out for Things by Annibale and Caravaggio"

Notwithstanding the arbitrary nature of all generalizations, a rapid survey of the principal public undertakings and private commissions in the years spanning the two centuries makes it possible to point to the search for a new and accentuated naturalness, which can in some cases be described as naturalism, as the common denominator of the directions in which art was going. That "mannered painting, and from the example of nature" which Giustiniani regarded as the height of excellence was truly destined to revolutionize the artistic scene in Rome in the coming century. This was the direction taken, however timidly, by the Florentine painters who had moved more or less permanently to Rome around 1599, just before the jubilee year and following the major commission of the altarpieces for the chapel of San Girolamo in San Giovanni dei Fiorentini, the church of the Florentine community in Rome. The artists who worked on the chapel were Santi di Tito (1536-1603), Ludovico Cigoli (1559-1613) and Domenico Passignano (1559-1638), but they were joined in the papal city by Agostino Ciampelli (1565-1630) and Anastasio Fontebuoni (1571-1626). Although Cigoli and Passignano would continue to enjoy great success under the Borghese pontificate and Ciampelli in the Barberini one, their sphere of influence remained to some extent limited by circumscribed commissions and their novel and "intellectual" approach was overshadowed by the far more forceful innovations of Annibale and Caravaggio.

Shortly after the election of Clement VIII to the papal throne, Michelangelo Merisi came to Rome from Lombardy (1592-93), followed by Annibale Carracci from Emilia (1594). The former arrived in the city penniless and unknown, while the latter was summoned by Odoardo Farnese, stayed as a guest in the family palace and started to paint under the guid-

Annibale Carracci, *Pietà*. Museo Nazionale of Capodimonte, Naples

ance of the learned Humanist Fulvio Orsini in the small room known as the Camerino. For both, however, public recognition came some time around the year 1600, with two commissions indirectly connected with the jubilee in which the two great artists took the places of members of the old guard: Annibale's decoration of the gallery of Palazzo Farnese and Caravaggio's decoration of the Contarelli Chapel.

The great success of the man who within a short space of time would be unanimously acknowledged as the restorer of art to its former glory, as a "universal painter, a sacred, profane, playful, serious and true painter… [and] master of composition" was achieved rapidly under the patronage of the Farnese. It was a continuous and almost exclusive relationship, but one that was fated to deteriorate toward the end, provoking in the artist, according to his biographers, fits of melancholia, illness and his eventual death. In the years stretching from his decoration of the Camerino to the completion of the gallery, however, Annibale led a happy and productive life, his energies taken up chiefly by work in the palaces and chapels of his patrons' family or in the homes of the pope and of Ranuccio Farnese's bride, Margherita Aldobrandini. In particular, the years immediately following the jubilee, between his completion of the gallery's ceiling and his start on the walls, seem to have been the most prolific. Over this period Annibale executed for the Farnese the *Pietà* in Naples (Capodimonte), the *Portable Tabernacle with the Pietà* (1600, Galleria Nazionale di Arte Antica, Rome) and the *Sleeping Venus*, *Dawn* and *Night* (1602; 1602-03, Musée Condé, Chantilly); for the Aldobrandini family he painted *Christ Appearing to Saint Peter* (c. 1602, National Gallery, London) and two of the celebrated lunettes now in the Galleria Doria Pamphilj (c. 1604).

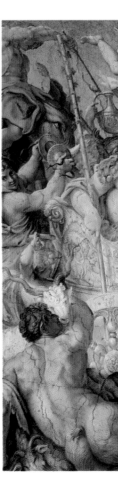

R ather than indicating the end of
the work, the date 1600 set on
the ceiling of the Farnese Gallery by
Annibale Carracci (1560-1609)
commemorates the wedding of
Ranuccio Farnese to Clemente VIII's
niece, Margherita Aldobrandini,
which took place that year. The
marriage was to bring the Farnese
family wealth and contacts in high
places and Annibale Carracci the
perpetual gratitude and protection of
the pope's family, deeply impressed
by the artist's work in the palace of
Margherita's husband. It is likely
that the iconography chosen is also
linked to this event, after the
decision was taken to discard the
previous idea of representing the
military exploits of Alessandro
Farnese in the Netherlands.
Odoardo, perhaps at Ranuccio's
urging, decided to celebrate the
prestigious marriage allegorically by
drawing a parallel between the
family stock and that of the gods,
expressed through amorous episodes

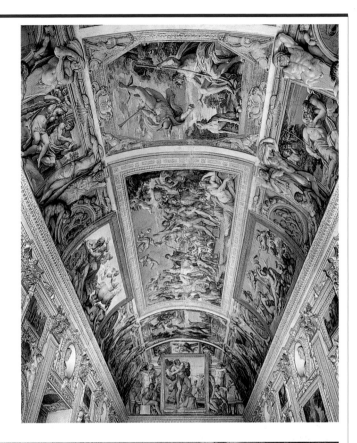

**Annibale Carracci's
ceiling of the
Galleria Farnese and
detail of the scene
with *The Triumph of
Bacchus and Ariadne***

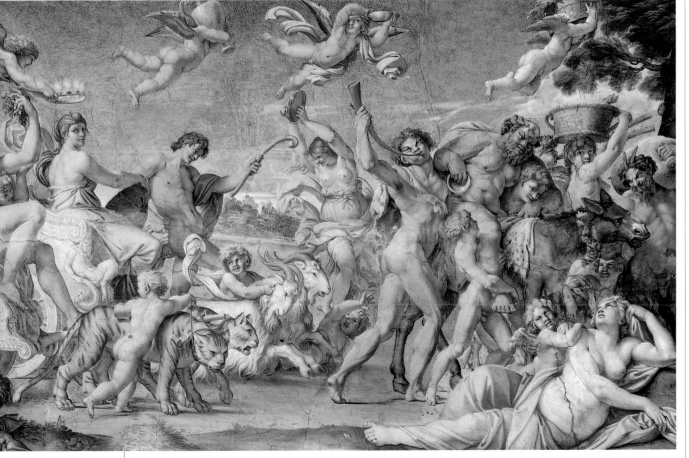

and themes veined with eroticism drawn from a variety of classical sources such as Ovid, Claudian, Philostratus, Pausanias, Virgil and Homer.

In Annibale's composition the episodes taken from these sources are turned into a series of nine pictures illusionistically superimposed on a painted architectural framework made up of herms, bronze tondi, balustrades, cornices, festoons of flowers and fruit, masks, fauns and satyrs. As if they were the verses of ancient poems, the mock-heroic scenes of the loves of the gods are arranged on the ceiling in a balanced, refined and even monumental manner, according to a scheme which Annibale must have based on Raphael's famous decoration of the Farnesina as well, of course, as the daring one invented by Michelangelo for the Sistine Chapel. The considered use of *trompe-l'oeil*, on the other hand, derived from the artist's Emilian training and the example of Pellegrino Tibaldi (1527-96), but

must also have also been a response to the desires of the client, who had originally intended to entrust the decoration to two masters of illusionistic effects, the Alberti brothers.

In *L'Argomento della Galleria Farnese dipinta da Annibale Carracci*, published in 1657 and again in *Le vite de' pittori, scultori et architetti moderni* of 1672, the celebrated treatise writer, biographer and antiquarian Giovanni Pietro Bellori (1613-96) pointed out the presence of pairs of cupids engaged in playful contests at the four corners of the ceiling and suggested that they provide the key to the interpretation of the entire cycle. In his view, it represents the struggle between celestial and bestial love and the victory of the former. Bellori's interpretation, which contrasts glaringly with the earthy and lighthearted character of the images, has been questioned by many. While such a moralistic theme may indeed be suited to the

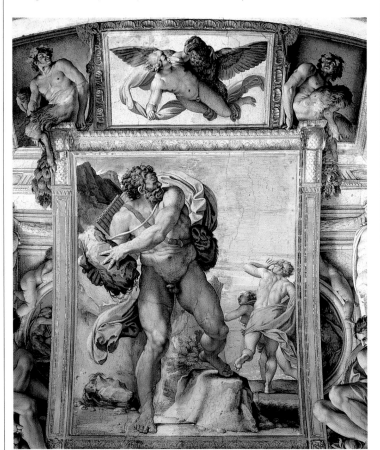

decoration of a cardinal's reception room, the occasion of the marriage and festivities in honor of the Aldobrandini-Farnese couple could well justify more earthy and sensual allusions. Yet Bellori, who was a friend of Francesco Angeloni, a man with close ties to the Farnese and the Carracci, ought to have been well-informed about the meaning of those images, which owed so much in their concept and form to the culture of antiquity, a literary and formal model

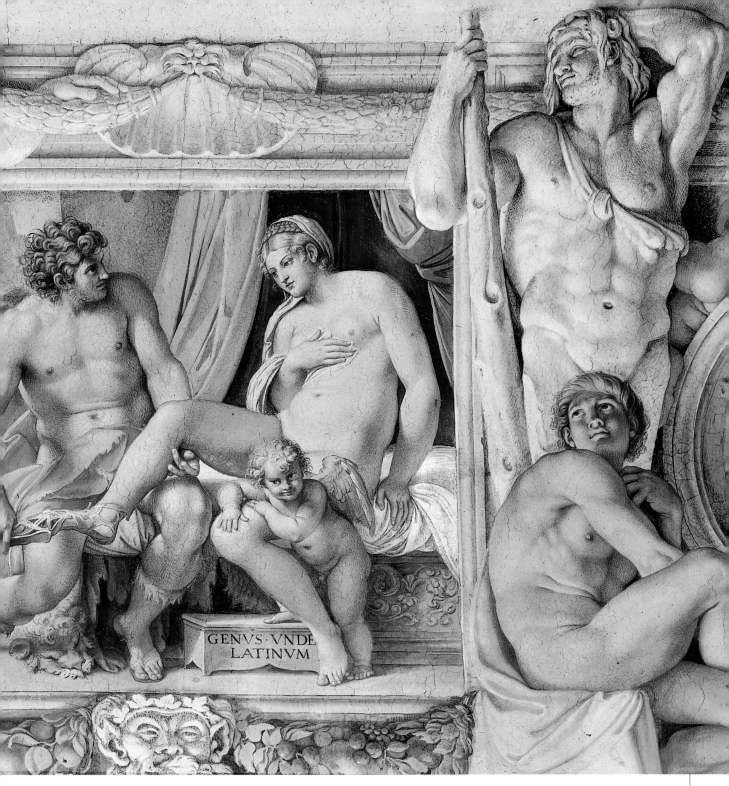

GENVS · VNDE
LATINVM

Annibale Carracci,
Venus and Anchises
and, on facing page,
Polyphemus and Acis

for Annibale in Palazzo Farnese and
for Fulvio Orsini, Giovan Battista
Agucchi, Francesco Angeloni and
Bellori himself. Moreover, if less
emphasis is placed on the struggle,
Annibale's gods and demigods,
triumphs and unions illustrate the
governing of human love by celestial
love, establishing a true parallel
between the divine couples and the
Farnese bride and groom celebrated
on the ceiling of the gallery by
Jupiter and Juno, Mercury and

Diana, Paris and Bacchus and
Ariadne.

After the ceiling was finished, it
was not until 1603 that Annibale,
with the help of assistants from the
Carracci Academy in Bologna like
Domenichino, Lanfranco, Sisto
Badalocchio and Antonio Carracci,
started work on the frescoes on the
side walls.
Here the decoration takes on a more
sober tone and the smaller scenes
have a more distinctly allegorical

character, underlined by small
personifications of virtues and
emblems of the Farnese family. The
paintings do not maintain the
extremely high level of quality
attained by Annibale on the ceiling
but are nevertheless of great
importance for the fact that they
served as an exercise for the
youngest of his pupils, each of whom
was destined to develop the legacy of
their master in his own highly
original way in the new century.

Caravaggio,
*Calling of
Saint Matthew*
and *Martyrdom
of Saint Matthew.*
San Luigi dei
Francesi

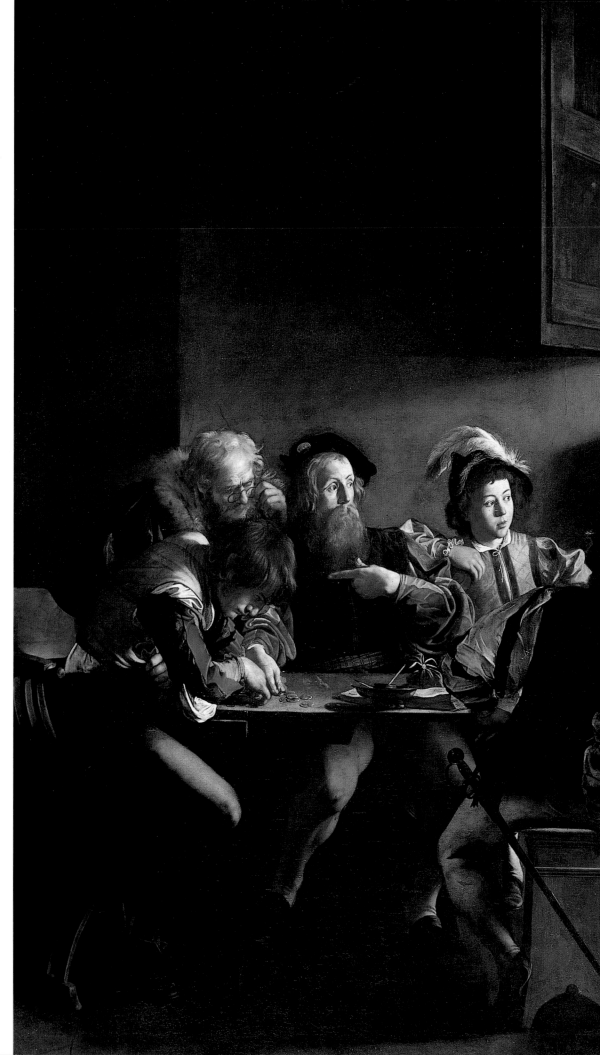

In 1600 Michelangelo Merisi (1571-1610) also made his public debut, delivering to the Crescenzi, executors of Matteo Contarelli's will, the two lateral pictures representing the *Calling of Saint Matthew* and the *Martyrdom of Saint Matthew* for the chapel in San Luigi dei Francesi that had previously been commissioned by Vincenzo Crescenzi from Cavalier d'Arpino: a debut that had been prepared for him by his first patron and client Francesco Maria Del Monte and that caused a sensation in Roman artistic circles. In spite of all the controversy and rivalry they provoked, these first works in the Contarelli Chapel marked the beginning of a successful and happy period for Caravaggio, who could now count on a circle of il-

lustrious patrons and clients. The most prominent of these, of course, was Cardinal Francesco Maria Del Monte, a relative of Federico Borromeo who had close ties with the Medici and with the Francophile and pro-Medici circles of the Roman nobility, such as the Mattei, Giustiniani and Crescenzi. During the years he spent as a guest at Palazzo Madama (from 1598 to 1601) and the ones immediately afterward, when he went to stay with the Mattei, Caravaggio painted a series of easel pictures for this group of art lovers: *Victorious Amor* (Staatliche Museen, Berlin-Dahlem) and *Christ in the Garden of Olives* (formerly in Berlin) for the brothers Vincenzo and Benedetto Giustiniani; the *Supper at Emmaus* (National Gallery, London), the *Incredulity of Saint Thomas* (Neues

Annibale Carracci, *Assumption*. Santa Maria del Popolo

Palais, Potsdam), the *Arrest of Christ* (recently identified as the painting in the National Gallery of Ireland, Dublin) and the *Saint John the Baptist* (Pinacoteca Capitolina, Rome) for the Mattei.

But it was Tiberio Cerasi, a high functionary of the papal curia, who managed to obtain, immediately after the completion of the Farnese Gallery and the Contarelli Chapel, the collaboration of Caravaggio and Annibale on his own chapel in Santa Maria del Popolo. On the basis of their different skills, the former was entrusted with the two lateral pictures and the latter, an undisputed master of the fresco, with the decoration of the ceiling and the altarpiece. The direct competition between the two greatest painters in Rome at the time proved a stimulating one and, in spite of their legendary rivalry, resulted in a partial convergence of the two artist's markedly different styles. There can be no doubt that Annibale and Caravaggio came to an agreement over the size of the figures and the general criteria of composition, creating together that impression of movement converging on the observer that characterizes both the *Assumption* of the altarpiece and the *Conversion of Saul* and *Crucifixion of Saint Peter*, where the figures reach out as if they were trying to break into the narrow space of the chapel.

The first contract with Merisi, drawn up in September 1600, specified the subjects of the two pictures, the material on which they were to be painted (wood) and the way in which they would be presented, providing for the submission of preparatory drawings or sketches prior to their execution. So it is still not entirely clear why Caravaggio was subsequently required to replace the two panel paintings with two different versions on canvas at very short notice. His malicious biographer Giovanni Baglione ascribed this to the first of a series of rejections by dissatisfied clients with which the painter was faced in the years prior to his flight from Rome in 1606, but it seems more likely that it was due to a desire for formal improvements. The first two versions, one of which is still in Rome, in the Odescalchi-Balbi collection, while the other is known to us only through copies, did however immediately find a home in the private collection of Cardinal Giacomo Sannesio, and Car-

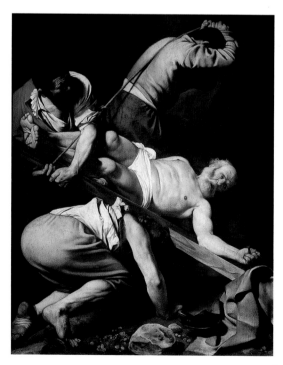

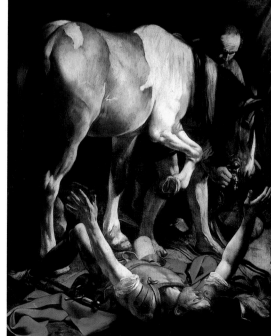

Caravaggio, *Crucifixion of Peter* and *Conversion of Saul*. Santa Maria del Popolo

On facing page, Carlo Saraceni, *The Miracle of Saint Benno*. Santa Maria dell'Anima

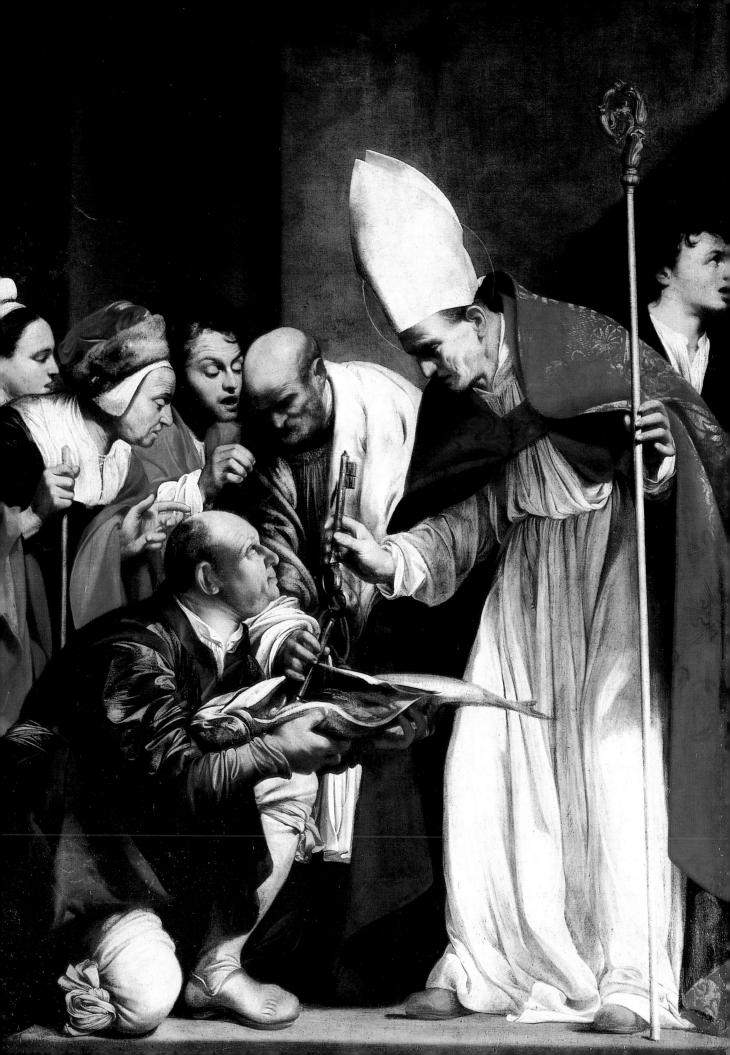

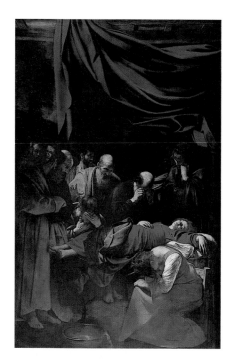

Caravaggio, *Death of the Virgin*. Louvre, Paris

Bartolomeo Manfredi, *Bacchus and Drinker*. Galleria Nazionale d'Arte Antica

avaggio was able to deliver the definitive pictures by the prescribed date (November 1601). The paintings represent the forceful culmination of a phase in the artist's research and seem to place the accent, in comparison with the earlier versions, on the most innovative elements of Merisi's art, such as the contrast between light and shade and the concentration on the center of the action, with the elimination of the relationship between foreground and background.

Influenced by Michelangelo's work in the Pauline Chapel, but also by Taddeo Zuccari and by his memories of the Lombard painter Moretto, Caravaggio produced two scenes of intense drama, presenting the moments of conversion and martyrdom as a direct encounter between man and God, an encounter that no longer smacks of the physical and the real – as in the *Calling of Matthew* in the Contarelli Chapel or in the first version in the Odescalchi-Balbi collection – but has become pure illumination, in which divine grace is powerfully visualized as a ray of light breaking into the darkness.

The series of rejections commenced in 1605 with the prestigious commission for the *Madonna del Serpe* (also known as the *Madonna dei Palafrenieri*) for the altar of Sant'Anna dei Palafrenieri in St. Peter's. Delivered in 1606, the altarpiece spent just two days in St. Peter's before being moved to the church of the Palafrenieri and finally, in June of the same year, the large collection of Paul V's nephew Scipione Borghese, newly made a cardinal. Shortly afterward, another rejection by the clergy of Santa Maria

della Scala, who turned down his splendid and revolutionary altarpiece representing the *Death of the Virgin* (Louvre, Paris), marked the beginning of a rapid decline in the painter's fortunes in Rome, culminating in his killing of the notary Ranuccio Tommasoni and flight, first to the Colonna fiefs of Paliano, Zagarolo and Palestrina, and then to Naples.

Setting aside the spurious motives of his indecorous behavior and the indecency of his pictures, as well as the combination of accursed painter and accursed painting so dear to artistic hagiography, the rise and fall of Caravaggio's reputation in Rome reflected the shift in political and cultural attitudes between the Aldobrandini and Borghese pontificates. The rebuff of Merisi's art was confined to the public and official spheres and contrasted with the constant and even growing appreciation of it shown by private collectors, who were ready to make do with copies or to request variants or echoes of the painter's style from his more or less direct followers, such as Bartolomeo Manfredi (1582-1662), Carlo Saraceni (1579-1620), Orazio Gentileschi (1563-1639) and Orazio Borgianni (1578-1616) when Caravaggio himself was no longer available. The market value of his paintings was also increasing, as is clear from the words addressed by the attentive observer Giulio Mancini to his brother in 1612: "Look out for things by Annibale and Caravaggio, for one of Caravaggio's pictures was recently sold for 300 scudi [...] And Annibale is considered to be on a par with Raphael [...] and people prefer the Farnese Gallery to Chigi's loggia."

Private Aestheticism and Public Virtue

The Pauline Chapel in Santa Maria Maggiore

Gian Lorenzo Bernini, *Bust of Paul V.* Galleria Borghese

Gian Lorenzo Bernini, *Bust of Scipione Borghese.* Galleria Borghese

In 1605 Camillo Borghese was elected to the papal throne as Paul V (1605-21). This was a blow both to the Francophile faction and to the reformist currents of the first few years of the century, to which Caravaggio and his clients were linked. The severity of the new pope was reflected in his patronage of the arts, where he turned away

from experiment and innovation to concentrate on works of engineering such as the construction of new aqueducts, on urban embellishment and on private commissions in the family chapel in Santa Maria Maggiore or in his new and princely residence on the Quirinal. Yet the continued development of art would be ensured by his nephew and protégé, the cultivated connoisseur Cardinal Scipione Caffarelli Borghese (1576-1633).

One of the first concerns of the newly elected pontiff was to provide his family with a private chapel worthy of a pope. In the basilica of Santa Maria Maggiore, where he had been vicar in his youth, at the time of the work carried out by his predecessor Sixtus V, Paul V dedicated a chapel to the Assumption of the Virgin and placed Flaminio Ponzio (1559/60-1613), a Lombard architect of whom the Borghese were particularly fond, in charge of its architecture, under the direction of Giovan Battista Crescenzi, a connoisseur and dilettante who was responsible for the design of the tabernacle with the icon of the Virgin. In 1611 work started on its frescoes: under the guidance of the Roman d'Arpino and following an iconographic program drawn up by the Oratorians Cesare Baronio or Tommaso and Francesco Bozio, they were executed by Giovanni Baglione, Ludovico Cigoli and Guido Reni (1575-1642). Although confined to part of the two wings of the chapel, the frescoes painted by Reni, who had just completed the decoration of the chapel of the Annunziata at the Quirinal (1610), met with general approval and aroused the admiration of Borghese, who would always hold the Emilian artist in high esteem.

Yet it is the daring fresco by Cigoli, depicting the Virgin

**Pietro Bernini,
Assumption. Santa
Maria Maggiore,
Pauline Chapel**

**Guido Reni, *Birth of
the Virgin.* Palazzo
del Quirinale, Chapel
of the Annunciata**

above a moon that reflected the astronomical ob-servations made in those very years by Galileo Galilei, which constitutes the thematic and formal hub of the decoration. It is to the Virgin that the stat-ues of *Saint John the Evangelist* by Camillo Mariani and Francesco Mochi and of *Saint Dionysius the Are-opagite* by Nicolas Cordier turn their gaze, as his-toric witnesses to the sacred event, and the *Assump-tion* is represented again inside the chapel, this time in the marble bas-relief carved in 1611 by Pietro Bernini (1562-1629). The prominence given to Gian Lorenzo's father in the team of sculptors working on Paul V's chapel is due, perhaps, to his apparent stylistic affinity with Cavalier d'Arpino, supervisor of the project. In fact it was the latter who had sum-moned the sculptor to Rome from Naples, clearing the way for him and, indirectly, for his son, who was in all probability already working alongside his father at the time of the Pauline Chapel.

The enormous expenditure required by the work on St. Peter's did not prevent the pope from em-barking on an ambitious plan for the renovation and completion of his residence on the Quirinal. Justifiably concerned about the unhealthy climate of the Vatican area, the pope never stopped thinking

about moving to the salubri-ous hill that had already been frequented and embellished by his predecessors, from Pius IV to Sixtus V, and which was at that time the home of his nephew Scipione Borgh-ese, who lived in the adja-cent palace, now called Pa-lazzo Pallavicini Rospigliosi. At around the time of the work on the Pauline Chapel in Santa Maria Maggiore, Fla-minio Ponzio was engaged to complete the block facing onto the gardens, restructure the wing on Via Pia (now Via XX Settembre), and build the Sala Regia and Pauline Chapel inside it (1615-17). In the same years work started on the decoration of the re-ception rooms. Under the di-rection of Agostino Tassi, it was carried out by Carlo Saraceni, Alessandro Turchi, Pasquale Ottino, Marcantonio

Bassetti, Spadarino and Giovanni Lanfranco, Borgh-ese's favorite painter who would shortly be entrusted with the task of frescoing the villa on the Pincio. Paul V assigned the work in the chapel of the Annunciata to another member of the Bolognese School, Guido Reni, while for the Pauline Chapel, after a grandiose program of decoration based on the model of the Sistine Chapel in the Vatican had been dropped in order to save money, the pope called on the ser-vices of a team of refined gilders and stucco workers.

At the same time as he was working on the Pauline Chapel, the architect Flaminio Ponzio was busy in all the principal private residences of the Borghese family. His decorative, ornate and almost two-dimensional style was better suited to works that had more to do with conspicuous consumption than with city planning, such as the less official commissions of the Borghese family for the *Foun-tain of the Aqua Paola*, the oratories of the abbey of San Gregorio on the Caelian hill or the precious casket of the villa on the Pincio. His delicate ele-

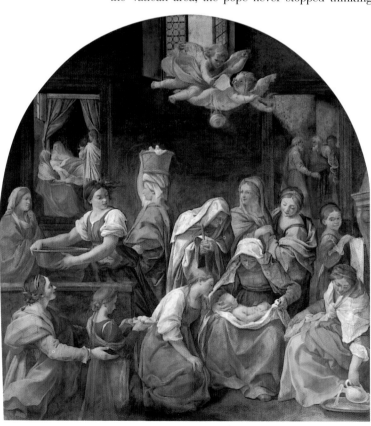

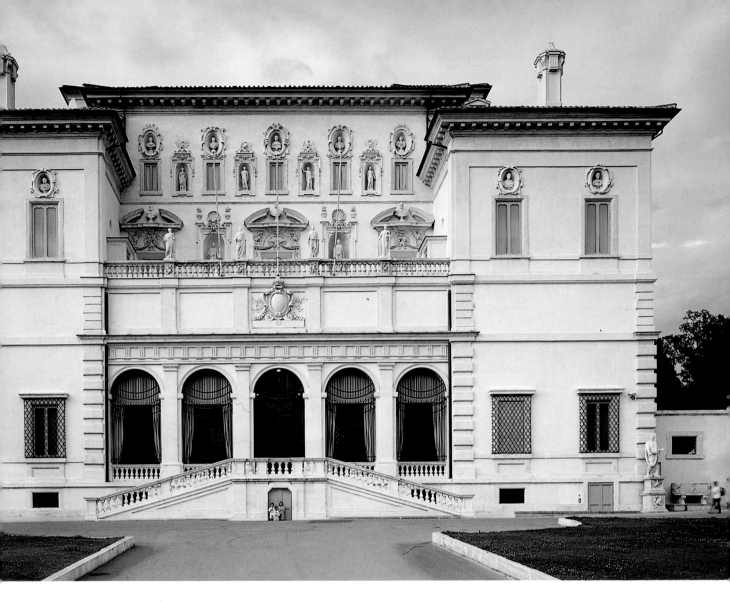

The Villa Borghese designed by Flaminio Ponzio and Giovanni Vasanzio

Carlo Maderno's dome of Sant'Andrea della Valle

gance answered to the need for private magnificence displayed by Cardinal Scipione Borghese in all his projects.

On the official level, it was the measured classicism of Carlo Maderno (1556-1629) that made the deepest impression on Roman façades and churches. The example he set, inherited in part from his uncle Domenico Fontana (1543-1607), would be taken up by the greatest of the architects of baroque Rome, his kinsman Francesco Borromini (1599-1667) who, alone among Maderno's successors, proved capable of surpassing and renewing his style. Having made his mark on the Roman scene with the façade of the church of Santa Susanna (1597- *c.*1603), Maderno reached the peak of his prestige with the commission to complete St. Peter's, a task energetically undertaken by Paul V immediately after his election. The work on the façade and nave of the

basilica was carried out in parallel with the completion of several other churches of great importance, such as San Giovanni dei Fiorentini, with the construction of its dome and apsidal chapels, or Sant'Andrea della Valle, culminating in the magnificent dome that the architect designed as a lightweight structure independent of the main building following the example set by Michelangelo. This was an example that would be widely followed by later architects, all the way up to Borromini and his dome for Sant'Agnese on Piazza Navona.

The official character and composed and classical balance of Maderno's architecture were less in tune with the tastes of the refined aesthete Cardinal Scipione Borghese. It was in the villa he created on the Pincio (1612-15) as a place of relaxation and showcase for the marvels in his collection that the more innovative aspects of Roman artistic culture on the threshold of the baroque era were able to find expression, thanks to the patronage of its owner and the collaboration of his most frequent and

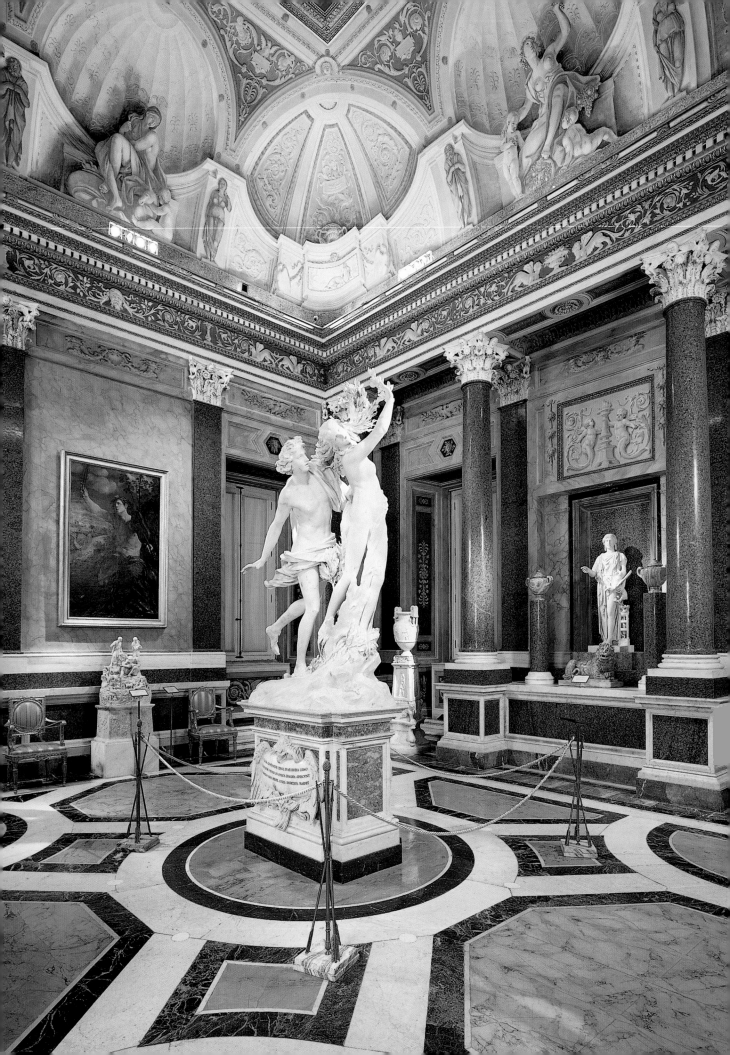

On facing page,
view of the Room of
Apollo and Daphne
in the Galleria
Borghese

Gian Lorenzo
Bernini, *Aeneas and
Anchises* and *David*.
Galleria Borghese

Gian Lorenzo
Bernini, *The Goat
Amalthea*. Galleria
Borghese

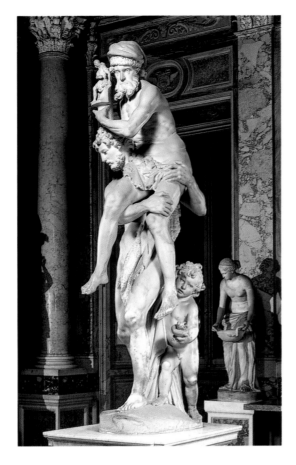

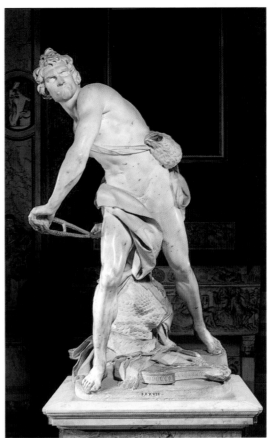

distinguished guests, including Cardinal Maffeo Barberini, the future Pope Urban VIII. Attentive to every artistic innovation, an admirer of literature and curious about the sciences, Scipione recognized that the young Gian Lorenzo Bernini (1598-1680), still working alongside his father, had the potential to become a sculptor of genius. In the pagan world of gods and heroes that Scipione re-created in his villa, some of the most significant works of art of those years took shape: Bernini's marble groups of the *Goat Amalthea* (c. 1615), *Aeneas and Anchises* (1618-19), *Apollo and Daphne* (1622-25), *David* (1623-24) and *Pluto and Proserpine* (1621-22), and the ceiling with Giovanni Lanfranco's *Council of the Gods* (1624-25).

The villa on the Pincio had been created to house the antique works of art in the Borghese collection, later transferred to France. It is only natural that Gian Lorenzo, who was also working as a restorer of ancient statues in those very years, should have vied with the great artists of antiquity in his sculptural groups. In fact they draw on – and almost cite – the works of Praxiteles, the *Apollo Belvedere*, the *Borghese Gladiator*, the *Pasquino Group* or the *Belvedere Torso*. But there was another and more recent model to whom the sculptor looked constantly, seeing himself as his emulator and successor in a "competition" that is stressed by his biographers and was certainly encouraged by his Tuscan patrons, the Barberini family. Although very different in his character and art, Bernini set out to establish a reputation as the new Michelangelo and succeeded in doing so with two works in particular, his *Saint Lawrence* (c. 1617, Contini-Bonacossi Collection, Uffizi, Florence) and *Saint Sebastian* (1617, Thyssen-Bornemisza Collection, Madrid). Both figures were commissioned by his greatest and most ardent admirer Maffeo Barberini, the future pope and a magnificent patron who is said to have told his favorite

artist: "It is your good fortune, sir, to see Maffeo Barberini pope, but we are still more fortunate to have Bernini living in the time of our pontificate." However, these words, if they were ever pronounced, belong to a much later period when Urban VIII, at the height of his celebrated reign (1623-44), had already given Rome a new, baroque appearance and, thanks to Bernini, created a universal Barberini style. Back in 1617, though, Maffeo had just returned after long years of absence serving as nuncio in Paris and Bologna, and had found a profoundly different city, transformed by the aesthetic taste of the Borghese pope and the experimentalism of his nephew.

The Emilians in Rome

This climate had had no chance of changing during the brief pontificate of Paul V's successor, Gregory XV Ludovisi (1621-23). All that the Bolognese pope could do over the course of his two-year reign was to further strengthen the monopoly of the Emilian school of art and introduce onto the Roman scene a painter of genius, Giovanni Francesco Barbieri called Guercino (1591-1666), who was at work from 1621 onward on the frescoes in the Casino Ludovisi.

In the years between the time when the first painters from the Carracci academy came to Rome with Annibale to work in Palazzo Farnese and the arrival of Guercino (1621), there had been not a moment's letup in the activity of Emilian artists in Rome. In fact they reigned supreme in the field of the large-scale fresco decoration, where the followers of Caravaggio or foreign artists had never offered any real competition. Domenico Zampieri called Domenichino (1581-1641), Guido Reni, Francesco Albani and Giovanni Lanfranco had often worked together, and with the assistance of Agostino Tassi for the *trompe-l'oeil* perspective wall paintings, in the Casino dell'Aurora of the Palazzo Borghese on

Giovanni Lanfranco, ceiling with *The Council of the Gods*. Galleria Borghese

Gian Lorenzo Bernini, *Saint Lawrence*. Galleria degli Uffizi, Florence

Guercino, fresco on the ceiling representing *Aurora*. Casino Ludovisi

Guido Reni, fresco on the ceiling representing *Aurora*. Casino Rospigliosi Pallavicini

the Quirinal, in the oratory of Sant'Andrea at San Gregorio Magno, in the chapel of the Annunciata at the Quirinal and in the Sala Regia.

Domenichino, who was the most faithful to the teachings of their master Annibale, as well as the most thoughtful, old-fashioned and "diligent," found his greatest success in the retinue of his shrewd and

knowledgeable mentor Agucchi and followed him in his moves through Farnese circles and then to the Aldobrandini and finally the Ludovisi. Even though Zampieri contributed along with Guido Reni to the decoration of San Gregorio on the Caelian in the reign of Paul V, and Scipione appreciated his work to such an extent that he commissioned the picture of

the *Hunt of Diana* (1617) from him, it does not seem that the years of the Borghese pontificate were particularly favorable to the painter, who went on working for the rival Aldobrandini family. Lanfranco on the other hand, returning from a stay in Parma (1612-13), received official commissions like that of the Quirinal and, in the Buongiovanni Chapel of Sant'Agostino (1616), demonstrated just how great

a distance separated him from the "precise" painting of his fellow townsman and how much originality had already pervaded his own work at this time.

Fortune smiled on Domenichino again with the election of Pope Gregory XV, who immediately appointed him Architect-General of the Apostolic Camera. Occurring just a year after the prestigious and demanding undertaking of the frescoes in the pendentives and chancel of Sant'Andrea della Valle (1622-28), this marked the peak of Zampieri's success, but also the defeat of the elitist artistic program proposed by the pupil of Annibale and heir of Raphael. In the chancel of the Theatine church completed by Cardinal Alessandro Peretti Montalto, Domenichino was given the job of supervising the work of decoration. In all likelihood the cardinal entrusted him with the frescoes in the chancel and the dome with its pendentives and it was only later, on the death of Peretti and the Ludovisi pope, that Lanfranco was brought in so as to get the work finished in time for

Domenichino,
pendentives of the
dome of
Sant'Andrea della
Valle with the
Evangelists John
and *Mark*

Domenichino,
frescoes in the
chancel of
Sant'Andrea della
Valle with *Scenes
from the Life of
Saint Andrew*

the jubilee of 1625. In the *Scenes from the Life of Saint Andrew* in the chancel, the *Virtues* at the base and the four *Evangelists* in the pendentives, the artist took the opposite approach to the one that would be adopted by Lanfranco just a short time afterward. The numerous preparatory drawings and engravings ensured an execution that would be accurate down to the smallest details, the architectural framework decorated with stuccoes delimited the spaces as if they were reproductions of pictures inspired by the decorative inventions of his master Annibale in the Farnese Gallery but made no attempt at *trompe-l'oeil*, and the pure and "plain" colors spurned the late sixteenth-century

tradition of wall paintings in fluctuating, iridescent tones and followed instead the theories of the Theatine Matteo Zaccolini, author of the *Trattati sulla prospettiva* and, according to Bellori, Zampieri's teacher of perspective.

The appearance on the same scaffolding of Lanfranco, who from 1625 to 1627 deftly and rapidly completed the great fresco of the dome, and the ever growing reputation of Bernini induced Domenichino to leave Rome for Naples in 1630: at this point, with the age of experimentalism at a close, the various artistic styles that had previously existed side by side were absorbed and superseded by the "grand manner" of Rome in the age of Barberini.

The Empire of a Pope

While still a cardinal, Maffeo Barberini had shown no particular predilection for the Bolognese school of art that had established such a firm grip on Rome. On the contrary, wishing to distinguish his patronage from the usual one of popes and cardinals and to promote the artists of his own city, he had entrusted the Florentine Domenico Passignano with the decoration of his private chapel, on whose construction work had begun in 1604, along with that of Leone Strozzi and Orazio Rucellai, in Sant'Andrea della Valle.

Pietro Berrettini da Cortona (1597-1699) had

been trained in his hometown by Andrea Commodi and, through the efforts of the Florentine painter, had found work in Rome collaborating with his fellow citizen Pietro Paolo Bonzi on the gallery of Palazzo Mattei di Giove. The year of Maffeo Barberini's election, 1623, did not bring a sudden rise in the artist's fortunes, as happened with the French painters lured to Rome by the accession of an openly Francophile pope (Nicolas Poussin) or elevated to the highest ranks of the art world with the appointment as *Principe*, or president, of the Accademia di San Luca (Simon Vouet), but it did clear the way for his inexorable progress, an advance that would eventually lead to him becoming the sole interpreter of the official Roman style of the Barberini pontificate.

Cortona's first protectors in Rome, and the men who won him an entry into the "court," were the Florentines Marcello and Giulio Sacchetti, influential patrons who were at this time having their own chapel in San Giovanni dei Fiorentini decorated by Lanfranco (1623-24). They also welcomed to the city Nicolas Poussin, who had just arrived with a letter of introduction from the poet

Domenichino, *Saint Cecilia Distributing Clothes to the Poor* and *Martyrdom of Saint Cecilia*. San Luigi dei Francesi

Nicolas Poussin, *Bacchanal with Putti*. Galleria Nazionale d'Arte Antica

Ceiling of the
Alaleone Chapel
in San Lorenzo in
Lucina decorated
by Simon Vouet,
and detail of the
pendentive with
*Saint John the
Evangelist*

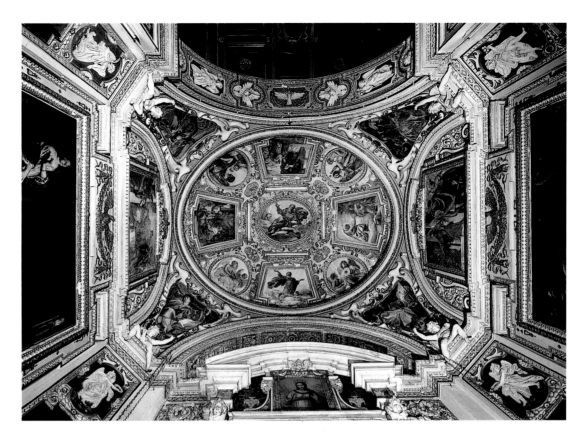

Giovan Battista Marino, and acquired Simon Vouet's painting of the *Powers of the Soul* (Pinacoteca Capitolina, Rome), perhaps as a token of gratitude on the part of the painter, who had received important commissions for the decoration of St. Peter's. So the leading figures in Roman artistic circles were working under Sacchetti patronage in the years 1623-25, immediately after Maffeo Barberini's election as pope. This suggests that the two brothers held the privileged position of his artistic advisers in the period preceding the return of his nephew Cardinal Francesco Barberini from his legateship in France (1627). Alongside the Sacchetti, Cardinal Francesco Maria Del Monte was still an undisputed authority in this period: long a patron of the Accademia di San Luca, he was still actively engaged in the discovery of new talents during the twenties, including the follower of Caravaggio Antiveduto Grammatica, the Neapolitan Fi-

lippo da Liagno, the Frenchman Simon Vouet and the young newcomer Andrea Sacchi. With the death of Cardinal Del Monte (1626) a witness to the experimental period in Roman art was lost. His role in the Accademia di San Luca was taken over by Francesco Barberini and Gian Lorenzo Bernini (1630) and Pietro da Cortona (1634), the artists of the pope-king, became its *Principi*.

Bernini's appointment as president of the academy came as the crowning point of an already well-established career in which he had been given responsibility for the pope's architectural and city-planning projects and after he had been made architect of St. Peter's. The sculptor's first commission for the basilica had come in 1623, when Urban VIII had entrusted his protégé with the task of erecting a new structure to replace the traditional baldachin over the tomb of St. Peter instead of giving the job to the official architect Maderno. Following a

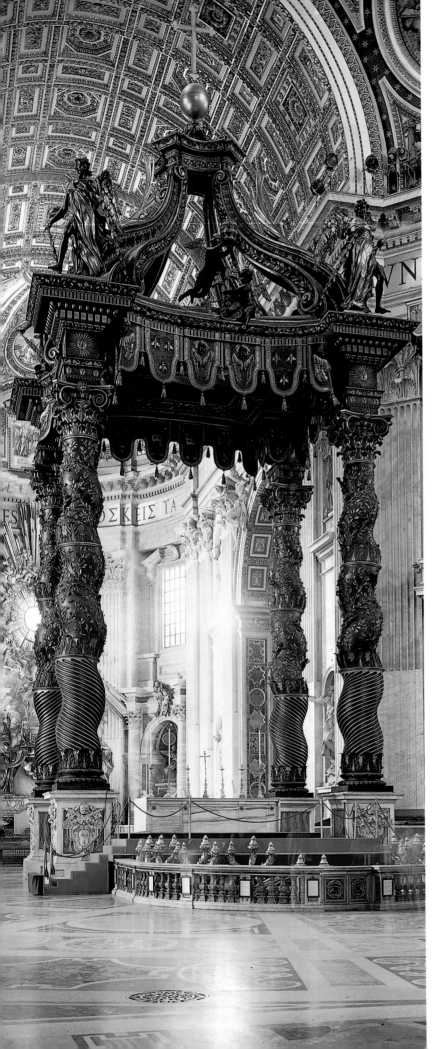

practice that was to become usual in his subsequent projects of architecture and urban beautification, Bernini took over the plans already drawn up by Maderno, which envisaged a cloth canopy resting on four spiral columns supported by marble angels, but inverted it by adding ribs at the top with angels and putti. The result was a bold and revolutionary structure that combined monumentality and lightness, challenging the laws of statics as well as the traditional categories of sculpture and architecture. The occasion for the first work of architecture designed and executed in its entirety by Bernini presented itself in 1624, when restoration of the area of the altar in the small church of Santa Bibiana brought to light an urn presumably containing the remains of the saint and of her sister Demetria and mother Daphrosa. Interested in anything relating to the history of the Church and the early Christian martyrs – the pope and his nephew Francesco had promoted the first studies of Christian archeology – Urban VIII decided to have the entire building renovated at once, with the aim of "ennobling this church with a graceful façade, and a portico, ornament of all the old churches." Bernini designed a portico with three bays, three arches recalling the ancient temples of the early Christians, a loggia and a second and imposing tier that gave the façade a magnificent appearance, making the little church stand out clearly on the route from Santa Maria Maggiore to San Lorenzo. The interior was decorated with a statue of *Saint Bibiana* by the architect himself – a work that laid the foundations for the new technique and iconography of Counter-Reformation religious statuary, conveying a sense of ecstasy and emotion through an inner movement – and with *Scenes from the Lives of Saint Bibiana, Demetria and Daphrosa* by the painters Agostino Ciampelli and Pietro da Cortona.

For Cortona, who must certainly have learned from this commission the importance attached to relics in the pope's approach to the arts, the first opportunity to design the architecture of a religious building also coincided with the discovery of the presumed relics of a saint (Martina), and what is more, the saint to whom the church frequented by artists was dedicated, along with St. Luke. As early as 1623 the academicians of San Luca, with Cortona at their head, had drawn up plans for the

The façade of Santa Bibiana and Gian Lorenzo Bernini's statue of the saint

mer's new style on Roman painting had not prevented the perpetuation of Zampieri's fame through the work of artists of the caliber of Nicolas Poussin (1594-1665), who was also drawn for a short time into Lanfranco's orbit but soon turned to the more precise style of Domenichino, which was better suited to his own nature. The same bifurcation was repeated – this time with a theoretical awareness of the problem that was reflected in disputes within the academy – in Palazzo Barberini, where Andrea Sacchi and Pietro da Cortona worked in quick succession. Sacchi, a pupil of Francesco Albani and originally a protégé of Cardinal Del Monte, was taken into the circle of the Barberini family, becoming a "dependant" of Cardinal Antonio. Over the space of ten years (1629-39) the latter obtained a series of

renovation and repair of the crumbling church, but it was not until 1634, following excavations carried out after careful study and research and supervised with some anxiety by Francesco Barberini, that the saint's relics were brought to light, along with substantial epigraphic documentation. The money requested to start the work was made available at once. For Berrettini this came at the same time as the long sought-after presidency of the academy and gained the artist unparalleled prestige and political influence. Drawing on his Tuscan background and the repertory of Florentine Mannerism, Cortona produced a building in which the blend of classical and Renaissance elements was used to create an ample space, with an airiness that was already fully baroque. The surfaces of the inside walls were hemmed in between columns and therefore excluded any possibility of a pictorial decoration, something for which Cortona was later criticized by Giovan Battista Mola. And yet these were the very years in which the architect of Santi Luca e Martina was painting the ceiling of the pope's family palace with the prototypical work of the Roman baroque, the *Allegory of Divine Providence and Barberini Power* (1632-39).

After the rift between Lanfranco and Domenichino during the decoration of Sant'Andrea della Valle, the enormous influence of the for-

Pietro da Cortona, *Allegory of Divine Providence and Barberini Power.* Palazzo Barberini

On facing page, Gian Lorenzo Bernini, baldachin. St. Peter's

Andrea Sacchi, Allegory of Divine Wisdom. Palazzo Barberini

important commissions for him, including the four cartoons for the mosaics in the pendentives of St. Peter's, the *Vision of Saint Romuald* (Pinacoteca Vaticana, Rome), the *Miracle of Saint Anthony of Padua* for the Capuchin church of Santa Maria della Concezione and the decoration of the whole of the Lateran Baptistery. On the basis of the arguments put forward by the seventeenth-century biographer and theorist Giovanni Bellori, the *Allegory of Divine Wisdom*, the fresco that Sacchi painted for Palazzo Barberini, has been regarded as a manifesto of the classical painting of the 1630s and as an affirmation of the continuity of the example set by Domenichino and his sober and thoughtful style with its emphasis on clear drawing, in a line that runs all the way from Raphael to Poussin. And it is true that, even if we do not accept the rigid theoretical positions of Bellori's *a posteriori* interpretation, the contrast between Sacchi's *Wisdom* and Cortona's *Providence* reveals a profound difference in the conception of fresco decoration, between the legacy of the Bolognese school and tradition and the means of communication that were

adopted to convey the political and allegorical message of Barberini power. Sacchi painted the equivalent of an easel picture based on a rigid geometrical composition and containing just the few figures required to get across the contents of the symbolic, political and astrological program: "the other women that are set around [the figure of Divine Wisdom] will be suitably dressed, with the symbols of the various constellations, these being something divine and represented in heaven." Cortona, on the other hand, deployed all his skill as an eloquent wielder of the paintbrush on the ceiling that he painted, in a "grand manner" that combined the Tuscan art of drawing, the expressiveness and composure of the Bolognese School and the brushwork of the Venetians with a respect for Roman traditions. The Virgilian and heraldic imagery of the fresco transforms the program devised by the court poet Francesco Bracciolini into a stirring and animated narration in which the details are overwhelmed by a general impression of grandeur that speaks directly to the senses.

Frugality and the Jubilee

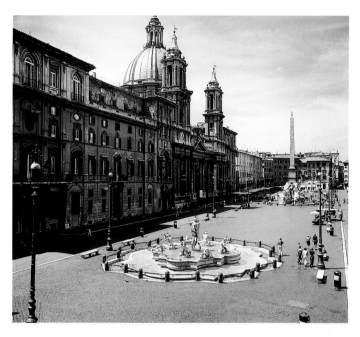

On the death of Urban VIII (1623-44), after a long reign of twenty-one years, art in Rome underwent a drastic change in direction. The discontent that arose following the disastrous outcome of the war of Castro and the ensuing shift in alliances led to the election of the pro-Spanish Giovan Battista Pamphilj, a Roman nobleman whose origins lay in the Umbrian town of Gubbio, as Pope Innocent X (1644-55). Little interested in patronage of the arts and the promotion of culture, the new pontiff concentrated almost exclusively on the commissions that were regarded as obligatory for a man in his position, i.e. the erection of a dynastic palace and a family church to house his tomb and the construction or renovation of a variety of ecclesiastical buildings in preparation for the grand jubilee to mark the half century (1650).

In carrying out this "minimal" program, however, Innocent X created what can be regarded as the most important baroque square in Rome. In fact Piazza Navona was the center of Innocent X's city-planning ac-

tivities and work continued on it throughout his pontificate. In addition, this coincided with a period in which the great protagonist of Roman baroque, Gian Lorenzo Bernini, was in relative disfavor. The appearance of cracks in St. Peter's basilica following the erection of one of the two campaniles that were intended to frame the façade, completed by Bernini at the behest of Urban VIII, resulted in his dismissal as architect in charge of the fabric. The special commission that took this decision was chaired by the pope himself and it was to Francesco Borromini (1599-1667), protégé of the Oratorian Virgilio Spada, private al-

Piazza Navona in a recent picture and in a view by Bernardo Bellotto now in the Musée des Beaux-Arts, Nantes

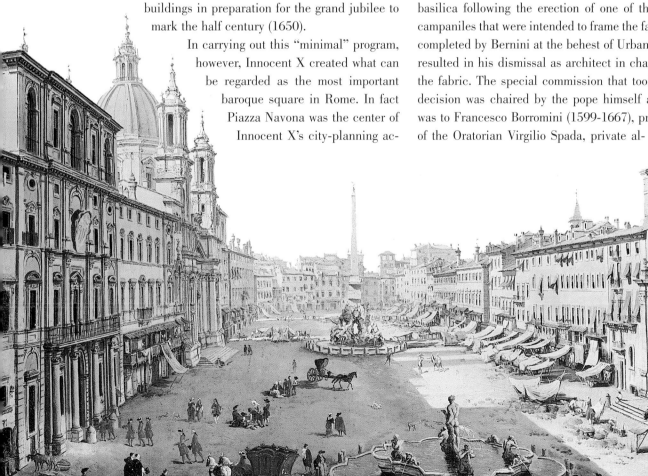

Alessandro Galilei's
façade of San
Giovanni in Laterano
(1732-35) and the
interior designed by
Borromini

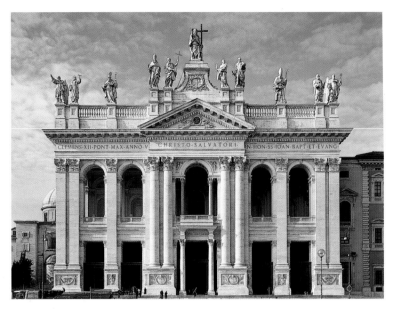

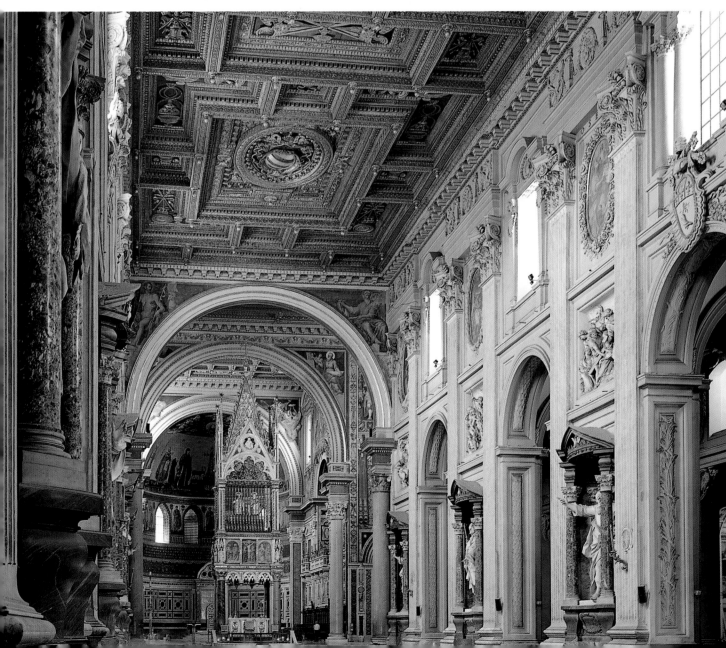

Sant'Agnese in
Agone and, bottom,
the façade of
Sant'Andrea della
Valle built by Carlo
Rainaldi

moner of the pontiff and superintendent of papal constructions, that the most important official undertaking of those years was entrusted. This was the "restoration" of the early-Christian basilica of San Giovanni in Laterano, carried out in record time, from 1645 to 1650, so that it would be ready for the jubilee year.

We know that the pope imposed limitations on Borromini: in contrast to what had been done in St. Peter's, he wanted to preserve the early-Christian basilica with its nave and four aisles, the first official seat of the papacy and a model for all other early basilicas, "as much as possible in its original form."

So the task facing Borromini was an arduous one, given the dilapidated state of the church's structures and the additional veto on demolition of Daniele da Volterra's wooden ceiling. Nevertheless Borromini succeeded, in his restructuring of the nave and aisles, in reshaping the early-Christian architecture to produce a rhythmic alternation of solids and voids, i.e. of round arches and pillars. In some of the latter were set niches of colored marble that were later occupied by statues of the Apostles.

In 1653 Borromini was also assigned the task of continuing work on the new church of Sant'Agnese in Piazza Navona, adjacent to Palazzo Pamphilj and already begun by Rainaldi (1611-91). As the interior was by then at an ad-

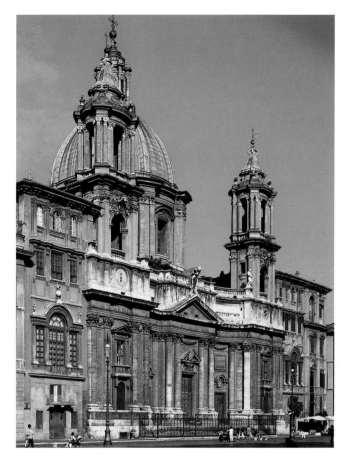

vanced stage, Borromini had to resort to sophisticated technical expedients to modify Rainaldi's design and give it a greater verticality, but he demolished the part of the façade that had been built and erected a new one to his own design. The new, concave façade appears to be set back from the square

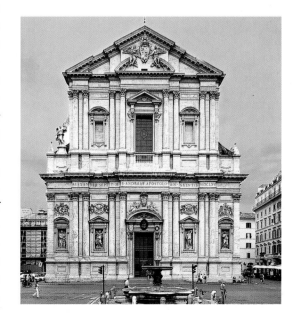

Alessandro Algardi, Meeting between Leo the Great and Attila. St. Peter's

The apse of Santa Maria Maggiore, a significant example of the Roman baroque

and it extends onto the adjoining buildings, creating enough space for the towers.

At the same time Bernini was losing ground in the realm of sculpture as well, with the Pamphilj family giving even greater space to his more placid contemporary Alessandro Algardi (1595-1654). Trained in Bologna at the academy run by the Carracci under the guidance of Ludovico, Algardi came to Rome in 1625. He first attracted attention in 1634, when Roberto degli Ubaldini entrusted him with the task of executing a tomb in St. Peter's for his uncle, Leo XI de' Medici, whose reign as pope had lasted for only twenty-seven days in 1605. The monument was not completed until 1644, the year of Innocent X's election, and it is evident that its composition was derived from Bernini's *Tomb of Urban VIII*, constructed over the same period, but designed and commenced earlier.

However, the Pamphilj did not provide many great opportunities for sculptors. In addition to executing the fountain in the courtyard of San Damaso in the Vatican, Algardi began his most important work in 1646, the relief depicting the *Meeting between Leo the Great and Attila* in St. Peter's. This is a sort of three-dimensional picture reaching a height of over seven meters or twenty-three feet that created a new baroque genre.

Cardinal Camillo Pamphilj

On the other hand, Algardi did considerably more work for Camillo Pamphilj. Camillo was the true patron of the arts during the Pamphilj pontificate. The pope made his only nephew, the son of his brother Pamphilio and the astute and ambitious Olimpia Maidalchini, a cardinal at the age of twenty-two. While this gave him the prospect of accumulating lucrative benefices, it meant that he would be unable to perpetuate the dynasty. All this changed, however, in 1647, when Camillo suddenly left the purple and married the young widow of Paolo Borghese, also called Olimpia and better known for being the niece and only heir of the extremely wealthy Cardinal Pietro Aldobrandini, himself the nephew of Clement VIII and an enlightened collector.

It is Camillo, a cultured man as well as an amateur painter and architect, whom we must thank for the exis-

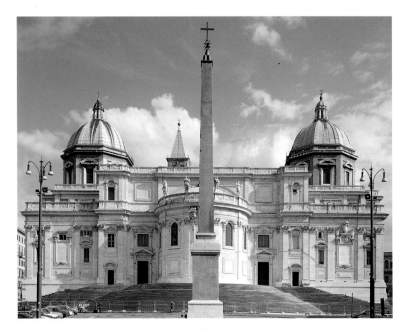

The Casino del Belrespiro. Villa Doria Pamphilj

tence of the sophisticated suburban residence in the vicinity of the Janiculum known as the Casino del Belrespiro, whose construction and decoration were entrusted to Alessandro Algardi and Giovanni Francesco Grimaldi. Thus a sculptor and a painter were employed to create this place of "good cheer," embellished inside and outside with ancient and modern sculptural reliefs and surrounded by sumptuous gardens that were used to receive guests, hold learned conversations, stage entertainments and theatrical performances and, above all, display Camillo's collection of antiquities. Although it is not certain that Algardi was exclusively responsible for the design of the ar-

chitecture – it has been suggested that he received advice from Bernini – he was the principal coordinator of the construction. Algardi also carved some of his finest portraits for the Pamphilj, rendered with attention to the tiniest details and surprisingly lifelike.

Bernini too carved a memorable marble portrait of *Innocent X* in 1650. In fact his relations with the pope grew more cordial when he was entrusted with one of the most important commissions of the Pamphilj pontificate, the execution of the *Fountain of the Rivers* in Piazza Navona, or the "Isola Pamphilj" as it was known. The construction of a magnificent new fountain to replace the existing

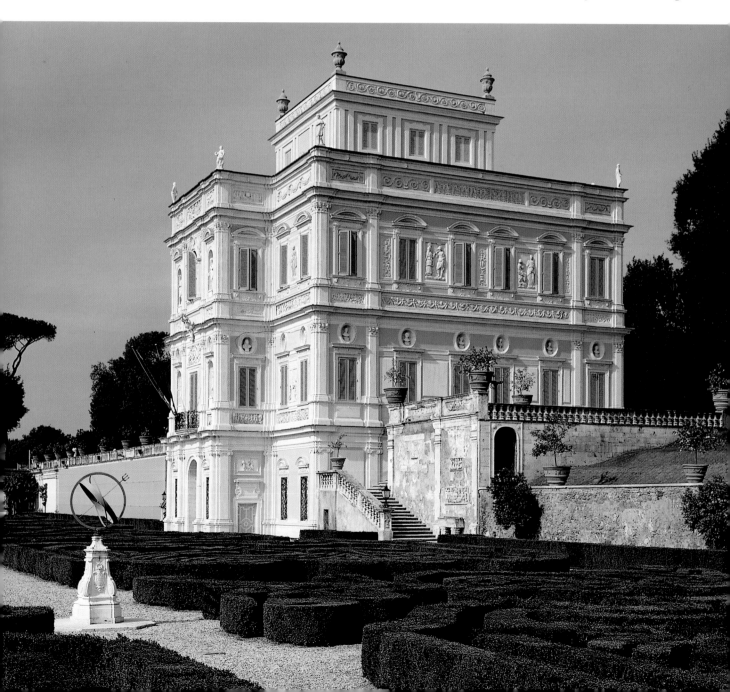

The Fountains of Rome

The appearance of innumerable fountains in Roman squares from the 1570s onward, fountains that were to serve as a proving ground for illustrious sculptors and architects throughout the seventeenth century, was a consequence of the major overhaul of the city's water supply undertaken with great alacrity by the

kind to be found in the Tiber, had influenced the location of aristocratic villas and gardens over the course of the sixteenth century, when most of them had been laid out around the important source called *treio*, now the *Fountain of Trevi*. The decision of Pope Julius III (1550-55) to alter the course of the Aqua Virgo so that

moved to what is now called Piazza Nicosia; the one in Piazza della Rotonda was drastically modified during the pontificate of Clement XI (1700-21); the two fountains built for Piazza Navona were moved to Villa Borghese. However, they remain fragmentary testimonies to a style that was still linked to the "grotesque" inventions of late Mannerism in its use of masks and monstrous animals.

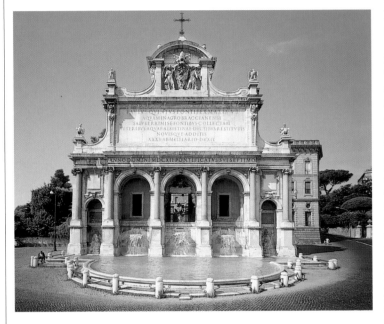

The protagonists of the first significant effort to solve the problem of the water supply and build new fountains were the rivals Guglielmo (1500-77) and Giacomo della Porta (1533-1602). The latter, chief architect in Rome at the time, was responsible for all the most important fountains designed in 1570 and built during the reigns of Pius V (1566-72) and Gregory XIII (1572-85) in almost all of the city's principal squares: from Piazza della Rotonda to Campo dei Fiori and from Piazza del Popolo to Piazza Navona. None of della Porta's works has remained in its original state: the one executed by the architect for the Porta del Popolo has been

The *Fountain of the Aqua Paola*

The *Fountain of the Turtles*

On facing page, the *Fountain of the Rivers* with, bottom, detail of the *Ganges*

pontiffs, commencing with Pius V who, in 1570, finally completed the restoration of the ancient aqueduct known as the Aqua Virgo. Before this, the supply of water had been a serious problem for the people of Rome, ever since the conduits had fallen into disuse and ruin in the Middle Ages. The shortage of water, apart from the not exactly healthy

it passed through his new gardens on the Via Flaminia, in order to supply the ornate nymphaeum and the pair of fountains at the entrance constructed by Bartolomeo Ammannati (1511-92), aroused great controversy.

The celebrated *Fountain of the Turtles*, executed in the 1580s by the Tuscan sculptor Taddeo Landini and so-called for the turtles that were added almost a century later, has a quite different character, that of a sumptuous work of urban decoration. The four delicate ephebes riding on dolphins that support the precious bowl carved out of gray African stone and the large shells of *portasanta* are the fruit of a new and sculptural rather than architectural conception of the fountain, which was built for the powerful Mattei family in the square in front of their palace. In 1587 Pope Sixtus V (Felice Peretti) inaugurated the new Aqua Felice and the terminal of the aqueduct, the *Fountain of Moses* built by Domenico and Giovanni Fontana in a heavy and monumental style and representing, with old-fashioned bombast, *Moses Striking Water from the Rock*, *Aaron Leading the Thirsty Jewish People to the Waters* and *Gideon Choosing His Soldiers by Their Manner of Drinking*.

The opening of another new

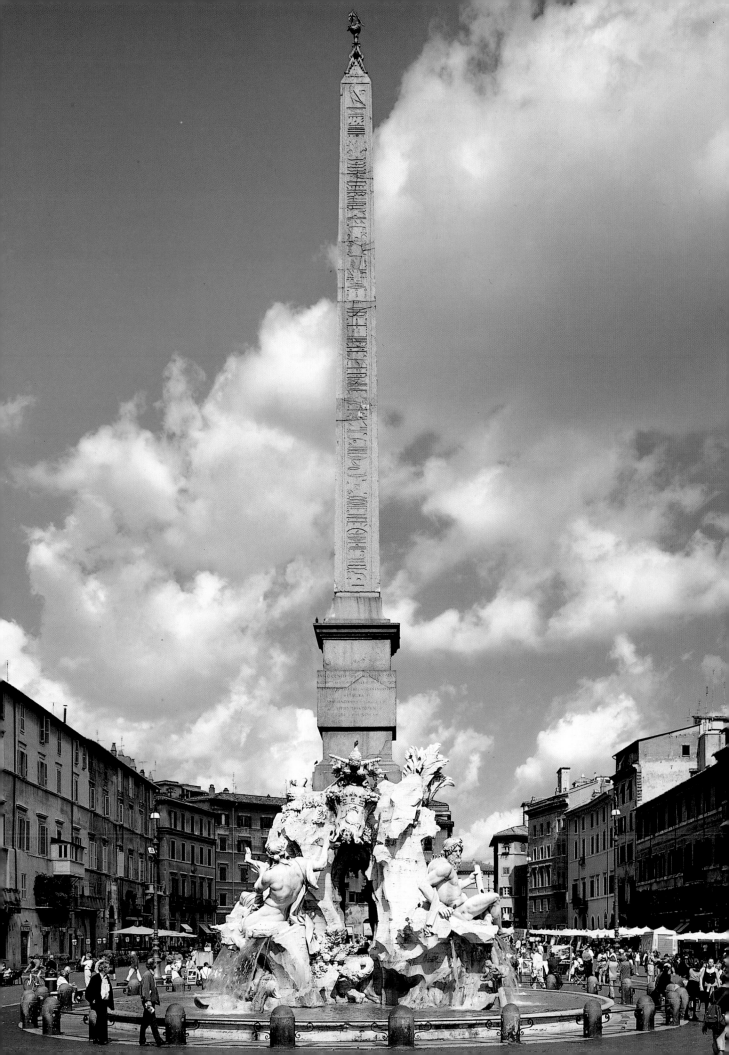

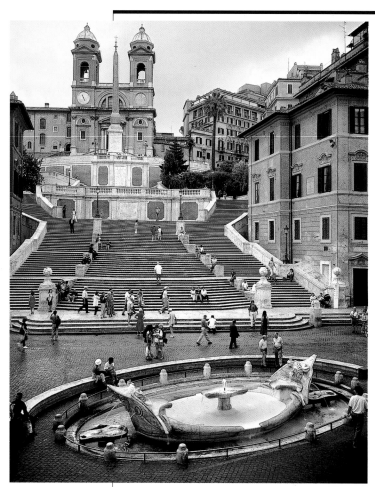

Paola, on the top of the Janiculum, required the intervention of numerous architects, from Flaminio Ponzio to Giovanni Fontana and then again, in 1690, Carlo Fontana.

A new era was opened by Gian Lorenzo Bernini who, starting out his brilliant career as a sculptor for villas and gardens, gave Rome some of its finest and most characteristic fountains. Still linked to the sixteenth-century Florentine tradition, his *Fountain of Neptune* for Villa Montalto can no longer be fairly judged in its true context (the statue is now in London's Victoria and Albert Museum). But in the *Barcaccia* (*Tub* or *Old Boat*) in Piazza di Spagna, executed between 1627 and 1629, and even more in his masterpiece of the *Triton* in Piazza Barberini, dating from 1642-43, Bernini created monuments of urban decoration in which functionality, art and concept are wonderfully fused in a contest between art and nature from which the sculptor

emerges as the decisive winner.

The opportunity to demonstrate the full extent of his versatile and extraordinary talent was given to Bernini by the very pope who least favored and appreciated him. For the jubilee of 1650 Innocent X Pamphilj (1644-55) decided to renovate the

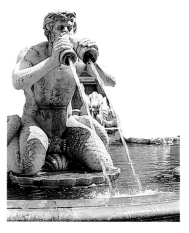

aqueduct bringing in water from Lake Bracciano occupied much of the energies of Pope Paul V Borghese (1605-21), who earned himself the nickname of the "great plumber" by his passion for the construction of fountains. The grandiose terminal of the Aqua

The steps of Trinità dei Monti with the *Fountain of the Barcaccia*

Top right, the *Fountain of the Triton*

The *Fountain of the Moor* with detail of a *Triton*

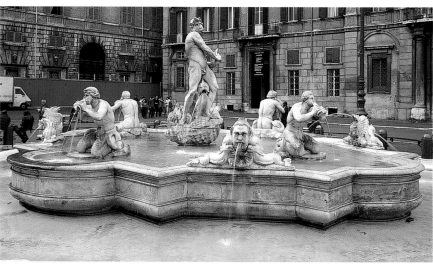

area of the "Isola Pamphilj" and, deviating the Aqua Virgo to Piazza Navona, entrusted the construction of the monument to the sculptor, architect and organizer of baroque Rome. The majestic structure of the *Fountain of the Rivers*, inaugurated in 1650, transformed the square and celebrated the universal authority of the Pamphilj pope and the Church through an impressive allegory. A few years later, in 1652-55, Bernini built the *Fountain of the Moor* which, when compared with that of the *Rivers*, looks almost like a return to the models of his youth.

With these unsurpassable works the artist left a legacy to the coming generations that could not be ignored. On the threshold of the eighteenth century the architects and sculptors at work on the design and construction of the imposing terminal of the Aqua Virgo in Piazza di Trevi recalled and reinterpreted Bernini's models, making them softer and more graceful in line with the dictates of the new rococo style. Ferdinando Fuga, Niccolò Salvi, Luigi Vanvitelli and Alessandro Galilei all submitted designs for the competition held by Clement XII (1730-40). Salvi came out the winner in 1732 and his theater of water was completed by Giuseppe Pannini in 1762 with the

collaboration of the sculptors Pietro Bracci and Filippo della Valle, who were among the principal exponents of the brief period of Roman rococo but still strongly influenced by the example of Bernini. The architecture of the *Fountain of Trevi*, with its distinctly classical stamp, makes concessions to the rococo style only in Neptune's shell and the curvilinear shape of the basins, but overall is derived chiefly from Bernini and Cortona.
The naturalistic rocks were taken from the former, while the brilliant idea of combining the façade of the building behind with the fountain came from the latter, who had already proposed it in his ambitious but never realized design for Palazzo Chigi in Piazza Colonna.

The *Fountain of the Bees*

The *Fountain of Trevi*

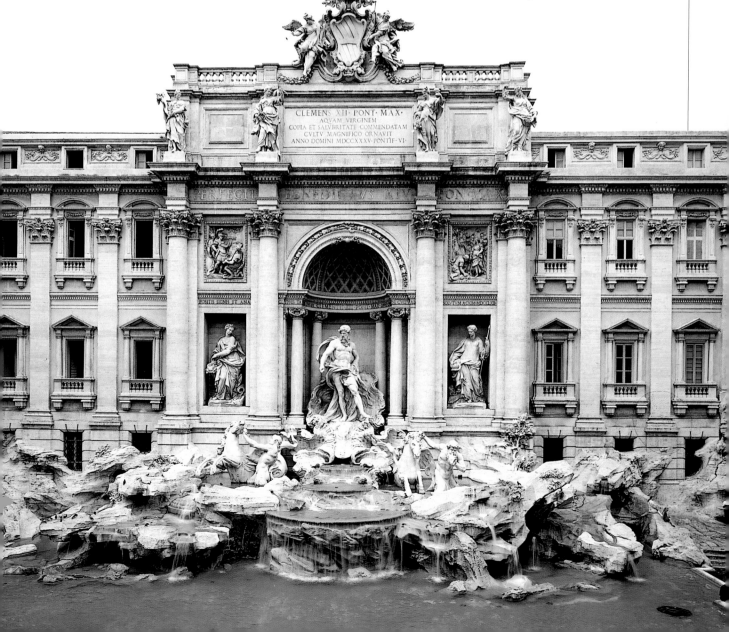

one at the center of the square had been one of the pope's first thoughts and as far back as 1644 he had given Borromini the job of increasing the supply of water from the *Fountain of Trevi*. Once the work on the conduit was finished in 1647, the pontiff held a sort of competition in which the sole condition was the presence of an obelisk. Tradition has it that, instead of presenting a wax model of his design like all the other entrants, Bernini made one out of silver and sent it to the influential Olimpia Maidalchini. As soon as he saw it, the pope gave Bernini the commission, preferring him over Borromini and Algardi who had also submitted designs. The irregular rock of granite thronged with symbolic animals on which are set the male figures personifying the *Danube*, *Ganges*, *Nile* and *River Plate*, one marking each axis of the square, and surmounted by an obelisk with the Pamphilj dove, was perfectly in tune with the pope's propaganda aims. A glorification of the pontiff and his family, but also a triumphal image of the Church ruling over the four corners of the world at a particularly difficult moment in its history following the Peace of Westphalia (1648) and the consequent recognition of the rights of the Protestant Churches and countries. While it is very likely that the idea for the iconographic motif of the four rivers came from Borromini and Virgilio Spada, once again it was Bernini who proved to be the artist best able to get across the complex ideology of that time.

Bernini's reputation as a portraitist had in no way been dented by three years of exclusion from official commissions. The story of the *Bust of Francesco I d'Este* in 1650 is exemplary. Francesco had asked his brother, Cardinal Rinaldo, to sound out Bernini and Algardi about carving his portrait. While "for Cavalier Bernino, who only works as a favor to his friends, or at the urging of important people, it is not possible to determine either a time or a price," Algardi, whose beautiful portrait of the pope's sister-in-law, Olimpia Maidalchini, had made a great impression on Cardinal Rinaldo, was much more precise. Not only did he promise to execute the work rapidly, but he asked 150 scudi per bust, excluding the

cost of the marble. Yet as soon as Bernini accepted, Algardi's name vanished from the documents related to the commission. The end result, in spite of the difficulties presented by the absence of the actual sitter, is one of Bernini's masterpieces, the culminating point in his development of the half-length portrait and at the same time a step beyond. The duke was so satisfied that he paid Bernini the princely sum of 3000 scudi, the same as Innocent X had paid for the *Fountain of the Rivers*.

The Predominance of Pietro da Cortona

In the field of large-scale pictorial decorations Pietro da Cortona was still the undisputed protagonist in the middle of the century. Returning to Rome from Florence in 1647, he resumed his collaboration with the Oratorian Fathers of Santa Maria in Vallicella, where he painted the frescoes of the dome, unveiled on the feast day of St. Philip Neri in 1651. At the same time he was given the job of frescoing the most important room in the new Palazzo Pamphilj on Piazza Navona: the large gallery on the *piano nobile* designed by Borromini in 1646.

Principal reception room and main link between the pope's public and private apartments, the long and narrow gallery runs right through the palace, with a Serlian window at each end facing onto Piazza Navona and Via dell'Anima respectively. The groin vault is decorated with scenes from the *Aeneid*, underlining the family's Roman origins. Given the unusual dimensions of the room, Pietro da Cortona avoided the use of any kind of ornament in relief and set the scenes of the gods in a large central panel flanked by two ovals with richly decorated frames, while Aeneas's earthly adventures were laid out on the rest of the ceiling without any architectural framework. The blue sky that links together the scenes of Aeneas is the main protagonist of the composition, where the density of the color and the crowding of the figures on the ceiling of Palazzo Barberini has given way to a lightening of the palette and to the use of a range of subtle and luminous shades that hints at future directions in Roman painting.

Gian Lorenzo Bernini, *Bust of Francesco I d'Este.* **Galleria Estense, Modena**

On facing page, the ceiling of Santa Maria in Vallicella with Pietro da Cortona's *Vision of Saint Philip Neri*

Alessandro Algardi, *Bust of Olimpia Maidalchini.* **Galleria Doria Pamphilj**

The Grandiose City-Planning Schemes of Alexander VII

The situation was very different during the pontificate of the Sienese Fabio Chigi (1655-67), who took the name of Alexander VII in honor of his fellow citizen, Alexander III Bandinelli, but whom contemporary sources did not hesitate to compare with the much better known Alexander the Great. A descendant of Agostino Chigi, called "the Magnificent," the most important banker and patron of the arts in early sixteenth-century Rome, Fabio Chigi had been nuncio in Cologne where he had taken part in the negotiations of the Peace of Westphalia that had led to such an unfavorable conclusion for the Catholic Church. In reaction to these events, Alexander VII set out to bolster the supreme spiritual and temporal authority of the papacy. Unlike his predecessors, he had no intention of erecting a magnificent private villa in the suburbs, but concentrated on making the city of Rome worthy of its role as universal capital of the Church. Like Sixtus V before him, Alexander opened new streets, created new squares and devoted almost daily attention to improving and maintaining the system of roads.

The chief architect of this renewal was Gian Lorenzo Bernini, in whom the new pope placed unlimited faith in spite of the fact that his experience in the field was then confined to the design of the façade of Santa Bibiana and the unfortunate episodes of the chapel of the Re Magi in the Collegio di Propaganda Fide and the campanile of St. Peter's. In fact he was appointed architect of the Sacred Palaces, the Apostolic Camera, Castel Sant'Angelo, St. Peter's and the *Fountain of Trevi*. He also became the pope's personal sculptor and designer of furnishings, decorations for festivals and carriages, as well as his advisor on those works that were not directly assigned to him.

Medal struck during the pontificate of Alexander VII with Bernini's design for **St. Peter's Square (Biblioteca Apostolica Vaticana), and a recent view of the square**

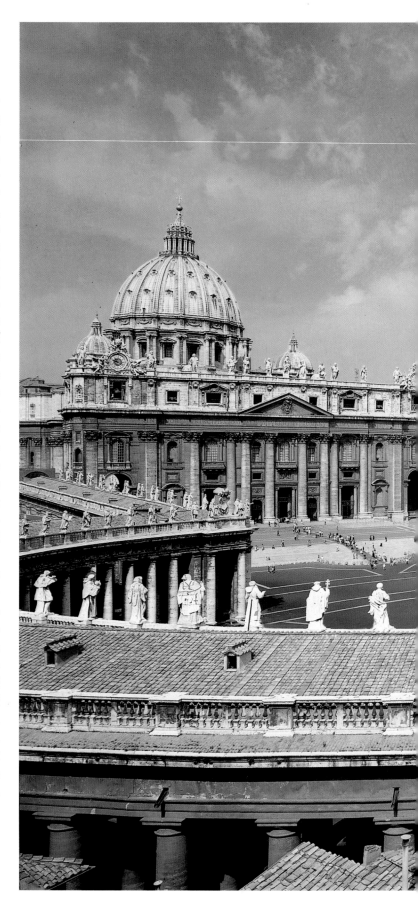

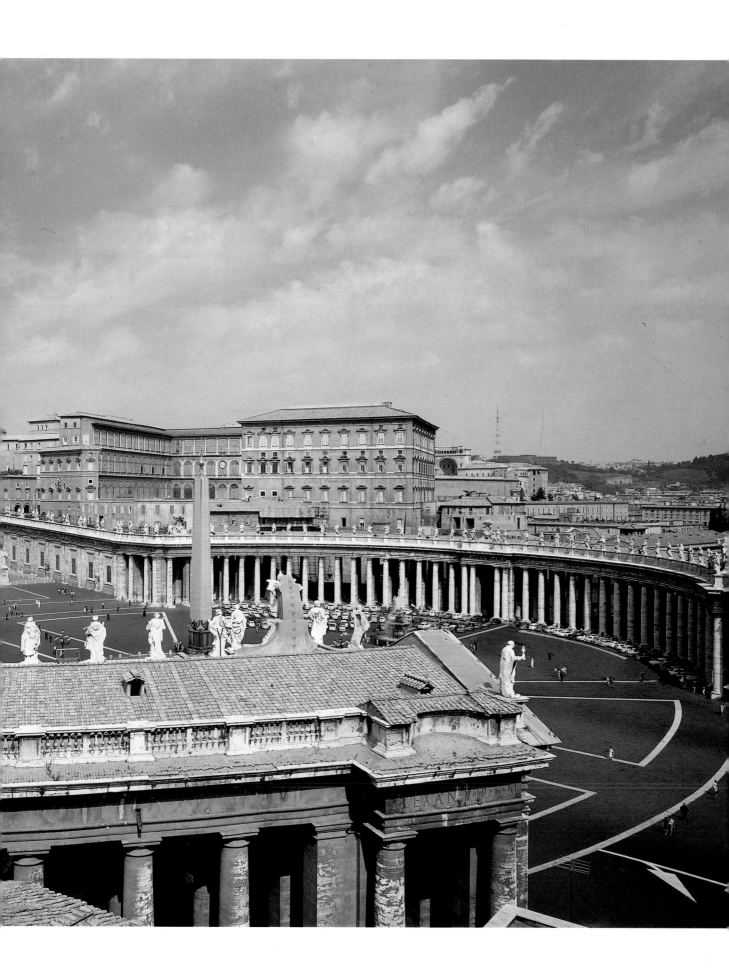

The culmination of all this ambitious and wide-ranging activity was St. Peter's Square, whose construction took up the whole of Alexander VII's pontificate and became its emblem. As soon as he was elected, the pope took steps to rectify the situation of the area in front of the basilica of St. Peter. This had a formless appearance, with the western side taken up by the basilica's façade, too low to make a proper visual impression, and the southern part by various buildings of different sizes, including the noble Palazzo Cesi. The obelisk, raised in 1586, was located on the left side of the square as no road had been constructed along its axis. The final plans were approved by the pope in May 1657, but Bernini made a number of fundamental changes to them just a few days before the first stone was laid, defining the colonnade as we see it today. The coupled Corinthian columns of the original design were replaced by sturdier single Doric columns. There are around three hundred of these columns, arranged in

The façade of
Santa Maria della
Pace designed by
Pietro da Cortona

Sant'Andrea
al Quirinale and
Gian Lorenzo
Bernini's dome

On facing page,
Gian Lorenzo
Bernini, *Ecstasy of
Saint Teresa*. Santa
Maria della Vittoria

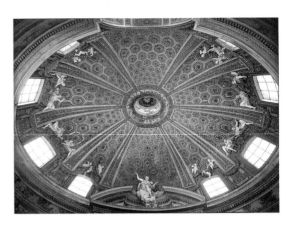

four rows with a passage in the middle for carriages. The square was left unfinished on the death of the pope: the famous "third arm" with which Bernini planned to link the two curves was never built.

On a smaller scale but no less spectacular was the layout of the church of Santa Maria della Pace and the narrow square in front, entrusted to Pietro da Cortona. The place had a high symbolic and personal value for the pope, in that the first chapel on the right had been founded by Agostino Chigi and decorated for him by the great Raphael.

Pietro da Cortona's name is also linked with the single major work of painting commissioned by Alexander VII, the decoration of the gallery in the Palazzo Quirinale, built during the reign of Sixtus V. The decoration of the space, which is now divided into three different rooms, was designed but not executed by Cortona, who was busy on Santa Maria della Pace. However, it was the Tuscan artist who chose the painters for its execution, though the pope of course had his own suggestions to make. Alongside his most faithful pupils Ciro Ferri, Lazzaro Baldi and Carlo Cesi, these included Filippo Lauri, Guillaume Courtois, Giovan Francesco Grimaldi, Gaspard Dughet, Paolo Schor and artists from the more classical tendency, Bartolomeo Colombo, Giovanni Angelo Canini and Jan Miel. The last two, together with Pietro Testa and Fabrizio Chiari, had already worked alongside Gaspard Dughet on the new decoration of the church of San Martino ai Monti. But the most significant scenes in the cycle in the Quirinal Palace are those of *Joseph Recognized by His Brothers* painted by Pier Francesco Mola and the *Nativity* by Carlo Maratta. The former had returned to Rome in 1647 after a long stay in Venice and made a great impression with his warm, neo-Venetian colors and

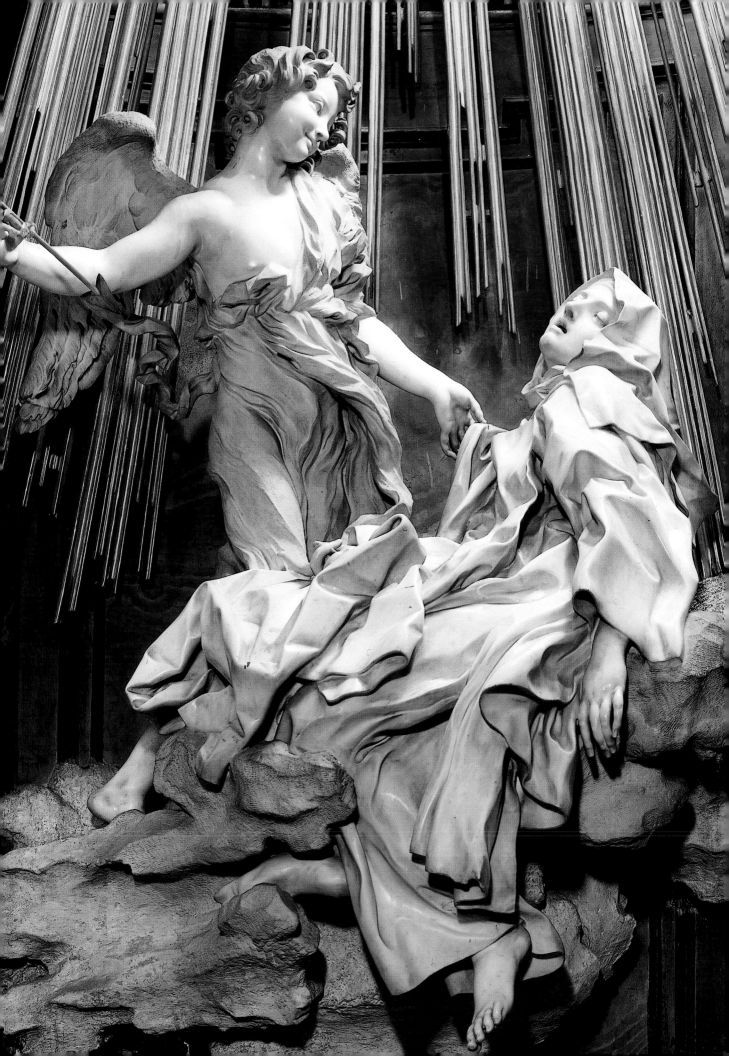

Guercinesque manner, while the latter, a pupil of
Sacchi's who had already collaborated with him in
the Lateran Baptistery, was the real man of the fu-
ture. In fact Maratta would go on to impose the clas-
sical current on baroque painting and finally break
the persistent dominance of Cortona's influence.

In the field of private commissions, Bernini drew
up plans for the renovation of the palace on Piazza
Santi Apostoli belonging to the pope's nephew Car-
dinal Flavio Chigi, a well-known collector of antiq-
uities and *mirabilia* who owned celebrated paint-
ings by Gaulli, the Sienese Bernardino Mei and
Giovan Antonio Canini. At the pontiff's request but
to a commission from Camillo Pamphilj, Bernini
also designed the new church for the novices of the
Society of Jesus, Sant'Andrea al Quirinale.
One of the most important patrons of the second
half of the century was the "Minerva of the North,"
Queen Christine of Sweden, an intellectual and
cosmopolitan woman who moved to Rome in 1655
following her conversion to Catholicism and abdi-
cation the previous year. Already an avid collector
in her home country, the queen brought her splen-
did collection with her, made up chiefly of paint-
ings that had formerly belonged to Emperor
Rudolph II. Greeted with festivities and lavish
decorations, she took up residence in the Palazzo
Riario (now Corsini) on the Lungara. Here she set
up a lively literary circle, which developed into the
Accademia dell'Arcadia. In addition to the well-
known art connoisseur Bellori, who became her li-

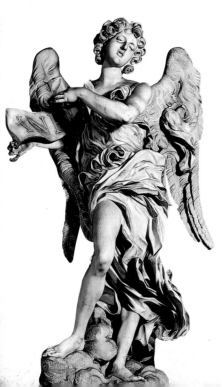

The Ponte
Sant'Angelo as
renovated by
Bernini and the
Angel with a Scroll
in Sant'Andrea
delle Fratte

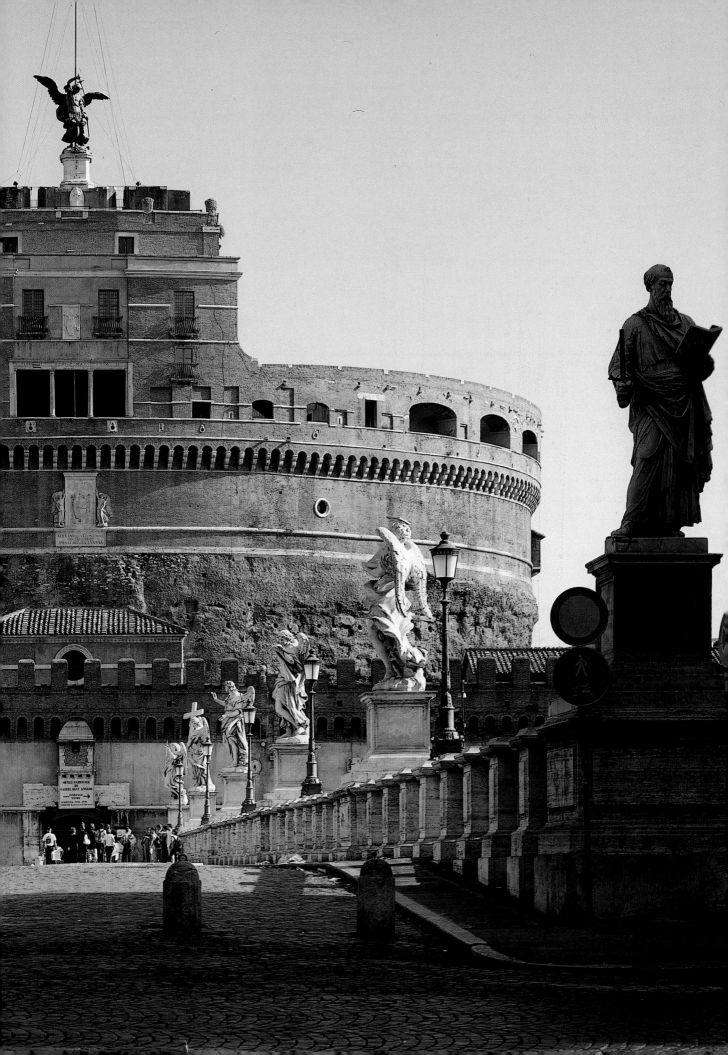

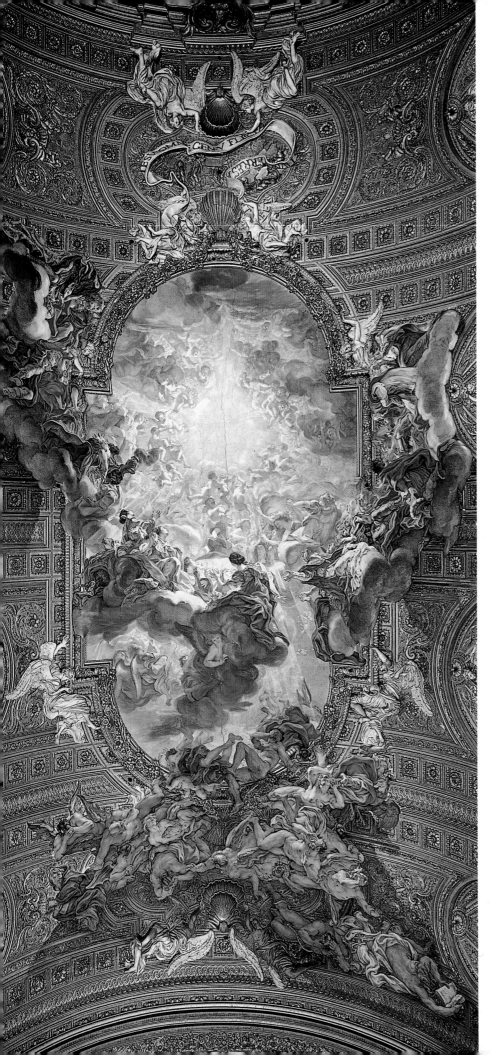

brarian and antiquarian, it was once again Bernini who acted as the chief adviser to the queen, to whom he gave his last work when on his deathbed, a marble bust of the *Savior*, as a sort of spiritual testament. Before he died, however, Bernini still had time to draw up plans for the reconstruction of Ponte Sant'Angelo for Alexander VII's cultivated successor, Clement IX Rospigliosi (1667-69). This was in 1668 and the elderly artist designed the parapets of the bridge with their diamond-patterned bronze gratings through which the water of the river can be seen and imagined them lined with angels carrying the symbols of the Passion. The only two angels that Bernini actually carved himself were so much to the pope's liking that he decided to send them to his native city of Pistoia and have copies made for the bridge. In actual fact the marble statues never left Rome: Clement IX died after just two years on the throne and they were not taken to their present home, the church of Sant'Andrea delle Fratte, until 1729.

With the death of Alexander VII and of Bernini shortly afterward, the golden age of the Roman baroque drew to a close. The two majestic ceilings of the churches of Il Gesù, commenced in 1672 by Gaulli, and of Sant'Ignazio, by Padre Andrea Pozzo (1691-94), took the developments of the previous years to their extreme consequences. Gaulli transposed Bernini's idea of combining fresco and painted stucco and arranging the figures in areas of light and dark onto a monumental scale, while Pozzo, starting out from the same premises, added the use of a virtuoso *quadratura*, or perspective painting, a technique recently brought to Rome by Enrico Haffner.

The ceiling of Sant'Ignazio with the *Entrance of Saint Ignatius into Paradise* by Andrea Pozzo

The ceiling of the church of Il Gesù with *The Triumph of the Name of Jesus* by Gaulli

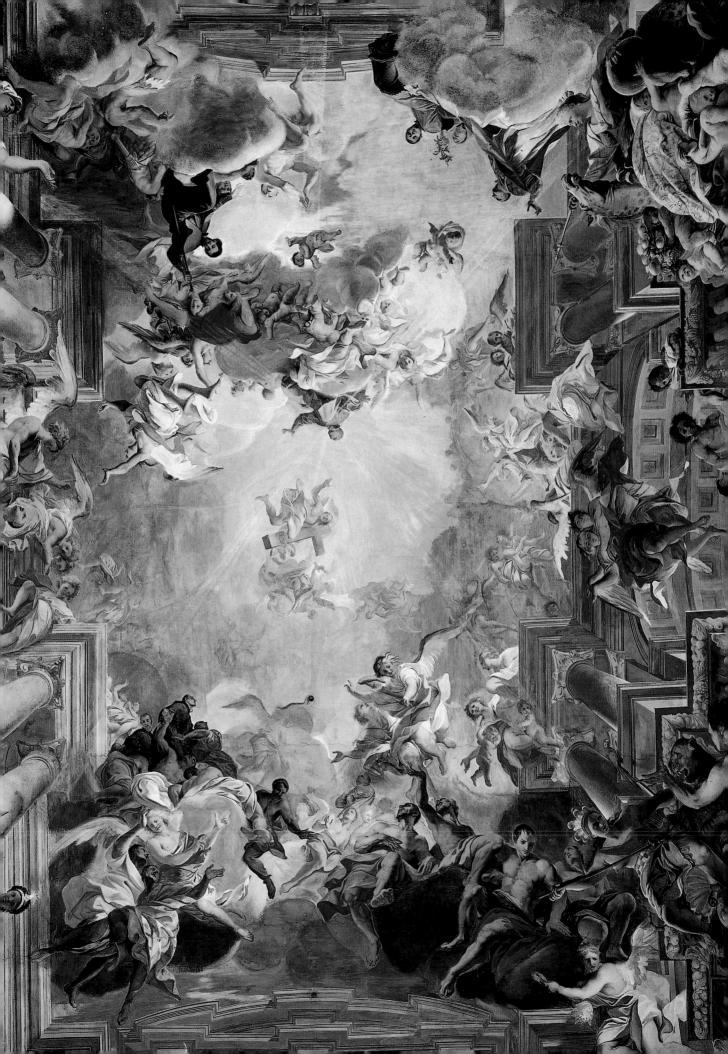

Francesco Borromini in Rome

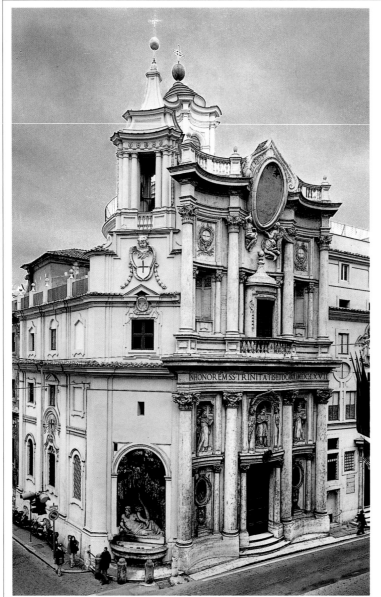

San Carlo alle Quattro Fontane and detail of the lantern

The perspective corridor of Palazzo Spada (1652-53)

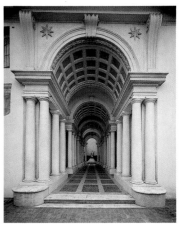

The lantern and campanile of Sant'Andrea delle Fratte (1654-65)

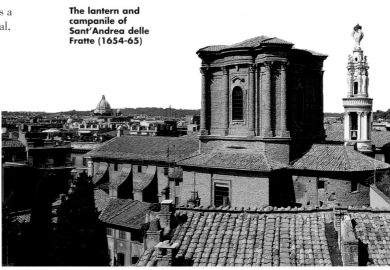

After a period spent working as a stonecutter in Milan Cathedral, the Ticinese Francesco Borromini (1599-1667) came to Rome at the end of the second decade of the seventeenth century to assist Carlo Maderno, his distant relative and chief architect of the fabric of St. Peter's. In Rome Borromini learned the secrets of the craft, which he combined with a thorough study of antiquity and the work of Michelangelo. His first commission came in 1634, when the Discalced Trinitarian Fathers entrusted him with the construction of the monastery

Sant'Ivo alla Sapienza, the interior of the dome and, bottom, the small lantern

Right, the Oratory of St. Philip Neri

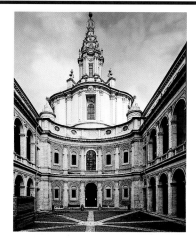

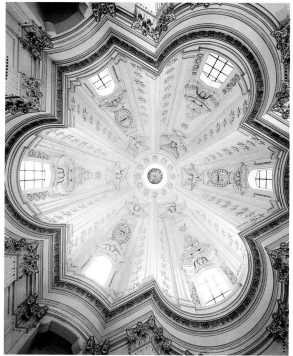

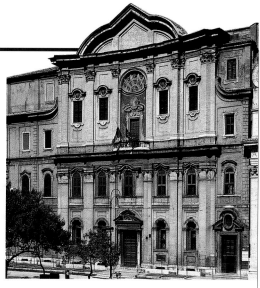

for their house adjacent to Santa Maria in Vallicella. Here Borromini developed the experience he had gained with San Carlino, building a curved brick façade. Between the end of the 1630s and the beginning of the 1640s, Borromini was engaged on a series of minor constructions: the work on Santa Lucia in Selci (1636-43) for the Augustinian nuns, the enlargement of Palazzo Falconieri on Via Giulia (1646-56) and the church of Santa Maria dei Sette Dolori for the Augustinian Oblates (1643-46). In 1632 he was also entrusted with the construction of the Palazzo della Sapienza and the annexed church of Sant'Ivo. Here, though constrained by the presence of the existing palace, Borromini produced one of his most distinctive works. The star-shaped plan, vertical thrust and complete novelty of the spiral lantern make the church of Sant'Ivo the emblem of Roman baroque architecture.

The election of Innocent X (1644) marked the beginning of a period of particular fortune for Borromini, culminating in 1646 in his supervision of the renovation of the longitudinal section of the basilica of San Giovanni in Laterano and continuation of the work on the church of Sant'Agnese in Piazza Navona. His last great work before the despairing decision to take his own life was the Collegio di Propaganda Fide (1646-67), for whose chapel of the Re Magi Borromini demolished the preexisting building constructed by his rival Bernini.

of San Carlino, or San Carlo alle Quattro Fontane. During this first phase, he also built the small octagonal cloister with coupled columns. The interior of the church, executed between 1638 and 1641, has a plan of elliptical shape that is emphasized by the curved surfaces of the walls, with columns arranged in groups of four. The elliptical dome is decorated with cruciform and hexagonal coffers. The daring and the technical and formal inventiveness of the tiny complex makes it stand out strongly from the rest of Roman architecture.

In 1637 Borromini won the competition held by the Oratorians

National Gallery of Ancient Art

Palazzo Barberini

Palazzo Barberini
and Borromini's
spiral staircase

Carlo Saraceni,
*Saint Cecilia and
the Angel*

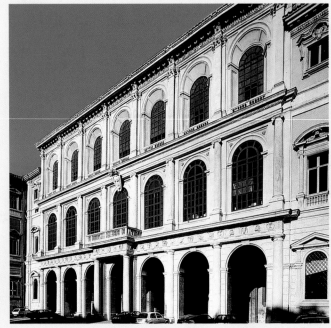

In 1625 Urban VIII Barberini, a cultured pope and great patron of the arts, acquired a palace with an attached garden from Duke Alessandro Sforza and gave his nephew Taddeo the job of supervising the renovation of what was to become one of the most majestic residences in Rome.

Carlo Maderno (1556-1629), the first of the great architects who

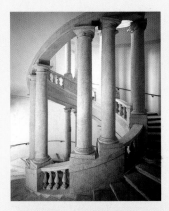

were to work on it, came up with a design for the new building that, in addition to incorporating the existing palace, envisaged a quadrangular structure with wings that would be able to combine the dual function of a townhouse and a suburban villa in a single construction.

On Maderno's death, responsibility for the work was given to Gian Lorenzo Bernini (1598-1680), who stuck largely to the plans drawn up by his predecessor. His only substantial modification was the eastern front (on Via Quattro Fontane) where seven large windows suggest a loggia. However, the design was enriched by the idea of the large central hall, linked to the oval room at the rear and with a vault that would be decorated with Pietro da Cortona's majestic fresco.

Finally, the contribution made by Francesco Borromini (1599-1667) consisted of a number of decorative details and the design of the helical staircase with coupled columns, on the right of the palace.

As the construction work was carried out at an extraordinary pace, decoration of the rooms got under way as well. The frescoes, which had to allude in every detail to the greatness of the Barberini family, were executed by some of the most important painters of the day (Andrea Camassei, Andrea Sacchi and Pietro da Cortona). A typical example of this is

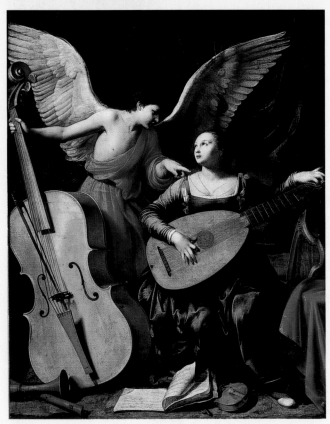

**Caravaggio,
*Judith Beheading
Holofernes,*
1597-1600**

Cortona's large painting on the ceiling of the main hall, representing the *Triumph of Divine Providence and Barberini Power* and studded with the family emblem, bees crowned with laurel. With this work, the painter firmly established his reputation as the principal exponent of the large-scale baroque decoration.

The majestic building was acquired by the state in 1949 and is now the seat of the Galleria Nazionale d'Arte Antica. This consists in part of the prestigious Barberini collection of pictures, along with a number of later additions. One of the most recent of these, acquired in 1951, is Caravaggio's masterpiece *Judith Beheading Holofernes*, painted sometime between 1597 and 1600. This was Merisi's first canvas to depict such a dramatic subject. The beauty of Judith's face, almost untouched by the cruel act she is performing, contrasts with the wrinkled features and exaggerated expression of the old serving woman. In 1916 the gallery was donated another picture attributable to the early part of Caravaggio's career, the

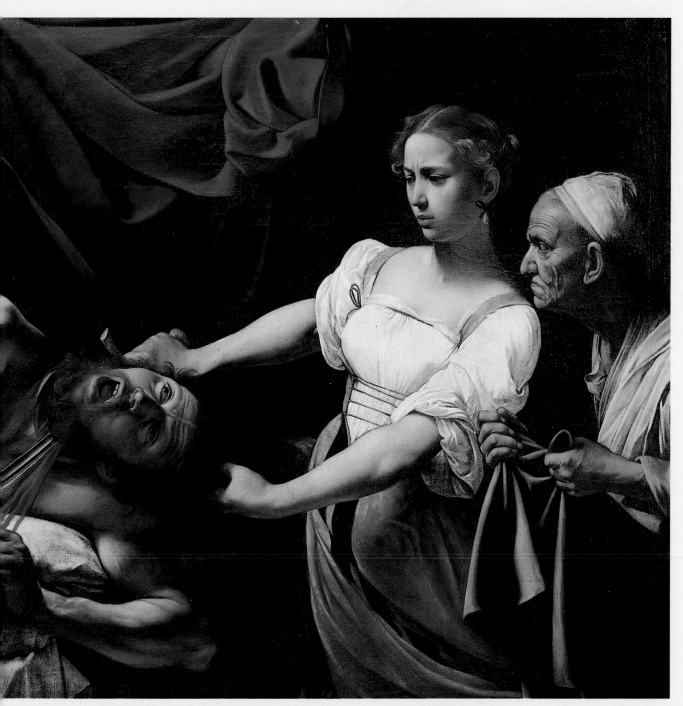

Narcissus. The painting contains a single figure, the youthful and handsome Narcissus of Ovid's tale, reflected in the water of a pool. From the collections of the Monte di Pietà came the large canvas with *Saint Cecilia and the Angel* by Carlo Saraceni, a Venetian follower of Caravaggio who arrived in Rome in 1598. The composition is dominated by the white wings of the angel, which stand out against the dark

background in the upper part of the painting.

Orazio Borgianni's *Holy Family*, which fuses Caravaggio's influence with that of Raphael, entered the gallery from the Roman monastery of San Silvestro in Capite in 1922: the beautiful basket on the right is a homage to Giulio Romano's *Madonna della Gatta* (Capodimonte, Naples).

In addition to important examples of seventeenth-century painting, the gallery houses masterpieces from the fifteenth, sixteenth and eighteenth centuries. Perhaps the most outstanding are two works by Filippo Lippi (the *Madonna di Corneto Tarquinia* and *Annunciation*), Raphael's celebrated *Fornarina*, which may be a portrait of the artist's lover and exercised a powerful influence on many later painters, Bartolomeo Veneto's *Portrait of a Gentleman*, Bronzino's *Portrait of Stefano Colonna* and an interesting group of eighteenth-century Venetian *vedute*.

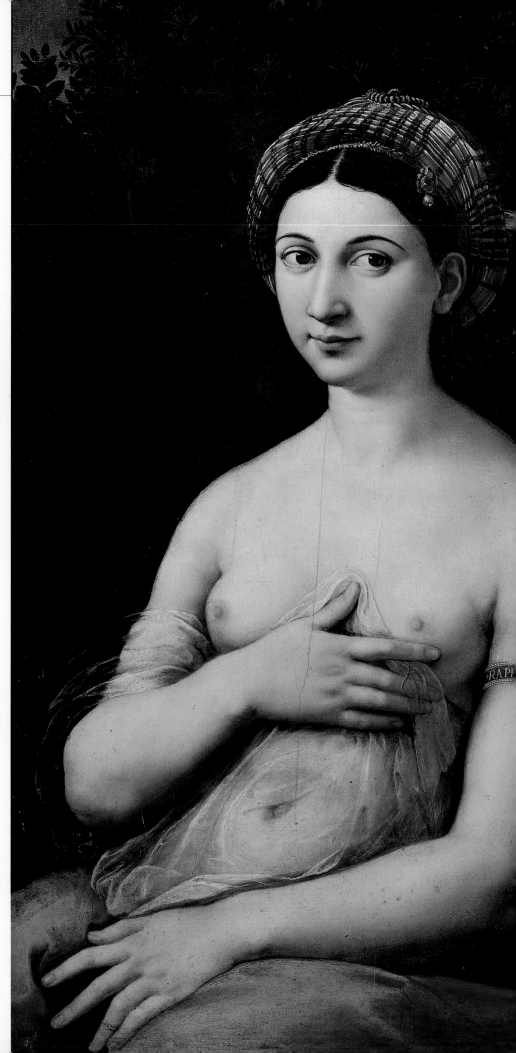

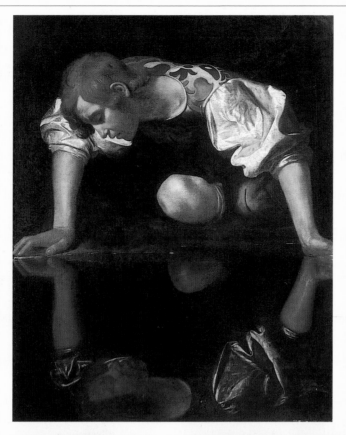

Caravaggio (attrib.),
Narcissus, 1597-99

Below, Agnolo
Bronzino, *Portrait of
Stefano Colonna*,
1546

On facing page,
Orazio Borgianni,
Holy Family,
c. 1611-15

Raphael, *Fornarina*,
1518-19

Bartolomeo Veneto,
*Portrait of a
Gentleman*, 1512-20

Filippo Lippi,
Annunciation,
1440-45

Corsini Gallery

Part of the Galleria Nazionale d'Arte Antica is housed in Palazzo Corsini on the Lungara. The original nucleus of the building was constructed in the sixteenth century for the Riario family, but they only lived there for a limited period. In the seventeenth century, in fact, it was rented to a series of illustrious tenants, the most famous of whom is undoubtedly Queen Christine of Sweden, who moved to Rome in 1659 following her conversion to the Catholic faith. It was Christine who turned the palace into a sophisticated coterie of writers and artists. The building's eighteenth-century guise, still visible in spite of subsequent

and became the seat of the Galleria Nazionale d'Arte Antica, which since the 1950s has also been housed in Palazzo Barberini.

Reflecting the variegated tastes of the Corsini, the museum contains a fine group of sixteenth-century paintings, including Jacopo Bassano's *Adoration of the Shepherds*. In the same room are hung works by Rubens, van Dyck and Murillo (*Madonna and Child*). Room III houses Caravaggio's *Saint John the Baptist*, dating

Caravaggio, *Saint John the Baptist*, c. 1603

On left, Jacopo Bassano, *Adoration of the Shepherds*

Bottom left, Bartolomé Esteban Murillo, *Madonna and Child*

Below, Salvator Rosa, *Battle*

alterations, is due to the intervention of Ferdinando Fuga at the behest of its new owners: the Corsini of Florence. They bought the palace and the gardens at its rear (now the Botanical Garden) in 1736, six years after the election of Lorenzo Corsini as Pope Clement XII. It was around this time that the pontiff and his two nephews, Neri Maria and Bartolomeo, assembled the family's Roman collection, much of which can still be seen in the palace today. In 1886 Palazzo Corsini was donated to the State

from the early years of the seventeenth century and the *Madonna and Child* by Orazio Gentileschi, which was assigned to Merisi in the old inventories.

Alongside pictures by the Caravaggisti there are a large number of still lifes such as Jacob van Staverden's *Fruit Seller* and *Rest on the Hunt* and the painting *Sinite parvulos*, formerly attributed to Caravaggio or Valentin but now assigned to the Frenchman Nicolas Tournier. Still lifes or views are to be found in many of the remaining rooms, which house works by

Christian Berentz. (*Still Life with Clock*, the *Casino dell'Aurora*, *Roman Vegetables*) and Cornelis Decker (*Fruit*). Room VI contains paintings by the Roman school of the seventeenth and eighteenth centuries, including the *Portrait of a Man* by Maratta – founder of the classical current in Rome in the second half of the seventeenth century – and the next room, pictures from the Emilian school, among them several canvases by Guido Reni.

What is now Room VIII used to be the "Gallery of Pictures" in the time of Neri Maria Corsini and now houses some of the collection's seventeenth-century masterpieces: works by Salvator Rosa (*Battle*, *Landscape*, *Seascape with Ruins*, *Seascape with Lighthouse*), Luca Giordano (*Jesus among the Doctors*) and Ribera (*Venus Finding the Dead Adonis*).

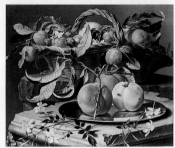

Above, Cornelis Decker, *Fruit*

Top left, Christian Berentz., *The Casino dell'Aurora*

Top right, Guercino, *Et in Arcadia ego*, c. 1618

On left, Carlo Maratta, *Portrait of a Man*

Capitoline Picture Gallery

The history of the Musei Capitolini begins in 1471, the year in which Pope Sixtus IV Della Rovere (1471-84) donated a number of statues to the "people of Rome," including the celebrated *She-Wolf*, the *Spinario*, a bronze statue of a boy removing a thorn from his foot, and the colossal *Head of Constantine*. But the true opening of the museum came in 1734 when Clement XII inaugurated its new home in the Palazzo Nuovo, built in imitation of the Palazzo dei Conservatori opposite.

At this time the Capitoline Palaces housed a prestigious collection of ancient sculptures, second only to the papal one, but no paintings as yet. It was the public exhibition of 450 pictures held in the courtyard of San Giovanni Decollato in 1736 that suggested the idea of opening a picture gallery in the Palazzo dei Conservatori. Thus the Pinacoteca Capitolina was born, as a public museum of paintings for Rome, set up in 1749 by Benedict XIV and housed in rooms built for the purpose by Fuga above the Capitoline Archives.

The first group of pictures came from the Sacchetti and Pius of Savoy collections, acquired at the behest of the pope and on the advice of his

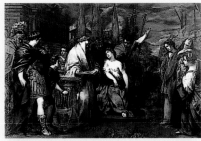

Pietro da Cortona, *The Sacrifice of Polyxena*, before 1626

Giovanni Gerolamo Savoldo, *Portrait of a Woman*, 1535-37

Bottom left, Guercino, *Saint Petronilla*, 1623

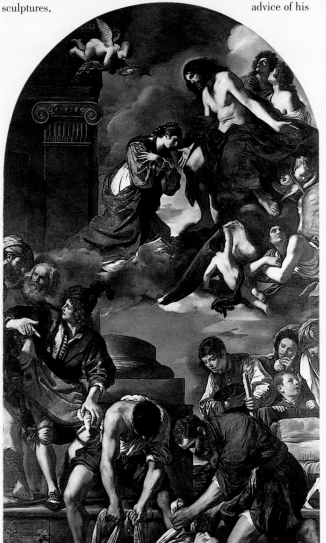

secretary of state, Cardinal Silvio Valenti Gonzaga. The celebrated Sacchetti collection was created by Cardinal Giulio, papal legate in Ferrara from 1626 to 1631 and a close friend of Guido Reni. But the Sacchetti are famous above all for their connection with the Roman debut of Pietro da Cortona. In fact Cardinal Giulio's brother Marcello was the young artist's first patron and his two revolutionary canvases depicting the *Sacrifice of Polyxena* and the *Rape of the Sabine Women* used to hang in his bedroom. Rendered in an extraordinary range of colors that betrays his Tuscan training, these pictures hint at future developments in his art through their introduction of daring and unprecedented compositions and made his name in the Roman art world. Two of Cortona's works from the same period can also be seen in the gallery, the *Triumph of Bacchus* and the *Chariot of Venus*.

The other important group of paintings, the Pius of Savoy collection, was acquired in 1750 when Prince Gilbert went to live in Madrid and asked to be allowed to take with him his valuable collection, made up largely of Venetian paintings. Benedict XIV agreed, but only on condition that "a few pictures" be kept for the gallery: in fact he managed to get hold of 126 of them, selected naturally from among the finest. They included Titian's *Baptism of Christ*, a rare work from the beginning of his career (1512) that was painted for Juan Ram, a Spanish merchant resident in Venice, who is portrayed at bottom left dressed in dark clothing. The beautiful *Portrait of a Woman* by Giovanni Gerolamo Savoldo, dating from 1535-37, reveals the debt owed by the painter to Lotto's portraiture. The presence of the disquieting and yet peaceful figure of a dragon on the left, held on a leash as if it were a pet, has led to the speculation that the lady portrayed was called Margherita, as the dragon is an attribute of the saint of the same name.

The second gallery was built in 1752 and is now called the Room of St. Petronilla after the huge altarpiece painted by Guercino in 1621 for St. Peter's basilica. After its replacement by a mosaic copy in the church, the painting found various homes before being allotted to the Pinacoteca Capitolina by Pius VII.

Titian, *Salome with the Baptist's Head,* 1511-15

Still owned by the Doria Pamphilj family, the picture gallery owes its existence to an advantageous but controversial marriage: the one celebrated in 1647 between Olimpia Aldobrandini, the widow of Paolo Borghese, and Camillo Pamphilj, nephew of Innocent X (1644-55) and a former cardinal. The couple set up residence in the palace on Via del Corso, owned by the Aldobrandini, in which the museum is now housed. The core of the collection, in fact, is made up of the works brought by Olimpia as her dowry and the acquisitions made by Prince Camillo. The majority of the "antique paintings," i.e. the ones pre-dating the formation of the collection in the seventeenth century, come from Lucrezia's collection, while Camillo tended to choose still lifes and landscape and genre paintings, in line with the tastes of his time.

To make room for his collection Camillo had the palace enlarged so that it faced onto Piazza del Collegio Romano as well. The following century Camillo Junior had the entire building renovated by the architect Gabriele Valvassori (1683-1761), who also designed the new façade on Via del Corso. The internal arcade of the Renaissance courtyard was enclosed and turned into an exhibition space. The current arrangement of the paintings, covering the walls of the rooms in their entirety, is based on a predilection for symmetry and for the creation of pendants or companion pieces and reproduces the one devised by the architect Francesco Nicoletti in the 1760s.

The new rooms, opened at the end of 1996, house a number of masterpieces originally in the collection of Borgia d'Este. They include *Salome with the Baptist's Head*, an early work of Titian's executed between 1511 and 1515, not long after the end of his collaboration with Giorgione. The girl's rapt and melancholic air has led people to suggest that the picture is based on the medieval legend that Salome was in love with John the Baptist. The presence of a cupid on the arch opening onto the landscape would appear to support this hypothesis, while another source claims that Titian, "a victim of love," had painted a portrait of himself in the severed head on the platter.

In the same room hangs Raphael's *Double Portrait* (1516): the clear influence of Venetian coloring on the palette and the marked contrasts in the lighting of the figures are unusual features in the artist's production, but the painting's authenticity is confirmed by the typical rendering of the faces of the sitters, now identified as the Venetian men of letters Andrea Navagero and Agostino Beazzano. Other extremely important works from the sixteenth century include *Venus and Mars with Cupid* by Paris Bordone and the *Slaughter of the Innocents* by Ludovico Mazzolino.

In the room devoted to the seventeenth century we find two celebrated pictures by Caravaggio that Camillo bought on the Roman market, the *Rest on the Flight into Egypt* and *Mary Magdalen*. Camillo, who greatly admired Merisi's work,

Raphael, *Double Portrait*, 1516

Ludovico Mazzolino, *The Slaughter of the Innocents*, 1515-20

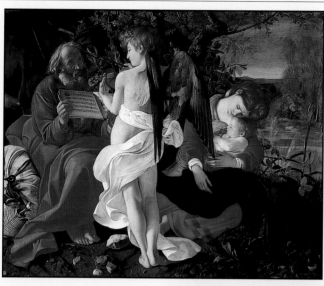

vogue of the time for *pittura di paesi*, or the painting of country scenes, here handled by Annibale in a calm and "classical" style.

This vision of nature contrasts with the pictures by Jan Brueghel the Elder, in particular the series of the *Four Elements* (c. 1611), where the landscape is represented in his customary analytical manner.

Diego Velázquez's *Portrait of Innocent X* – perhaps the most famous picture in the gallery – was painted by the Spanish artist during his second stay in Rome (1649-50) and is influenced by the great tradition of the Italian portrait. In spite of the traditional three-quarter length format, the virtuoso handling of the tones of red and white, framing the pontiff's dark and stern gaze, show that Velázquez was one of the most up-to-date portraitists of his time, much sought-after by the Roman nobility.

Caravaggio, *Rest on the Flight into Egypt*, 1595-96

Caravaggio, *The Magdalen*, 1590-99

Diego Velázquez, *Portrait of Innocent X*, 1650

also acquired the *Fortune Teller*, donated to Louis XIV in 1655 and now in the Louvre. The *Rest*, one of Caravaggio's few pictures to have been painted in pale and luminous tones and set in a landscape, was executed in Rome between 1595 and 1596 while he was a protégé of Cardinal Del Monte.

The famous *Aldobrandini*

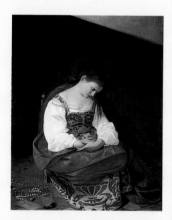

Lunettes, painted for the palace's chapel by Annibale Carracci and his pupils, are housed in the first arm of the quadrilateral. The first of them, attributable in its entirety to Annibale, was executed between 1603 and 1604 and sets its sacred subject, the *Flight into Egypt*, in a landscape typical of the Roman countryside. The figures are placed in the foreground, but on a small scale, in line with the

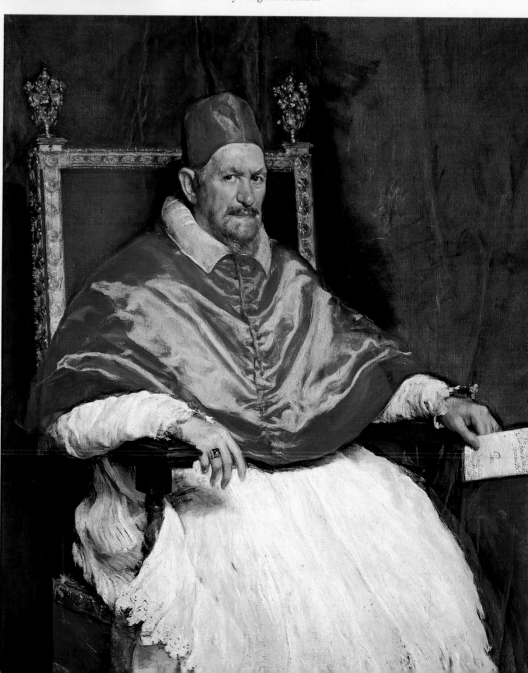

Borghese Gallery

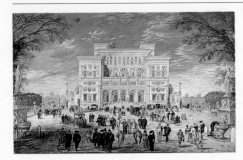

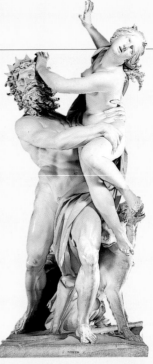

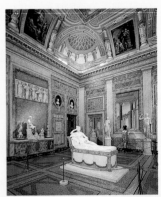

Built for Cardinal Scipione, the nephew of Paul V, the Villa Borghese was designed by Vasanzio and constructed between 1613 and 1615, in imitation of the most famous of all suburban Roman residences, Agostino Chigi's villa on the Lungara.

A container, in Baglione's words, for "every sort of delight that one might desire and have in this life, all adorned with beautiful ancient statues, and modern ones, excellent paintings and other precious things with fountains, pools and other embellishments," the refined villa marked the birth of a new taste. It was here that the cardinal kept the extraordinary group of sculptures he had commissioned from the young Gian Lorenzo Bernini, the *Goat Amalthea, Apollo and Daphne, David* and *Pluto and Proserpine,*

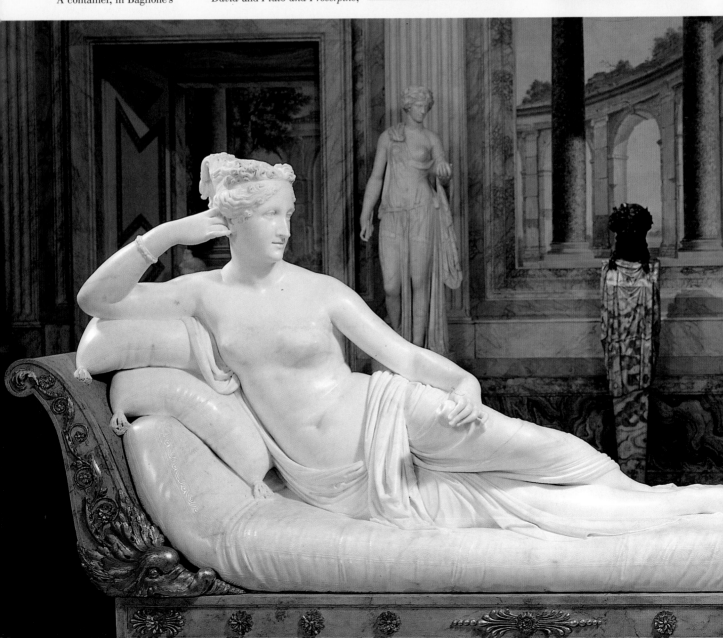

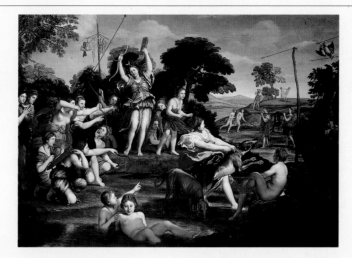

and that Giovanni Lanfranco decorated the ceiling of the gallery with the *Banquet of the Gods*. Remaining the property of the Borghese family until 1902, the fascination of the villa continued to grow over the centuries. Between 1770 and 1800 Marcantonio IV entrusted the architect Antonio Asprucci with the task of altering the garden and interiors to bring them into line with the contemporary neoclassical style.

His heir Camillo established ties with Bonaparte's family by marrying Napoleon's sister Pauline, whose wonderful *Portrait as Venus* carved by Canova (1805-08) can still be seen in the gallery. After the statues in the garden and the reliefs on the façade were removed and sold to France (they are now in the Louvre), the villa was renovated again in the nineteenth century by the architect Luigi Canina, before being ceded to the State along with all its collections and turned into a public museum.

Among the more sensational of Cardinal Scipione "acquisitions" still on view in the gallery is Raphael's *Deposition*: painted in the first decade of the sixteenth century for the Perugian noblewoman Atalanta Baglioni, it remained in its original location, the church of San Francesco al Prato in Perugia until 1608, the year in which it was secretly removed

on the orders of Paul V and given to Scipione for his private collection.

Domenichino's picture of the

Hunt of Diana, which was actually painted for the gallery of Cardinal Pietro Aldobrandini, was acquired in a similarly highhanded fashion. The work was supposed to hang alongside a number of well-known paintings by Bellini, Titian and Dosso that Aldobrandini had brought to Rome from Ferrara and this explains the "neo-Venetian" character of this scene from Virgil's *Aeneid*. In his representation of the archery contest with a dove as target described by Virgil, Domenichino substitutes Diana and her nymphs for Aeneas's soldiers. Enamored of the painting, Scipione had Domenichino imprisoned and took the picture for his collection.

The gallery proper is filled with numerous masterpieces, including a splendid *Portrait of a Man* by Antonello da Messina (c. 1430-79), another *Portrait of a Man* by Lorenzo Lotto, Dosso Dossi's *Melissa*, Correggio's *Danaë* and several works by Titian. Among these is his early masterpiece known as *Sacred and Profane Love* (1514), executed for the marriage of the Venetians Niccolò Aurelio and Laura Bagarotto.

One room houses six out of

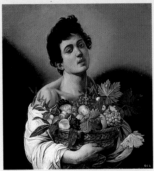

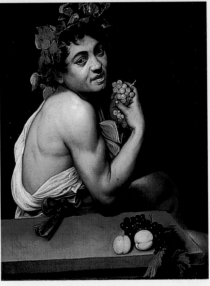

the twelve paintings by Caravaggio owned by Scipione, who was an avid collector and admirer of Merisi's work. In fact it was the cardinal who bought the large altarpiece known as the *Madonna dei Palafrenieri* for the sum of a hundred scudi after it had been removed from the chapel of the Confraternita dei Palafrenieri in St. Peter's just a few days after its installation, for reasons that are not entirely clear. The *David and Goliath* dates from 1610 and was sent to the papal court by Caravaggio after his flight from Rome, in the hope of obtaining a pardon. The torso and arm of the youthful and pensive David, an image whose iconographic precedents lie more in the field of sculpture

than of painting, are caught by a sudden flash of light that reveals the terrible, bloodstained head of Goliath, according to tradition a self-portrait of the unhappy artist. A very different kind of picture is the early *Boy with a Basket of Fruit* (1594), in which the still life betrays Merisi's northern training. It formed part

of a larger group of paintings, including another of Caravaggio's works, the *Sick Bacchus*, that were confiscated by Paul V from the studio of Cavalier d'Arpino, Merisi's first master in Rome, and then donated to Cardinal Scipione.

The four tondi by Francesco Albani depicting *Venus Dressing Her Hair*, *Venus and Adonis*, the *Triumph of Diana* and *Venus in Vulcan's Forge* (Room XIV) were executed between 1617 and 1618, before the artist's definitive return to Bologna. The first cycle of mythological landscapes painted by Albani, the tondi used to hang in one of the villa's bedrooms.

Titian, *Sacred and Profane Love*, 1514

Caravaggio, *Boy with Basket of Fruit*, 1594

Caravaggio, *Sick Bacchus*, 1593

Bottom left, Correggio, *Danaë*, c. 1531

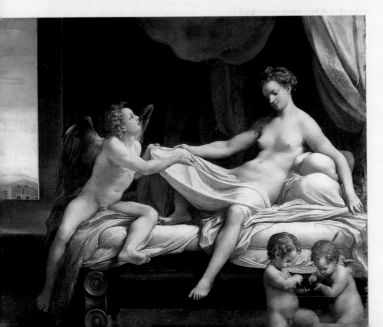

Spada Gallery

Just a short distance from the imposing and severe Palazzo Farnese stands the exuberant Palazzo Spada Capodiferro, built by the architect Bartolomeo Baronino (1511-54). Constructed for Cardinal Girolamo Capodiferro (1502-59), it was purchased in 1632 by Bernardino Spada, made a cardinal by Urban VIII. Following its acquisition by Spada the palace underwent radical alterations, though the sixteenth-century decorations

Guido Reni, *Portrait of Cardinal Bernardino Spada*, 1631

Guercino, *Death of Dido*, 1631

were preserved. One of the most significant changes was the illusionistic gallery designed by Borromini on the left side of the courtyard: barely nine meters or thirty feet long, it creates the impression of being at least four times as deep. The statuette of a warrior from the Roman era, now replaced by a copy, was only set up at the end of the gallery in 1861, by Prince Clemente Spada.

The interests in perspective and science displayed by the

learned Cardinal Bernardino and his brother Virgilio, pontifical majordomo, are also reflected in Niccolò Tornioli's painting the *Astronomers*, acquired in 1645, in which distinguished astronomers of the past and present (Aristotle, Ptolemy, Copernicus), along with a personification of Astronomy, discuss the two competing theories of the day: the Ptolemaic and the Copernican. The presence of a telescope is a homage to Galileo Galilei.

The picture gallery, now open to visitors, is chiefly the fruit of Cardinal Bernardino's collecting interests and is located in the seventeenth-century wing of the palace. Acquired by the State in 1926, the building still retains the appearance of a residence of the time, with part of its original decorations and furnishings. The works chosen by the cardinal were supplemented by another important group purchased by his great nephew Cardinal Fabrizio (1643-1717). The first room, called the "sala dei Papi," houses the *Portrait of Bernardino* by Guido Reni and donated to him by the painter himself. Guercino painted the large canvas representing the *Death of Dido*, located in the "Galleria del

Cardinale," the room that was designed in 1636-37 to house Bernardino's collection. The sumptuous contemporary costumes and the grand sweep of the composition opening onto a limpid seascape make the picture one of the Emilian artist's finest works. The same room houses Ciro Ferri's picture of the *Vestal Virgins* (c. 1670), painted in a more subdued version of his master Pietro da Cortona's style. In the room dedicated to work by the followers of Caravaggio we find Orazio Gentileschi's *David with Goliath's Head*: only partly derived from Merisi's painting of the same name now in the Prado in Madrid, the subject has been reworked in

Gentileschi's characteristic coloring. Among the works commissioned by Virgilio we find the *Revolt of Masaniello*, painted in 1648 by Michelangelo Cerquozzi with the assistance of Viviano Codazzi for the architectural setting. Representing the popular insurrection that broke out in the marketplace of Naples on July 7, 1647, it is an example of the new predilection for "perspective painting" and for scenes from the life of ordinary people.

Top right, Nicolò Tornioli, *The Astronomers*

Below, Ciro Ferri, *Vestal Virgins*, c. 1670

BIBLIOGRAPHY

Ancient Rome

R. Bianchi Bandinelli, *Roma. L'arte romana nel centro del potere*, Milan 1969.

F. Castagnoli, *Topografia e urbanistica di Roma antica*, Bologna 1969.

F. Castagnoli, *Roma antica. Profilo urbanistico*, Rome 1978.

F. Coarelli, *Roma sepolta*, Rome 1984.

P. Gros, M. Torelli, *Storia dell'urbanistica. Il mondo romano*, Rome-Bari 1988.

La grande Roma dei Tarquinii, catalogue of the exhibition edited by M. Cristofani, Rome 1990.

L. Richardson Jr., *A New Topographical Dictionary of Ancient Rome*, Baltimore 1992.

F. Coarelli, *Guide Archeologiche Laterza: Roma*, new ed., Rome 1995.

Medieval Rome

G. Matthiae, *Mosaici medioevali delle chiese di Roma*, Rome 1967.

R. Krautheimer, *Roma. Profilo di una città. 312-1308*, Rome 1981.

R. Lanciani, *La distruzione dell'antica Roma*, Rome 1986.

R. Krautheimer, *Tre capitali cristiane. Topografia e politica*, Turin 1987.

G. Matthiae, *Pittura romana del Medioevo*, Rome 1988.

E. Hubert, *Espace urbain et habitat à Rome du Xe siècle à la fin du XIIIe siècle*, Rome 1990.

E. Parlato, S. Romano, *Roma e il Lazio (Italia romanica*, vol. 13), Milan 1992.

A. Augenti, *Il Palatino nel Medioevo. Archeologia e topografia (secoli VI-XIII)*, Rome 1996.

A. Carandini, *La nascita di Roma. Dei, lari, eroi e uomini all'alba di una civiltà*, Turin 1997.

F. Gregorovius, *Storia della città di Roma nel Medioevo*, Turin 1997.

P. Delogu (editor), *Roma medievale. Aggiornamenti*, Florence 1998.

V. Fiocchi Nicolai, F. Bisconti, D. Mazzoleni, *Le catacombe cristiane di Roma*, Regensburg 1998.

Renaissance Rome

H. Voss, *Die Malerei der Spätrenaissance in Rom und Florenz*, vols. I-II, Berlin 1920.

J. Pope-Hennessy, *Fra Angelico*, London 1952.

F. Zeri, *Pittura e Controriforma. L'arte senza tempo di Scipione da Gaeta*, Turin 1957.

L. D. Ettlinger, *The Sistine Chapel before Michelangelo: Religious Imagery and Papal Primacy*, Oxford 1965.

V. Golzio, G. Zander, *L'arte in Roma nel secolo XV*, Bologna 1968.

J. Shearman, "The Vatican Stanze: Functions and Decoration," in *Proceedings of the British Academy*, 57, 1971.

C. L. Frommel, *Der römische Palastbau der Hochrenaissance*, vols. I-III, Tübingen 1973.

Umanesimo e primo Rinascimento a S. Maria del Popolo, catalogue of the exhibition edited by R. Cannatà, A. Cavallaro, C. Strinati, Rome 1980.

P. Prodi, *Il sovrano pontefice. Un corpo e due anime: la monarchia papale nella prima età moderna*, Bologna 1982.

A. Chastel, *Il sacco di Roma, 1527*, Turin 1983.

J. F. D'Amico, *Renaissance Humanism in Papal Rome*, Baltimore 1983.

Oltre Raffaello. Aspetti della cultura figurativa del Cinquecento romano, catalogue of the exhibition edited by L. Cassanelli, S. Rossi, Rome 1984.

Roma 1300-1875. L'arte degli anni santi, catalogue of the exhibition edited by M. Fagiolo, M. L. Madonna, Milan 1984-85.

Raffaello in Vaticano, catalogue of the exhibition, Milan 1984.

A. Lo Bianco, "La pittura del Cinquecento a Roma e nel Lazio," in *La Pittura in Italia. Il Cinquecento*, edited by G. Briganti, vol. II, Milan 1987.

A. Pinelli, "La pittura a Roma e nel Lazio nel Quattrocento," in *La pittura in Italia. Il Quattrocento*, edited by F. Zeri, vol. II, Milan 1987.

C. Robertson, *"Il Gran cardinale." Alessandro Farnese Patron of the Arts*, New Haven-London 1992.

Roma di Sisto V, catalogue of the exhibition edited by M. L. Madonna, Rome 1993.

P. Joannides, *Masaccio and Masolino. A Complete Catalogue*, London 1993.

C. L. Frommel, "Roma," in *Storia dell'architettura italiana. Il Quattrocento*, edited by F. P. Fiore, Milan 1998.

I. D. Rowland, *The Culture of the High Renaissance. Ancients and Moderns in Sixteenth-Century Rome*, Cambridge 1998.

Baroque Rome

R. Wittkower, *Arte e architettura in Italia, 1600-1750*, Turin 1972.

C. Strinati, "Roma nell'anno 1600. Studio di pittura", in *Ricerche di Storia dell'Arte*, 80, 1980.

F. Haskell, *Mecenati e pittori. Studio sui rapporti tra arte e società italiana nell'età barocca*, Florence 1985.

R. Krautheimer, *Roma di Alessandro VII. 1655-1667*, Rome 1987.

M. Calvesi, *La realtà del Caravaggio*, Turin 1990.

A. Zuccari, S. Macioce (editors), *Innocenzo X Pamphilj. Arte e potere a Roma nell'Età Barocca*, Rome 1990.

Roma 1630. Il trionfo del pennello, catalogue of the exhibition, Milan 1994.

Domenichino 1581-1641, catalogue of the exhibition, Milan 1996.

Pietro da Cortona 1597-1669, catalogue of the exhibition edited by A. Lo Bianco, Milan 1997.

A. Angelini, *Gian Lorenzo Bernini e i Chigi tra Roma e Siena*, Milan 1998.

Bernini scultore. La nascita del Barocco in casa Borghese, catalogue of the exhibition edited by A. Coliva, S. Schütze, Rome 1998.

Algardi. L'altra faccia del barocco, catalogue of the exhibition edited by J. Montagu, Rome 1999.

Gian Lorenzo Bernini. Regista del Barocco, catalogue of the exhibition edited by M. G. Bernardini, M. Fagiolo Dell'Arco, Rome 1999.